MADAM

&

EVE

MADAM

&

EVE

WOMEN PORTRAYING WOMEN

Liz Rideal and Kathleen Soriano

FOREWORD

Madam and Eve was conceived of as our personal views and opinions, and came out of a desire to investigate, by examining a range of artworks of women by women, what kind of impact the feminist movement of the 1970s has had on the development of contemporary art. This seems especially relevant at a time when museums and galleries, curators and art historians are re-considering, re-positioning and revealing anew the presence of women artists in their collections after centuries of relegation. As lifelong friends, little did we imagine the differences that our own experiences – one of us as artist, the other curator – would bring to our selection of artists and images. The ten-year age gap between us defined a unique aesthetic sensibility and appreciation in each of us, as did our varying perspectives of the feminist revolution of the 1960s and subsequent waves of feminism. One of us experienced formative teenage years in the late 1960s (from Jimmy Hendrix to Mary Quant), the other in the late 1970s (from The Osmonds to Punk); one is single, one is married; one is a mother, the other not; these facts also helped carve out distinct identities that influenced our choices more than we had anticipated. In making the selection, we first plundered the knowledge gained through our collective 70 years of working in the art world. As we worked on the project, having firmly established the concept of women artists portraying women since 1970, relevant material emerged from everywhere, resulting in a mountain of fascinating imagery that fitted our criteria. This material, in one way or another, helped us to develop our themes, and was noticeably eye-catching, poignant, powerful, political, idiosyncratic, ludic, awkward, passionate, sexy, positive and, in our judgement, good.

Through discussion, research and visual analysis, the amassed images gravitated towards the subject areas that evolved into the chapters of the book: Body, Life, Story, Death and Icons. At that point we began the difficult process of elimination, with a limited number of vetoes permitted to each author. Once the images had spoken, then began the ping-ponging of texts between us as we built and shaped our responses, descriptions and arguments, which culminated in a self-imposed purdah at a women writers' retreat in rural Warwickshire.

The publication of this book comes 50 years after the game-changing unfurling of a protest banner that read 'Women's Liberation', by the feminist group New York Radical Women at the 1968 Miss America pageant, and aims to celebrate the work of many women artists since that time. *Madam and Eve* acknowledges a debt to the significant feminist art-historical theory of the last half-century, but is primarily a visual celebration, with a Western focus, that reflects our own experiences and encounters. By nature of the themes, the selection has a predisposition to the figurative, although on occasion it strays into the conceptual. In gathering our artists, we set ourselves some ground rules: each artist should be represented by one work only, regardless of the breadth and range of their output, and no male figure should feature. We have taken liberties with the gender of Death, which surely must be in question, but felt less able to make exceptions for God or the baby Jesus. Finally, works co-produced by female and male artists have been excluded, unless there is a clear sense of unique female authorship as part of that process. The impact of gender fluidity and changes in sexuality form the current and next revolutions in our world, deserving deeper examination in time. *Madam and Eve*, to a degree, attempts to recognize the impact that such developments are already making.

Overall, we have attempted to broaden the canon by choosing a large percentage of artists who are probably less familiar to a general audience. With an emphasis on artists from the late twentieth and early twenty-first centuries (with the exception of the historical overview in the introduction), our wide selection of works suggests a remarkably fluid, globalized art world in which artists share some common interests and forms of cultural exchange. Our intention is to provide a range of work rather than to create a hierarchy of women artists in conflict with male-dominated art history. Using what we believe are manageable overarching themes and jargon-free language to highlight the variety and quality of contemporary artists, we hope that the book will appeal to a broad range of readers, whatever their gender.

Liz Rideal and Kathleen Soriano

A HISTORICAL FRAMEWORK

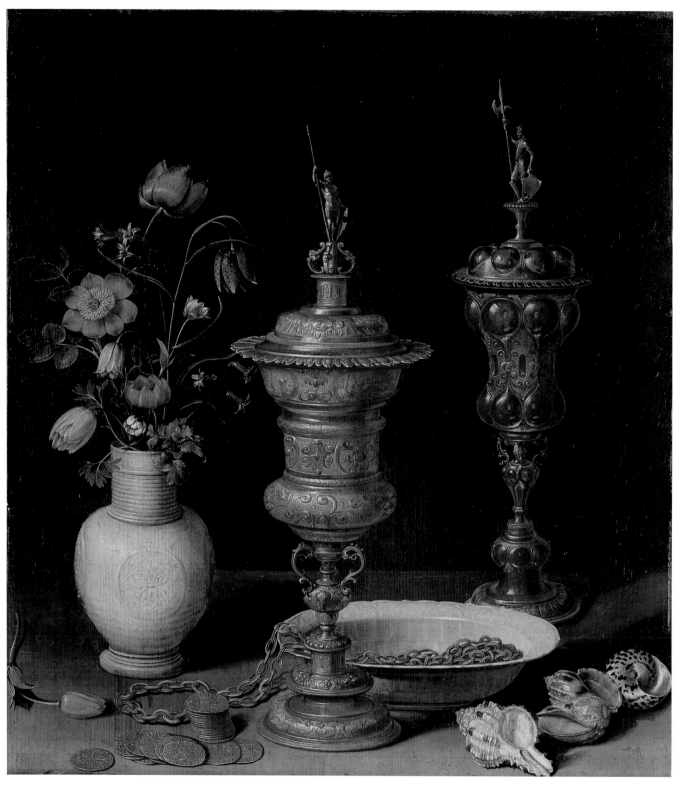

Clara Peeters (fl.1607–21)
Still Life with Flowers and Gold Goblets, 1612
Oil on wood, 59.5 x 49 cm (23⅜ x 19½ in)
State Art Gallery, Karlsruhe

*My womanhood is intrinsic to my work,
as a male artist's manhood is intrinsic to his. The difference
between men and women is inalienable. It is not a political
fact subject to cultural definition and redefinition but
a physical verity. We do truthfully experience our lives
differently because our bodies are different. It is in what we
do with our experience that we are the same. We feel, absorb
and examine with the same intensity, and intense experience
honestly examined informs the art of both sexes equally.*

— Anne Truitt (1997)

Clara Peeters' clever, covert self-portrait in this still-life painting encapsulates a sly iteration of identity and skill that many women still recognize in their own behaviour and that of others of their sex. Given the widely accepted patriarchal bias of art history, and of society in general, women artists typically employ a variety of methods to claim their place in the world and draw attention to their own visual perspectives. To a casual eye, this still life is a sumptuous array of seventeenth-century objects that signify life's luxuries. By drawing attention to them, Peeters communicates that these are but temporary goods, and so reminds us of the certitude of ever-present death – but look closely at this vanitas painting and you will see her reflected face on both honour cups. This is her signature, displayed in tandem with her public achievement; the celebration in paint of the natural and the man-made.

Much has been written about the position of women artists within the history of Western European art. This introduction provides a brief historical overview, considering works from 1500 to the present day, to give the concept of the book – images of women created by women, using the lens of the last 50 years – a clearer perspective, and to set it within a broader context. At our specific moment in time, when gender itself is viewed as having increasing fluidity, a further wave of feminism appears to be manifesting itself, and as the art museum and gallery sector focuses more closely on its own role in society, the subject requires further scrutiny. As art historian Linda Nochlin has observed, 'what is important is that women face up to the reality of their history and of their present situation. Disadvantage may indeed be an excuse; it is not, however, an intellectual position. Rather, using their situation as underdogs and outsiders as a vantage point, women can reveal institutional and intellectual weaknesses in general, and, at the same time that they destroy false consciousness, take part in the creation of institutions in which clear thought and true greatness are challenges open to anyone – man or woman – courageous enough to take the necessary risk, the leap into the unknown.'[1]

A Historical Framework

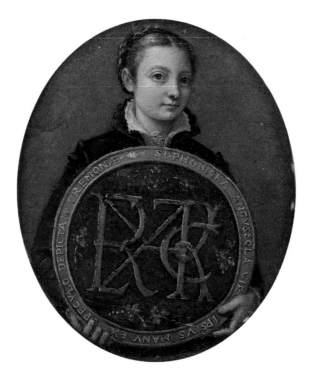

Sofonisba Anguissola (1532–1625)
Self-Portrait, c.1556
Varnished watercolour on parchment, 8.3 x 6.4 cm (3¼ x 2½ in)
Museum of Fine Arts, Boston

Sofonisba Anguissola produced more self-portraits than any artist active in the period between Albrecht Dürer and Rembrandt van Rijn, and cleverly used this vehicle to practise and advertise her skills. Painted when she was around 24 years old, this miniature on vellum shows the sitter holding a medallion inscribed in Latin around the rim. The inscription translates as: 'The maiden Sofonisba Anguissola, depicted by her own hand, from a mirror, at Cremona.' She holds it like a shield, the entwined letters a monogram of her father's name. There is a pleasing balance between the oval of the miniature, the roundness of the 'shield', her position within the space behind it and her ability to depict hands – the tools of her trade.

In the late 1550s, Anguissola famously painted her self-portrait as if it was painted by her teacher, Bernardino Campi, thereby documenting the master-pupil relationship. As art historian Whitney Chadwick has written, this was 'perhaps the first historical example of the woman artist articulating the complex relationship between female subjectivity and agency, its positioning within patriarchal structures of knowledge, and the role of woman as an object of representation'.[2] Anguissola's talents found a home when she became a painter and lady-in-waiting at the Spanish court from 1559 to 1573. Singled out by

sixteenth-century writer Giorgio Vasari for comment in his *Lives of the Most Excellent Painters, Sculptors and Architects* (1550), he noted that she 'executed by herself alone some very choice and beautiful works of painting'. She was also visited and painted by Anthony van Dyck in 1624 – further confirmation of her special position within artistic society.

Making art is a risky venture and the few known women painters from the sixteenth century are justly fêted as exceptions to the rule. Lavinia Fontana, a native of Bologna, Italy, came, like many recognized artists of this time, from a family of painters. In this work she employs the tropes of the time to create a beautiful yet standard portrayal of the mythological goddess Minerva in the process of dressing, armour at the ready. It is a charming genre piece, typical of the period. The idea of subject matter for painting being both prescribed and reiterated might seem anathema to us today, but it was not so then. Regarded as the first professional woman artist who worked outside the confines of a convent or the patronage of a court, she painted in a variety of genres, including portraiture (typically acceptable for women), mythological, such as this nude, and religious works. Fontana died in Rome, having been elected to the Academy of St Luca in an accolade for her professional status.

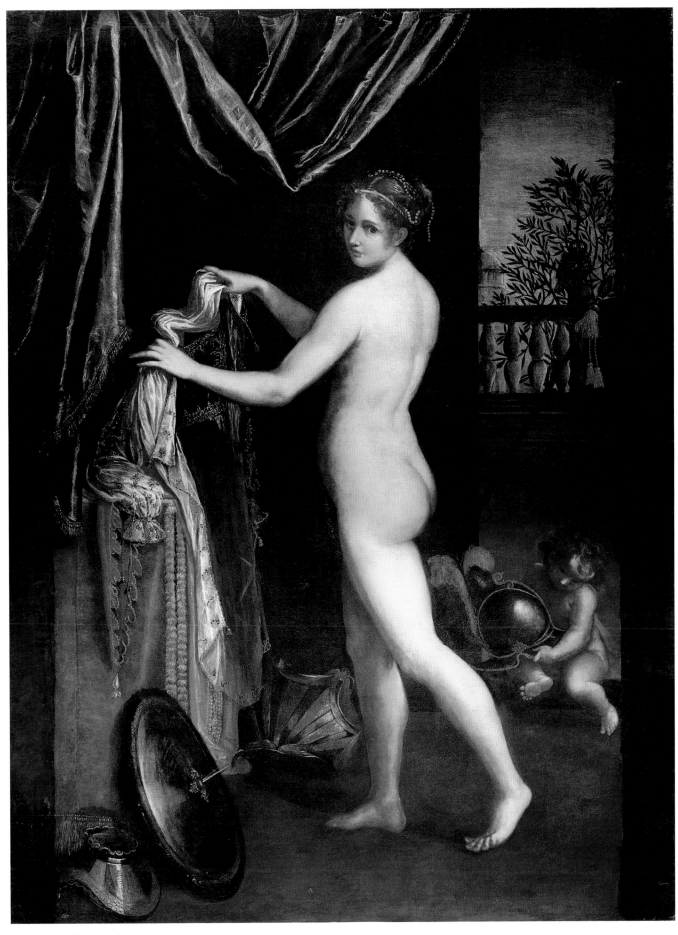

Lavinia Fontana (1552–1614)
Minerva Dressing, 1613
Oil on canvas, 154 cm x 115 cm (60⅜ x 45¼ in)
Galleria Borghese, Rome

A Historical Framework

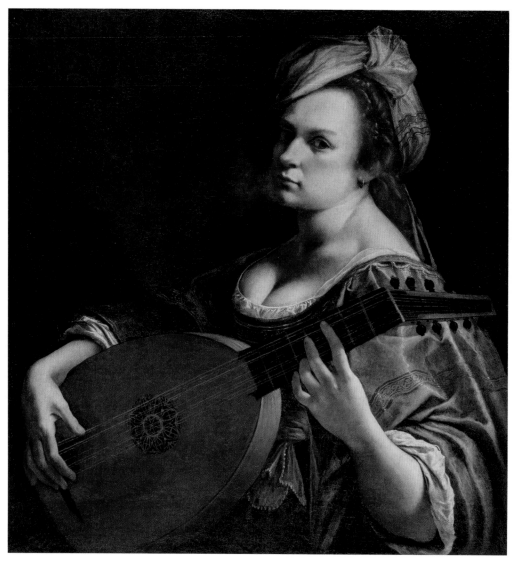

Artemisia Gentileschi (1593–c.1656)
Self-Portrait as a Lute Player, c.1615–18
Oil on canvas, 77.5 x 71.8 cm (30½ x 28¼ in)
Wadsworth Atheneum Museum of Art, Hartford

Artemisia Gentileschi's well-documented history
as the daughter of a well-known artist and the victim
of a rape by her teacher Agostino Tassi, has often
overshadowed her reputation as a great painter.
Here, she shows herself playing the lute; a clear allusion
to the traditional skills and attributes of a cultured
woman of the time. The sophisticated composition,
with the dramatically lit figure in *contrapposto*
(a counterpose that twists the upper body and thrusts
it forward), places the lute in the foreground in
order to show off the skilled rendering of her hands.
However, the deep bosom holds the centre of this
classic triangular configuration of a portrait within
a square, an unusual format even at that time.

The fact that most women artists at this time stemmed
from artistic backgrounds makes sense, for once
they were absorbed into the family trade, it was deemed
normal and desirable for women to practise their
painterly skills. Tintoretto's daughter Marietta
Tintoretto, like Gentileschi, learned painting in her
father's studio. She could also have been a musician,
but excelled in portraiture; her growing fame, however,
was arrested by marriage to a silversmith, and her
talents were then employed to portray the members of
that guild. In 1633 Judith Leyster's self-portrait further
clarified the female artist's position by showing herself
at work, with palette and brush, on a genre portrait
of a man smiling and playing the violin. Her painting
confirmed that she was earning her living as an artist,

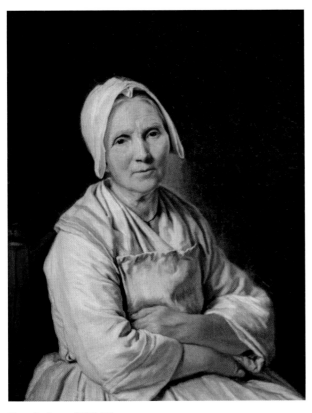

Françoise Duparc (1726–78)
The Old Woman, date unknown
Oil on canvas, 78 x 64 cm (30¾ x 25¼ in)
Musée des Beaux-Arts, Marseille

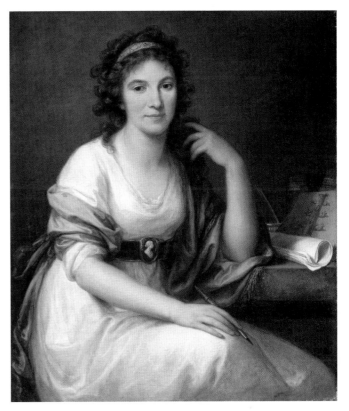

Angelica Kauffmann (1741–1807)
Ellis Cornelia Knight, 1793
Oil on canvas, 96 x 80 cm (37¾ x 31½ in)
Manchester Art Gallery

and was proud of this accomplishment and ready to advertise the fact. Like Gentileschi, Leyster was acknowledged as an artist of note, but her marriage to painter Jan Miense Molenaer curtailed her activities. Until 1893, many of Leyster's paintings were thought to be by Frans Hals, despite containing her distinctive signature, the initials J and L crossed by a star, which had often been over-painted.

In the Low Countries, religious imagery started to be replaced with other secular genres, thanks to the rising middle classes and their financial power. The fashion for flower painting matched the growing 'tulipomania' craze, and in the late seventeenth and early eighteenth century Rachel Ruysch's exquisite bouquets paved the way for Jan van Huysum to make his own career in painting flowers, which, together with portraiture, was often seen as a feminine domain. Despite seeming a 'second-class' genre, from the fifteenth to the twenty-first centuries women artists such as Giovanna Garzoni, Maria Sibylla Merian, Margaretha Haverman, Anne Vallayer-Coster, Marianne North and Charlotte Verity have developed the field and made it their own, specifically linking it to academic botanical study.

Artists' stories lay the foundation for the territory that *Madam and Eve* explores, and through them – since

paintings created by women were often attributed to men and then sometimes became 'masterpieces', re-attributions adding to the conundrum – overt subjectivity and ingrained prejudices are exposed. The parameters of art have changed radically in the last 50 years, and the idea of 'greatness' in art has evolved to include art that is innovative, interesting, provocative and less male-centric. Such changes in attitude relate to the social and financial developments that are reflected in fashions in painting. The eighteenth-century knowledge disseminated through Denis Diderot's vast *Encyclopedia, or Dictionary of the Arts and Sciences* resulted in a shift of what was deemed viable subject matter and, ultimately, to the appearance of homely genre pictures. This working woman at rest, with her apron and plain cap, is a character portrait. Painted by Françoise Duparc who worked near Marseille, it confirms a new understanding of social hierarchies and the classification of these strata. Painting here offers a view of a brave new mechanized world populated by those who work and play in it at all levels.

Angelica Kauffman, Swiss by birth and trained in Italy, had an instinctive understanding of how to move within, and up through, the prescribed social layers of the time. This portrait of a fellow artist and writer, with

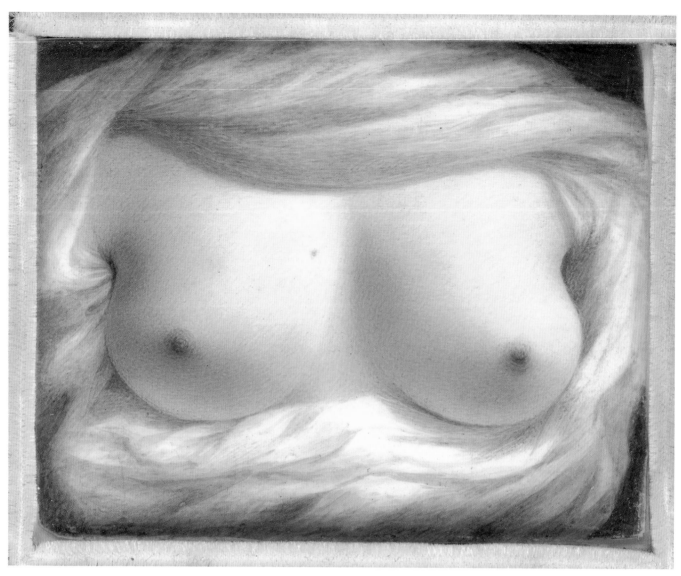

Sarah Goodridge (1788–1853)
Beauty Revealed, 1828
Watercolour on ivory, 6.7 x 8 cm (2⅝ x 3⅛ in)
Metropolitan Museum of Art, New York

her pen and paper, is painted in Kauffman's mature style and shows the sitter in a *robe en gaulle* (a simple, loosely fitted muslin gown). The self-portrait cameo of the artist on the sitter's belt testifies to their friendship. Famously one of only two women included as founding members of the Royal Academy of Arts, London, Kauffman was a child prodigy and was just as talented in music as she was in art. She spoke German, French, English and Italian and knew the art historian Johann Joachim Winckelmann, the writers Johann Wolfgang von Goethe and James Boswell (who described her as 'musician, paintress, modest, amiable'), and the artist Joshua Reynolds. Her gifts, hard work and ambition invited both admiration and jealous criticism.

Sarah Goodridge was one of nine children of a Massachusetts farmer and, along with her sister, decided that she would pursue the life of an artist.

Her miniature portraits were so in demand that it was not long before she was able to support herself and several family members. *Beauty Revealed* was a private gift created for the married American Senator Daniel Webster, who had sat for her at least 12 times between 1827–51. Lover's-eye miniatures are well known, but this unusual update of the genre is strikingly original and resonant, and our assumptions about the strictly moral Victorian climate appear to clash with the brazen naturalness of this observation in paint on ivory.

Autodidact Elisabeth Louise Vigée Le Brun depicts Marie Gabrielle de Gramont, the Duchess of Caderousse in this commission. Like Kauffman, Le Brun was skilled, charming, pretty and ambitious, the necessary mixture of 'attributes' for women to succeed at that time. Here, in the painting of her friend, Le Brun uses portraiture as a vehicle to display her skill in still-life

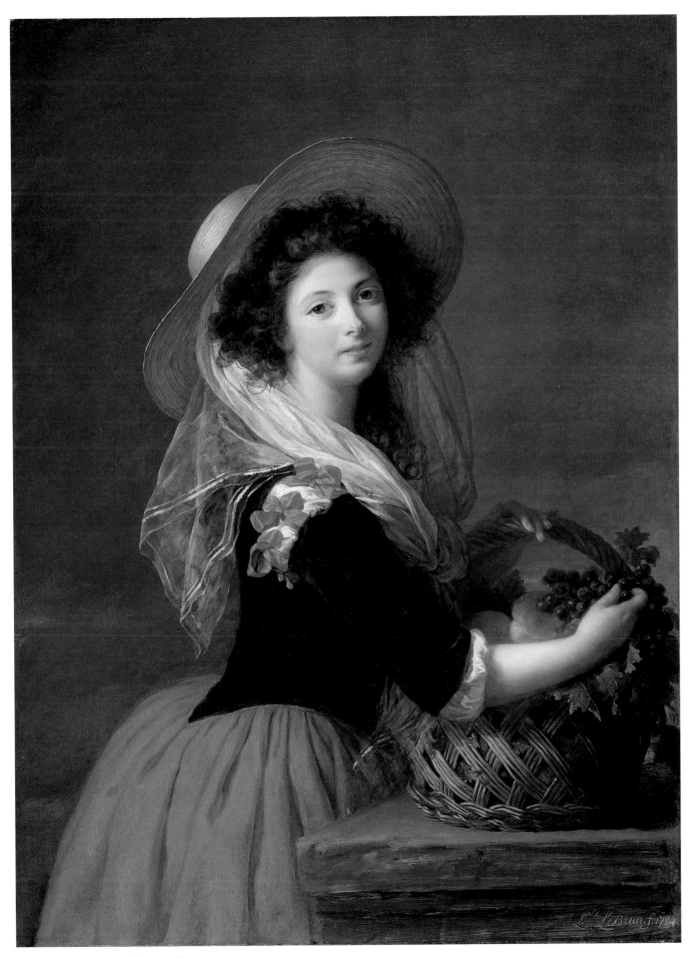

Elisabeth Louise Vigée Le Brun (1755–1842)
Portrait of Marie Gabrielle de Gramont, Duchesse de Caderousse, 1784
Oil on wood panel, 105.1 x 75.9 cm (41⅜ x 29⅞ in)
Nelson-Atkins Museum of Art, Kansas City

A Historical Framework

Elizabeth Southerden Thompson, Lady Butler (1846–1933)
Elizabeth Southerden (née Thompson), Lady Butler, 1869
Oil and pencil on card, 21.9 x 18.1 cm (8⅝ x 7⅛ in)
National Portrait Gallery, London

painting, coordinating the red of the sitter's skirt with the blush-red of the peaches and expensive grapes in the basket. The fashion for rustic simplicity, as illustrated in her dress, is quoted in recognition of her friend Queen Marie Antoinette, whose patronage was useful when in power, but dangerous at the time of the French revolution. The intrepid Le Brun was obliged to flee the country and found work in the courts of Italy, Austria, Germany and Russia, painting over 600 portraits in her lifetime.

The invention of the romantic artist living alone in a garret was not an avenue of existence open to women – it would have been social suicide. Instead, they were identified as producers of genteel watercolours, a skill considered an asset within the marriage-brokering system. Nineteenth-century art education prolonged this situation and while the two World Wars could be regarded as incentives for a new position of the woman artist, the same negative perceptions remained.

Elizabeth Southerden Thompson, Lady Butler, known as Mimi Butler, had a privileged and liberal upbringing that ensured that her passion and ambition for painting could be realized, and she went on to make a unique contribution to the genre. Her unusual choice of subject matter was not pretty flower arrangements, but the military: thundering horses, men in uniform and bloody battle scenes. This claim to history painting brought her stupendous success and when her painting of a battle-weary battalion of Grenadier Guards, *The Roll Call,* was exhibited at the Royal Academy of Arts in 1874, police were stationed on guard in order to control the jostling, admiring crowds. Queen Victoria purchased the work and the artist's status was sealed. Butler married an army officer, travelled throughout the Empire with him, bore six children and continued with her commitment to painting. Compared to the complexity of the military landscape set pieces, her portrait appears modest and private.

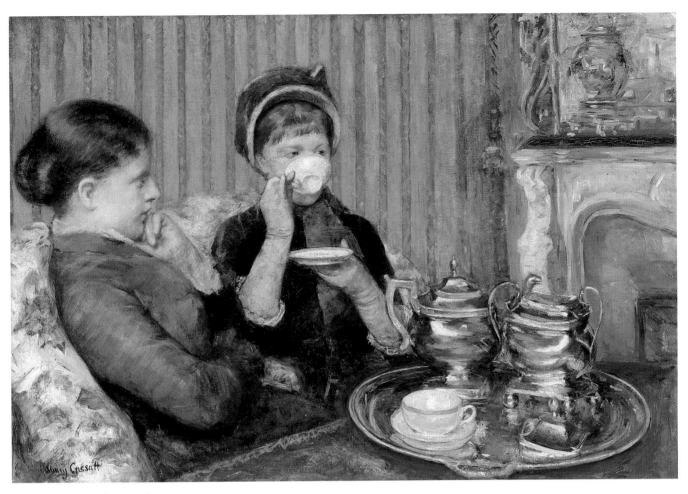

Mary Stevenson Cassatt (1844–1926)
The Tea, c.1880
Oil on canvas, 64.8 x 92.1 cm (25½ x 36¼ in)
Museum of Fine Arts, Boston

Political change at the beginning of the nineteenth century segued with invention and innovation to create the atmosphere for social advancement. The discovery of a variety of ways to fix a photographic image in the 1820s caused an artistic sensation and a profound transformation in the way that the world was perceived and art was made. The camera liberated painting, influenced portraiture and allowed women a new voice. Technical advancements, such as the reproducible photographic image, heralded a revolution in the arts, and artists were excited about compositional effects such as cropping the image. The Impressionists, already painting *en plein air* thanks to the collapsible paint tube, co-opted new effects like distorted perspectives and points of view from the camera eye. This mechanical instrument became a reference tool and many women found themselves able to earn a living through it. Although Julia Margaret Cameron only started taking pictures when she was 48 years old, she went on to become one of the leading photographers of the

nineteenth century. She determined to create an equivalent to George Frederick Watts' 'Hall of Fame' series and took his advice on portraiture, developing the 'out-of-focus' image that would go on to distinguish her signature style.

Mary Cassatt's polite afternoon tea, set in Paris where she worked, evokes a society of ribbons, bustles and restriction, both social and intellectual, but this work also describes a burgeoning new climate of female liberation. Cassatt suggests intimacy and simultaneous separateness. Here, the partaking of tea represents a universe of new ideas, knowledge and revised attitudes at a time of major social changes in fashion, wealth and status, even the development of liberating modes of transportation, like the bicycle. The puffed-up cushion supports the figure on the left and is a foil to her dull brown clothes, while the signal stripes of wallpaper remind us that this is a contemporary interior with an upbeat message. It is modern for the

A Historical Framework

Elizabeth Alice Austen (1866–1952)
Self, Julia Martin and Julia Bredt, October 15, 1891
Black and white photograph
Collection of Historic Richmond Town

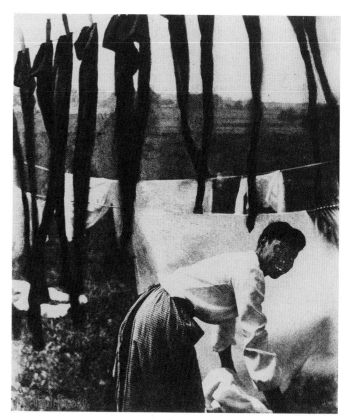

Gertrude Käsebier (1852–1934)
Black and White, 1903
Gum bichromate print, 21.1 x 17.5 cm (8¼ x 6⅞ in)
Museum of Modern Art, New York

time and 'impressionistic', though to present-day eyes it might seem to communicate a static, oppressive and claustrophobic world.

It is notable that many of the women in this introduction had supportive relationships with artist family members or male artist friends who helped draw attention to the quality of their work. Artists such as Mary Cassatt, a close friend of Edgar Degas; Kauffman, supported by Reynolds; and Gentileschi, working alongside her father Orazio, all benefitted from these alliances. However, the association could be double-edged: on the one hand, the female artists were relegated to the second division after their male counterparts, but on the other, their association brought them professional attention.

While French ladies were taking tea in Paris, on Staten Island during the same period Elizabeth Alice Austen (known as Alice) was recording the upper and lower classes in New York, together with her own particular predilection for dressing up in men's clothes. Her chemistry professor uncle had introduced her to photography and it became her lifelong devotion. The speed with which images could be made with a camera facilitated this human desire to dress up. After the Wall Street crash of 1929 left her penniless, over 3,500 of her glass negatives went to the local historical society and emerged by dint of pure circumstance in the form of a Picture Press research project into American women in 1950. Austen's fortunes were reversed, and the sales from her work permitted a more salubrious retirement in an old people's home.

Minna Keene (1861–1943)
Malay Laundry, 1906
Black and white photograph, 21.2 x 28.2 cm (8⅜ x 3⅛ in)
Royal Photographic Society/National Museum of Science & Media

This trend for rediscovery and re-evaluation of artistic merit has taken hold in today's art market, especially for women artists when their estates can be exploited financially. Furthermore, late fame for women has become a new route to recognition, as a result of detective work by art historians who wish to redress the balance of knowledge of artistic output of the time. These actions continue to broaden discussions around previously accepted historical perspectives, and thus reinstate and celebrate earlier achievements that may have been overlooked.

Other American women photographed workers, updating the eighteenth-century genre scenes and focusing on action. Gertrude Käsebier's image is a social comment: the black worker is silhouetted against the white sheets and surrounded by a black vertical prison of paired stockings on the line. Women's work, as the dictum goes, is never done, and another photograph of the life of a laundry maid provides further comparison of social situations as well as an insight into the development of the late nineteenth- and early twentieth-century photographic art movement called Pictorialism, which emphasized beauty. Minna Keene took this picture of a laundry run by Malays in Cape Town, South Africa, in 1906. The peaceful workers belie the realities of their repetitive work, and the gently filtered light lends a romantic air.

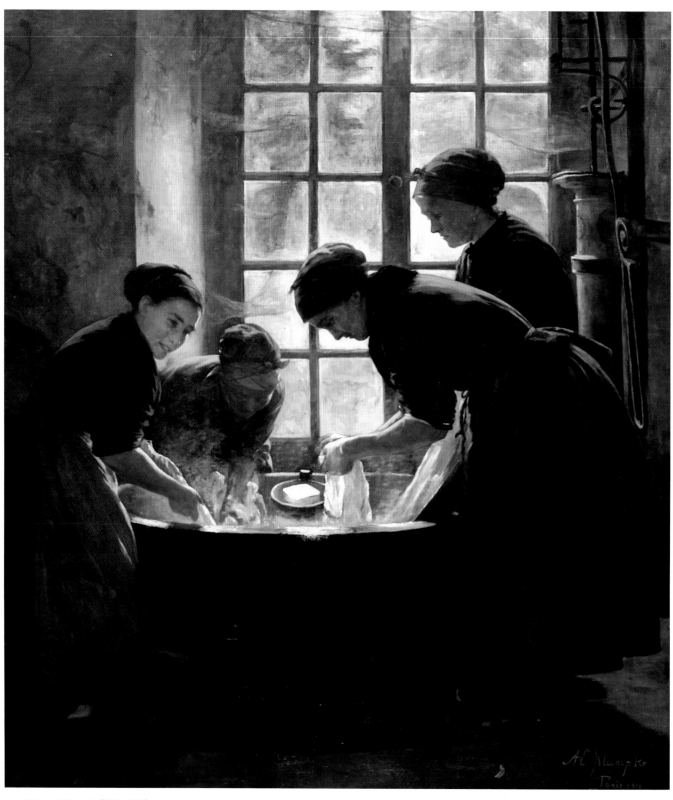

Anna Elizabeth Klumpke (1856–1942)
In the Wash-House, 1888
Oil on canvas, mounted on wood, 200.7 x 170.2 cm (79 x 67 in)
Pennsylvania Academy of the Fine Arts

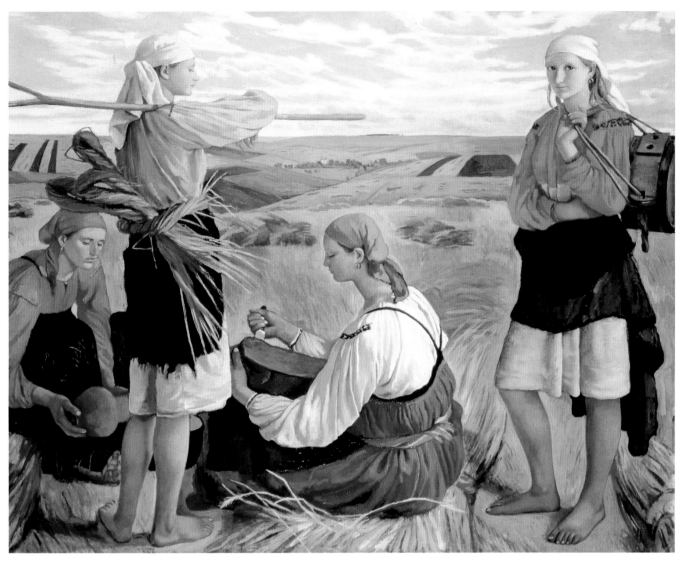

Zinaida Serebriakova (1884–1967)
The Harvest, 1915
Oil on canvas, 142 x 177 cm (56 x 70 in)
State Art Museum, Odessa

Anna Elizabeth Klumpke's painting *In the Wash-House* of 1888 reiterates the theme of girls happy together in collective effort. Round-skirted, capped and aproned workers bend over a barrel tub full of soap suds that glow in light reflected though the window shown in *contrejour* (with the light source behind it). Their compositional complicity is intense, and their silent concentration amounts to an almost religious fervour of teamwork. This fantasy has little to do with chapped hands and backache and all to do with romance.

Russian women artists leading up to, and at the time of, the 1917 revolution graduated to the centre of artistic developments. Zinaida Serebriakova's painting *The Harvest* shows women at work again, but this time in the fields. Serebriakova was related to the renowned artistic Benoit clan, and is now becoming more recognized as Russian oligarchs seek to invest in homegrown talent. Other artists connected to the Russian avant-garde such as Lyubov Popova, Varvara Stepanova and Alexandra Exter contributed

new approaches and ideas to the burgeoning artistic movements of Constructivism, Suprematism and Rayonism, creating work across the board in a variety of media. These three artists belonged, along with Alexander Rodchenko and Alexander Vesnin, to OBMOKhU: the Society of Young Artists. They were committed to presenting work as a collective, and combined easel painting with sculpture and applied arts. Like Henri Matisse, Popova came from a family involved in the textile business and produced abstract designs for fabric, in addition to paintings and theatre design. Popova's work here illustrates the fact that she, like Marcel Duchamp, was simultaneously investigating Cubist-style figuration (see p.24).

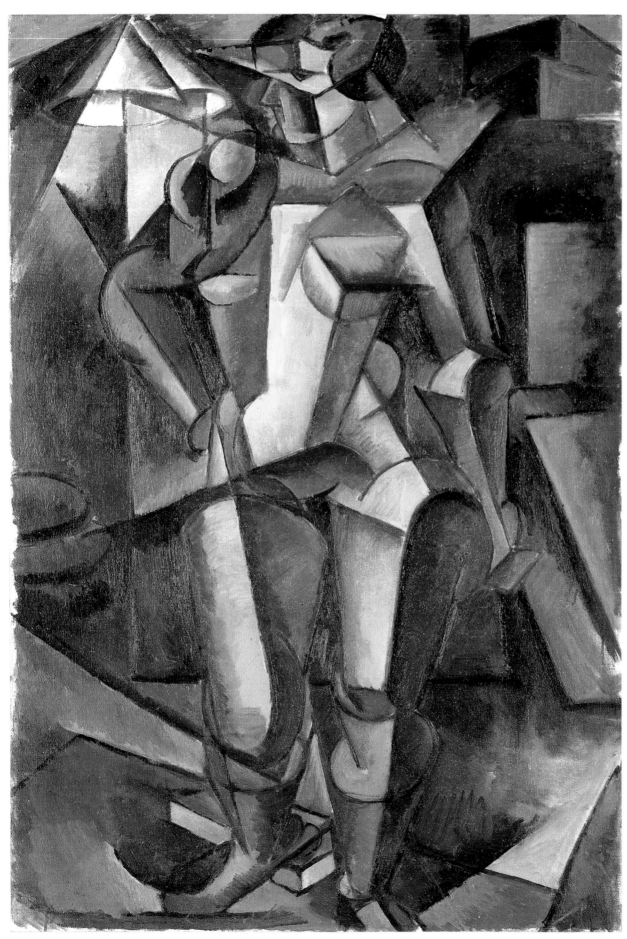

Lyubov Popova (1889–1924)
The Model, 1913
Oil on canvas, 106 x 71 cm (41¾ x 28 in)
State Tretyakov Gallery, Moscow

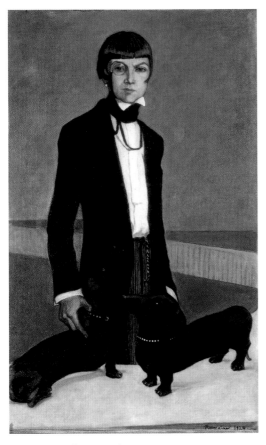

Romaine Brooks (1874–1970)
Una, Lady Troubridge, 1924
Oil on canvas, 127.3 x 76.4 cm (50⅛ x 30⅛ in)
Smithsonian Institution, Washington DC

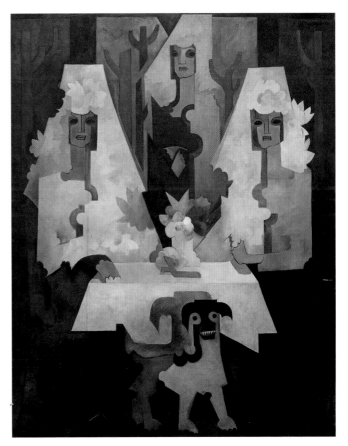

Natalia Goncharova (1881–1962)
Autumn Evening (Spanish Women) 1922–28
Oil on canvas, 260.3 x 199.5 cm (102½ x 78½ in)
State Tretyakov Gallery, Moscow

In the early twentieth century, while the Russians were building towards their revolution, the British were experiencing the militant tactics of the suffragettes who formed the Women's Social and Political Union in 1903 to force a change in the law and a right to vote, with the motto 'Deeds not Words'. As a result, in 1918 the vote was given to women over the age of 30 (with certain restrictions), and in 1928 to those over the age of 21. War consolidated changes in the perception of women's capabilities, but this progress was promptly negated in the post-war era.

The wearing of a suit brings connotations that are immediately challenged when a woman dons the uniform, as evidenced in Romaine Brooks's portrait of *Una, Lady Troubridge,* made in 1924. Lady Troubridge's elegance prefigures the introduction in 1966 of 'Le Smoking' tuxedo for women by Yves Saint Laurent, which was scandalous at the time but led the way for more androgynous female dressing. The stiff white shirt, monocle, angular short hair and loyal pair of dachshunds configure a triangular, stark and quietly aggressive portrait. Alumnus of the Royal College of Art, sculptor, translator of Colette and

partner to famous lesbian author Radclyffe Hall, Brooks's painting presages those by Alice Neel in terms of clarity and power.

Natalia Goncharova was a celebrated Russian Constructivist who extended her artistic influence into the theatre, where she worked with Diaghilev and the Ballets Russes. A controversial figure in Moscow and St Petersburg, known as much for wearing traditional male clothing or appearing topless in public (perhaps a Russian predeliction, revived today by Pussy Riot's performances) and publishing manifestos in 1913 and 1914, in addition to mounting her own one-woman exhibitions. While travelling to Spain with the Ballets Russes, Goncharova experienced an epiphany, producing a prodigious amount of work in which she discovered a strong affinity with that country, its music and culture, possibly heightened by its peasant life, work and riotous festivals. The three stylized ladies featured in *Autumn Evening (Spanish Women)* wear traditional Seville *feria* (festival) headdresses and, despite their sedate posture, recall Picasso's *Les Demoiselles d'Avignon* (1907). The trusty dog has something of the horned bull about him.

A Historical Framework

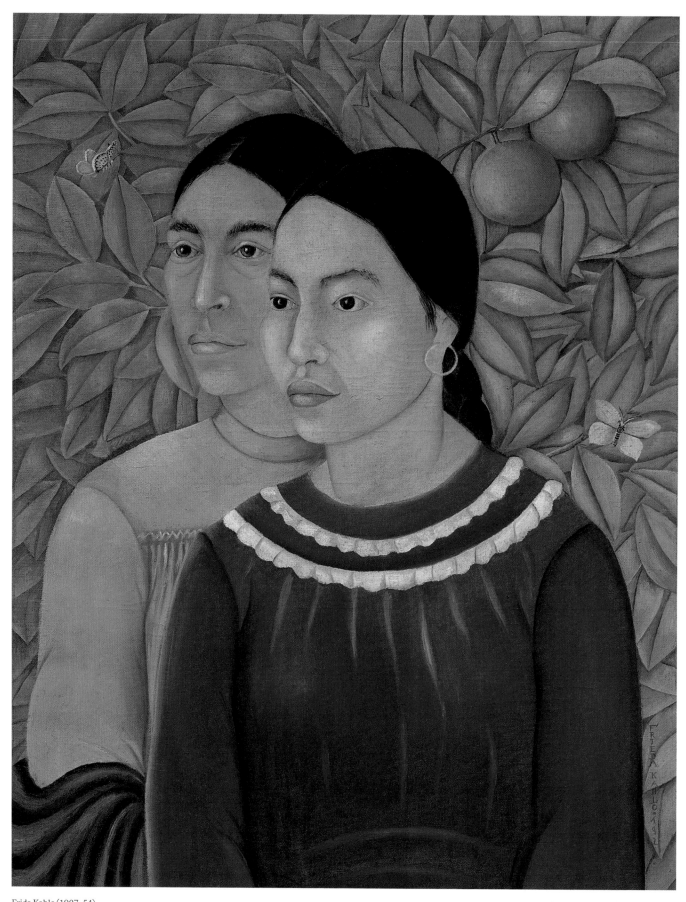

Frida Kahlo (1907–54)
Dos Mujeres (Salvadora y Herminia), 1928
Oil on canvas 69.5 x 53.3 cm (27⅜ x 21 in)
Museum of Fine Arts, Boston

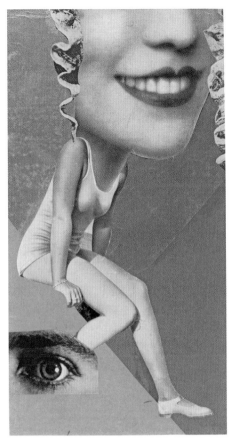

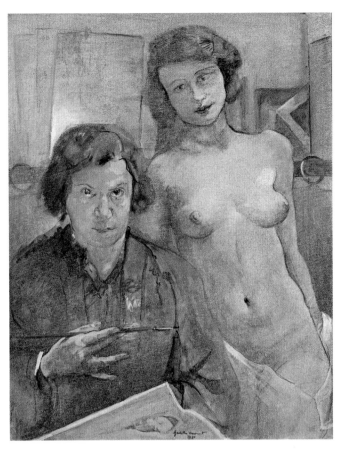

Hannah Höch (1889–1978)
Made for a Party, 1936
Collage and photomontage, 36 x 19.8 cm (14⅛ x 7¾ in)
Institute for Foreign Cultural Relations, Stuttgart

Charlotte Berend-Corinth (1880–1967)
Self-Portrait with Model, 1931
Oil on canvas, 90 x 70.5 cm (35⅜ x 27¾ in)
National Gallery, Berlin

An exponent of extreme examples of self-portraiture, which include images of her own birth, Frida Kahlo also depicted a range of other subjects, including her husband, the artist Diego Rivera, in paintings that often included imagery celebrating Mexican folklore. In *Dos Mujeres (Salvadora y Herminia),* she portrays two women who worked at her mother's house. The maids are shown against a backdrop of lush greenery set with two butterflies as counterpoints to a pair of perfectly round fruit. This work was the first painting ever sold by Kahlo, and her working-class subjects have an independent stature of their own. There is a pleasing symmetry about the painting: both sets of black eyes in the three-quarter profile gaze into the distance, silent but with neutral expressions that convey mountains of knowledge and experience.

Hannah Höch was an artist who exhibited at the First International Dada Fair in Berlin in 1920. Her work became synonymous with the practice of photomontage, a method of working also used by John Heartfield, in critical response to the crushing Fascistic politics of the German state. Höch's aesthetic, expressive use of this practice includes colour, scale, juxtaposition and print in order to subvert the accepted

functions of the picture plane, and injected a new understanding about the possibilities of pictorial space. Deft and witty, though deemed lightweight because she worked in the medium of paper and glue, she updated the medium, which had been made famous in the eighteenth century by the formidable Mary Delany, creator of remarkable, intricate flower découpage and member of the women's social and educational movement, the Blue Stockings Society. Höch's later work was consistently self-reflexive and this insistence on self-portraiture is common to many women artists, often for the practical reason that modelling for oneself is convenient, available 24 hours a day, and free.

The inclusion of both model and the artist in the image is a device that draws attention to both passive and active roles. Painted when she was 53 and still in Germany, Charlotte Berend-Corinth is significantly older than her model, who could be her daughter, who was 24 years old when this was painted. Both stare straight at the viewer, their unflinching gaze and hairstyles similar. The work is set in the studio, the backdrop full of rectangles that contrast with the natural forms of the subjects. The artist's hand with poised brush is particularly effective, adding tension

A Historical Framework

Olga Della-Vos-Kardovskaia (1875–1952)
Portrait of Anna Akhmatova, 1914
Oil on canvas, 86 x 82.5 cm (33⅞ x 32½ in)
State Tretyakov Gallery, Moscow

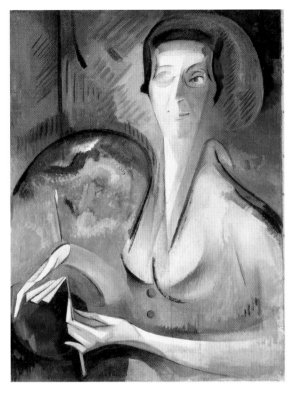

Alice Bailly (1872–1938)
Self-Portrait, 1917
Oil on canvas, 81.3 x59.7 cm (32 x 23½ in)
National Museum of Women in the Arts, Washington DC

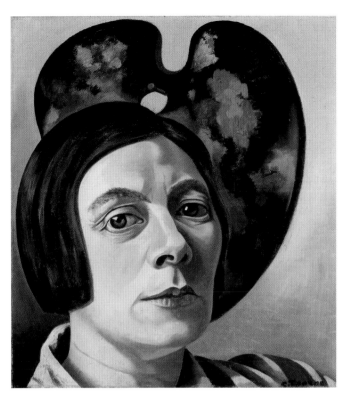

Charley Toorop (1891–1955)
Self-Portrait in Front of a Palette, 1934
Oil on canvas mounted on plywood panel, 45.6 cm x 40.3 cm (18 x 15⅞ in)
Kröller-Müller Museum, Otterlo

to the scene. Berend-Corinth joined her husband's name to hers when she married her teacher, Louis Corinth, in 1903, becoming his model and the mother of their two children. Active in the Vienna Secession, her work was subsumed by her life with Corinth, even after his death in 1925, as she was left to manage his estate. Despite this, she retained artistic independence, was head of a school of painting in Berlin, had a retrospective at the Galerie Nierendorf in 1930 and, after emigrating to the USA in 1933, set up her own art school in Santa Barbara in 1943.

Olga Della-Vos-Kardovskaia's painting of revered poet Anna Akhmatova combines a sense of grace with determination. The uncompromising profile set against an expressionist sky and landscape accords her regal pose, verve and energy. Akhmatova's life was one of political persecution, and her partner and son were imprisoned during the 1930s. Her Modernist poem *Requiem* (1935–61), was first published in Munich in 1963, and became her best-known work. It was regarded as a lament for the victims of Stalin's revolution.

Alice Bailly knew many of the avant-garde artists of her time, including Fernand Léger, Francis Picabia and Marie Laurencin. Her self-portrait encapsulates the vast range of painting influences that she experienced in her life. It fuses Cubism, Futurism and Fauvism, yet, despite this medley, there is a great pulse of originality about the painting. The conventional inclusion of the palette, which confidently clarifies her profession, is elegantly incorporated and echoed in the colourful sweep above her head.

Charley Toorop's work, by contrast, avoids the suggestion of the dreamlike atmosphere evoked by Bailly's grey shadows and ambiguous forms. She was the daughter of Symbolist painter Jan Toorop, and her grandmother was of Javanese/Chinese extraction. Toorop's work is clear cut and delineated, and serious despite the inference here that the palette behind her head is some kind of bizarre hat-fascinator. The gaze is a direct, challenging stare. She specialized in this brand of vivid self-portraiture, documenting her ageing face 18 times over the years.

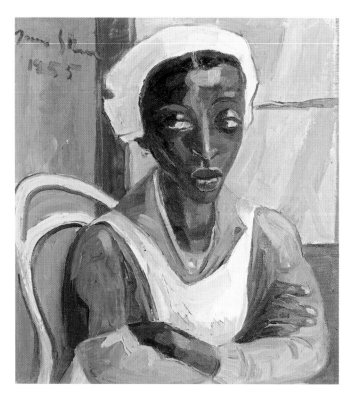

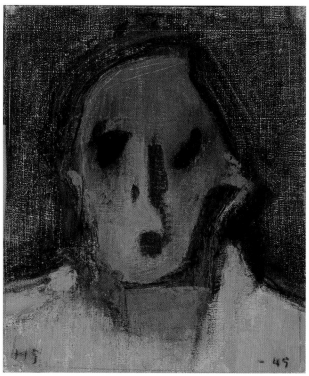

Irma Stern (1894–1966)
Maid in Uniform, 1955
Oil on canvas, 69 x 63 cm (27⅛ x 24¾ in)
Irma Stern Museum, Cape Town

Helene Schjerfbeck (1862–1946)
Self-Portrait (An Old Painter), 1945
Oil on canvas, 36 x 23 cm (14⅛ x 9 in)
Courtesy John Lindell, Helsinki

Similarly avant-garde, though less obvious and fêted, is this image of a housemaid by South African Irma Stern, who trained in Germany and was clearly influenced by the German Expressionists, having her first exhibition in Berlin in 1919. A year later she returned to live in Cape Town, where she continued to paint for the rest of her life and her art gained currency in the 1940s. This delicious combination of straightforward portraiture, combined with a focus on a beautiful woman dressed in a maid's uniform who, with her arms folded, appears defiant and bored at the same time, reminds us of Françoise Duparc's painted servant (see p.15). She is quite a character, with her glowing globe eyes, her pointed chin, an apron that echoes the form of the white painted bentwood chair, and a spotless cap. The emphasis on white, a symbol of cleanliness, contrasts with the drudgery of repetitive dirty work. These ideas are pivotal to how we interpret the painting, and the importance of uniform and clothing in relation to the recording images of women's lives and jobs is vital.

Finnish painter Helene Schjerfbeck made innumerable self-portraits during her long life, culminating in this near-abstract *Self-Portrait (An Old Painter)*. Floating between dream and reality, her works repeat a format while changing the emphasis of mood and composition using colour and brush texture. Here, the pallid skin recalls a staged Pierrot figure, while the ghostly, ghoul-like stance suggests phantom of her former self.

Famous for creating *Object* (1936), the furry cup and saucer that epitomizes the Surrealist ethos, and for being the model at the printing press in Man Ray's *Untitled* (*Meret Oppenheim 'Veiled Erotic'*) of 1933, Meret Oppenheim was an original firebrand working across media. Her niece recalled a conversation with her about having children, during which she said, 'You know, you can be a complete woman without having children!' and also stated 'There's no such thing as male art or female art. Art is androgynous.'[3] This proud self-portrait has her face inscribed like a warrior, a fierce stare daring the viewer to look away. Although the title includes the word 'tattoo' (which also refers to drumming), the pattern on her face appears to be gouged out rather than inscribed, reflecting her fascination with indigenous masks, and her feather earrings take us towards Native American territory. The fabric of her clothing is pierced, echoing the punctuations on her forehead, which emphasize the effects of age on her face; she is in her late sixties here.

Artists like Anguissola and Oppenheim created more than one self-portrait, enabling us to track their ageing process. However, the self-portrait is frequently the province of the young artist, who is trying to find their style or investigate the psychoanalytical perspectives of artistic life and find practical solutions to the issues that arise in figure painting. It is also an opportunity to flag up independence and assert ownership, stylistic invention and new ways of creating art itself.

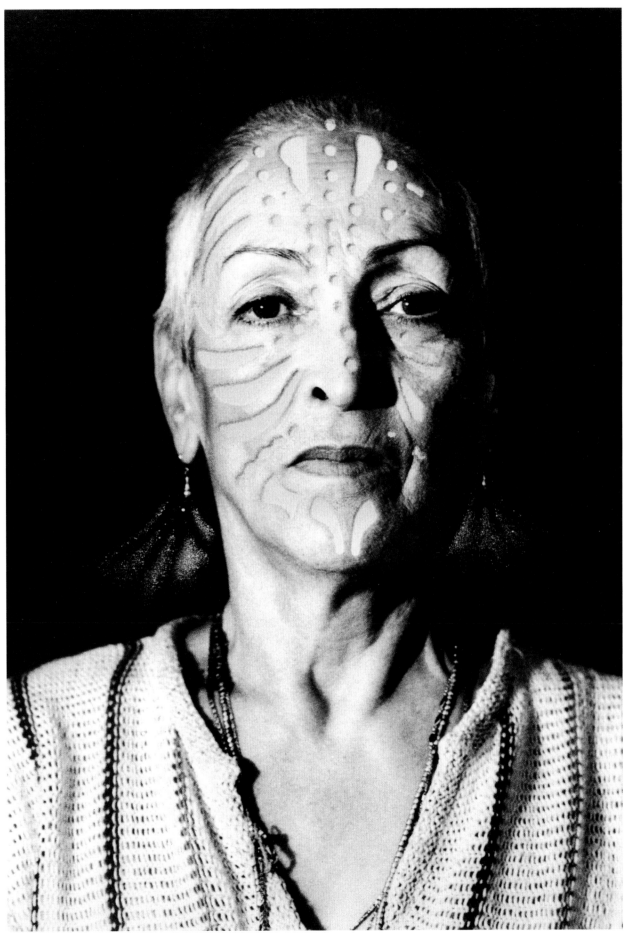

Meret Oppenheim (1913–85)
Portrait with Tattoo, 1980
Stencil and paint on photograph, 29.5 x 21 cm (11⅝ x 8¼ in)
Museum of Fine Arts, Bern

A Historical Framework

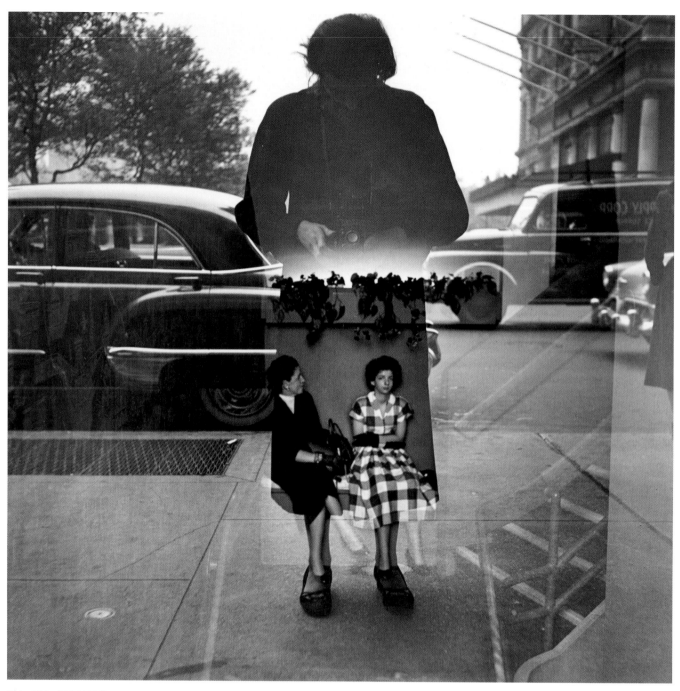

Vivian Maier (1926–2009)
New York City, September 10, 1955
Black and white photograph, 30.5 x 30.5 cm (12 x 12 in)
Courtesy Howard Greenberg Gallery, New York

Vivian Maier had neither formal training in photography nor peer support within the discipline. She operated alone while working as a professional nanny and left behind a cache of over 100,000 images taken between 1950 and 1990. These had been shown to no one, and remained a private record documenting her view of the world until she failed to continue payments for the storage of her images and the entire archive was sold. Many of the images were ultimately put online, leading to her current fame. This abrupt termination of a life's work chimes well with her thoughts about the end of life itself: 'We have to make room for other people. It's a wheel – you get

on, you go to the end, and someone else has the same opportunity to go to the end, and so on, and somebody else takes their place. There's nothing new under the sun.'[4] This particular photograph is a highly complex orchestration of diverse elements, in which she skilfully juggles perspective and double reflection, as she does in much of her work. She is central within the picture frame and, acting like a puppeteer, she incorporates the legs of her subjects into her own, cleverly coraling the feet so that she becomes a giant and they Liliputians within her domain. Reflective surfaces, even if they are just the bathroom or dressing table mirror, are essential props of self-portraiture. The mirror is key for Venus

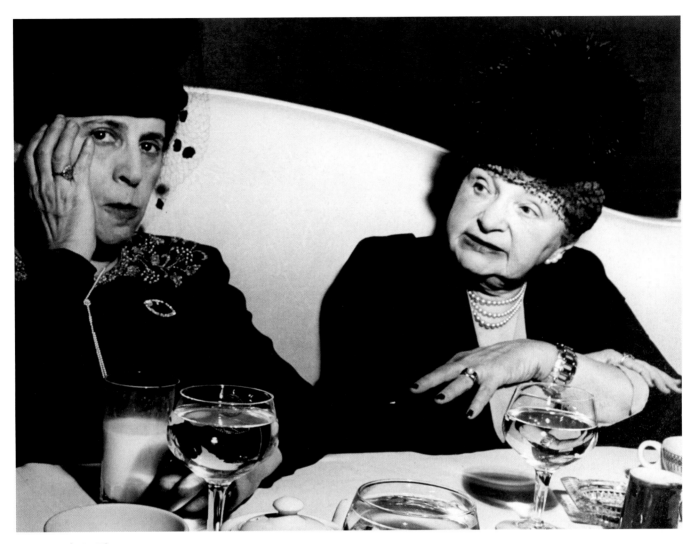

Lisette Model (1901–83)
Fashion Show, Hotel Pierre, New York, c.1940–46
Photograph, gelatin silver print on paper, 40 x 49.5 cm (15¾ x 19 1/5 in)
Courtesy Bruce Silverstein Gallery, New York

and Narcissus, mythological figures that populate art history, and for women, in particular, it is a requirement for the application of make-up and an important part of continual self-scrutiny. Shop windows also allow for the inclusion of contextual backdrops and provide a supporting narrative.

Lisette Model studied music with Arnold Schoenberg when growing up in Vienna, but turned to photography in 1933. Her iconic photographs of figures on the Promenade des Anglais, Nice, later made her name. She lived in Paris, and then emigrated to the USA, where her work was published in *Harper's Bazaar*. Photographer Berenice Abbott was a friend and Diane Arbus a pupil. Her eye was compassionate yet candid; the good, the bad and the ugly are caught in her view and, like Maier, she recorded humanity on the street. Model also lacked formal training, yet from 1951 she taught photography in New York, urging students never to take a photograph of anything they were not

passionately interested in. Model felt that the snapshot came closest to the truth precisely because of the lack of control and openness to imperfection. This photograph embodies the great sympathy she had for her subjects: she managed to let her characters shine while being honest about their foibles. We can recognise this attitude in, for example, her well-known image of an enormous ball of a woman joyously rollicking in the sea (*Coney Island Bather, New York*, 1939–41) and in these two old dames – the odd couple – dressed up to the nines and out on the town: bejewelled, drinking and confident. The lady on the left looks us straight in the eye, her dark irises punching black holes that echo the spots on her hat net. The work is titled *Fashion Show, Hotel Pierre, New York* – are they viewing new outfits or are they on parade with their seed pearls and pompoms, embroidery and nail varnish? The details captured in sharp focus bring them back to life seventy years on.

A Historical Framework

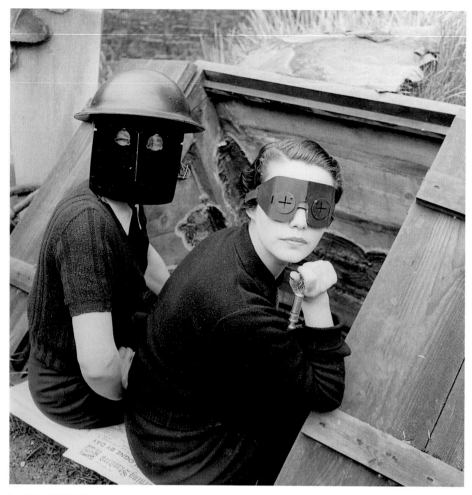

Lee Miller (1907–77)
Fire Masks, Downshire Hill, London, England, 1941
Black and white photograph
Courtesy Lee Miller Archives

Lee Miller's photography sits within the realm of photojournalism. In this image, she portrays these women in wartime as if they were modelling some new fashion. The surreal element may owe something to the time she spent in Man Ray's Parisian studio. The photograph was taken during the Blitz, and the women are sitting on a copy of the *Evening Standard* on the steps of Miller's own air-raid shelter in Hampstead, London. Definitely humorous, the way the whistle is held in a manicured hand with painted nails is a characteristic touch. Miller was the only female combat photographer during the Second World War, and on 29 April 1945, while on active service with her colleague David E. Scherman, she documented the horrors of Dachau and Buchenwald concentration camps. It was only after her death that some 60,000 of her prints and negatives were found in her attic. In a letter to Roland Penrose, her husband, with news of her pregnancy, Miller had joked, 'Let me know how you feel about being a parent – sure you want it? and why? There's only one thing – MY WORKROOM IS NOT GOING TO BE A NURSERY. How about your studio? HA HA.'[5]

Laura Knight's double portrait shows one figure staring out of the frame engaging the viewer, while the other appears almost oblivious to the artist's scrutiny, echoing the relationship of Model's sitters. This work is typical of Knight's style: the frank portrayal of people, firmly placed in the context of their jobs by uniform and equipment (a gas mask is casually slung over a chair back). The detailing of shiny buttons, coloured honour stripes, earphones, pencils, measures, map and notepaper (pink and white), is super. Serious and in control, both with lips reddened at the ready, these two women have gravitas. In fact, both sitters earned medals for bravery: when the RAF station in Biggin Hill, Kent, was attacked by enemy bombers, they continued to run the switchboard and telephones despite the building being hit and catching fire. In 1929 Knight was created a Dame of the British Empire, and in 1936 famously became the first woman elected to the Royal Academy since its foundation in 1768. Despite this, she was never allowed to attend its all-male annual dinner. In 1946 she documented the war crimes trials in Nuremberg, Germany.

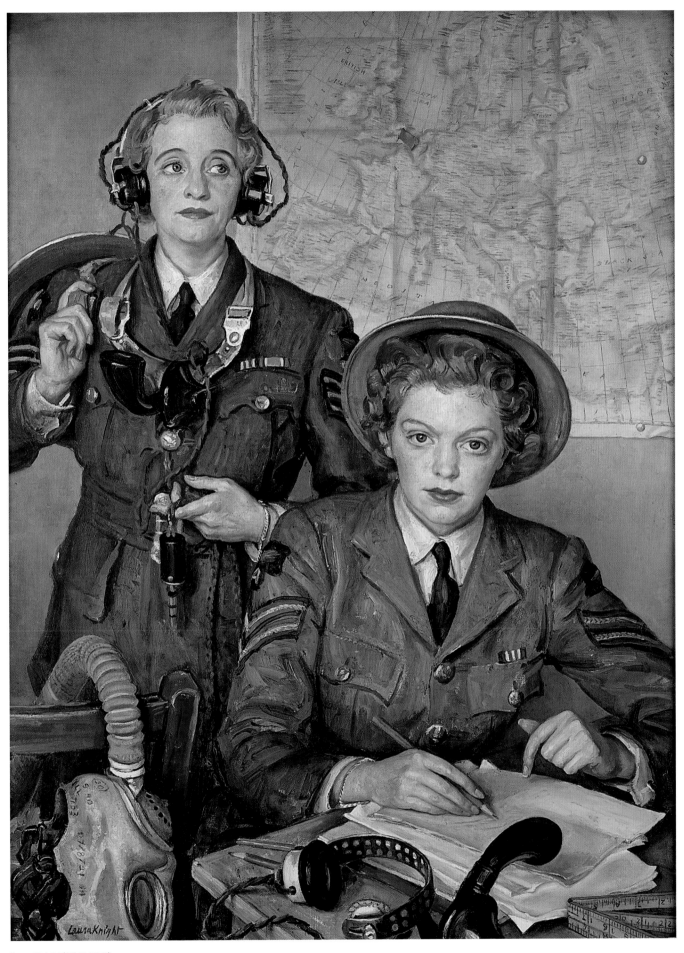

Laura Knight (1877–1970)
Corporal Elspeth Henderson and Sergeant Helen Turner, 1941
Oil on canvas, 114 x 81 cm (45 x 32 in)
Courtesy of Royal United Services Institute, London

A Historical Framework

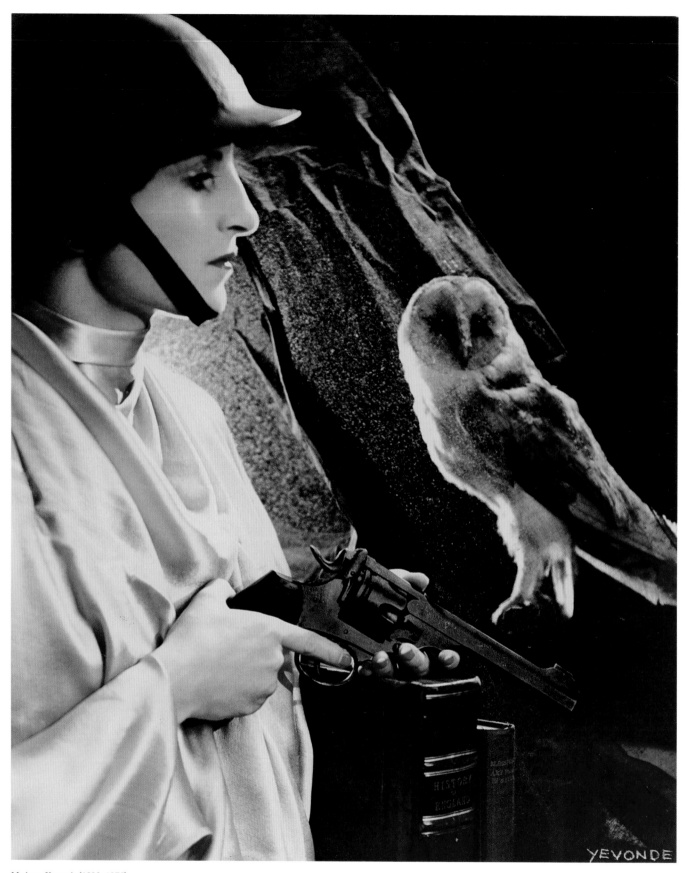

Madame Yevonde (1893–1975)
(April) Aileen Freda Balcon (née Leatherman), Lady Balcon as Minerva, 1935
Photograph, Vivex colour print, 34.2 x 27 cm (13½ x 10⅝ in)
Yeronde Portrait Archive

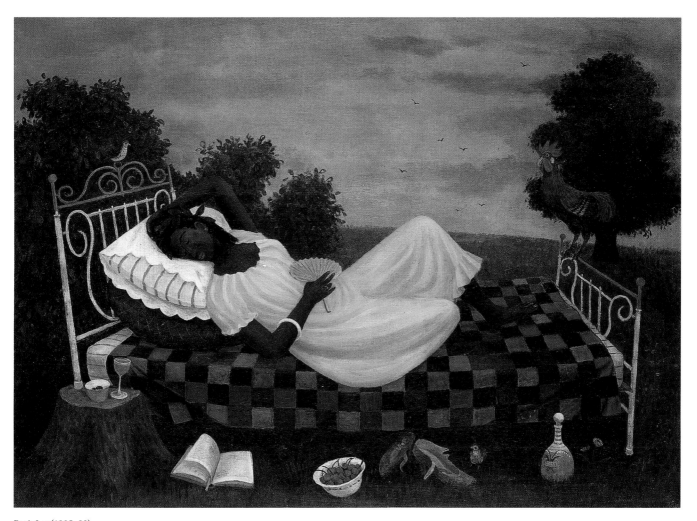

Doris Lee (1905–83)
Cherries in the Sun (Siesta), c.1941
Oil on canvas, 68.6 x 91.4 cm (27 x 36 in)
National Museum of Women in the Arts, Washington DC

Madame Yevonde said that, 'Women as a rule make better photographers than men, possessing to a greater degree … personality, tact, patience, and intuition … and of course, their inherent knowledge of clothes and eye for detail is great asset in a profession.'[6] This photograph by Madame Yevonde (née Yevonde Cumbers Middleton) shows the sitter in the guise of Minerva, the Roman goddess of war and wisdom, as well as the patron of learning and the arts and crafts. The accoutrements of helmet and gun refer to war, and the books and stuffed owl signify wisdom. Yevonde's colourful (she used a new Vivex Carbro printing process) and surreal 'Goddesses' series is a blend of imaginative fantasy with the real-life commissioning process. The original impetus came

from the Olympian Party, a charity ball in aid of the blind held at Claridge's Hotel on 5 March 1935. Curator Robin Gibson suggested in his 1990 catalogue, 'It is a fair assumption that one or more of the ladies attending the party presented themselves at her studio to be photographed in their costume and either inspired the project or cooked it up together with her.'[7]

Doris Lee's 'goddess' in *Cherries in the Sun* is more relaxed and shown in a private world of her own, a delicious scene of *dolce far niente* (sweet idleness) that invades the imagination. Lee worked as a muralist and for *Life* magazine, for whom she travelled widely, recording life in Cuba, Mexico and North Africa. She also painted scenes of American rural life.

A Historical Framework

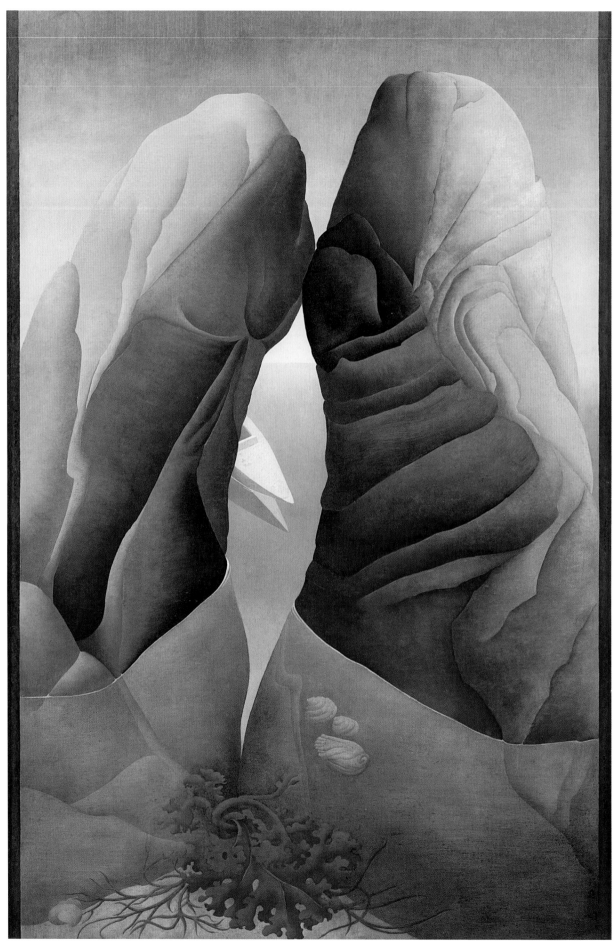

Ithell Colquhoun (1906–88)
Scylla, 1938
Oil paint on board, 91.4 x 61 cm (36 x 24 in)
Tate, London

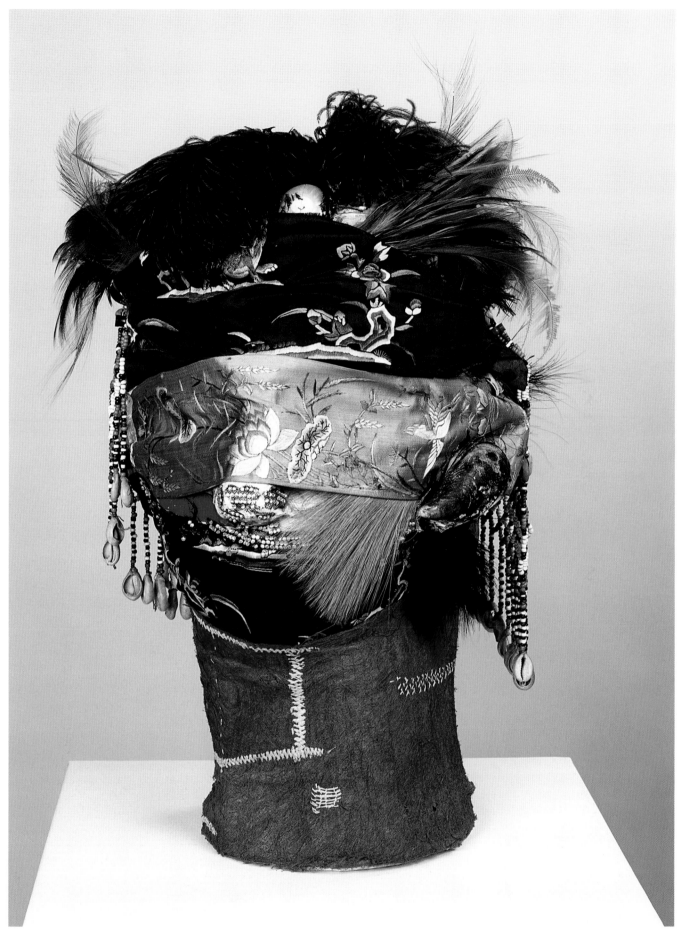

Eileen Agar (1899–1991)
Angel of Anarchy, 1936-40
Plaster, fabric, shells, beads, diamante stones and other
materials, 52 x 31.7 x 33.6 cm (20½ x 12½ x 13¼ in)
Tate, London

A Historical Framework

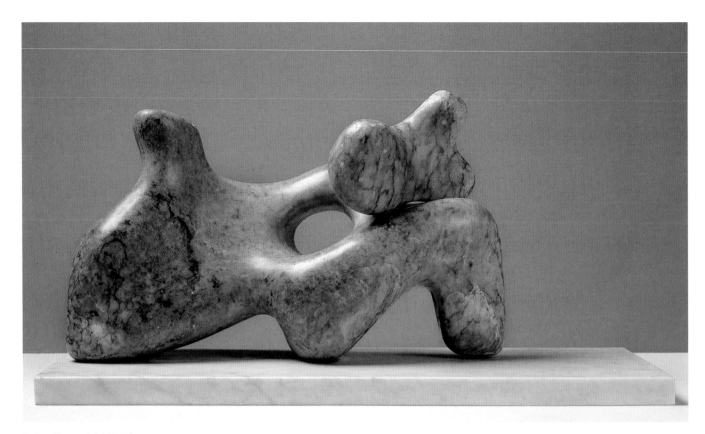

Barbara Hepworth (1903–75)
Mother and Child, 1934
Cumberland alabaster, 23 x 45.5 x 18.9 cm (9 x 18 x 7½ in)
Tate, London

Dada and Surrealism found a British home in the work of Ithell Colquhoun and Eileen Agar, both of whom trained at the Slade School of Fine Art. Both of these works are remarkable and innovative in their own ways, and could also be read as types of self-portraits. They are unique, elegant visualizations that are clever, strong and bizarre, and neither is what they purport to be. Colquhoun was a Surrealist, writer and occultist who worked across media and technique, and the title of her *Scylla* conjures up the maritime dangers of the rocks and whirlpools of Scylla and Charybdis in Homer's *Odyssey*. Scylla was originally a beautiful nymph who had been transformed into a monster by the jealous Amphitrite. In the painting, the thighs masquerade as rocks while seaweed nestles between the 'legs' like soft fronds of pubic hair as a boat approaches. The artist said, 'It was suggested by what I could see of myself in a bath … it is thus a pictorial pun, or double-image'.[8] Agar's Parisian sojourn, from 1928 to 1930, also propelled her into the world of Surrealism. This wrapped head was possibly inspired by her visits, with the sculptor Henry Moore, to view ethnographic sculpture in the British Museum, and is a good example of the freedom of her three-dimensional work. She was the only British woman artist to exhibit in the 1936 *International Surrealist Exhibition* in London.

Barbara Hepworth's small alabaster sculpture is a quintessentially period piece, the abstracted figure reclining with an object that looks like a toy balanced on the bent knee, representing the child – but it was, for its time, a very modern statement. It is an elegant form, reminiscent of a drawing in space that has been translated into three dimensions. Hepworth used a technique of direct carving into stone, emphasizing the simple organic shape and linking by process and format to primitive, ancient sculptures. In 1934 she gave birth to triplets, following the birth of a son in 1929, and one can assume that her personal experience would have informed this work.

Carol Rama's *Dorina* is an exuberant and dynamic work by an artist whose first exhibition, in 1945, was closed by police for indecency. Rama, who claimed that she made art to heal herself, was largely untrained. Her early works, inspired by the Dada movement and Marcel Duchamp, responded to her mother's incarceration in a mental hospital, and her fetishization of the rubber tubing used in her artworks may well allude to her father, a bicycle manufacturer, who committed suicide. It is hard to know from this image whether the 'snake', with its many connotations, is emerging or being inserted.

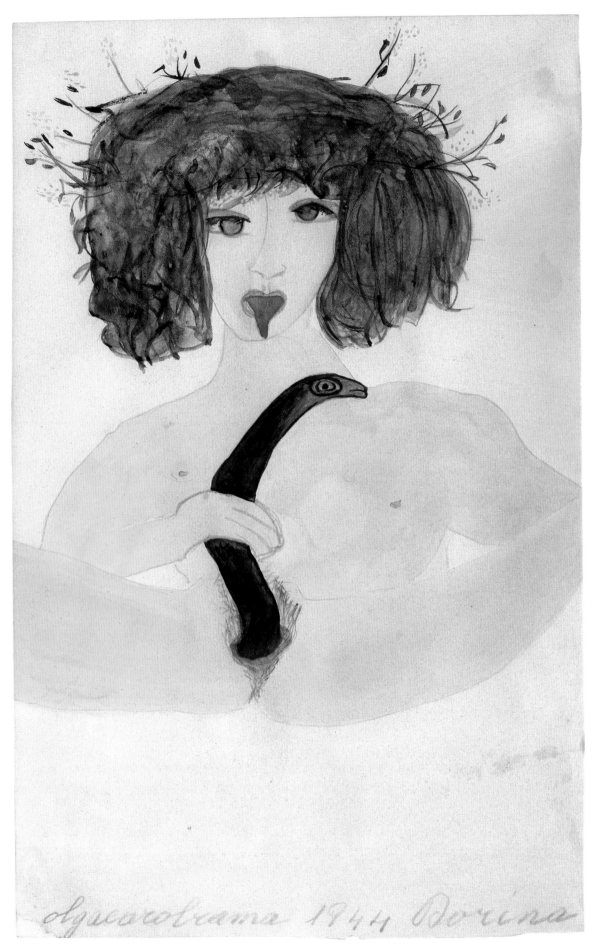

Carol Rama (1918–2015)
Dorina, 1944
Pastel and watercolour on paper, 24.5 x 15 cm (9⅝ x 5⅞ in)
Carol Rama Archive, Turin

41

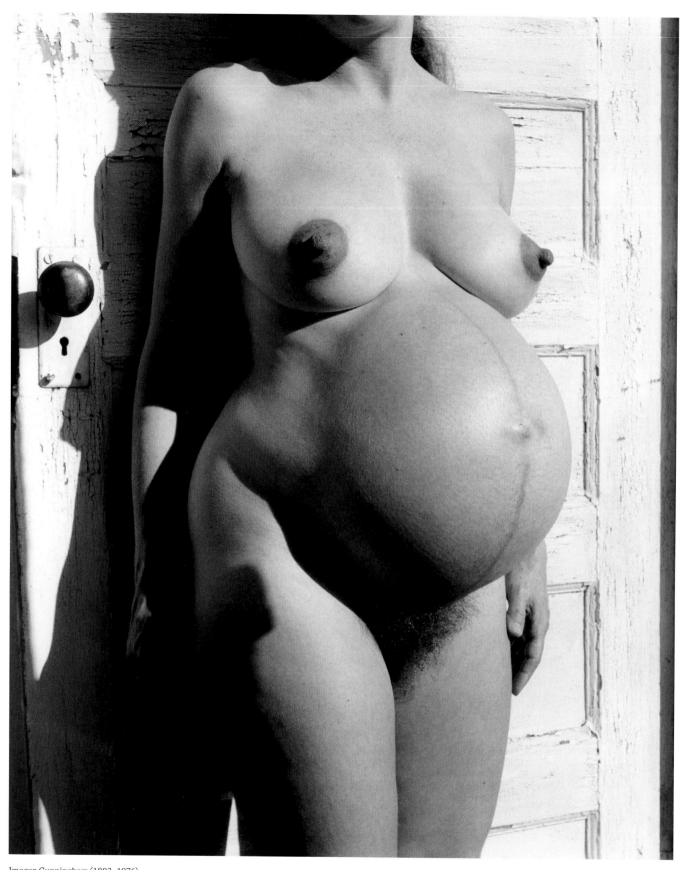

Imogen Cunningham (1883–1976)
Pregnant Nude, 1959
Photograph, gelatin silver print, 24.1 x 19.1 cm (9½ x 7½ in)
Imogen Cunningham Trust

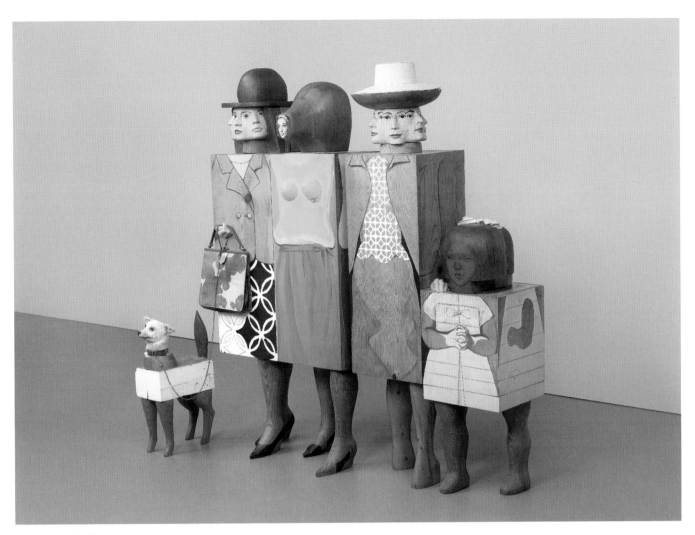

Marisol (1930–2016)
Women and Dog
Wood, plaster, synthetic polymer and taxidermied dog head,
186.8 × 194.6 × 67.9 cm (73½ × 76⅝ × 26¾ in)
Whitney Museum of American Art, New York

Imogen Cunningham's take on pregnancy is completely different in tone; the sharp, bright light creating black shadows. The shining, almost bursting, belly is full and stands out smooth against the craggy paintwork of the door. With the sitter's head cropped off, our focus is filled with the straining skin around the abdomen. Cunningham's career spanned seven decades on the west coast of America, and even at 93 she was working on a series of portraits of those of a similar age. She studied chemistry before turning to photography, inspired by Gertrude Käsebier; she also met the photographers Alvin Langdon Coburn in London and Alfred Stieglitz in New York. During an interview, Merry Renk, the sitter, said of Cunningham that 'she was a wonderful woman, very sharp and almost vinegary in her attitudes. And sometimes she would startle you because what she would say would be so tart … I had never done any nude posing for anybody … I had about

a four-hour afternoon with her in this house before it was renovated.'[9] That session resulted in this image.

Marisol's life-size sculpted wooden works, made in the 1960s, explore the notion of family and relationships in form and colour. Artists describe the world they inhabit in order to display their talent but also to satisfy a creative urge in making sense of it. Recording 'the other' (and the world) clarifies and gives form to a moment in time, particularly in portraiture, which can perform as an artistic vehicle to express the style of the moment. The coexistence of, and complicity between, men and women produces a natural biological lineage. The camaraderie and the support systems between women are recognizably different but just as important. The matriarch is as fêted as the patriarch, but perhaps less well advertised.

A Historical Framework

Marisa Merz (1926–)
Untitled, 2012
Mixed media on wood, 15.1 x 25.1 cm (9⅞ x 9⅞ in)
Courtesy Merz Archive, Turin

Running a family home might equate with running a business, and similarly, managing an international art studio could be paralleled with dealing with the operating complexities of a major country house and estate. Successful artists in the seventeenth century ran their own workshops or artistic cooperatives like family collectives, in which men and women worked together to create the art for sale or on commission. Men mainly called the shots, but women were not absent from the business roster, as new art historical research into old practices is revealing, thanks to the recently increased emphasis on how social history and economics have affected art production and the art trade. It was not uncommon for artists to be involved in operating a family co-operative in which all members would contribute according to their particular specialisms, be that painting portrait heads or still lifes, mixing paint, preparing supports or filling in backgrounds.

The merged, submerged and sometimes stolen identities of women within artist couples forms another branch of artistic evolution. Some, like Barbara Hepworth, managed better than others to retain their distinctive practices. We are familiar with Camille Claudel (Auguste Rodin), Vanessa Bell (Duncan Grant), Sophie Taeuber-Arp (Jean Arp), Sonia Delaunay (Robert Delaunay), Frida Kahlo (Diego Rivera), Georgia O'Keeffe (Alfred Stieglitz), Jeanne Claude Christo (Christo), Annette Messager (Christian Boltanski), Sarah Morris (Liam Gillick) et al, but is it possible to dissect and properly recognize the individual qualities of these creative 'sandwiches'? Every couple has their *modus vivendi* and levels of competitiveness and success, and artist couples are no different. The attendant prejudices and methods of working are par for the course, as this revealing comment by Sarah Lucas makes clear: 'One of the reasons I was interested in the feminine was that I wasn't successful. I lived with [the artist] Gary Hume.

THE ADVANTAGES OF BEING A WOMAN ARTIST:

Working without the pressure of success
Not having to be in shows with men
Having an escape from the art world in your 4 free-lance jobs
Knowing your career might pick up after you're eighty
Being reassured that whatever kind of art you make it will be labeled feminine
Not being stuck in a tenured teaching position
Seeing your ideas live on in the work of others
Having the opportunity to choose between career and motherhood
Not having to choke on those big cigars or paint in Italian suits
Having more time to work when your mate dumps you for someone younger
Being included in revised versions of art history
Not having to undergo the embarrassment of being called a genius
Getting your picture in the art magazines wearing a gorilla suit

A PUBLIC SERVICE MESSAGE FROM **GUERRILLA GIRLS** CONSCIENCE OF THE ART WORLD

Guerrilla Girls
The Advantages of Being A Woman Artist, 1988
Screenprint on paper, 43 x 56 cm (17 x 22 in)
Courtesy of the artists

I was reading a lot of feminist writings and that led to arguments, because I was angry with him for being so successful.'[10] Historically, there are examples of female breadwinners and 'new man' husbands such as Charles Beale, who ran the seventeenth-century portrait painter Mary Beale's studio. Elisabeth Vigée Le Brun was socially supported by her dealer husband, and Angelica Kauffman made enough money to support her husband.

Marisa Merz's work is utterly distinctive from her husband Mario Merz's, yet repetitive, machine-fabricated components occur in both of their sculptural installations. Her portrait is simplicity itself, direct and beautiful, an example of how an artist who makes large and complex sculptures can also create small, elegant pieces. It could be a homage to another era, with its shades of Alexej von Jawlensky and Kees van Dongen, but rather it stands as an investigation into the thin line that divides abstraction and figuration. Merz

was the only female artist associated with the Arte Povera movement and she won a Golden Lion lifetime achievement award at the 2013 Venice Biennale. A variety of circumstances mitigates against the woman artist within the home, the most pressing being time, space and housework. This could be one reason for a plethora of performance and photographic women artists from the 1970s. 'The personal is political' was the rallying cry from feminists of the time, and they achieved much, including the creation of a new art-historical theory and gender-based discourse – now termed avant-garde feminism – that changed the way people thought about art and sexuality. The role of biography has had a startling impact on the type of art produced, what is now deemed 'art' and the way that the viewer is prepared to engage with it. As women incorporated the cycle of their lives within their art, we moved on from the great history painting, and the portrait and flower painting of the past.

A Historical Framework

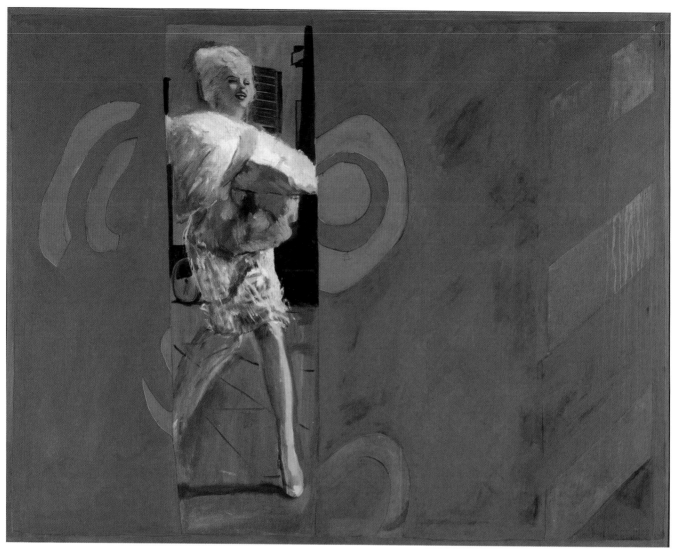

Pauline Boty (1938–66)
The Only Blonde in the World, 1963
Oil on canvas, 122.4 x 153 cm (48¼ x 60¼ in)
Tate, London

In practice, these more contemporary subjects are often more easily accommodated now, and new ways of making art exploited. The separate environment of a painting studio is an expensive luxury that dictates traditional approaches and values. The freedom from the studio that new media such as video, photography and performance afford, on the other hand, opens up opportunities, with no rules or authorities, that women artists (as well as men) can exploit. The artist Rose Finn-Kelcey wrote, 'The work itself draws inspiration from a number of diverse sources. Materials and methods of working differ according to the nature of a particular idea. Underlying all the work is a belief that my orientation as a woman determines a point of view which is different from a man's, and is therefore reflected, in *some* way, in any material manifestation. This may involve developing what traditionally might be seen

as dangerous, or undesirable qualities, and a sense of form or aesthetic at variance with existing cultural patterns.'[11]

Sexual and social status was, and still can be, a barrier to advancement, much like the idea of breaking through the glass ceiling. Some things have changed for women artists, but the ongoing existence of the Guerrilla Girls group (formed in 1985), and now Pussy Riot (formed in 2011), reminds us of the prevailing need to question and challenge the status quo. The Guerrilla Girls' statements of 1988 still largely ring true.

Marilyn Monroe became her own stereotype and exploited her position, building on historical representations of female sexuality and seductiveness to become a blonde bombshell, large-bosomed persona with a little-girl voice, almost a caricature of something

VALIE EXPORT (b. 1940)
Untitled (Woman with Vacuum Cleaner) (after Cranach), 1976
Black and white photograph, 60 x 50 cm (23⅝ x 9⅝ in)
Courtesy of the artist

'hot'. Pauline Boty created her version of Monroe as a ball of fluff on teetering heels, her mouth-open face in a breathy style, her cone of bleached hair and meringue-like fur stole lit up with frothy white paint. The jazzy colours accentuate the impression of the figure on the move, giving us a brief flash of perfect legs and a lightbulb memory of her most famous role in *Some Like it Hot* (1959). Eve Arnold also took remarkable and poignant photographs of her on the set of *The Misfits* (1961), written by Monroe's husband Arthur Miller, which are candid, charming and full of impending doom.

The artists discussed in these pages managed to negotiate and triumph over the vast, complex network of social and economic circumstances that affected their creative lives. This collection is not intended as a pious hagiography; rather, it aims to clarify aspects of the cultural backdrop behind today's vibrant female art producers. In considering this backdrop, it is also essential to investigate the question of art as vocation versus art as profession and the invidious connection between these two concepts that impact so strongly on the art market, as well as considering how male and women artists might operate differently within that market.

In the 1970s political feminism found its voice and any Biblical notion that a spare rib was responsible for

womankind evaporated. Ideas like equal opportunities and pay reinforced notions that had taken root at the beginning of the twentieth century, when votes for women became law in many western countries. The established idea that chromosomes decide aspects of ability and creativity was challenged by a groundswell of enthusiastic revolutionaries. Art created by women that dealt with their own perspectives on personal issues flourished, and firebrands such as Miriam Schapiro, Dara Birnbaum and Joan Jonas, to mention but three, commented on society in avant-garde ways, employing unusual materials in an innovative fashion. Performance art as a genre evolved from early 'happenings' in the 1960s.

Such performances were photographed and filmed, and their reiterations in the press were sometimes ridiculed; reports often focussed on what were then perceived as shocking elements of the work. VALIE EXPORT adopted the cigarette brand name Export as her upper-case moniker, in place of Waltraud Höllinger, in an act of media subversion. 1960s artists like her debunked ideas about female creativity being inextricably linked to the reproduction of the species and rejected the automatic selection of a male-centric iconography that stifled female art. They questioned the prevalence of 'acceptable' masculine art and demanded that the 'invisible' work of womankind be made visible.

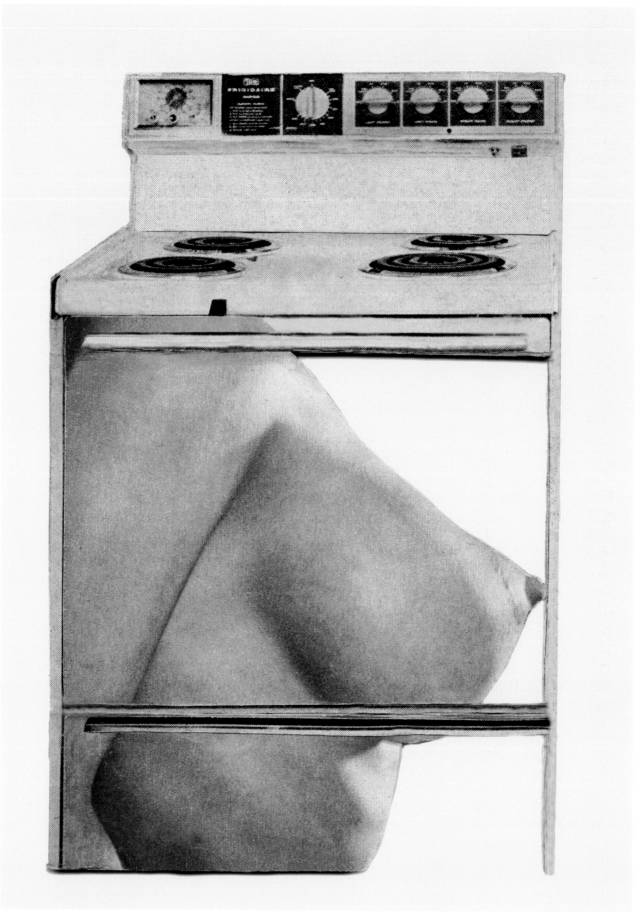

Martha Rosler (b. 1943)
Kitchen I, or Hot Meat
from the series 'Body Beautiful, or Beauty Knows No Pain', 1966–72
Photomontage as C-print, 34.8 x 27 cm (13⅝ x 10⅝ in)
Courtesy of the artist

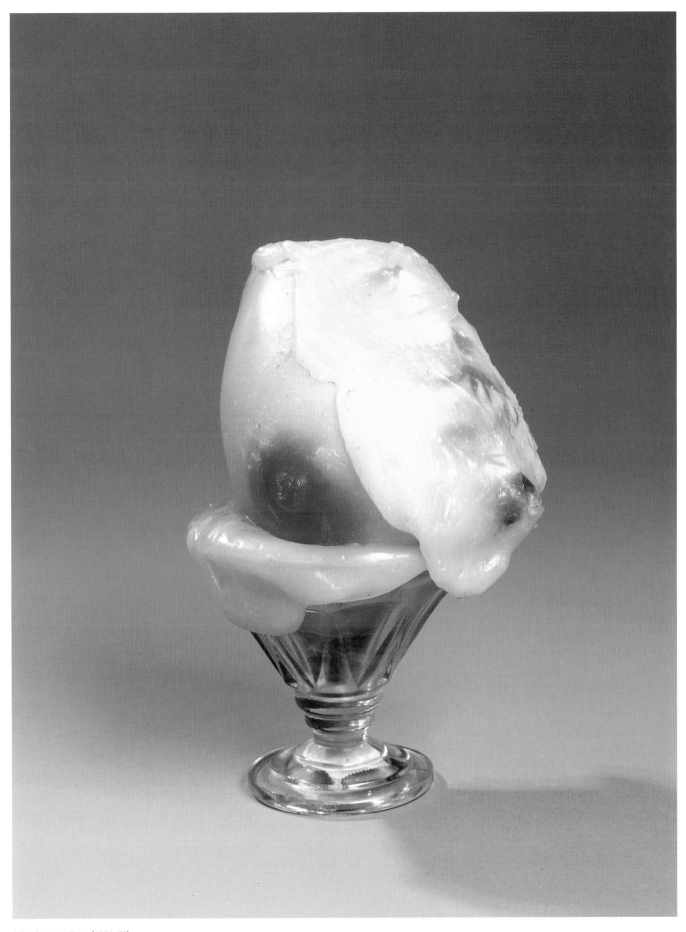

Alina Szapocznikow (1926–73)
Dessert II, 1970–71
Polyester resin, glass, photographs, 19 x 13 x 13 cm (7½ x 5⅛ x 5⅛ in)
Private collection

49 *A Historical Framework*

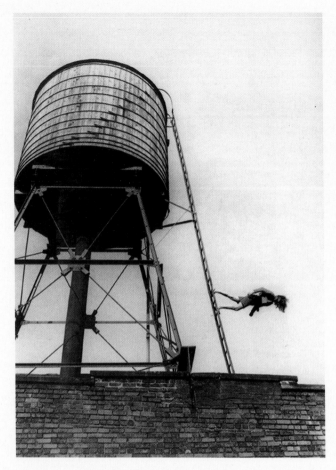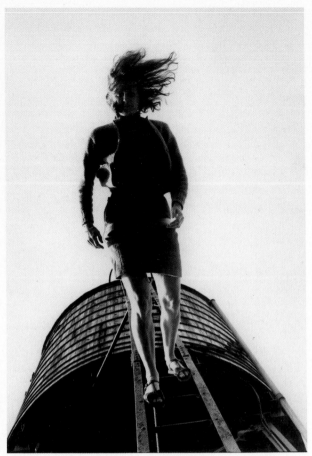

Trisha Brown (1936–2017)
Woman Walking Down a Ladder, 1973
Diptych of black and white photographs, 20.3 x 25.4 cm (8 x 10 in)
Courtesy of the artist

Rather than ghettoise their production, these women artists sought to infiltrate the norm with new art of equal value, often with wit and humour.

The fearlessness of using body parts to express these challenges to traditional art history was paramount at this time. Martha Rosler updates Hannah Höch (p.27) with ingenious self-deprecation; the structure that contains the breast is a cooker, and the title of the work a neat analogy for the sexual politics and unreconstructed male views of women prevalent at the time. Rosler's photocollages deal with war and the home, equalizing subject matter with her wit and swift scalpel. Artist, theorist, author and educator, her work spans time and technique, and her hilarious parodic video *Semiotics of the Kitchen* (1975) has become part of the feminist canon.

Alina Szapocznikow's direct body imprints are offered as alternative *memento mori,* positive casts that represent her, now that she is dead, in a blatantly physical way. Here, the artist makes her breast analogous with ice cream, thereby commenting on kitchen semiotics and women as sweetmeats, with an underlying tone of bedroom erotica. The casual simplicity of the work belies its complexity. Her sculpture becomes more poignant when we discover that she was diagnosed with breast cancer in 1969, and made the work specifically in response to that fact. Her extraordinary experimental use of materials like polyester resin and polyurethane add an element of chance to her output. Her work is a curious blend that prefigures Annette Messager and Tony Oursler by using domestic lighting as armature and illumination, as an integral part of her sculpture.

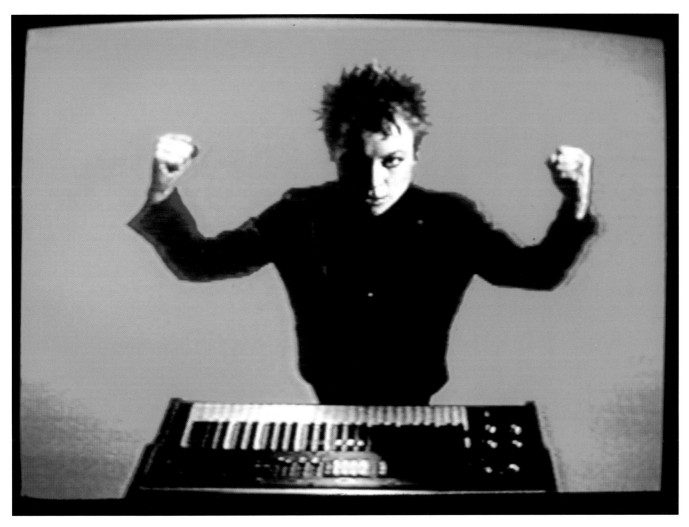

Laurie Anderson (b.1947)
O Superman, 1981
Video, 8 min, 21 sec
Courtesy of the artist

Our view of the intrepid Trisha Brown is primarily one of disbelief as she appears to walk horizontally down a vertical ladder that descends from a water tower. The second part of the diptych reveals this to be true, but in this image we also become aware of her harness. Derring-do feats of this nature were not uncommon in the 1970s – a time when artists strove to push the boundaries of what might be considered art, while completing physical endurance tests that distinguished them as mad, artistic and newsworthy. All artists seek to develop their own original, implicit creativity, are competitive and evolve their art in relation to the lives they lead. Different types of art offer us a variety of windows into the specific artistic world of their creator, while reflecting our shared world.

Laurie Anderson's smash hit *O Superman* consolidated her position as a sound and performance artist, which, by dint of international record sales success, propelled her into the unusual hybrid position of being a visual artist and a famous pop singer. Her poetic commentaries on the everyday nature of the world were made with a knowing and critical voice that understood the peccadilloes and discourses of the contemporary gendered landscape: as the song goes, 'Hold me Mom in your long arms, your petrochemical arms, your military arms, your electronic arms.' Delicately balancing this audio self-portrait with her famous *aperçus* and special wit, Anderson continues to provoke and delight with her electric violin and ironic perspectives. This new type of classical yet funky, fashionable avant-garde performance art opened up a pathway for a stream of other vivid works in this medium.

A Historical Framework

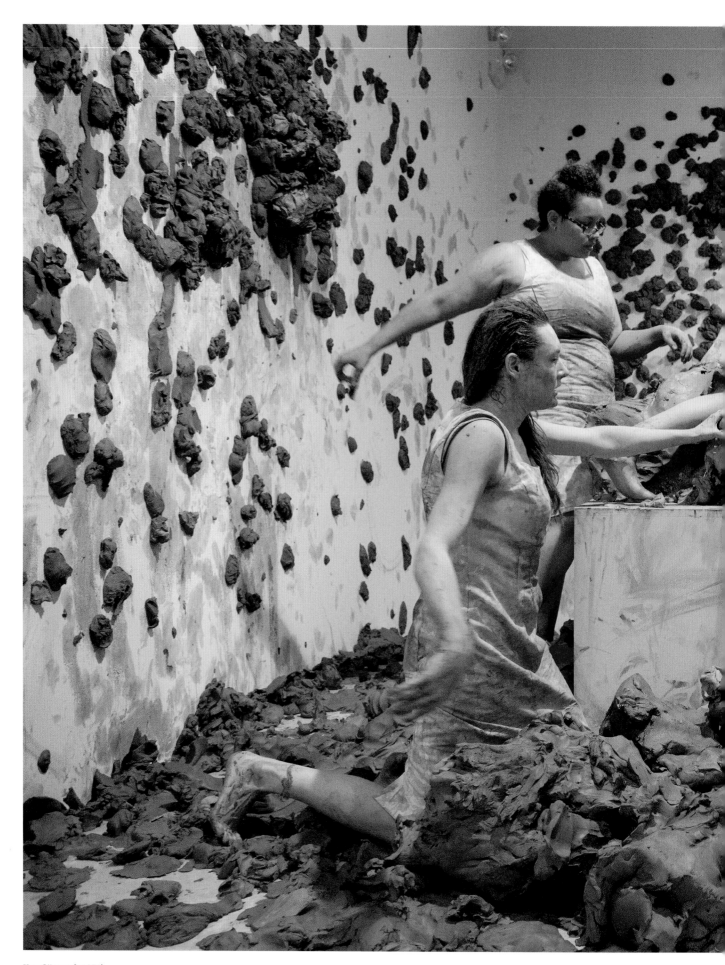

Kate Gilmore (b.1975)
Through the Claw, 2011
Performance/Installation
Courtesy of the artist and David Castillo Gallery, Miami

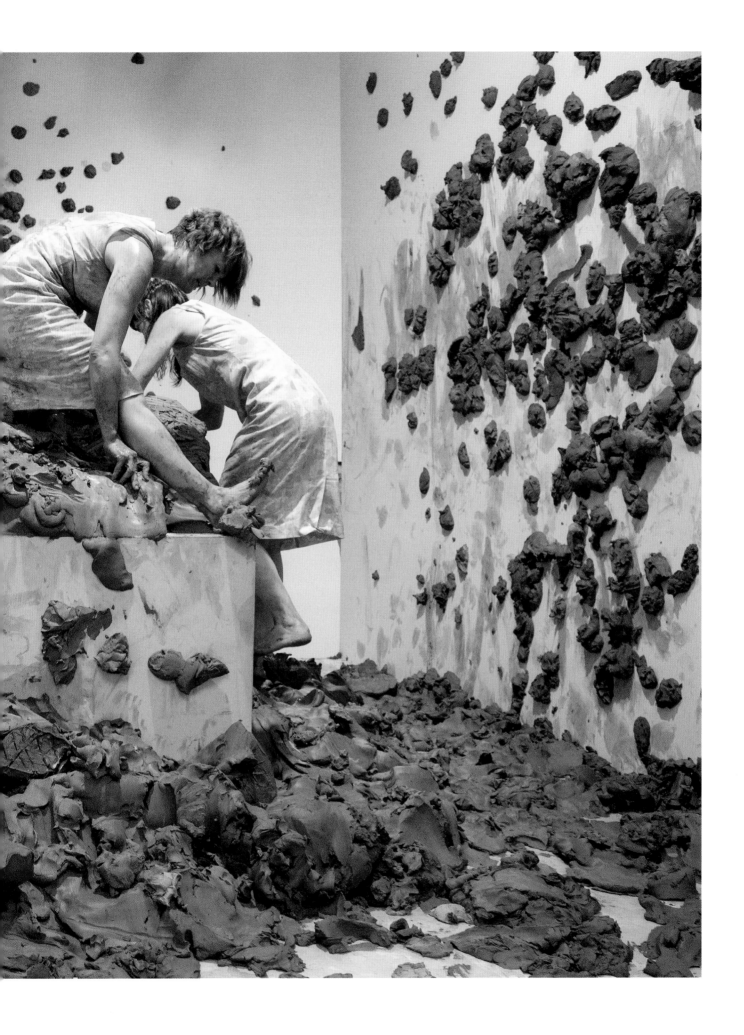

Kate Gilmore epitomizes the coruscating and sometimes vicious outpourings of such artists, who continue to challenge the status quo and our artistic preconceptions. The block of clay that is being torn apart and deconstructed by the team of women in floral summer dresses not only represents the fundamental sculptural medium of which it consists, but also resembles the plinth on which it might sit, and which the performance ultimately reveals, thereby questioning the very nature of subject matter and contemporary minimalist sculpture.

We have met, so far, a selection of renowned women artists who have depicted womankind and womanhood from the Renaissance to the present day. The images reveal artistic styles, historical clothing and personal lives in order to provide a background to the radical events that affected women's lives in the twentieth century – major historic changes including the abolition of slavery, the invention of photography, the vote for women, the universal right to own property and the contraceptive pill. Their images have survived over time and have emerged as representative, often for subjective reasons, since most responses to art are subjective and follow the premise of the arguments the artwork promulgates. What has not changed over history is the significantly lower number of female artists who have survived in the pool from which such selections are made, so the closed-shop, male-dominated status quo is 'innocently' perpetuated. A recent tally at the Prado Museum in Madrid revealed 41 female and 5,000 male artists represented in their collection. These statistics were released in 2016 on the occasion of their first-ever exhibition dedicated to a woman artist, *The Art of Clara Peeters*.

One way of analysing this conundrum might be to consider the history of exhibition programming. In the 1968 book *Recent British Painting,* which related to an exhibition about the Peter Stuyvesant Foundation-funded collection, the introduction was by Alan Bowness (then Reader in the History of Art at the Courtauld Institute of Art, subsequently Director of the Tate Gallery), its preface by Norman Reid (then Director of the Tate Gallery) and the third selector was Lilian Somerville (then Director of the British Council): all powerful signatories. The nucleus of the selection was from the Whitechapel *New Generation* exhibition of 1964, the brief to explore 'the main tendencies in British painting since the late 1950s'. Of 51 artists, six were women and of these, all were abstract painters: Mary Martin, Prunella Clough, Sandra Blow, Gillian Ayres, Bridget Riley and Tess Jaray. Connoisseurship has traditionally been the domain of the male art historian and museum director, from Bernard Berenson to Ludwig Wittgenstein, Kenneth Clark, Neil MacGregor and

Philippe de Montebello through to Anthony Blunt. Three things have changed since 1968: documentation records no longer list 'one-man exhibitions', cigarette companies do not sponsor state art purchases, and the proportion of women to men on artist selection panels has been somewhat readjusted.

The still-extant New York A.I.R. Gallery was an all-female gallery cooperative instigated in 1972 by Sue Williams and Barbara Zucker. It was the first non-profit, female artist-run gallery in the USA, set up precisely to counteract a male-dominated art scene. Luminaries such as Lucy Lippard, Nancy Spero, Louise Bourgeois and Harmony Hammond were involved from an early stage. The declared aims of the gallery were as follows: 'A.I.R. does not sell art; it changes attitudes about art by women. A.I.R. offers women artists a space to show work as innovative, transitory and free of market trends as the artists' conceptions demands.' At the Los Angeles County Museum of Art in 1976, Linda Nochlin and Ann Sutherland curated an exhibition entitled *Women Painters: 1550–1950,* another attempt at readjusting the public perception of the accepted male-dominated artistic canon. However, this type of segregation encouraged the perspective that Germaine Greer outlines in *The Obstacle Race* (1979): that of struggling minorities, reinforcing the negative views of women artists viewed in relation to their gender counterparts.

Over 30 years later, *WACK! Art and the Feminist Revolution,* was a historical survey of art made in response to feminism at The Geffen Contemporary at MOCA, Los Angeles, comprising 120 women artists from 21 countries. Segregation of gender in this way attracts criticism, such as Greer's, but this exhibition offered a way of mirroring the politics and art of the time. Furthermore, the accompanying scholarly catalogue recorded the evolution of a broader history of art, embedding new theoretical structures alongside the standard methodologies of art history. Women have gradually become more equally represented in exhibitions and museum collections, consequently, if gradually, improving their fiscal clout and voice.

Recent research by the Freelands Foundation in 2016 suggests that fewer than 30 per cent of all solo shows in major UK and US museums are by women. In 2015 only four of the top 50 prices paid at auction were for works by women artists. New initiatives in the form of foundations and prizes have been set up to encourage a broader view, together with a keener awareness of an imbalance on the part of museum curatsors. It is generally accepted that museums should reflect the culture of their time, and so should incorporate contemporary values and changes in human behaviour and interaction. Centre Pompidou in Paris, the Museum of Modern Art in New York and

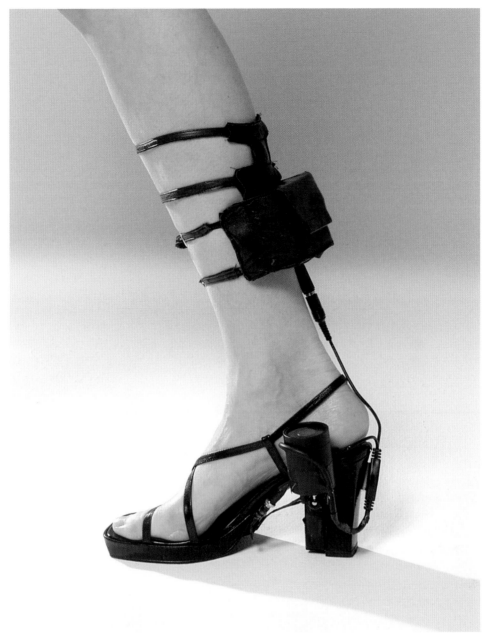

Jill Magid (b.1973)
Surveillance Shoe, 2000
High heels, IR surveillance camera, battery pack and transmitter,
used to make *Legoland*, digital video, 6 min
Courtesy of the artist

Tate Modern's recent rethinking of their displays and publications reveals a contemporary desire to rework the portrayal of art histories. At the same time, a cynic might remind us that art remains a fluctuating, market-driven product that, for some, continues to be an investment or luxury item.

The debate around clothing and the nude or naked body could be seen to constitute a cornerstone of the feminist discourse. The formidable and iconic Queen Elizabeth I declared that she may not have had the body of a man but that she did possess the mind of one, and the nineteenth-century painter and sculptor

Marie Bashkirtseff similarly announced that 'There's nothing of the woman about me but the envelope'.

Jill Magid's *Surveillance Shoe* pushes the 'envelope' further. Her witty six-minute video fulfils any voyeur's ultimate fantasy while simultaneously performing as a 'self-portrait-Peeping Tom', and referencing the trend for using mobile phone cameras to take unsolicited photographs. The camera sits underneath, while the surprising view is straight up and crotch-wards. The issue here (and with Magid's work) is the fine line: when does the protest work cease to be titilatory, and if it doesn't, how do we mediate our response?

A Historical Framework

The opportunism of the artist is a given, regardless of gender. A new development in the quest for success and recognition is the recent fashion for public cross-dressing and the male appropriation of the female gender, as well as the adoption of the earlier feminist shock tactics of using the naked body in an overt and confrontational manner to grab press attention. In this way, male artists have managed yet again to invade the female space. In the end, does the male response differ from that of the female? Artists work with their natural instincts and not as slaves to theoretical positioning.

The five chapters that follow group works made by women artists since 1970 under the broad headings Body, Life, Story, Death and Icons. In so doing, there is an attempt to follow the progress of women through life, and to notionally reflect female narratives. Given the prominence of the physicality of the body in women's lives, we focus on its role in defining gender, stereotypically and otherwise, as a reproductive machine, as a tool – politically and mythologically – and the ways in which it has fallen victim to transformation, alteration and violence. The female gaze on the body is analytical, honest and self-critical; the latter quality could be considered a distinctively female trait. However, that honesty is a way of reclaiming proud and confident ownership of the body, so this view is not wholly self-conscious or derogatory.

In Life, there is a consideration of female relationships with family, friends and lovers, of the physical changes that our bodies experience over time, of the humdrum activities, alongside campaigning and championing, that represent the daily challenge in improving women's rights. Story explores the way in which narrative is used by women artists in their work to comment on worldwide issues, from sex and politics to fantasy and contemporary culture. Often the narratives riff on and exploit the Old Masters, sometimes in an irreverent way; the challenge here is for women artists to position themselves more authoritatively within art history. Death focuses on the inevitable, regardless of gender, but shows how female artists are more ready to expose the rawness of this ordeal with a humility and matter-of-factness that is not often found in male art history. Male figures are typically glorified and triumphant in death, portrayed as noble heroes and rarely shown (apart from the odd saint or wartime victim) to admit the simple human frailty that is our flesh. Finally, in Icons, we investigate routes to the apotheosis of women and the achievement of iconic status, along with its pros and cons. The distinctive stereotypes that surround such renown are considered further in the chapters that follow, along with the issues associated with the elevation and deconstruction of brand 'female'.

BODY

I AVOID LOOKING
DOWN AT MY BODY,
NOT SO MUCH BECAUSE
IT'S SHAMEFUL OR
IMMODEST BUT BECAUSE
I DON'T WANT TO SEE IT.
I DON'T WANT TO
LOOK AT SOMETHING
THAT DETERMINES ME
SO COMPLETELY.

Margaret Atwood, *The Handmaid's Tale* (1985)

The physicality of our form has defined the making of art by women more than anything else. The female body's distinctive shape and its reproductive potential unite the sex in a fundamental way. The women artists we have chosen for this book have developed a level of honesty in scrutinizing the female form, especially when it is their own. Not for these women the glamorized ripped torso of champions, but rather the critical eye that exposes before others do the exposing. These artists are not afraid to consider the basic functionality of our bodies, the process of ageing, sex and sexuality, or issues of difference associated with colour or size. With that level of critique also comes humour and the ability to laugh at the way in which our bodies are viewed, both by ourselves and by society more generally. Furthermore, women's perceptions of the changing male gaze have developed over time. This is not to suggest a victim mentality as we succumb to the painful transformations associated with contemporary ideals of beauty; on the contrary, women artists often take a methodical view of the sociological developments of our sex and the world around us, and are not afraid of taking a political stand. Influenced by the successive feminist waves during their own lifetimes, many of these artists continue to shoulder the responsibilities of their sex by producing works that campaign for change or that continue to draw attention to issues of violence and inequality, regardless of sex.

Sculpture delineates form, and the stature of David by Michelangelo (1501–4) imprints on the mind the mass and volume of a human being. Despite the fact that the female body regularly defies the onslaught of life itself through the act of giving birth, the mental imprint of womankind is that of a more delicately defined mass. Huge sculptures of women exist in the ancient world: Roman goddesses hewn out of marble astonish in the Archaeological Museum in Naples, and modern and contemporary equivalents are present in the work of Elisabeth Frink, Niki de Saint Phalle, Betty Tompkins or Kara Walker, in which scale dwarfs us, throwing us back on ourselves, making us feel small and sometimes insecure. This unnatural scale is useful to the artist because it increases tension in relation to the object, shifts the power balance and upsets expectations, encouraging new perspectives. Scale is just another tool, but when used in tandem with the body, it can become freakish – giants and Gulliver come to mind, and the door of perception to the fantasy world is opened.

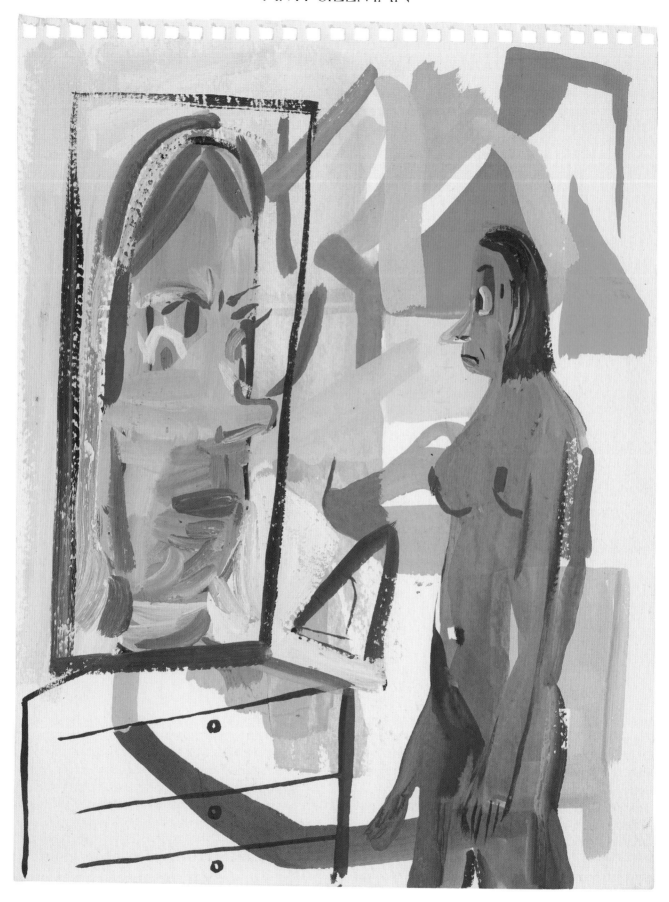

Untitled, 2005
Gouache on paper, 20.7 x 14.7 cm (8 x 6 in)
Courtesy of the artist

REBECCA WARREN

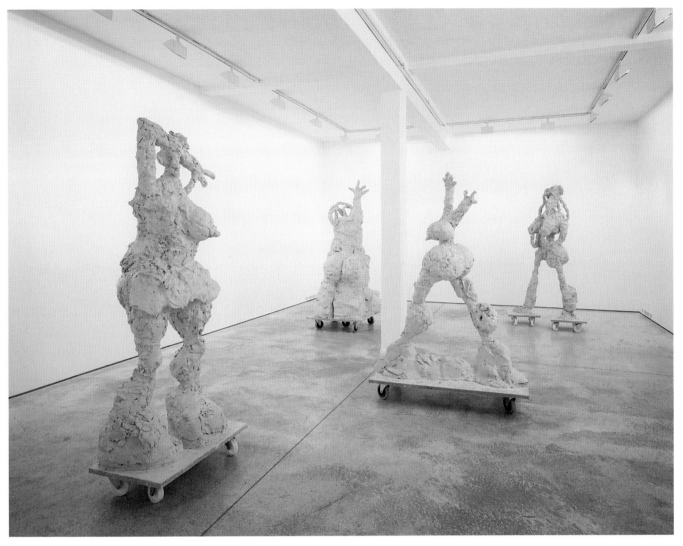

SHE, 2003
Unfired clay, MDF and wheels, dimensions variable
Installation view
Courtesy of Maureen Paley, London

The comic refrain 'does my bum look big in this?' encapsulates the endemic anxiety that many women seem to experience regarding the shape of their bodies, whatever their size. The mirror portrait by Amy Sillman (b.1955) says it all. The returning gaze is one of exasperation, the vicious orange signalling danger and discomfort, and the dual figures duel with their doubly recorded reflection.

Feminists from the 1970s made much of how the body itself performed, and how this performance impinged on the female world. The materiality of the body equates to the stuff of art work, the tools of the trade like paint, clay, chemicals – and artists of both sexes exploit this. Rebecca Warren (1965–) revels in clay and

makes it perform like the bodies she describes. This work brings to mind the very biblical fashioning of humankind on the armature of a rib, said to have taken God a brief moment in time. The prominently nippled breasts and aggressively swollen buttocks, often autonomously freed from their complete form, are confidently sexual on their own terms, and stand with one foot in early Modernism and the other in a caricature-cartoon style, influenced by the cartoonist Robert Crumb, an inspiration that Warren acknowledges. In a kind of fetishization, these wobbly women, sometimes wearing high heels, stand on makeshift plinths equipped with wheels for easy turning.

Body

*Post-Partum Document. Analysed Markings And Diary Perspective Schema
(Experimentum Mentis III: Weaning from the Dyad)*, 1975
1 of 13 works on paper, graphite, crayon, chalk and printed diagrams, each 28.6 x 36.1 cm (11¼ x 14¼ in)
Tate, London

 Mary Kelly (b.1941) is one of the *grandes dames* of feminist art, creating works that are provocative in both form and content. Kelly's rigorously researched and minimally displayed *Post-Partum Document*, originally shown in London's Institute of Contemporary Art, illustrates the natural results of motherhood recorded over time in relation to the child's physical development and the contents of its nappy. The exhibition caused such outrage at the time that Kelly was hounded by the paparazzi camping on her doorstep. That art should so move its public is success indeed, and scandal attracts debate. Tracey Emin's *My Bed* (1998) had a similar effect, as did Carl Andre's *Equivalent VIII* (1966) bricks at Tate, creating instant notoriety and provoking positive discussion around what it means to make art in our society today. All of these artists are posing the question: What is

the purpose of art now that the decorative function is no longer its primary *raison d'etre*?

Art changes in relation to the tastes of society; Rubens's voluminous women were fashionable in the seventeenth century, but in the twentieth century fat flesh was equally celebrated by Lucian Freud in a very different context. We are perennially dissatisfied by how we are made or how we have become and so, of course it makes sense, in the realm of the self-portrait, for artists to make work in relation to this issue. The multiple reflections in *Reflected Flesh* by Jenny Saville (b.1970) expose all aspects of her body as woman and artist. The huge, sagging breasts lolling in her 1992 painting *Branded* became a marker for comments about the evils of anorexia, dieting and the problems that plague women when they confront their own bodies.

JENNY SAVILLE

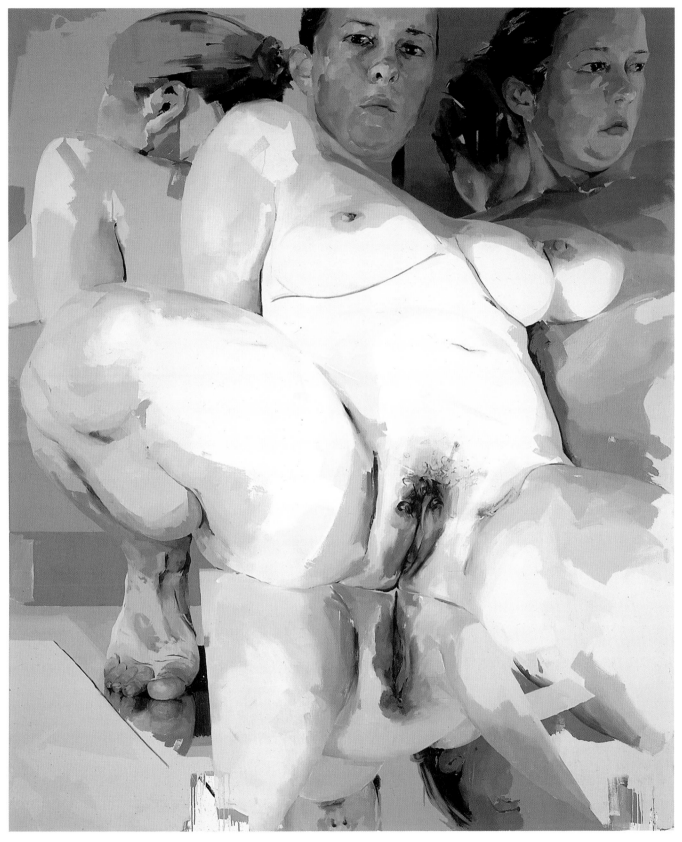

Reflective Flesh, 2002–03
Oil on canvas, 305.1 x 244 cm (120⅛ x 96⅛ in)
Courtesy of the artist and Gagosian Gallery

Body

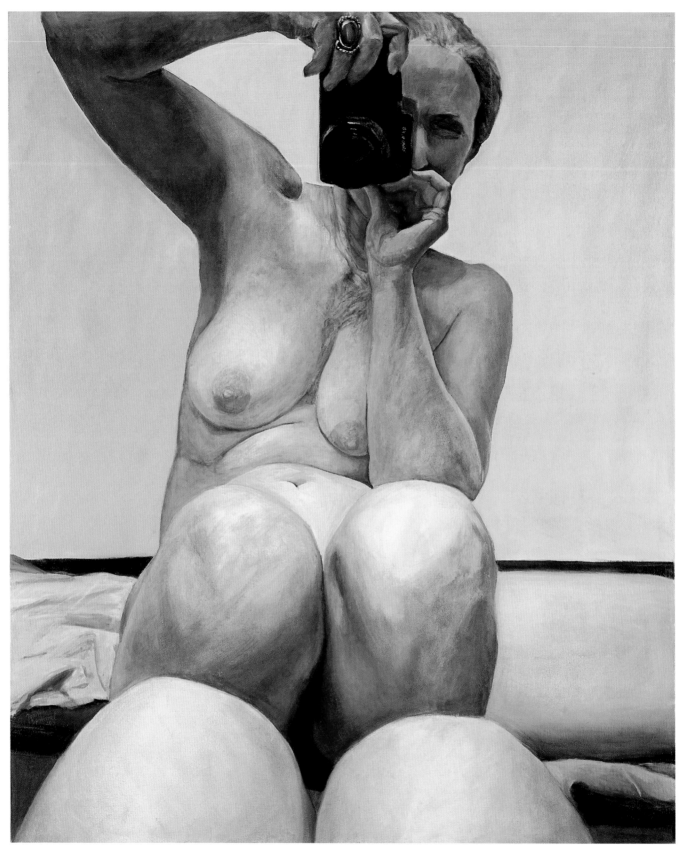

Knees Together, 2003
Oil on canvas, 152.4 x 121.9 cm (60 x 48 in)
Courtesy Alexander Gray Associates, New York

BIRGIT JÜRGENSSEN

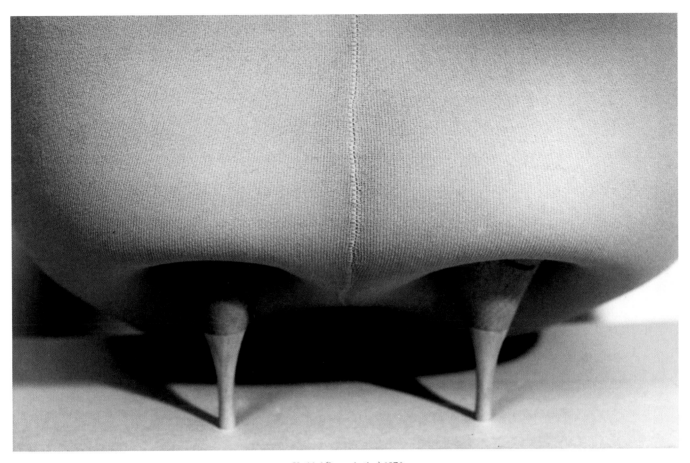

Untitled (Improvisation), 1976
Black and white photograph, 12.7 x 17.8 cm (5 x 7 in)
Private collection

Joan Semmel (b.1932) has embraced and observed the changes that our bodies experience in a durational research project. In New York in the 1970s, as second-wave feminism hit, she created her 'Sex Paintings' and the 'Erotic' Series, which unashamedly explored female sexuality. Since the late 1980s she has focused on recording the ageing female physique, largely through self-portraiture, in order to challenge the fetishization of female sexuality and the invisibility of the ageing female body. Of her work, she says: 'Much of the revolutionary nature of feminist art has been a seeking for new forms to invent a voice free of the dominant patriarchal tradition of the past. I have tried to find a contemporary language in which I could retain my delight in the sensuality and pleasure of painting, and still confront the particulars of my own personal experience as a woman. My intention has been to subvert the tradition of the passive female nude … I have explored the use of both the mirror and the camera as strategies with which to destabilize point of view, and to engage the viewer as participant.'[1]

Birgit Jürgenssen (1949–2003) was very influenced by the work of the French Surrealists, by their literature and poems as well as by the feminist images produced by VALIE EXPORT (see p.47). She applied the Surrealist principles to a subject that she genuinely loved, fashion, and created many photographs, drawings and sculptures of female 'shoes' in the 1970s. The shoes aim to subvert social stereotyping, fetishism and the enforced domestication of women, but retain a sense of humour in their construction. 'I wanted to show the common prejudices against women, the role models that society ascribed to them, the ones with which I was always confronted – and I wanted to depict everyday misunderstandings.'[2] Here, the sexuality associated with high heels is elegantly combined with the absurdity of the bottom encased in a pair of tights, simultaneously sexily alluring and laughable.

SARAH LUCAS

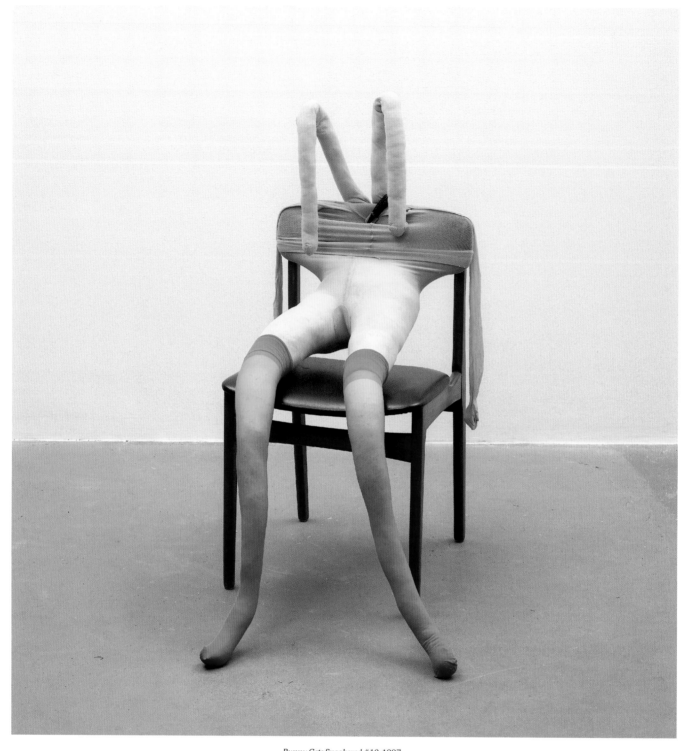

Bunny Gets Snookered #10, 1997
Tan tights, red stockings, wood and vinyl chair, clamp, kapok and wire, 104.1 x 71.1 x 88.9 cm (41 x 28 x 35 in)
Courtesy Sadie Coles HQ, London

Stuffed tights by Sarah Lucas (b.1962) masquerade as human dolls with more than a nod to Hans Bellmer's photographs and his dubiously manipulated 'dolls', as well as to the female forms of Louise Bourgeois. In her work, Lucas tends to lay it all out on the table, smack: breasts, cunt, fuck. There's a no-frills, downbeat grunge aesthetic. Her more recent work, dressed up in polished bronze, is flashy and expensive, but no longer possesses the shock value or vulgarity of her confrontational *Self-Portrait with Fried Eggs* (1996), in which fried eggs stand in for breasts, for which she gained notoriety.

ANTHEA HAMILTON

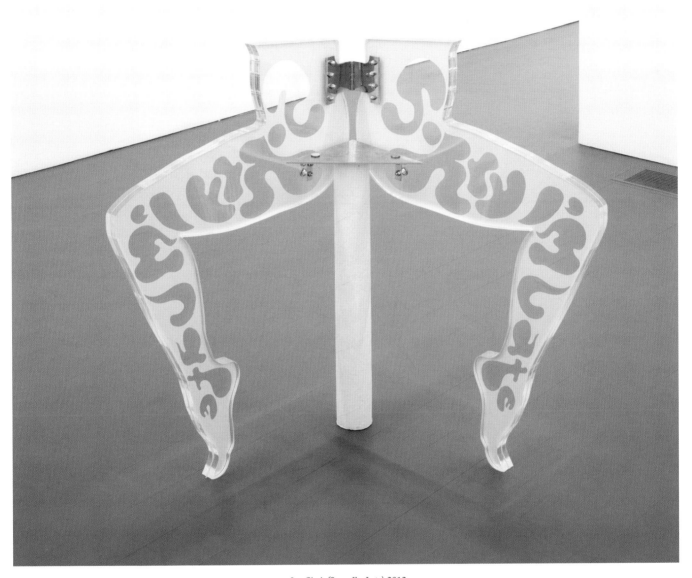

Leg Chair (Sorry I'm Late), 2012
Perspex, brass, paper and plaster, 84 x 87 x 47 cm (33⅛ x 34¼ x 18½ in)
Courtesy of the artist and the British Council Collection

In contrast to Lucas's soft tights, which replicate bendy female bodies, is the work of Anthea Hamilton (b.1978) whose *Leg Chair* performs an elegant and balletic plié. Freestanding and semi-transparent, the laser-cut perspex legs are set astride a bolted metal triangle fixed to a pole, which supports them and the bracketed semi-torso above. At first glance, this truncated body appears to hover in space, balancing on pointed toes and wearing what appears to be decorated leggings but, at the same time, the clear and simply presented construction of the sculpture implies the presence of mechanistic yet non-functioning automata.

Body

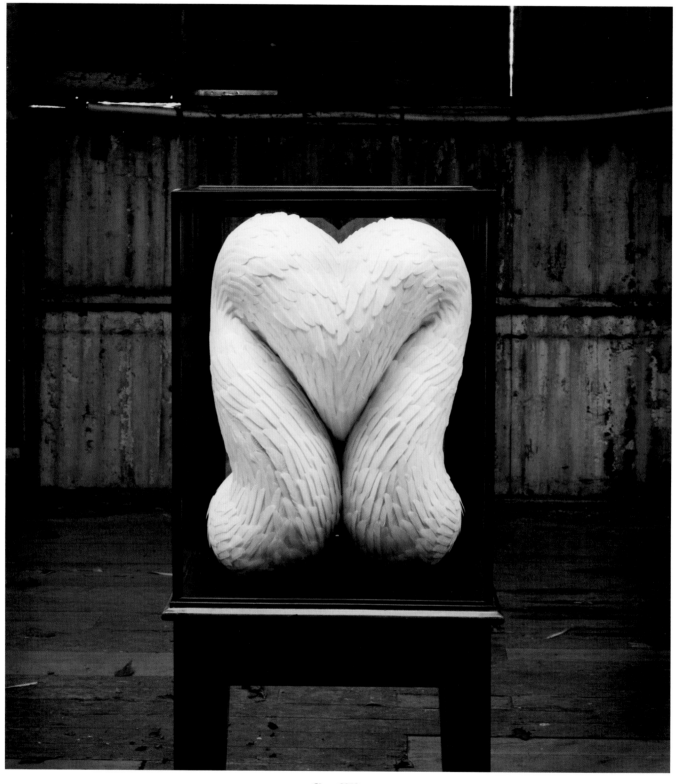

Cleave, 2012
Mixed media with pigeon feathers in antique cabinet, 61 x 46 x 162 cm (24 x 18⅛ x 63¾ in)
Courtesy of the artist

Corps étranger (details), 1994
Video installation, with cylindrical wooden structure, video projector and
player, amplifier and four speakers, 350 x 300 x 300 cm (137¾ x 118 x 118 in)
Courtesy of the artist

The more abstracted legs and lower torso of *Cleave* by Kate MccGwire (b.1964) are soft and seductive in their promise of hidden sexual encounter. MccGwire's work is traditionally composed of voluminous abstracted forms made from a range of bird feathers and quills, in this case dove and pigeon, that often have a sensation of being on the edge of exploding, spilling or leaking uncontrollably. Here, the white feathers hint at purity and innocence, emphasized by the sweet heart shape sitting atop the solid thighs, but the reeling, swooping form of the sculpture reveals itself as you move around it. The work bulges and thrusts around and inside itself, the swells emanating from the 'centre'; the clitoris, which is tucked away and marked by a cluster of nerve-ending quills. The degree of fluidity that MccGwire manages to achieve in her forms is unashamedly sexual but underneath this fundamental theme, and despite the aesthetic appeal of her work, lies decay, death and disgust.

There is a certain boredom in viewing the female body in its traditional role as ubiquitous model and muse; it confirms an unerringly familiar perspective.

Mona Hatoum (b.1952) explodes this view with *Corps étranger*, her anarchic vision providing us with a peculiar journey into and through her own body, aided by an endoscopic camera. This ultimate self-portrait originated in an idea of bodily auto-performance, collapses the boundaries between anatomical documentation and art and embraces technology in a magnificent dual statement of ownership and advertisement. The work comments on surveillance and violation responding to the artist's interest in Michel Foucault. In an interview with Janine Antoni, Hatoum explained that 'It had to be my body ... I wanted the work to be about the body probed, invaded, violated, deconstructed by the scientific eye. ... On the one hand, you have the body of a woman projected onto the floor. You can walk all over it. It's debased, deconstructed, objectified. On the other hand it's the fearsome body of the woman as constructed by society.'[3] The innovative use of the endoscopic camera means that even if we, the audience, might feel alienated by the blood and guts of the camera's progress, we are simultaneously transfixed by the brutal honesty of the images, which reveal a new, universal world that is also our own.

MILICA TOMIĆ

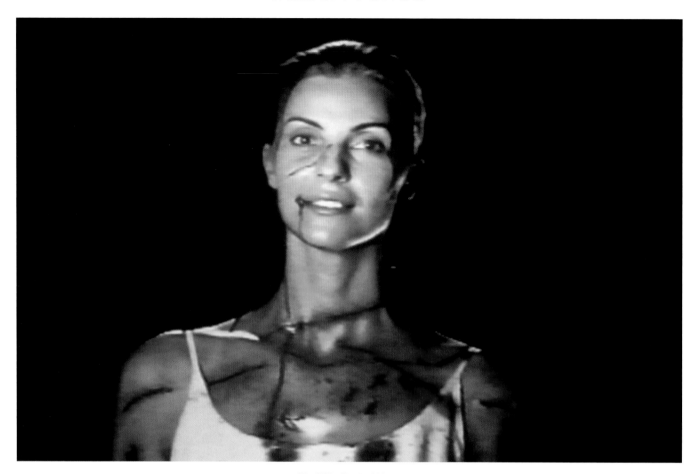

I Am Milica Tomic, 1998–99
Video installation, 9 min 58 sec
Courtesy of the artist

While Hatoum put her internal organs to work, Milica Tomić (b.1960) used her external casing as a screen, with the camera projecting onto her body. As she turns on a pedestal, she repeats her name and ethnicity, 'I am Milica Tomić – I am Serbian', 'I am Milica Tomić – I am Korean', in 64 different languages. This assumption of our collective identities points at the insignificance of any line drawn between identity and ethnic background. Dressed in a pure white slip, she has the air of a serene classical goddess, but this vision is disrupted by the lacerations that grow on her body as she turns, suggesting that the tensions and rivalries associated with cultural identity and national belonging continue to run rampant. The lack of progress in our world is emphasized at the very end of the video, when the bloody cuts and bruises across her face and body fade away, only for it to begin all over again.

KIRSTEN JUSTESEN

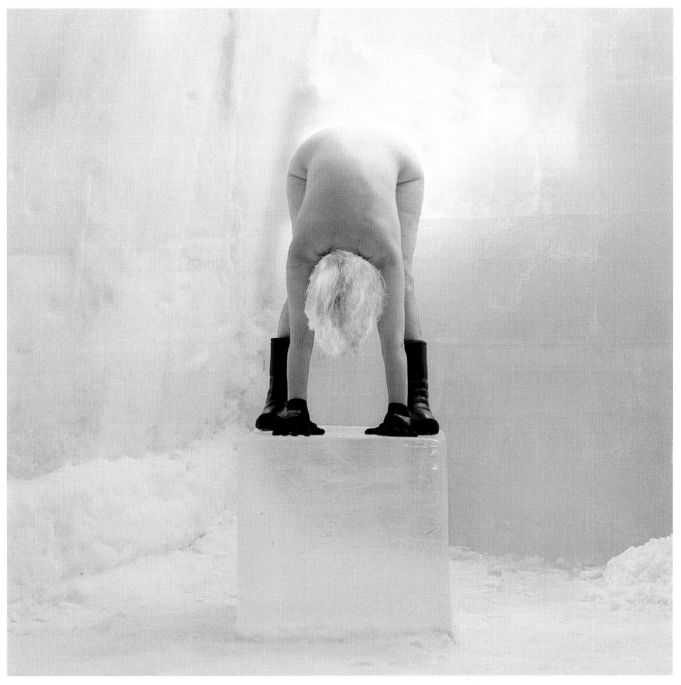

Ice Pedestal #1, 2000
C-Print mounted on 3mm Dibon/3mm mat acrylic, 145 x 145 cm (57 x 57 in)
Courtesy of the artist

Kirsten Justesen (b.1943) also uses her body as a tool in her work. In *Ice Pedestal* she challenges many accepted art-historical traditions. Sculptors have wrestled valiantly in modern times with the presence and value (or otherwise) of the plinth in elevating the elements it supports. Justesen subverts it further by placing herself naked, but for rubber boots and gloves to protect against the ice (a medium that she frequently employs), in a whimsical pose that bears no resemblance to the stance of the powerful male figure that we are used to seeing represented in sculpture, often with a view to reinforcing their own legacy. The meaning of her work is further undermined by the nature of the plinth's construction: the ice that elevates so grandly will melt away and return the sitter back to earth, reminding us of the passage of time and causing us to question, perhaps, our own legacy.

HAYV KAHRAMAN

Iraqi Kit, 2016
Oil on panel, 188 x 121.9 cm (74 x 48 in)
Courtesy of the artist and Jack Shainman Gallery, New York

Delicate paintings by Hayv Kahraman (b.1981) tackle the traditions of art history and culture, referencing Japanese prints and illuminated Arabic manuscripts as well as Italian Renaissance painting. She is most concerned, however, with the distinctions between Western and Middle Eastern aesthetics, racial politics and gender. Issues surrounding diaspora are at the heart of what she does, which is unsurprising given that she sought asylum from Iraq at the age of 12, and her work also explores the purity and power of pattern and geometry. In *Iraqi Kit* she reduces elements of the human form into distinct body parts to be ripped

off the frame and stuck together – to create, potentially, the perfect woman? Discussing her earlier paintings in the *New York Times* in 2013, she gives an explanation that also seems to describe *Iraqi Kit*: 'Having these women violently detaching their limbs, for me, is very reminiscent of the psyche of a refugee, and that sense of detachment you have from your land that you've had to leave behind. That's the idea of the diasporic women, who are fragmented, or cyborgs almost. They've had to give up part of themselves.'[24] Kahraman, conscious of her status as an Arab woman, uses photographs of herself from which she creates

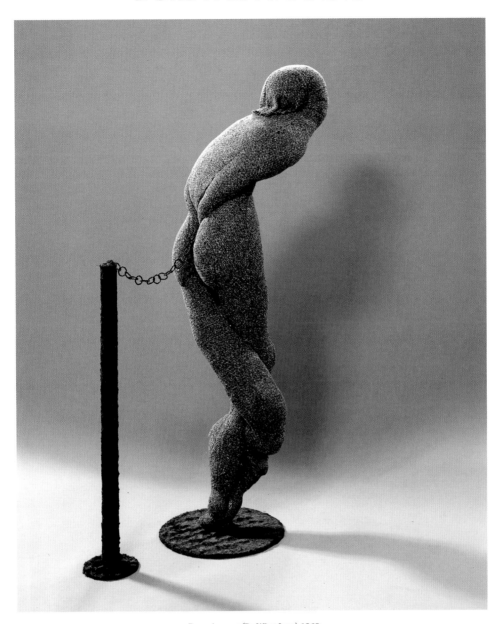

De quel amour (By What Love), 1969
Tweed, metal, wool, chain, and synthetic fur, 174 x 44.5 x 59 cm (68½ x 17½ x 23¼ in)
Centre Georges Pompidou, Paris

the distorted and sexily stylized naked and semi-naked women that populate her works, knowingly creating decorative and appealing works that are perfectly seductive and perfectly packaged, despite the trapped and tortured figures that sit within them.

Dorothea Tanning (1910–2012) created *De quel amour* (*By What Love*) out of tweed, metal, wool, plush and a chain. The chain restrains the figure that, like the Venus de Milo, has no arms, or, rather, has arms that she cannot use. Its form also recalls Michelangelo's tortured, semi-abstracted slave figures. The softness of this work

contrasts with the metal restriction of the attached chain and sets up a tension within the work. The haunch is remarkably realistic, and the modulation of the upper thigh, the twist of the tubular limbs and the ambiguity of head and feet, combine to create the impression of a body sewn from bias-cut cloth on a sewing machine – a nod to women's work. From the back, this truncated anatomy reads as a leaning spiral while from the front, it could be an elongated mouth or vagina. The strangeness of this work is reminiscent of Tanning's fetishistic Surrealist paintings of the 1940s.

LILI DUJOURIE

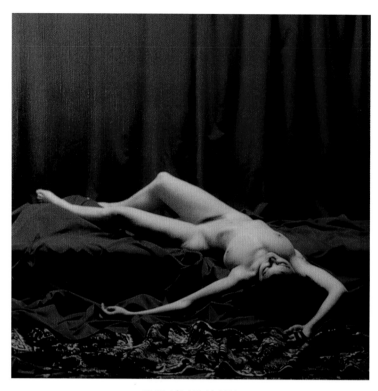

Untitled (Red Nude), 1984
Photograph on canvas, 45 x 45 cm (17¾ x 17¾ in)
Courtesy of the artist

There is no mistaking the painted drapery references in the work of Lili Dujourie (b.1941): the sumptuous velvets echo the surrounds of that most private part of a woman's body, those pleated folds that protect the only human organ devoted solely to pleasure, the clitoris, hidden from view like the faces of the languid models in her photographs. There is a connection between the pose and the feeling of the fabric, which reinforces the overall sexuality of the image.

In sharp contrast to Dujourie's softly draped, monochromatic backdrop to nakedness, this bizarrely posed woman painted by Sadie Lee (b.1967) holds many issues in balance and draws attention to skin colour in a frank and straightforward, yet novel and interesting fashion. The title is cunning in its inference, as the question is obvious: whose flesh colour is this? The bold, confrontational stance and the unsmiling, resigned, gaze of the model in her 'mixed race' underwear – not scanty and alluring, but practical and workaday – reinforces the irony. What holds our attention most, however, is the stretched nylon of the tights, rendered taut by the arms and the outwardly flexed fingers. The strange angle of the fingers reminds us of the dangers of sharp nails and rings (and their potential to ruin tights), the business of jewellery and its significance, symbolic or practical. This captive model is stuck within the flexible field of synthetic fibres and her attitude forces our attention to the ludicrous suggestion that 'flesh-coloured' is the definitive and correct title for such an item of clothing. Her honey-coloured skin gleams beautifully against the sunny yellow of the monochrome background. It is a strong rebuttal of societal complacency and testimony to the power of title and image functioning effectively together. It wasn't until 2016 that Christian Louboutin launched the first range of so-called nude ballet-flat shoes in seven varied skin tones, and professional black ballet dancers have only recently been able to buy skin-tone shoes that match their skin colour, rather than having to apply make-up to them before a performance.

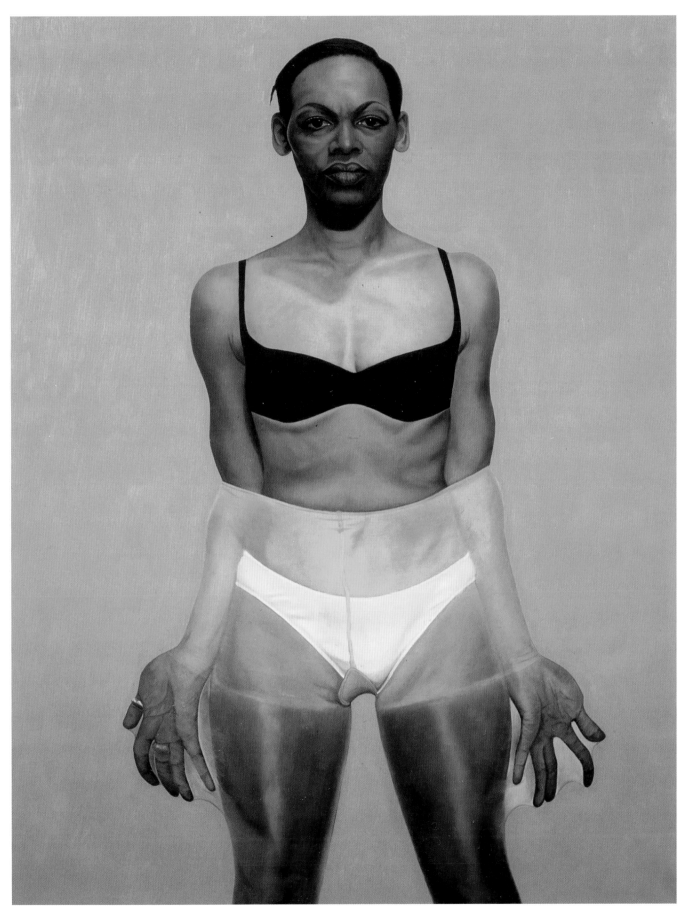

Flesh Coloured Tights, 1996
Oil on canvas, 152.4 x 121.9 cm (60 x 48 in)
Courtesy of the artist

ADRIANA VAREJÃO

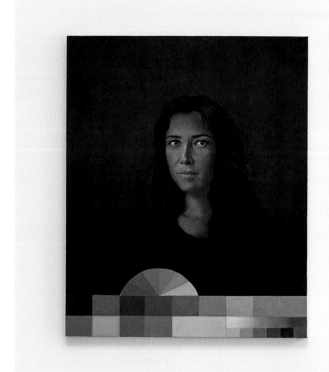 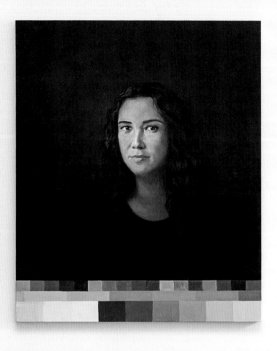

Polvo Portraits I, 2013
from the 'Classic Series'
Oil on canvas, 3 parts, each part 80 x 65 cm (31½ x 25⅝ in)
Courtesy of the artist and Victoria Miro Gallery, London

Adriana Varejão (b.1964) has long been fascinated with the issue of skin colour and its links with class and hierarchy, most notably in Brazil. The official Brazilian census places its citizens within five different categories of colour – white, black, red, yellow and brown – yet when a 1976 survey by the Brazilian Institute of Geography and Statistics asked the question 'What is your colour?', the responses included 136 distinct terms denoting specific shades of skin tone. For *Polvo Portraits*, Varejão created her own oil paints named after 33 colours from that survey. Her series

of paintings, consisting of 11 self-portraits in which her skin tone ranges from light to dark, were inspired by the casta paintings of the eighteenth century, which were introduced by the Spanish nobility in Hispanic America. This genre of painting sought to document and classify interracial mixing in the New World, with a view to recognizing 'purity', associated with whiteness, as well as creating a visual representation of the social hierarchy.

HAYLEY NEWMAN

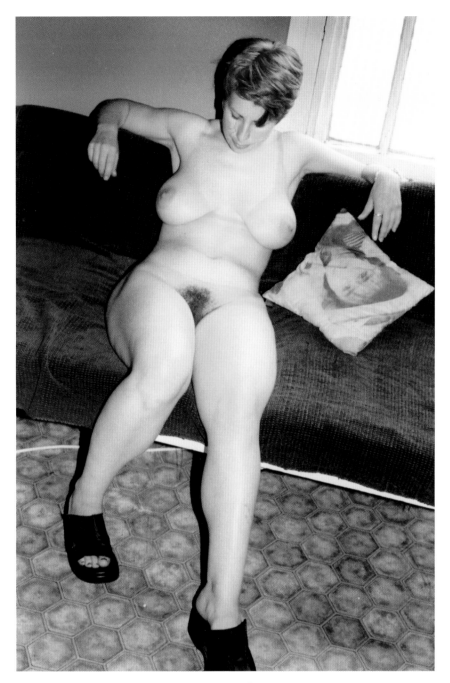

Meditation on Gender Difference, 1996
from the series 'Connotations Performance Images' 1994–98
Photograph, 40 x 27 cm (15¾ x 10⅝ in)
Courtesy of the artist and Matt's Gallery, London

Some people spend many hours sunbathing in order to acquire a fashionable tan and thereby erase the 'purity' of white skin. *Meditation on Gender Difference* by performance artist Hayley Newman (b.1969) reveals her as the subject of an intriguing experiment. Integral to the work is an explanatory text informing us that she had constructed an 'inverted bikini' that she had worn in the sun, resulting in her exposed breasts and genital area becoming tanned while the rest of her body remained lily-white. This unlikely story is presented as truth – 'In the work the body itself articulated

emanation through a controlled physical reaction expressed in the form of intense sunburn'[5] – and Newman's comments mimic the language of a formal scientific research paper. She is interested in the ways that text can describe or fictionalize the thing we are looking at, especially in relation to performances that are temporary and rely on documentation for their longevity. Documenting performances led her naturally to artworks that were 'stand-alone' photographs with value in their own right.

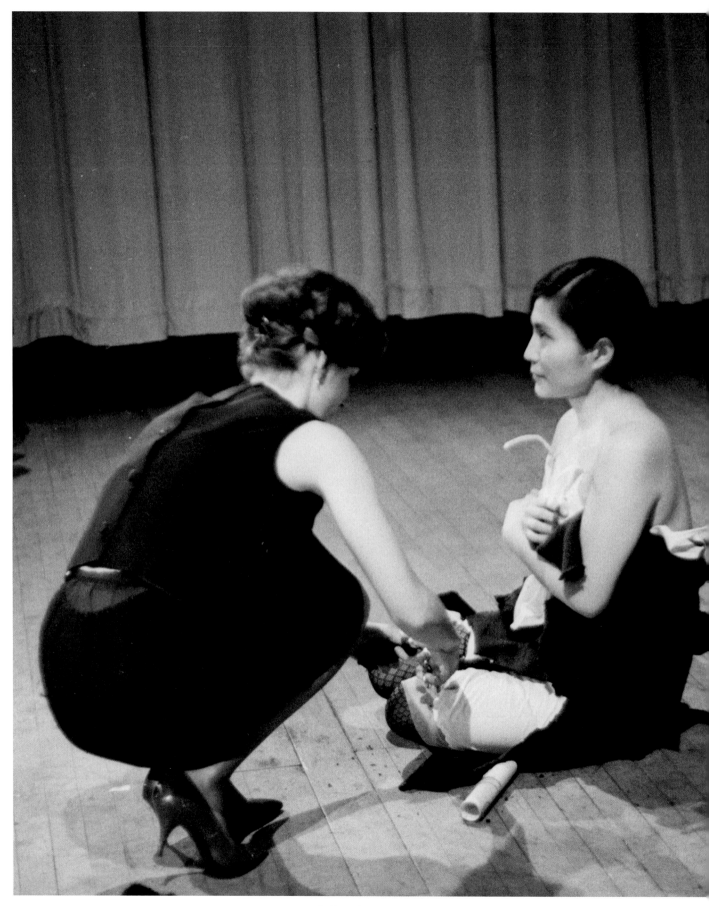

Cut Piece, 1964
Performance at Carnegie Recital Hall, New York, 21 March 1965
Courtesy of the artist

The way we consider the body in art often depends on how, or whether, it is covered. When women artists portray themselves without clothes, or making art naked, their work provokes even more complex layers of meaning and questions around how we see our bodies. Yoko Ono (b.1933) addressed this and other issues with her *Cut Piece*, first performed in Japan in 1964, and re-enacted many times since, both by her and others. Ono produced a script that she has said was inspired by the legend of Buddha, who wandered the world giving of himself, having renounced a life of privilege. However, she has welcomed the fact that over the years the piece has been open to different interpretations. In the performance, the subject sits on a stage with a pair of scissors on the floor in front of them. The instructions to the audience are to come on to the stage, one by one, and cut off a small piece of the clothing to take away. The power of the performance lies in the anxiety embodied in the scissors. Cutting close to the skin, they evoke both the control of the person cutting and the submission and powerlessness of the artist. Ono was letting the action happen to her, knowingly accepting the potential danger and the inevitable result – nakedness – is a state that has a number of reverberations, including the way we enter the world: vulnerable, needy, without control. The work allows vulnerability as a positive, a welcoming of the unknown, with enlightenment, religious or otherwise, as a reward.

Because the concept of the naked artist's model, traditionally female, is so dominant within art history and primarily associated with a male gaze, the idea of the muse and the objectification of the female body became a contested issue among artists who were creating new subject matter and consolidating new art forms in the early 1970s. Rose Finn-Kelcey spoke about her position that she would not remove her clothes in her art, commenting that she was not a 'good feminist' in this respect; she suggested that staying clothed and wearing make-up were 'two cardinal sins' and that 'it was assumed that part of your job as a performance artist was to reposition the body in relation to culture. To raise the audience awareness so they would take on board a more enlightened attitude toward the body, which on some level, de-sexualized it.'[6]

CAROLEE SCHNEEMANN

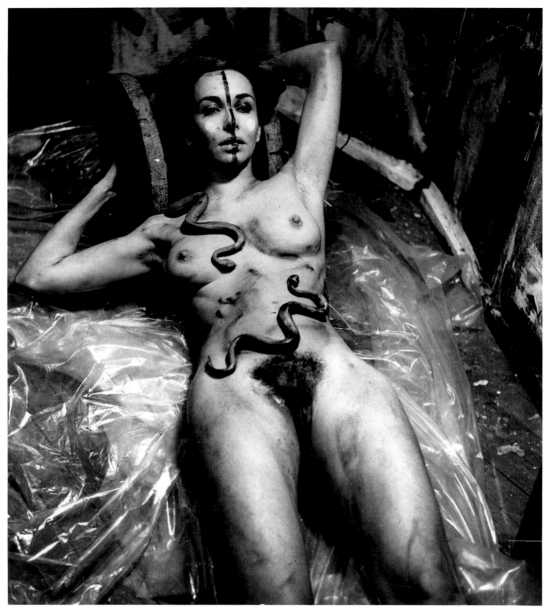

Eye Body: 36 Transformative Actions for Camera, 1963
Black and white photograph, 50.7 x 61 cm (20 x 24 in)
Courtesy of the artist

At the Institute of Contemporary Arts, London, in 1968, Carolee Schneemann (b.1939) performed her Naked Action Lecture using three slide carousels. She showed her paintings, constructions, kinetic theatre work, collages and performance stills while undressing and dressing on the podium. Her scripted questions challenged the audience: 'Can an artist be an art historian? Can an art historian be a naked woman? Does a woman have intellectual authority? Can she have authority while naked and speaking? Was the content of the lecture less appreciable when she was naked? What multiple levels of uneasiness, pleasure, curiosity, erotic fascination, acceptance or

rejection were activated in an audience?'[7] This direct challenge was designed to destabilize traditional attitudes while using 'standard' methodologies associated with traditional art-historical lectures. In confronting art history she stated that 'it was only with an ideal body that I could undermine the inherited aesthetic expectations for the female nude'.[8] Using her body as an extension of the materials of painting, as she does in this image, her intention is to actively collage it, in this case with polythene and the sexualized garden snakes, perhaps symbolic of Renaissance works such as the ancient depictions of Laocoön and his sons and portraits of Medusa.

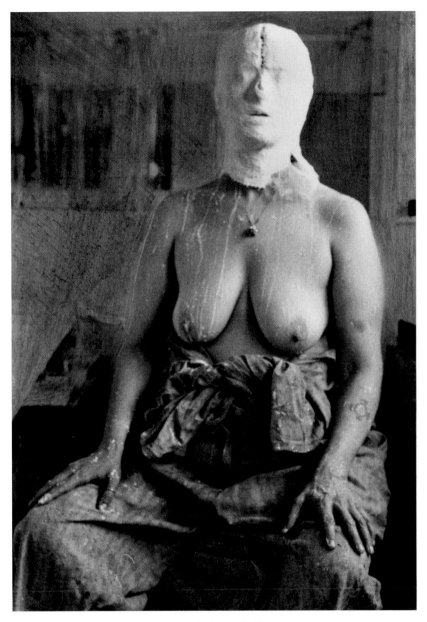

KIKI SMITH

Untitled (Self Portrait), 1996
Gelatin silver print, 22.2 x 15.2 cm (8¾ x 6 in)
Courtesy of Pace Gallery, New York

A key interest for Kiki Smith (b.1954) is in the idea of the exploited female body as the battleground for social and political ideologies. Her early work focussed on distinct body parts, but after the early 1990s she considered the life-size human figure, producing works posed in such a way that they had a sense of the sacrificial about them, possibly inspired by her Catholic upbringing. Smith's repeated self-portraits, often in carefully considered settings, allude to the representations of women portrayed in art history. Here we see Smith represented as the quintessential macho male sculptor at work in the studio, overalls tied at the waist, 'his' head cast for posterity in the life mask tradition. The reference is smashed by the prominent breasts, which leave little doubt as to her sex.

Body

JEMIMA STEHLI

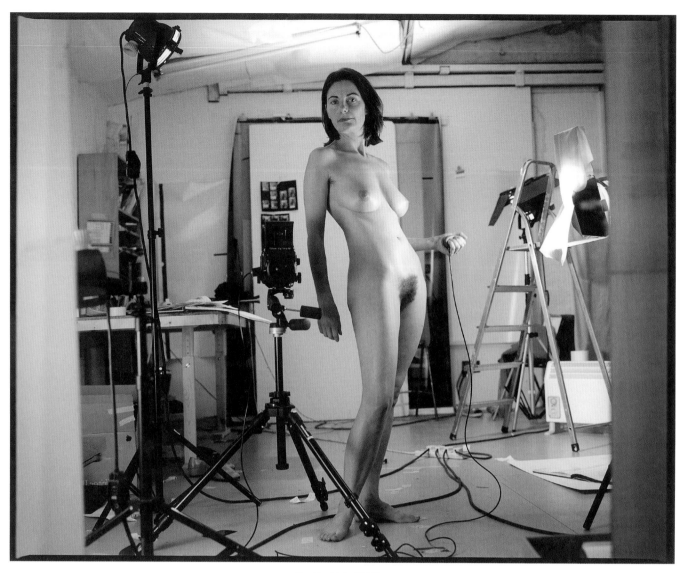

Standing Nude, 2000/01
C-print on aluminium
Courtesy of the artist

The debate around women artists' place in the art-historical canon continues in the work of many artists, such as Jemima Stehli (b.1961) who, in her *Standing Nude,* records her naked pose in the manner of Botticelli's Venus standing on her shell. Yet Stehli's character is in control, authoritative and beautiful. Set in her studio and surrounded by the tools of her trade, Stehli is as concerned with the performance as she is the self-portrait, using the body to challenge notions of desire, narcissism and sexuality, in her private-yet-public performance.

Clothes and make-up skim the surface of a raft of issues connected to body shape, hair growth and physical appearance generally. An artist who has gone under the knife to literally re-fashion her facial and physical features is ORLAN (b.1947). Her extreme approach is unusual and attention-grabbing, but it does encourage discussion around the real issues of plastic surgery, that strange scourge of the twenty-first century. Emphasis on looks has become even more of an issue with the prevalence of social media. Girls and women now have instant access to the ability to provoke either momentary or permanent changes to their faces and bodies. Models are required to be thinner and taller than before, despite the fashion industry statements to the contrary. Perhaps ORLAN's quoting of ancient South American art suggests a broader approach to our narrow western perspective, although her facial reconstructions remain heavily based on the Renaissance interpretations of female beauty, largely propounded by male artists.

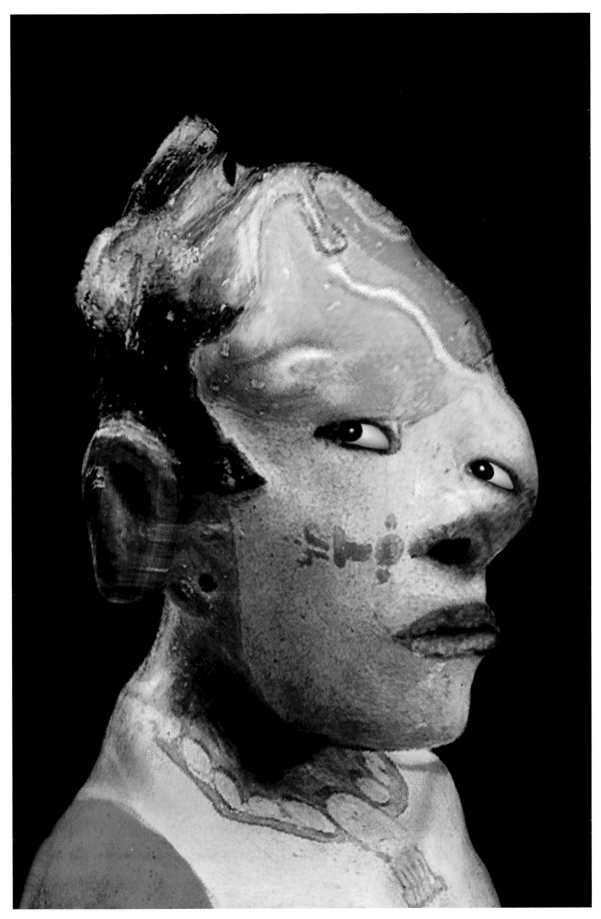

Disfiguration-Refiguration, Precolumbian Self-Hybridization No. 4, 1988
Cibachrome, 150 x 100 cm (59 x 39⅜ in)
Courtesy of the artist

LYNN HERSHMAN LEESON

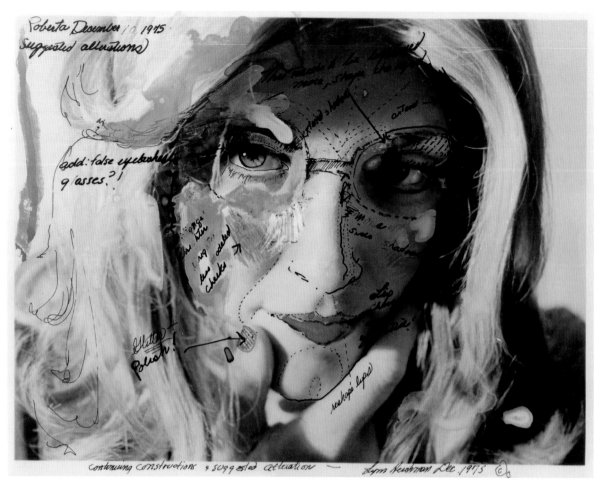

Roberta's Construction Chart #2, 1975
Digital pigment print, 50 x 63.8 cm (19⅝ x 25⅛ in)
Courtesy of the artist and Waldburger Wouters, Brussels

The interest in the idea of identity and transformation is made 'real', at one remove, by Lynn Hershman Leeson (b.1941) in the creation of the fictional Roberta Breitmore, first conjured in 1973. The artist developed a separate wardrobe, make-up, handwriting and mannerisms for the character, creating many works of art and performances over the five years of her existence. Before her 'exorcism' in 1978, 'Roberta Breitmore' applied for a driving license, credit cards, opened a bank account, joined Weight Watchers, had an extended correspondence with a therapist and led a 'normal' life, orchestrated by Hershman Leeson. In *Roberta's Construction Chart #2* we see the artist's mind at work as she describes and builds the individual elements that form this newly created being. This constitutes a type of portraiture sub-genre in which disguised personalities are constructed, controlled and developed, for example in work by artists such as Amalia Ulman (see p.149), and thus become artworks.

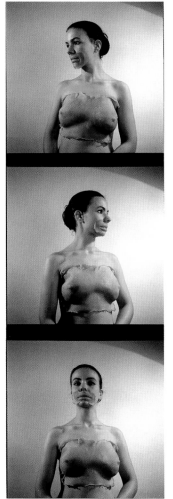
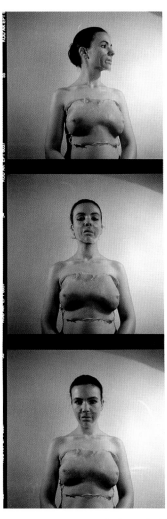
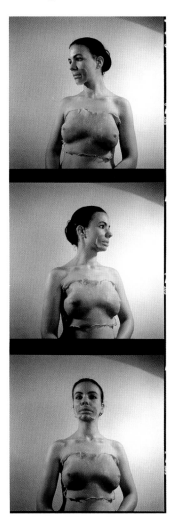
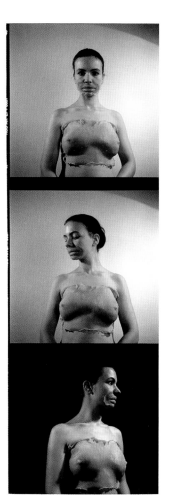

Self-portrait with Prosthesis, 1999
Medium-format photographs, 50 x 50 cm (19⅝ x 19⅝ in)
Courtesy of the artist

Isabel Castro Jung (b.1972), on the other hand, took a candid approach as a young art student in Barcelona, where she became interested in notions of the perfect female form. Realizing that her ideal body was represented by a range of elements that belonged to many other people, as opposed to one perfect individual, she set about making latex casts of specific body parts that she found to be perfect, from a range of people including herself. In the series of photographs she produced in an old-fashioned portrait photography studio, she records herself with these same perfect, lips, breasts, nipples and belly buttons attached to her own body, thereby appropriating the perfection of others – naked, yet clothed, in the bodies of her subjects. In her poses she chooses to emulate the traditional portraits of artists such as Jean-Auguste-Dominique Ingres and Francisco de Goya, connecting herself to a male art-historical tradition and to the wealth, power and beauty of the women who had sat for them.

MARTHA WILSON

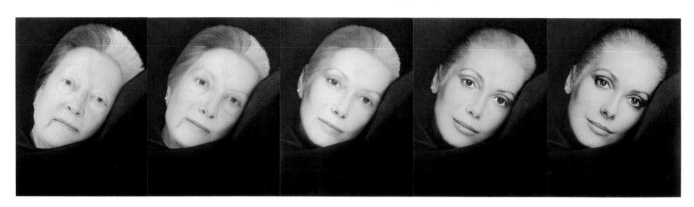

Makeover, 2015
Photograph and composite by Kathy Grove, 40.6 x 111.8 cm (16 x 44 in)
Courtesy of the artist and P.P.O.W Gallery, New York

Martha Wilson (b.1947) has a background in performance and famously set up the New York Franklin Furnace in 1976, a space that aims 'to make the world safe for avant-garde art'[9] and which she continues to run. The focus of her own art is on transformation, for example in *Makeover*, in which her own portrait transmutes in five steps: gliding from a portrait of the artist with two-tone ginger/white hair to the slicked blonde coiffure and visage of French actress and famous beauty Catherine Deneuve. Wilson calls these 'invasions' of other peoples' personae and sees them as a way of exploring her own female subjectivity. But these invasions are not permanently transforming (as they are for ORLAN, for example), and they allow the artist to slip playfully in and out of desirable and non-desirable characters.

TRISH MORRISSEY

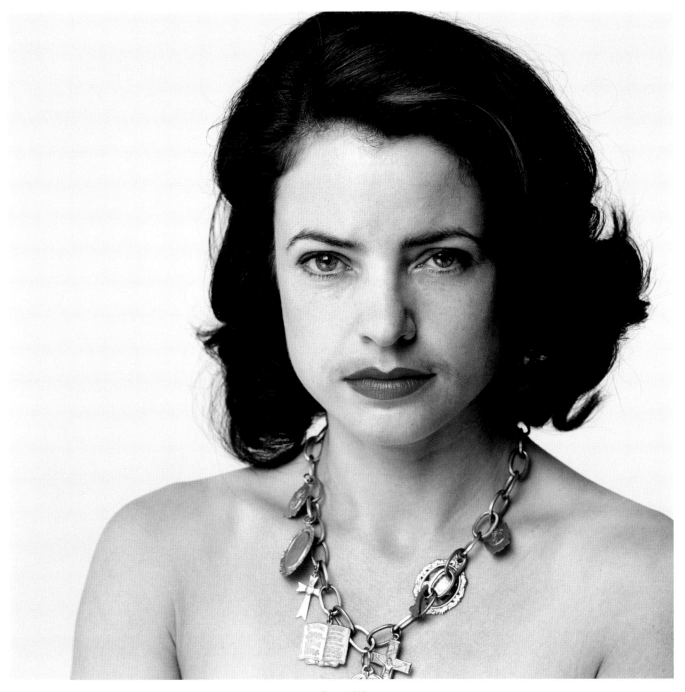

Tanya, 1988
from the series 'WWM'
C-type print, 123 x 123 cm (48⅜ x 48¾ in)
Courtesy of the artist

Hair, unwanted in some places and desired in others, has become a constant, manipulable fashion accessory – and perversely, even more associated with classic gender types in these fluid times. Trish Morrissey (b.1967) focusses our attention on facial hair in a way that recalls the so-called freaks of the circus sideshows of former times. She draws attention to what is considered acceptable or not, attractive or not, confronting the viewer in such a way as to encourage them to ask what is feminine and what defines

masculinity in our world today, and in doing so mocks our contemporary standards of the ideal and our confused notions of classic beauty. That hair is so intrinsic, personal and virtually indestructible gives it a special place as an artistic medium. It is both utterly symbolic: baldness heralds extreme youth, old age or illness; long, flowing locks denote strength, as in the case of Samson, or seductive beauty, as with Leonardo's *Mona Lisa* or Dante Gabriel Rossetti's Pre-Raphaelite portraits of Elizabeth Siddal.

Body

URSULA NEUGEBAUER

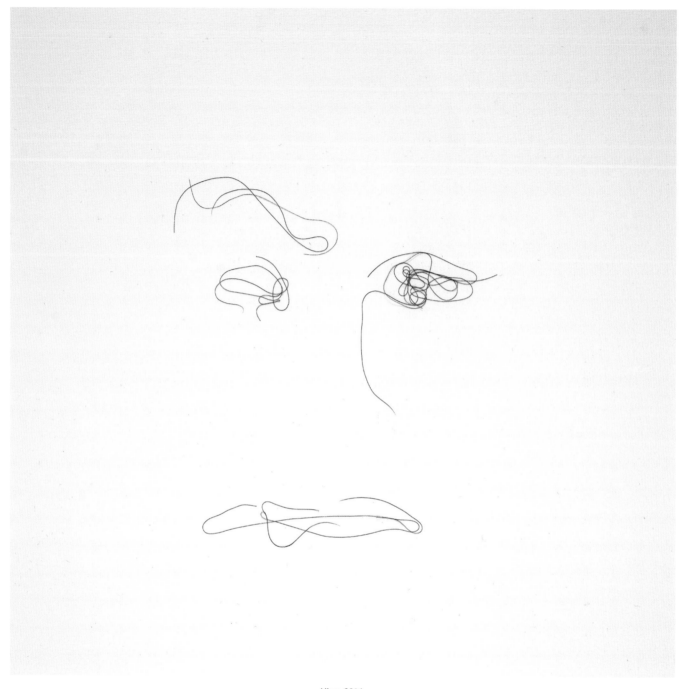

Aileen, 2014
from the series 'En Face', 50 hair drawings, each 43 x 43 cm (16⅞ x 16⅞ in)
Courtesy of the artist

There is a literal use of hair as calligraphic material in the series 'En Face' by Ursula Neugebauer (b.1960), for which she worked with Berlin prostitutes. Wanting to approach her subjects as human individuals, rather than commodities, she first drew them, then expanded the process, 'using the hair that these women gave to me I created likenesses of them. What came about were fifty hair drawings.'[10] These portraits are intrinsically of the sitters – they employ DNA-laden material – yet the depictions are of relatively anonymous renderings of facial features. The fact that they are named adds their unique character.

RITA DONAGH

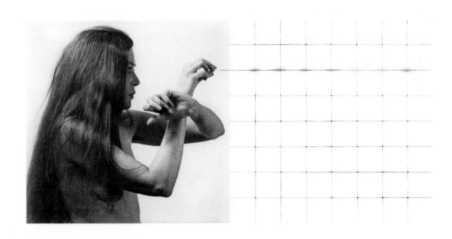

Slade, 1980
Etching and photogravure, 56 x 72 cm (22 x 28⅜ in)
Victoria and Albert Museum, London

Rita Donagh's long hair frames and obscures her naked body in *Slade*, which was inspired by her arrival for a day's teaching at the Slade School of Fine Art in the 1970s, where she was presumed to be the model and directed to the life studio – so rare was it for women to lecture in art schools at that time. Donagh (b.1939) reinforces her authority as an artist by depicting herself in the act of creation, employing the traditional painter's tool, the mahlstick, in the making of a work that clearly references colour theory. Ironically, the history of colour theory was also dominated by male figures: the scientist Isaac Newton, the writer and politician Goethe and the artist J. M. W. Turner. Donagh's nakedness references her status as model and creator, potentially in answer to one of Carolee Schneemann's earlier questions (see p.80).

Body

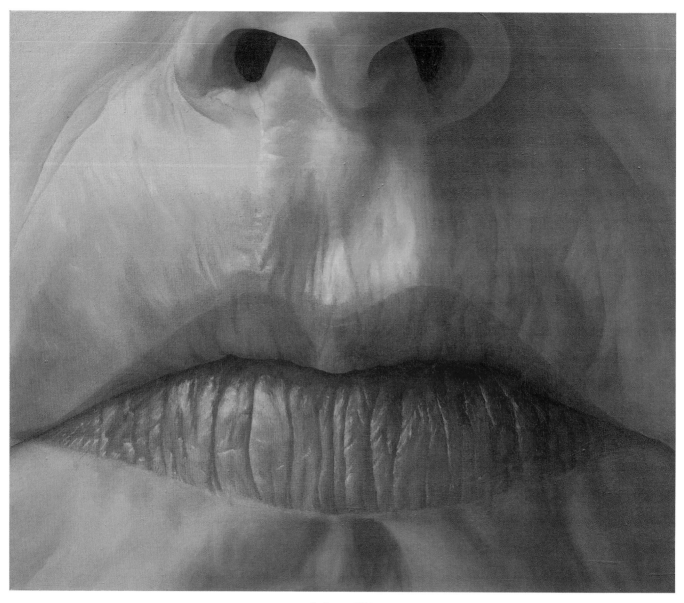

Persimmon, 1991
Oil on canvas, 60.3 x 74.9 cm (25¾ x 29½ in)
Courtesy of the artist and Peter Freeman Inc., New York

For many women, discomfort in their own nakedness is compounded by the lack of make-up or, conversely, we recognize that make-up is the armour needed to face the day (or night). In *Persimmon* by Catherine Murphy (b.1946), the ageing lips are depicted in unforgiving close-up, as if seen in a magnifying mirror, tracking the dispersal of the lipstick like some kind of Abstract Expressionist stained canvas. The sinister seepage confirms the unreliability of 'war paint', since lipstick smudges and runs, especially on older lips, where it tends to gather in the rivulets of wrinkles. Of the work, Murphy has said: 'It started when I was looking into my compact, putting lipstick on … and I think, "Look at that, my lips are no longer attached to my face. That's why guys like it so much, you don't even have a face, it's just the lips. Lips and breasts."'[11]

JESSICA LAGUNAS

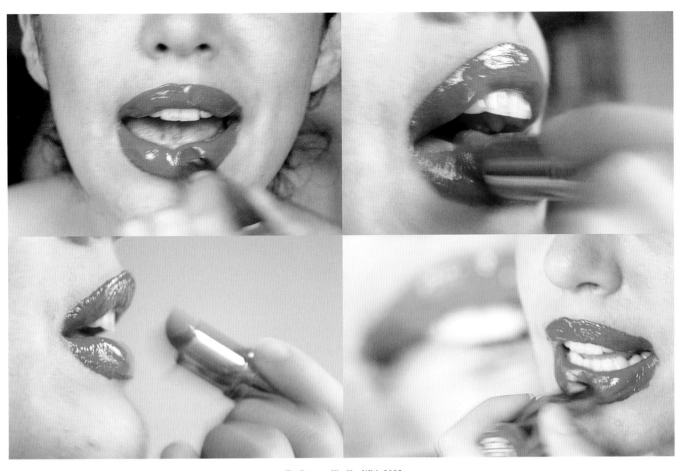

The Better to Kiss You With, 2003
Video performance, 57 min 48 sec
Courtesy of the artist

Lips also feature prominently in video performances by Jessica Lagunas (b.1971), in which she makes much of the ritualistic application of lipstick or mascara. These exaggerated actions suggest the pressures imposed on women by today's societies. Lipstick itself has an interesting history. During Roman times, it signified an elevated social status and was worn by men and women. In 1650 the British parliament tried to ban it, calling it the 'vice of painting', and Winston Churchill famously refused to ration lipstick in wartime Britain, for reasons of 'morale'. Describing the work, Lagunas has said, 'The camera focuses on the part of the body where the action takes place: With repetitive gestures – for one or two hours continuously – I apply make-up, questioning its power of seduction, or I depilate my pubis questioning the pressure to have a pre-pubescent appearance.'[12] Her work looks at the condition of women, questioning our obsessions with body image, beauty, sexuality and ageing. The title of the work makes reference to the fairytale *Little Red Riding Hood*, long burdened with sexual undertones and perversity.

Body

BETTY TOMPKINS

Cunt Painting #12, 2009
Acrylic on canvas, 137.2 x 106.7 cm (54 x 42 in)
Private collection

Works by Betty Tompkins (b.1945) constitute a fearless challenge to the idea of what might be thought of as acceptable subject matter for painting. The engulfing scale of her cunts is provocative: you can't miss these, nor pretend they are anything other than what they represent, for she employs a meticulously descriptive technique that is remarkable and seductive. The sheer scale of the works, combined with their tight focus on such intimate subject matter, is surprising and this, coupled with the skillful, detailed rendering of the paint, conjures an unexpected abstracted landscape.

JANA STERBAK

Vanitas: Flesh Dress for an Albino Anorectic, 1987
Mannequin, flank steak, salt, thread, colour photograph on paper (not shown),
158.1 x 41.9 x 30.2 cm (62¼ x 16½ x 1⅞ in) (mannequin)
Collection Walker Art Center, Minneapolis

Jana Sterbak (b.1955) peels the layers right back and cuts straight to the chase with her *Vanitas: Flesh Dress for an Albino Anorectic*, a dress constructed from 60 pounds of raw, salted flank steak hanging on a mannequin. Such a pure and radical gesture sits comfortably with her intention to provoke us into considering the notion of women as pieces of meat, or our obsessions with fashion, consumption and the distorted notion of the ideal body that so often tips young women (and now, increasingly, men) into eating disorders. The use of the word vanitas poignantly alludes to seventeenth-century Dutch still-life paintings that were made as reminders of our mortality, and the poverty of human life as compared to that of the spirit. The reference to decay in vanitas paintings is also clearly played out in this work, which slowly decomposes over time and which needs to be made afresh each time it is exhibited. The awkward stitching of the meat panels makes further reference to women's work and the traditional art of sewing.

SOPHIE RISTELHUEBER

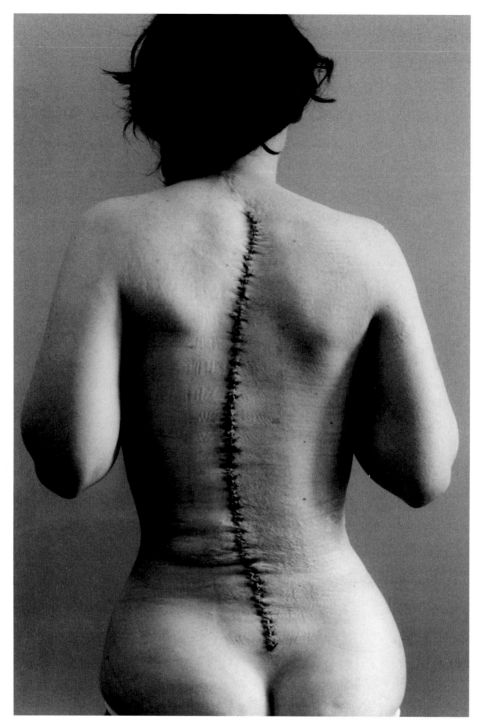

Every One #14, 1994
Gelatin silver print, 32.7 x 26 cm (12⅞ x 10¼ in)
Victoria and Albert Museum, London

Sophie Ristelhueber (b.1949) records the stitching of flesh in her project *Every One*, for which she took large-scale close-ups of fresh surgical stitches on the bodies of patients in Paris hospitals. Seen here, the sewing together of skin with needle and thread is a practical, rather than aesthetic, solution to closing up an open wound. The ruched skin becomes like folded fabric, referencing the physical scars inflicted on war-torn countries and the impact on their long-suffering residents. Ristelhueber seeks to reveal the marks of history on landscapes by highlighting them on bodies. The anonymity of the figures distances us from the realities of the painful medical procedures that must have been endured.

MARIA LASSNIG

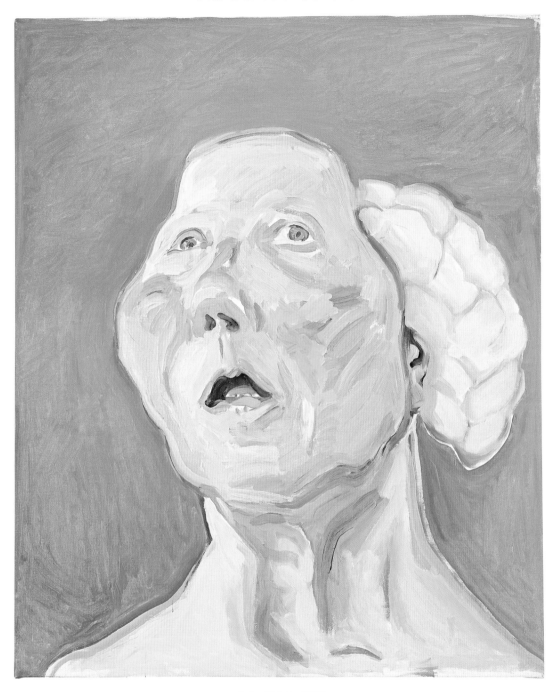

Lady with Brain, c.1990
Oil on canvas, 125 x 100 cm (49¼ x 39⅜ in)
Maria Lassnig Foundation, Vienna

If Sterbak (p.93) and Ristelheuber underpin the physical, Maria Lassnig (1919–2014) leads us into a spiritual terrain with her self-portrait *Lady with Brain*, which records her facial features and her own interpretation of the appearance of her brain. This organ is the powerhouse that drives our identity. It stores our memory and emotions and connects ways of thinking and doing; it is the locus of our personality, character, experience and humanity. Simultaneously combining face and brain, Lassnig creates a powerful, symbolic double self-portrait. Over her 70-year career, she focussed primarily on images of herself and the ways in which she was viewed as an artist and as a woman by others, often revealing personal traumas and fantasies with a disarming degree of honesty. That the work is painted in Lassnig's characteristic style and colours intensifies the statement, stamping it with her unique stylistic trademark.

BEVERLY SEMMES

Fingers, 2012
Ink on magazine page, 26.7 x 15.9 cm (10½ x 6¼ in)
Courtesy of the artist and Susan Inglett Gallery, New York

Beverly Semmes's work is less concerned with images of herself and more with those of others. Semmes (b.1958) works with sculpture, performance and paint, cutting across both figuration and abstraction and her series 'The Feminist Responsibility Project', begun in the late 1990s, combines those two genres. In it, she takes pages from what she terms 'gentlemen's magazines', then censors the orifices and female physical attributes with paint, effectively 'correcting' the view, as she terms it.

In this image, Semmes's actions have obfuscated the original purpose of the picture and make it hard to be confident even of the skin tone of the model portrayed. Semmes' obscuring, however, still draws our focus to the reclining and coquettish pose of the female figure, and the white hand draws our eyes directly towards the sexual organ that the sitter is revealing as the tool of her trade.

MIKA ROTTENBERG

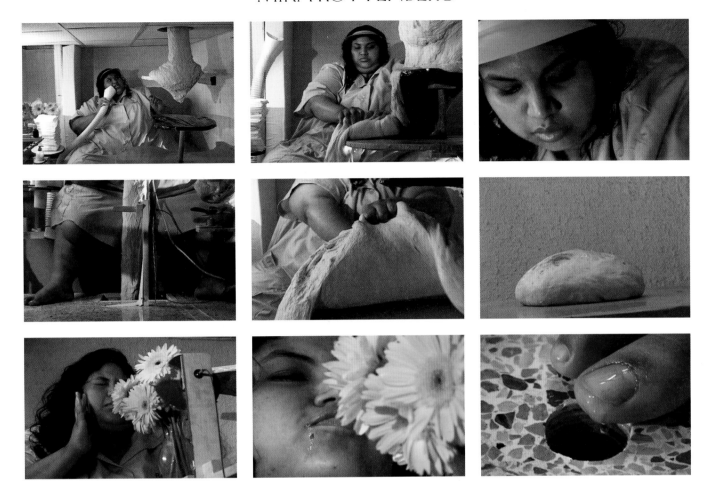

Dough, 2005–06
Single channel video, 5 min 52 sec
Courtesy of the artist

The videos made by Mika Rottenberg (b.1976) open up a world of surreal and often obscene activity connected with the body as a microcosm of broader issues associated with labour, class and society. Both funny and grotesque, her view promotes and encapsulates the bizarre activities of our world using, as a lens, people with exaggerated characteristics who are often performing perfunctory, factory-like activities on strange contraptions set within claustrophic, fabricated settings of her own invention. Her characters are employees who already rent their bodies as part of their own work. Queen Racki, who performed in *Dough*, for example, is a 'squasher' who sits on people for a living and a 'size-activist' who founded the website largeincharge.com. Rottenberg's characters are often seen to multitask, a stereotypically 'female' skill, using different parts of their bodies simultaneously in the creative act. In this work, the process of producing the material, dough, allies industrial and bodily functions and alludes to digestion, excretion and birth. As the artist has said, 'I'm not really interested in objects. I'm more interested in the whole operation around it … How it is to live in the architecture of the body. Being wrapped inside a skin, you know having limits. Psychologically, that feeling of being trapped. That's what it's about for me.'[13]

NANCY SPERO

The First Language (detail), 1981
HandprintIng, printed and painted collage on paper in 22 panels, 20 in x 190 ft (50.8 cm x 57.91 m)
Courtesy the estate of Nancy Spero and Galerie Lelong

In a series of 22 panels entitled *The First Language* by Nancy Spero (1926–2009), there is a sense of ancient freedom and movement which is being physically celebrated – almost the opposite of the constrained imprisonment of Rottenberg's characters (p.97). Spero's work is known for its focus on political violence and sexism, using the crimes and assaults on women from all eras and cultures to reveal the horrors of what is often hidden. In the 1980s she developed a pictorial language of body movement that resembled hieroglyphics and had a cinematic quality, which represented women from pre-history to the present.

Her inspiration came from the phrase *peut-être la première langue – c'est la danse* ('dance was perhaps the very first language') from the book *Forty Thousand Years of Modern Art* (1948), from which she also appropriated some of the first images of pre-historic women, notably those of Australian Aboriginal figures. Here, her cast of characters, as she liked to call them, are intended to be running, not dancing, like the hunting cavemen one might find on the walls of a prehistoric cave or on a Greek urn. 'You know, I don't believe in progress in art.' she said. 'Prehistoric art can't be beat! Sophistication isn't progress.'[14]

LIFE

YOU LOOK AT YOURSELF IN THE MIRROR. AND ALREADY YOU SEE YOUR OWN MOTHER THERE. AND SOON YOUR DAUGHTER, A MOTHER. BETWEEN THE TWO, WHAT ARE YOU? WHAT SPACE IS YOURS ALONE? IN WHAT FRAME MUST YOU CONTAIN YOURSELF? AND HOW TO LET YOUR FACE SHOW THROUGH, BEYOND ALL THE MASKS?

Luce Irigaray, 'And the One Doesn't Stir without the Other' (1981)

Figuration and portrait-making reinforce existence itself by making visual references that describe the experiences of life. All manner of two-and three-dimensional representations, from Cycladic figures to Greek and Roman statuary, Aztec wall painting and High Renaissance art, echo our place in the world. Abstract and realist modes of representation crowd around us, and women artists add to the mountain of references. Certain works become visible through the miasma, offering specific and original comment. What does it mean to be alive and testify to that state? How to convey the feeling of sun on your skin, or terror in someone's eyes? How can artists show us the world by creating their own equivalent responses?

It is difficult also to visualize the inception of life, the bringing of life into the world and the celebration of this mystery. Frida Kahlo famously painted *My Birth* (1932) shortly after her miscarriage and the death of her mother. Painted in the style of a *retablo* (Mexican folk-art devotional painting), the work describes her own birth, as it is Kahlo's head that appears from between the legs and out of the vagina, symbolizing her own creativity. The relationship between the act of physically giving birth and that of creating art is intertwined, and is more frequently alluded to where women's creativity is concerned (Kahlo was childless). As the artist Marina Abramović has said, 'People ask why there are so few female artists who succeed. It's because women are not ready to sacrifice as much as men. Women want a man, they want a family, they want to have children, they want to be loved, *and* to be an artist. And they can't; it's impossible'[1] – though artist mothers Louise Bourgeois, Phyllida Barlow, Cornelia Parker and Marlene Dumas might disagree.

In this chapter, we consider work by women artists whose art touches on the issues that affect everyday life: life as a young woman, life as an adult, as a mother, a grandmother or a friend – without losing sight of the impacts of power, achievement, politics, economics and feminism. Self-portraiture, pregnancy, children and family, together with examples of siblings, community and other forms of connection, are explored, and the process of daily life is observed and assessed in sometimes clinical and at other times emotional ways. Disability, sex, skin colour and sexuality are the things that life is made up of – as well as the washing up, which also figures.

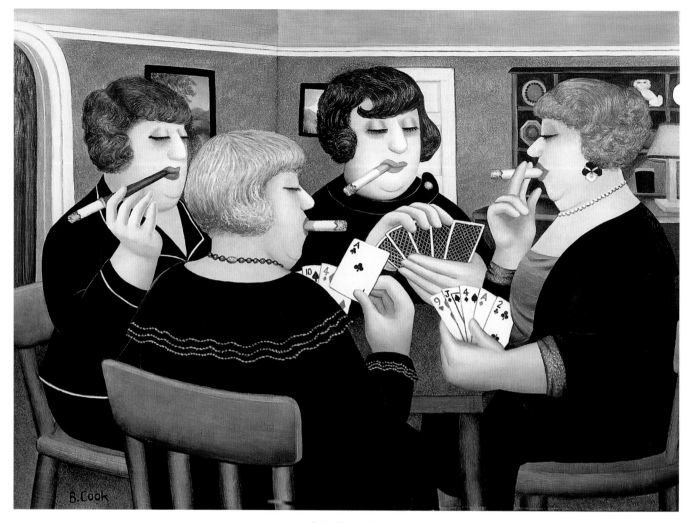

Bridge Party, 1997
Oil on canvas
Courtesy of ourberylcook.com

As we know, the only things we can be certain of in this world are birth and death, but for women the so-called 'biological clock' is also a permanent reality, one that is connected to the specific number of eggs available to each woman for potential fertilization, and the lifespan of those eggs. Along with pain and pleasure, humour affirms our position as sentient humans and is one way of addressing the terror of these certainties, but how to make great art that is funny? The immediacy of drawing and the punch of graphic communication allow a flexibility of expression that creates space for humour. Wit and excoriating political comment are firmly rooted in the work of artists such as James Gillray, William Hogarth and Gerald Scarfe in the UK. In France, Claire Bretécher built an entire career on her cartoon strip *Les Frustrés,* which features a set of female characters who enact the foibles of women's everyday lives and the filtered impact of politics. One of her early characters was called Cellulite. In the UK, we have enjoyed the gentle, witty paintings by Beryl Cook (1926–2008) and Posy Simmonds's long-running comic strips in the *Guardian* newspaper, which describe a liberal middle-class family, mocking their anxieties about political correctness and exposing their base human nature. In the 1950s Jackie Ormes was the first African American to create a syndicated comic strip, *Torchy Brown*. Her single strip *Patty-Jo 'n' Ginger,* about the relationship between sisters, followed and ran for eleven years.

ELLA KRUGLYANSKAYA

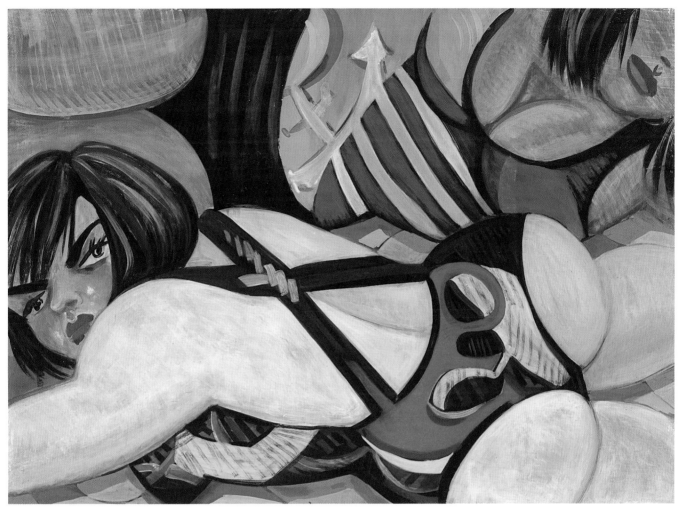

Bathers XII, 2012
Egg tempera on panel, 61 x 81.3 cm (24 x 32 in)
Courtesy of the artist and Thomas Dane Gallery

Characters depicted by Ella Kruglyanskaya (b.1978) are almost cartoonish in their stylization, but they are all about the female form, sexuality, social interaction and the everyday activities of our lives. Her women on the beach wear swimming costumes that revel in pattern and colour and are testament to Kruglyanskaya's interest in fashion, form and function, and are reminiscent of Russian constructivist painting in their dynamism and sense of movement. 'Fashion is important to me, I don't dismiss it as this light thing … But I'm definitely not interested in fashion for fashion's sake. I use certain elements of clothing for the composition … it fragments the body in this aggressive, visual way.'[2] Her paintings, mostly of women, portray individuals with attitude, confident in their physiques, engaging with each other and the viewer in direct and challenging ways.

MCCREA DAVISON

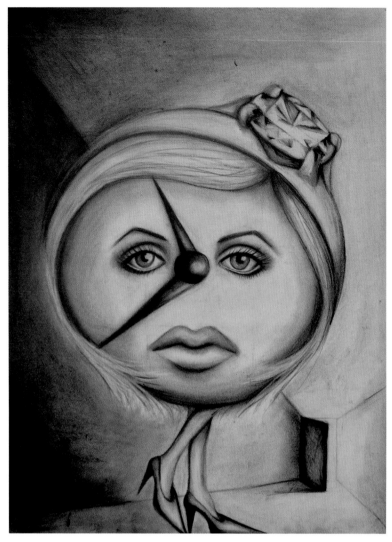

Biological Clock, 2013
Charcoal, 55.9 x 76.2 cm (22 x 30 in)
Courtesy of the artist

McCrea Davison (b.1991) is a young artist making work in response to her experience of the social and physical constrictions of femininity, and this drawing concisely suggests an old-fashioned conundrum. It bears the trademark imagery of a historically recognizable situation – that the subject needs a relationship – indicated by the standard single-diamond engagement ring worn as an Alice band. McCrea's cartoon shows a large-headed, perfectly coiffed blonde with immaculately made-up eyes, her lips echoing their shape. In her pointy high-heeled shoes, with sad eyes she considers her own biological clock ticking away, causing anxiety because she is trapped, Alice-style, in a room that has a door too small to escape from. She is passive, without arms, stymied by needing a sire to help make a child before her own sell-by date.

This type of deadpan humour relies on a graphic, schematic way of communicating the female form. *Little TV Woman: 'I Am the Last Woman Object'* by Nicola L's (b.1937) is a visual and ironic play on its title. The woman is functional and functioning: there is a soundtrack that declares she can be touched (for the last time), the breasts have TV knobs for channel hopping and the legs are elastic enough to lie spread out and welcoming. The first outing for this tongue-in-cheek lady, who is reminiscent of the assemblage sculptures of Edward Kienholz, was in a Parisian jewellery shop window belonging to Alfred Van Cleef, which made a rather neat comment on the relationship between money, jewels and sex. According to the artist, the work was probably inspired by the nascent feminist politics of the time, much of which reflected on the objectification of women.

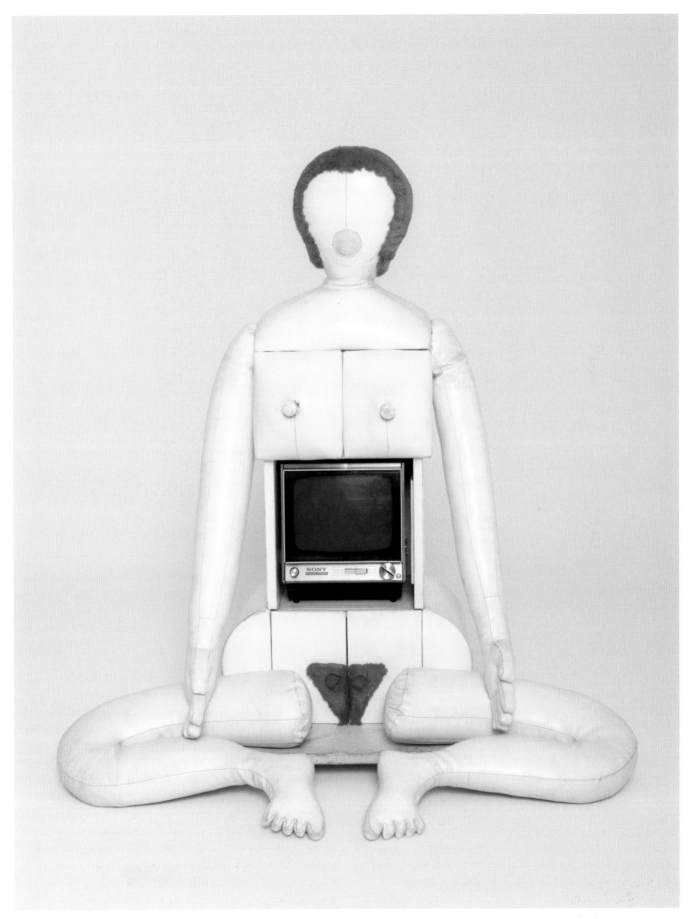

Little TV Woman: 'I Am the Last Woman Object', 1969
Vinyl, wood, television, 111.5 × 50 × 45 cm (43⅞ x 19⅝ x 17¾ in)
Collection Xavier Gellier

LOUISE BOURGEOIS

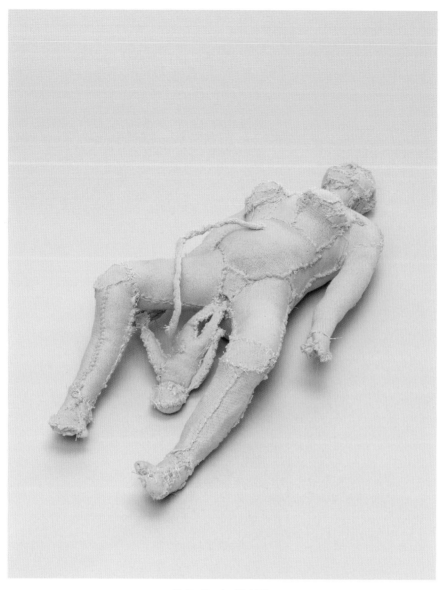

Do Not Abandon Me, 1999
Pink fabric and thread, 12 x 52 x 21.5 cm (4¾ x 20½ x 8½ in)
Private collection

Louise Bourgeois's soft sculptures of doll-like figures have a fantastic presence. Small in size and simple in pose, in them Bourgeois (1911–2010) reiterates the iconic relationship between the mother and child. The pale pink fabric, reminiscent of old-fashioned sticking plasters, is stitched together in vaguely symmetrical, but nonetheless haphazard, fashion. The infant emerges, still connected to the mother by the umbilical cord, although, unnaturally, the cord is connected to the exterior of the mother figure, as if we are both inside her body sharing the experience and outside watching it. The title of the work hints at

the levels of fear and physical demands that come as part of the birthing process, but might also allude to the ultimate loss of that child as it grows up and develops a life of its own. In fact, the almost frozen and lifeless appearance of the figures, without any bone structure to underpin them, makes them not unlike mummified corpses. They are soft and vulnerable, yet curiously detached from this momentous personal event. Bourgeois often offers a conundrum in her works: on the surface they appear simple, iconic even, but their subject matter resonates on many levels.

PATRICIA PICCININI

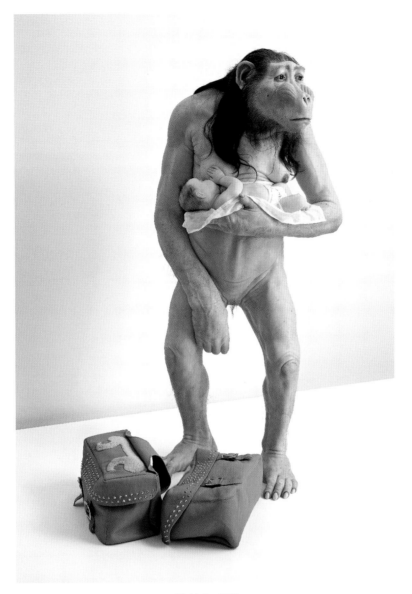

Big Mother, 2005
Silicone, fibreglass, leather, human hair, satchels, 175 x 90 x 85 cm (68⅞ x 35⅜ x 33½ in), dimensions variable
Courtesy of the artist, Tolarno Galleries, Melbourne and Roslyn Oxley9 Gallery, Sydney

Patricia Piccinini (b.1965) sculpts the next stage of the story after birth, but her protagonist is apeish and surreal. This pale figure, with translucent saggy skin reminiscent of a waxwork, has long, wig-like hair on her head but barely any on her body, as one might expect from an animal. The protective gesture is a familiar one as this stooping, knee-bent, naked apparition cradles the human child who suckles from a thin breast. The only clothes in evidence are the nappy and the oddly incongruous blue bags at the mother's feet, supposedly full of baby equipment and clothing. The work was inspired by a true story the artist heard about a baboon whose baby had died while she was still nursing it. Overwhelmed by grief, the baboon abducted

a human child, which was later recovered unharmed. The artist has said, 'I didn't grow up in an environment with a lot of animals around me, but for me, the essence of life is to nurture and be nurtured, and that is something that cuts across species.'³ She goes on to tell the story of how, when she had trouble breastfeeding her newborn son, her sister suggested that she suckle her daughter (the artist's niece), which she did, and through that experience learned how to feed her own child. There is something unpleasant, yet melancholy, about the figure. The piece challenges our expectations of what a mother is, all the more so now that, for most of us, wet nurses are a thing of the distant past.

Life

ALICE NEEL

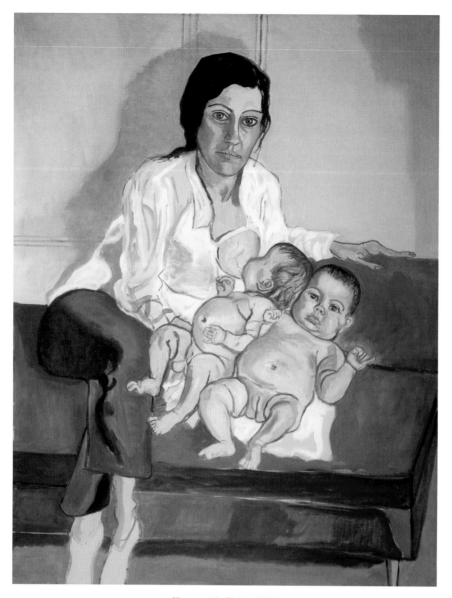

Nancy and the Twians, 1971
Oil on canvas, 137.1 x 101.6 cm (54 x 40 in)
Courtesy of David Zwirner, New York/London

In this portrait by Alice Neel (1900–84), we have a conventional scene, albeit one that fills many mothers with trepidation at the thought of having to feed two small mouths, rather than one. Famously quoted as a 'collector of souls', Neel is one of the great portrait artists of the twentieth century, and persevered with figuration during the rise of Abstract Expressionism and Pop art. She recorded images of New York's intelligentsia in the 1960s and 1970s, but was especially known for her frank and tender portraits of family and friends in and around Spanish Harlem, where she lived. In *Nancy and the Twins*, she depicts her daughter-in-law with her twin daughters, Alexandra and Antonia, with their sex confidently on display. Despite the sweetness of the subject matter, Neel's paintings of mothers and children acknowledge the sense in which women are enslaved by the role of motherhood and how, in paternalistic societies, women are defined by, and valued according to, their ability to bear and nurture children. Neel's own experiences, of losing one child to diphtheria and then suffering a nervous breakdown when the second child was taken away from her by a fugitive husband, compound the sadness.

RINEKE DIJKSTRA

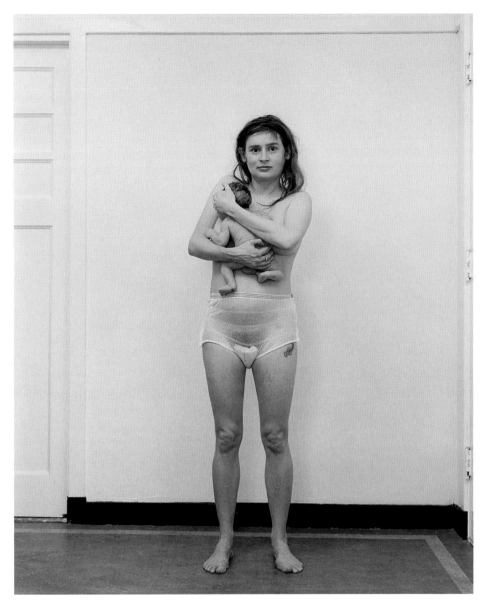

Julie, Den Haag, Netherlands, February 29 1994
from the 'New Mother' series
Colour photograph, 117 x 94.5 cm (46 x 37¼ in)
Courtesy of the artist and Marian Goodman Gallery, New York

Even franker depictions of motherhood are portrayed by Rineke Dijkstra (b.1959) in her photographic series of women who have literally just given birth and appear somewhat traumatized and bloodied by the experience, far removed from the more divine, beatific and pain-free Madonna-and-child images of the past. As the art historian Lynda Nead has written, historically 'the forms, conventions and poses of art have worked metaphorically to shore up the female body – to seal orifices and to prevent marginal matter from violating the boundary dividing the inside of the body and the outside.'⁴ The work seems rational in the face of the most extraordinarily creative, yet life-threatening, human activity. Hers is a kind of analytical experiment of comparison that harks back to the tradition of anthropological classifications, or the recording of types as seen in the photographer August Sander's images. Are the women clothed or naked? Is there blood? What impact has the birth had on the woman's body shape? How do they hold the child? How big is it in relation to their hands? The women's gaze at the camera holds nothing of the pride in achievement that we might expect; we glimpse instead the shock and fear in their eyes. In *Julie*'s case, Djikstra likened her stare to that of a wild animal, natural and protective. At this point in their lives the mother and child are no longer one, but have become two separate entities, and the psychological impact of this transition is as significant as the physical impact of giving birth.

Life

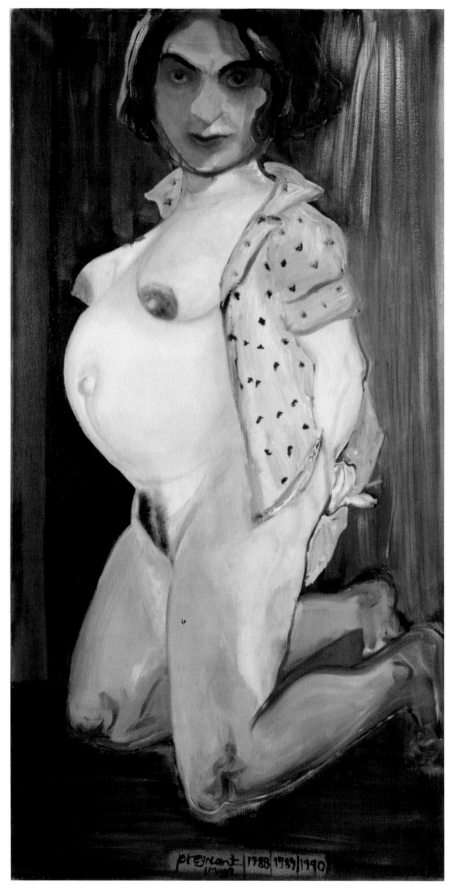

Pregnant Image, 1988–90
Oil on canvas, 180 x 91.1 cm (70⅞ x 35⅞ in)
Courtesy of David Zwirner, New York/London

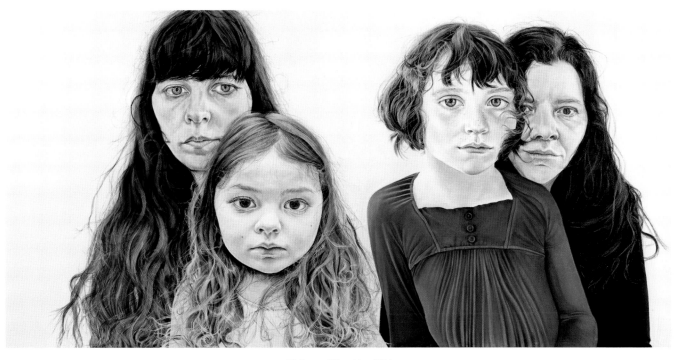

Mothers and Daughters, 2014
Oil on canvas, 65 x 130 cm (25½ x 51⅛ in)
Courtesy of Flowers Gallery, London and New York

Pregnant Image is a composite portrait, rather than depicting any one individual, and is possibly based on photographs, as is standard practice for Marlene Dumas (b.1953). This pregnant figure is still confident in her sexual allure as an as-yet-unencumbered female. The painting was begun in 1998, the year in which Dumas became pregnant, but she completed it in two further stages, the last one after the birth of her own daughter, after which she famously said 'I'm not one of the boys any more.'[5] The years of engagement with the work are recorded along the bottom of the painting – 1988, 1989, 1990 – the three dates reminiscent, perhaps, of the three trimesters of pregnancy.

Dumas's work is a good starting point for some consideration of the history of representations of pregnancy in self-portraits. Pressure on silhouette is an issue during pregnancy, as there is no control over the gradual and inevitable localized expansion of the body. One rarely sees the Madonna pictured as overtly pregnant – blooming, yes, but then in tandem with the immaculately conceived son. Examples exist of paintings depicting women at the point of – and during – giving birth since Medieval times, but it was not until the twentieth century that attitudes regarding 'suitable' artistic subject matters relaxed and artists shone a spotlight on specific bodily functions, using them as a vehicle for exposing the raw and basic 'farmyard' level of our physicality. Paintings such as Stanley Spencer's

self-portrait with Patricia Preece, *Double Nude Portrait: The Artist and his Second Wife* (1937) started to reveal the raw and visceral nature of our bodies.

Self-portraits, whether by men or women, often concentrate on peculiarities or changes in physique that are recordable, such as the withering of the body in old age or fluctuations in shape and size. Pregnancy recurs as a theme, but erections only rarely. Perhaps that is because historically, women have been seen by society at large as victims of their emotions and bodies, of hormonal imbalances that cause hysteria and other problems. And yet, men are thought of as being in control, despite being at the mercy of their erections, so a different set of criteria for what should be shown in self-portraits has been applied, as illustrated by many of the self-portraits in this book. It is also worth noting that, while we accept the reflection of death in the images of war that invade our screens on a daily basis, the merest hint of life-giving menstrual blood still causes affront.

Ishbel Myerscough (b.1968) and Chantal Joffe (b.1969) have tracked their progress as friends, artists, women and mothers since they attended Glasgow School of Art in the 1980s. Mutual expanded portraits create a record of artistic humanity and friendship. Over time, all the participants grow and develop, as does the nature and relative skill of the art. The overriding bond

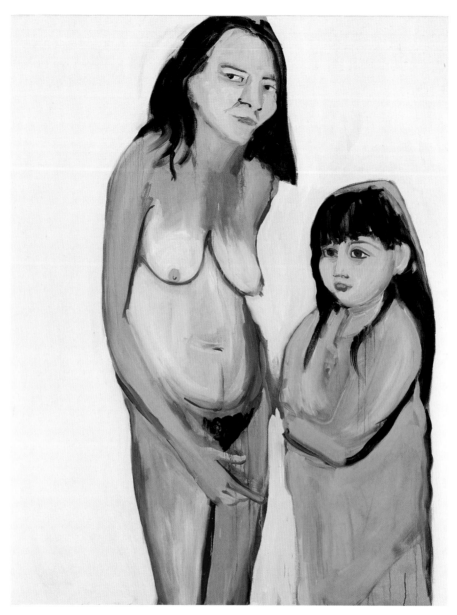

Naked Self-Portrait with Esme in a Pink Nightshirt, 2014
Oil on canvas, 244 x 183.5 cm (96⅛ x 72¼ in)
Courtesy of the artist and Victoria Miro, London

between the two artists is reinforced in Myerscough's portrait by the title, which makes the presence of their daughters almost inconsequential. The relationship and the bond is between the two artists. This is no saccharine record of their offspring, but an exercise in technique and composition. Myerscough is not one to romanticize the notion of motherhood. In her self-portrait *Misery* (2006) she sits gazing intently and desperately with her young child in her lap, the title giving more than a hint of her mood at the time. While Myerscough's realist portraits of famous sitters

have found a home at the National Portrait Gallery in London, Joffe's more expressionist and abstract style saw her elected a Royal Academician in 2013. In her work, Joffe focuses largely on female figures – 'I don't want to make pretty paintings. I'm after an honest, almost brutal quality. That's why I love to paint myself.'[6] That honesty extends to her self-evaluation, which also references the inevitable rhythms of life: 'I look like an old banana in a fruit bowl beside a ripe peach'.[7] The connections between artistic and physical female productivity (motherhood, in other words) can

MAMMA ANDERSSON

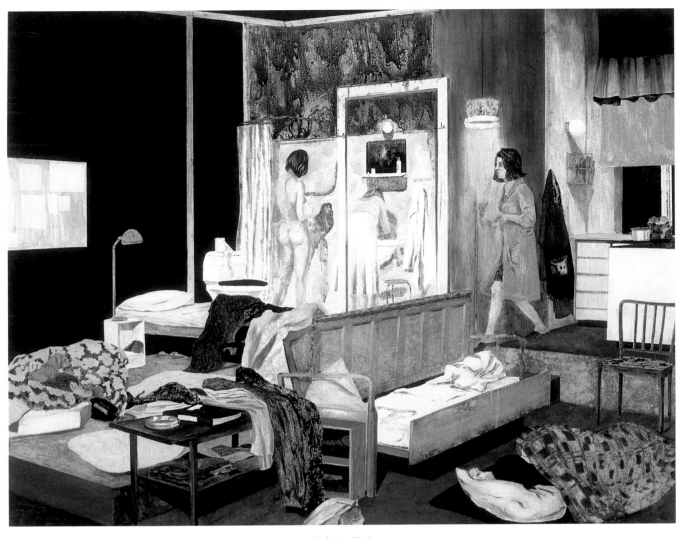

Leftovers, 2016
Acrylic and oil on panel, 122 x 160 cm (48 x 63 in)
Courtesy of the artist; Galleri Magnus Karlsson, Stockholm; Stephen Friedman Gallery,
London and David Zwirner, New York

sometimes be confused, and have been described by feminist critic Tal Dekel as a 'deeply rooted problematic inherent in the nexus between art, images of the female body, and the maternal experience'.[8] More than just the tracking of physical changes, there is a profound link between the act of recording offspring and the artists' ongoing development – as in the example of Myerscough and Joffe.

Mamma Andersson (b.1962) tackles the notion of female friendship in an almost theatrical set she has

created for her cast of characters in *Leftovers*. A sense of dreamlike ambiguity is often found in her work: is this a representation of one individual engaged in many different ritual activities in one space, as in a time lapse; or is it a scene of contemporary shared accommodation with all the comings and goings of daily city life? The title hints either at a failed relationship or at women described as being 'left on the shelf', allowing the viewer to invent their own narrative.

Life

ARWA ABOUON

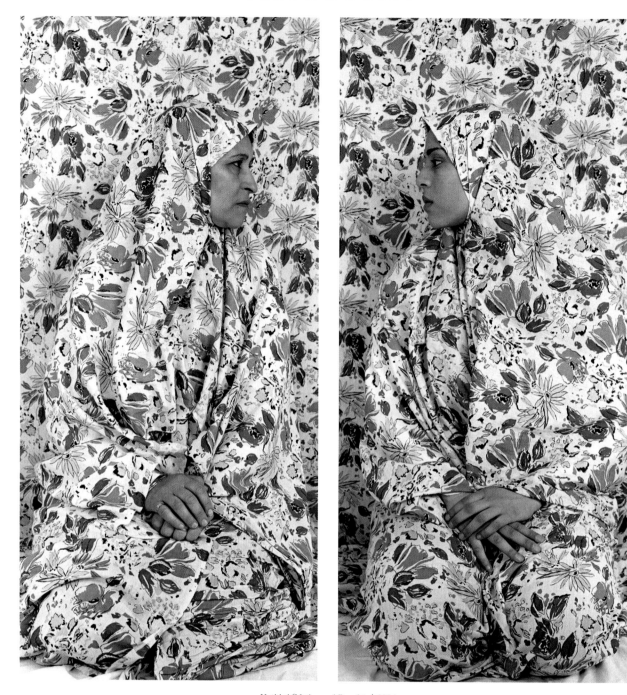

Untitled (Mother and Daughter), 2004
from 'Generation Series'
C-prints, each 111.7 x 203.2 cm (44 x 80 in)
Courtesy of the artist

If the ties of female friendship can be strong, those between family members, and especially between mother and daughter, can be fundamental. Prints by Arwa Abouon (b.1982), which show mother and daughter enveloped in the same fabric, suggest the subjects' genetic connection while drawing attention to their shared cultural inheritance through the style of clothing. The fact that the poses echo each other encourages comparison of their profiles, perhaps evoking ideas of genetic sampling and the eventual potential of such tools for the manipulation of future generations. The subjects are bound by social mores and the sexual division implied by their clothing, but Abouon continues to seek humour in her exploration of the tensions inherent in being a Muslim from Libya living in the western culture of Canada.

114

LALLA ESSAYDI

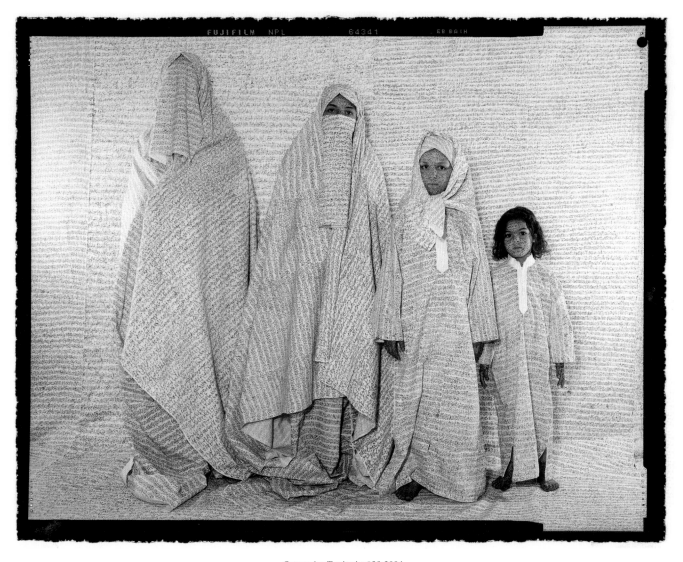

Converging Territories #30, 2004
Chromogenic print, 84.7 × 103.3 cm (33⅜ × 40¾ in)
Courtesy of the artist and Edwynn Houk Gallery, New York

Lalla Essaydi's photographic work is concerned with the Islamic culture of her childhood, and most specifically with the greater emancipation of Arab women. For Essaydi (b.1956), her intention is not to condemn but to communicate the richness of tradition, ideas and the strength of the relationships and bonds that lie within that culture, and which can be misrepresented in the West. Her photographs often reference the way in which Islamic culture can impose rules on women, for example in covering parts of their body as they grow and develop from childhood, through puberty and into adulthood. Her use of hennaed texts across the background, the clothes and sometimes the skin, gives her women a voice, and references the fact that, traditionally, calligraphy should not be practised by women in Islamic cultures – yet another form of communication is withheld from them. This photograph was taken in the house where women and girls from Essaydi's family, including Essaydi herself, were held in punishment, sometimes for weeks, when they transgressed the rules of Islam.

ANNA MARIA MAIOLINO

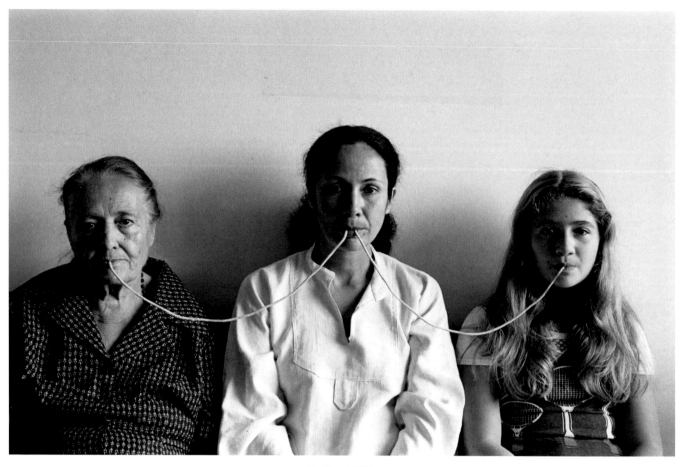

By a Thread, 1976
Black and white photograph, 27 x 40.5 cm (10⅝ x 16 in)
Courtesy of the artist

Three generations of women appear here, literally connected by mouth, a recurrent theme in work by Anna Maria Maiolino (b.1942). This curious image, whose Portuguese title *Por um fio* translates as 'by a thread', invites interpretation of the thread as umbilical cord as connector between generations, evoking ideas of genetic tracing and the inheritance of characteristics both physical and mental. The artist has stated: 'I would go as far as saying that my works about digestion come from what my mouth remembers of my mother's breast, the comfort of that first food, while as a counterpoint, I see defecation as the 'first work … We live and die from the mouth to the anus … these are experiences that are fundamental, corporal and vital to us.'[9] Vitalia, Anna and Veronica are, respectively, the artist's mother, the artist and her daughter. This mapping of the artist's life trajectory reflects the subjects' three countries of origin: Ecuador, Italy and Brazil respectively.

In theory, Cindy Sherman's view of the mother-daughter relationship by is suggested by these two over-made-up women, who echo each other in poise and artifice. They are all plastic bauble and man-made fabric, with hair that seems not only to get its colour from a bottle, but also to have been fabricated elsewhere. The sealed smiles are surgically fixed and their emotional make-up is in the freezer. The background of the photograph is mundane and lifeless, like a corporate hotel lobby, without so much as a vase of flowers; instead, flowers are woven into the fabrics and the swirling floor carpet. Sherman (b.1954) has made an entire career of masquerading as different types of women and/or photographing body parts in disarray, leaving the viewer to create the stories and relationships that she merely suggests in her images. In her work she draws attention to the situation of women, whether as painted Renaissance icons or as film idols, such as her series of 'Untitled Film Stills' from the late 1970s, which relentlessly parody stereotypes of women, often with very little apparent sympathy.

CINDY SHERMAN

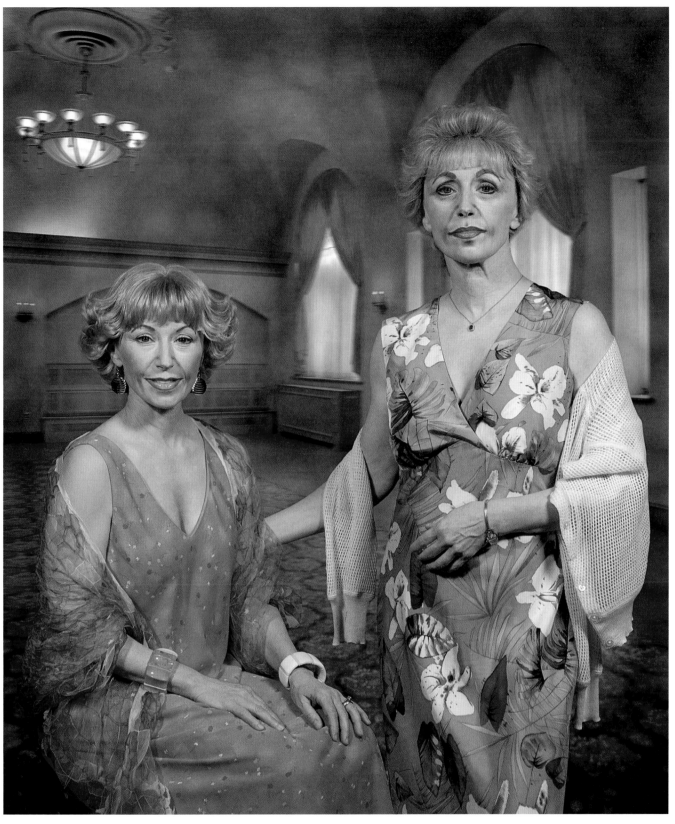

Untitled #475, 2008
Chromogenic colour print, 219.4 x 181.6 cm (86⅜ x 71½ in)
Courtesy of Metro Pictures and Sprüth Magers Gallery

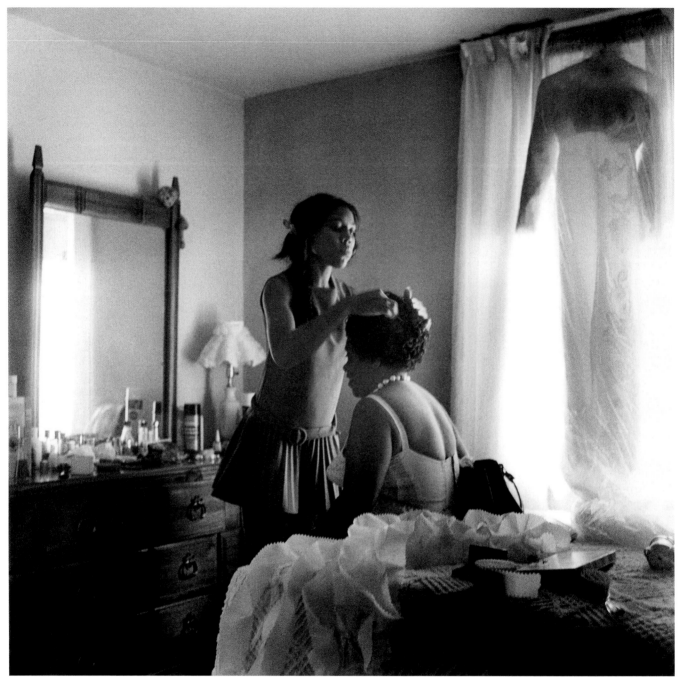

Mother and Daughter, West Oakland, 1970
Black and white photograph, 15.2 x 15.2 cm (6 x 6 in)
Courtesy of the artist

Relations between mother and daughter are particularly relished by some women artists, as we can see in the candid and touching work of Joanne Leonard (b.1940). In *Mother and Daughter*, it is as though we have been granted a glimpse into a private domestic scene that is somehow familiar. The mirror and dressing-table scenario is an ancient reference, a vanitas, talking as it does about make-up and self-beautification, and the hairdo is another significant part of the preparation ritual for going out on a special occasion. Here, the daughter is in attendance, expertly manipulating the curls while the mother meekly bends her head in obeisance, making it seem like a blessing that she is receiving. The light is filtered through the drapes and bounces off the mother's beautiful double-curved back. Her body is held in tight structure by the serious underwear that forces her breasts into cones, much like the fluted lampshade in the corner. Its frilliness is echoed in the abundance of textured ribbon ruffles in the foreground and has a quality reminiscent of the divine intervention of an annunciation painting, the young girl attending to her mother with an almost religious concentration.

CARRIE MAE WEEMS

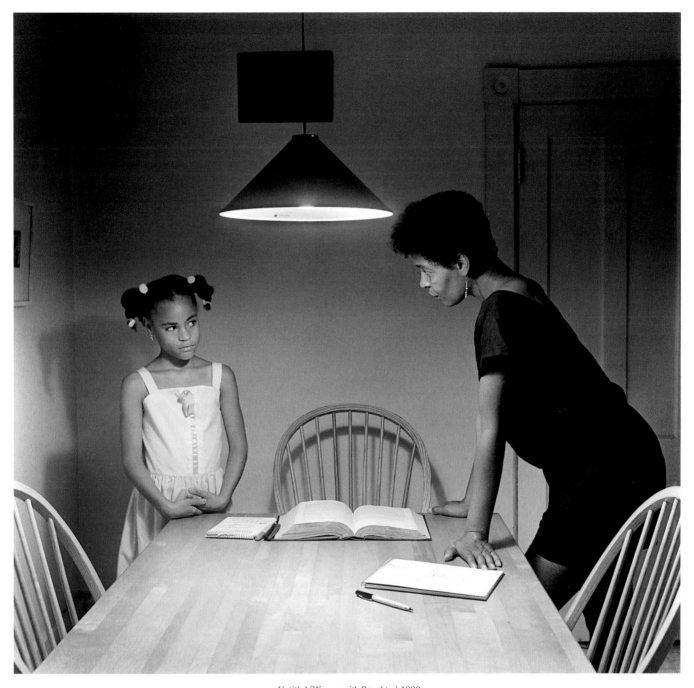

Untitled (Woman with Daughter), 1990
from the series 'Kitchen Table'
Silver print, 71.8 x 71.8 cm (28¼ x 28¼ in)
Courtesy of the artist and Jack Shainman Gallery, New York

In the 'Kitchen Table' series by Carrie Mae Weems (b.1953), we see the supposed centre of a woman's world, the kitchen table, as the fulcrum around which aspects of daily life are performed. It is a place for card games, meals and gatherings of friends and family, with empty bottles filling the table and stale smoke the room, as witnessed in other images from the series. But it is also a space where the artist, who is the central character in this image, is allowed to express her sexuality and sensuality. In exploring the idea of family, Weems blurs the boundaries between the real and the fabricated in these meticulously directed images that use the tropes of documentary. The image shown here reminds us of the role that women have played in the rearing and the professional development of children and the value of the matriarch in black culture. Weems notes that prior to this series 'most images of family, and in particular black families, had been utterly stereotyped.'[10] and goes on to say, 'I think that most work that's made by black artists is considered to be about blackness … Unlike work that's made by white artists, which is assumed to be universal at its core. I really sort of claimed the same space, and I think the work in many ways is universal at its core'.[11]

119

Life

MELANIE MANCHOT

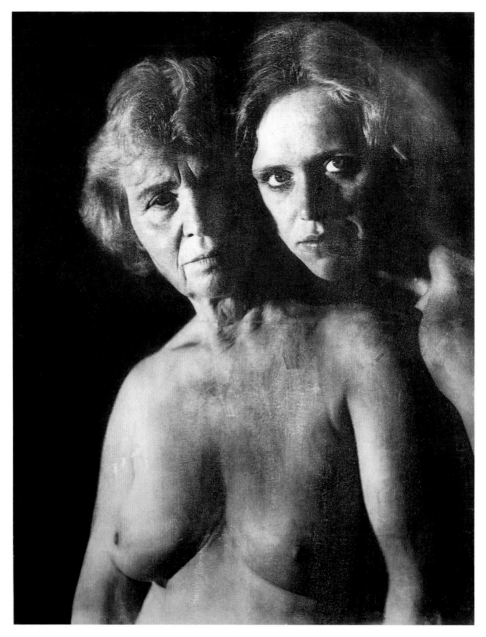

Double Portrait Mum and I, 1997
from the series 'Look at You Loving Me'
Gelatin silver print on canvas, 150 x 120 cm (59 x 47¼ in)
Courtesy of Parafin, London and Galerie m Bochum, Germany

Melanie Manchot (b.1966) portrays herself alongside her mother. The older woman appears bare-breasted, her form filling the frame. This black and white photograph has been printed onto canvas using light-sensitive emulsion, worked over with chalk and charcoal. The mother's worn flesh is rendered honestly and her natural beauty shines through what is palpably an aged frame. Their close and trusting relationship, echoed in the pose, allows for the almost-taboo subject of female ageing to be literally exposed. Made over a period of four years, Manchot created over 40 works in this series, which charts and investigates questions of the invisibility of the older woman and the objectification of the female form.

Alongside our twenty-first century prejudices against aged women and sagging flesh, the work *Cavity* from the series '(M)other' by Helen McGhie (b.1987) brings the lack of elasticity of old flesh sharply into the limelight. The tonal modulation transforms what one assumes to be folds of skin on the back into a craggy landscape that, thanks partly to its title, is also suggestive of a vagina. The full installation of photographs, as described by a judge for the 2016 British Women Artists Competition, is 'a multiple portrait of an archetypal Mother figure conflated with the interiors of an ageing house. Its walls, like her body, have passed their period of youthful pristine surfaces.'[12]

Cavity, 2014
from the series '(M)other'
C-type print, 61 x 49 cm (25⅛ x 19¼ in)
Courtesy of the artist

LUCY JONES

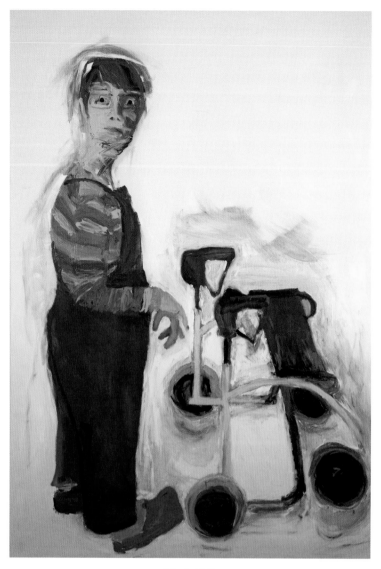

Wheelie, 2012
Oil on canvas, 180 x 120 cm (71 x 47¼ in)
Courtesy of Flowers Gallery, London and New York

Confronting the disabled body provokes anxieties similar to those about ageing. Lucy Jones (b.1955) has long painted her own twisted shape, creating the most remarkable, honest and transfixing images of herself, with and without walking aids. She has cerebral palsy. Discussing how much viewers should be aware of the difficulties this causes her, she comments, 'I am an artist, not a disabled artist … I think my work speaks without my personal narrative attached to it as it covers the universal about how difficult it is to be human.'[13] Jones is a colour junkie who revels in the juxtaposition of jazzy tints and sombre tones and uses colour to elevate and communicate the joy of paint.

Bodily changes by way of physical abuse are a common theme in women artists' work. The caption that accompanies the photo-lithograph by Tracey Moffatt (b.1960) provides the following explanation for the sitter's swiftly moving head, blurred by the speed with which it has turned: *On Mother's Day, as the family watched, she copped a backhander from her mother*. Moffatt's creative world is cinematic, unravelling complex stories that defy any linear reading due to the artist's refusal to explain. She prefers to leave interpretation open to the viewer, providing headline information only, such as the title of this series, 'Scarred for Life'. Moffatt draws the viewer into the activities and in this work the point of view is that of the perpetrator, which causes conflicting emotions in the viewer: horror at the reality of what is being done and a sense of complicity in the action.

TRACEY MOFFATT

Mother's Day, 1975 On Mother's Day, as the family watched, she copped a backhander from her mother.

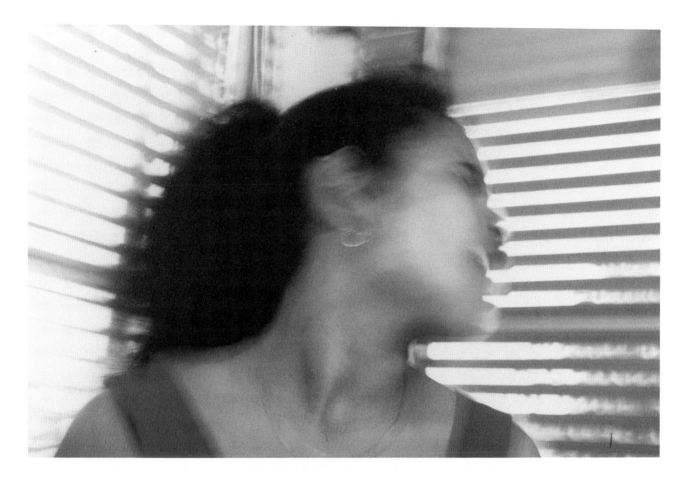

Tracey Moffatt

Mother's Day, 1975
from the series 'Scarred for Life'
Photolithograph, 80 x 60 cm (31½ x 23⅝ in)
Art Gallery of New South Wales, Australia

KLARA KRISTALOVA

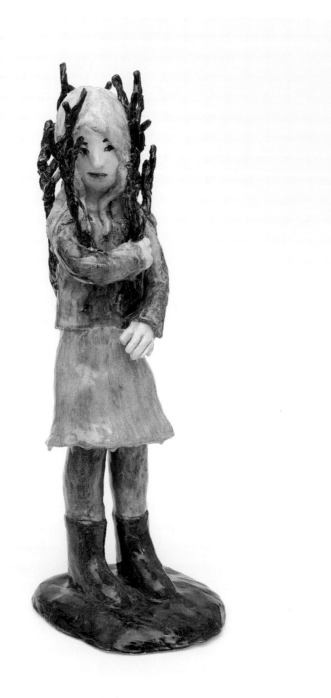

Young Girl Growing, 2013
Glazed stoneware, 102 x 33 x 36 cm (40⅛ x 13 x 14⅛ in)
Courtesy of the artist and Lehmann Maupin Gallery, New York and Hong Kong

Klara Kristalova (b.1967) sculpts docile figures that appear as doll replicas of the homemade variety. The figures are stiff, sometimes fearful, crackle-glazed and shiny, and are inspired by traditional Dresden dolls. They are big for ceramics, typically the size of small children, and are all made and kiln-fired in the artist's Swedish woodland studio. The work explores changing female identity during childhood, adolescence and womanhood, but rather than painting a bucolic picture of that progress, the awkwardness of the constructions contributes to a sense of foreboding and of potential exploitation. Kristalova's work explores memory, trauma and the loss of childhood, carrying with it a sense of the macabre and the anti-fairy tale. The branches that appear to be growing from the child's chest in this sculpture might allude to the Greek myth about Daphne, who was turned into a tree by her father in order to avoid the uninvited advances of Apollo.

LORETTA LUX

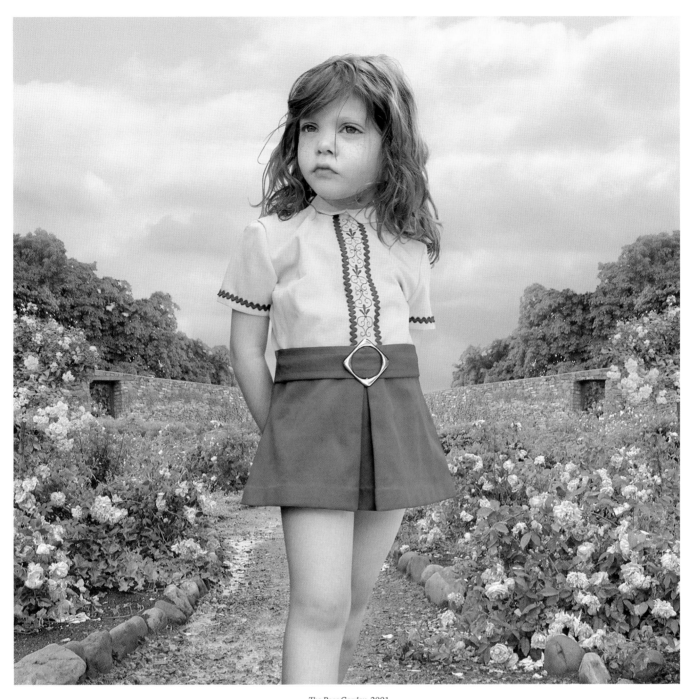

The Rose Garden, 2001
Ilfochrome print, 38.5 x 38.5 cm (15 x 15 in)
Courtesy of the artist

The photographs by former painter Loretta Lux (b.1969) purport to be cute and surreal but are in fact achingly suggestive of paedophile porn and are strangely reminiscent of Balthus's controversial paintings of young females. Lux's girls appear to be from another world; perhaps they have a sixth sense, or perhaps they have emerged from a film set about aliens. The artist uses Photoshop software to manipulate the imagery and create translucent skin for the children she 'borrows' from friends for modelling purposes. She dresses her models in vintage clothing, which flavours the work through its colour, style and

pattern, then drops them into backgrounds that she has either painted or photographed. The entire process takes two to three months per image. 'My work isn't about these children,' she explains. 'You can recognize them, but they are alienated from their real appearance – I use them as a metaphor for innocence and a lost paradise.'[14] There is a parallel with Julia Margaret Cameron's photographs of Victorian urchins. Lux (a pseudonym) regards the making of her photographs as more allied to painting than photography, inspired by her love of the Old Masters.

Life

GILLIAN WEARING

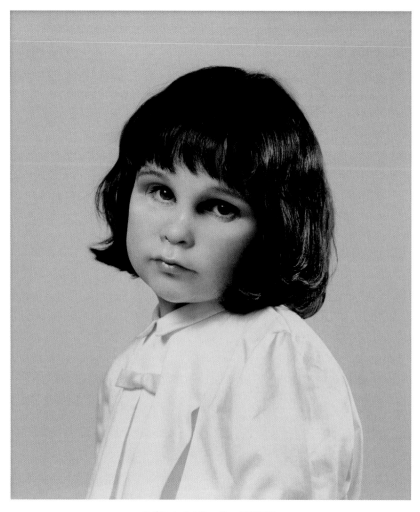

Self-Portrait at Three Years Old, 2004
Chromogenic print, 182 x 122 cm (71⅝ x 48 in)
Solomon R. Guggenheim Museum, New York

Gillian Wearing (b.1963) often works with her own image, using masks to make connections between aspects of her physical self and similar traits that occur in her family. In 2003 she started recreating images from a family photo album by carefully modelling wax mannequins, from within which her own eyes peer out at us eerily. Her continuing interest in reality TV programmes, in which we can observe all human life at a remove, feels related to this form of hidden watching: simultaneously inside and looking out, she can be seen to be observing and assessing us, as viewers. As she has said, 'You always feel that you are the mask to some degree … The photo of my mum I used was from before I was born, when she was 23. She was this quite innocent, optimistic young woman, I think. You are trying to get that across, somehow. I mean, my eyes are the only thing I have to use, but I try to make them as hopeful and young as possible.'[15] The use of disguise occurs frequently within the genre of self-portraiture.

Wearing a mask is one way of deflecting attention – or, at least, appearing to hide from the viewer. Crying on camera suggests another kind of deflection: are these real or crocodile tears? *Woman Crying #2* by Anne Collier (b.1970) possesses a fabulous intensity. The light play on the skin makes reflections that are picked up on the well-defined lips, the tear drop, the inner eyelid and the eyeball itself. The closely cropped face is intense and the blackness of the eye socket, framed by the painted arc of the brow, is seductive and suggestive. Although we only see a section of the face, the impact is strong and sculptural. Collier's work draws on the world of print advertising, and this image comes from a series of weeping women that featured in advertising images from the 1950s to the 1980s. Her selections, featuring these ready-mades, re-present the stereotypically female act of crying, and by repeating she draws attention to the masquerade and pretence.

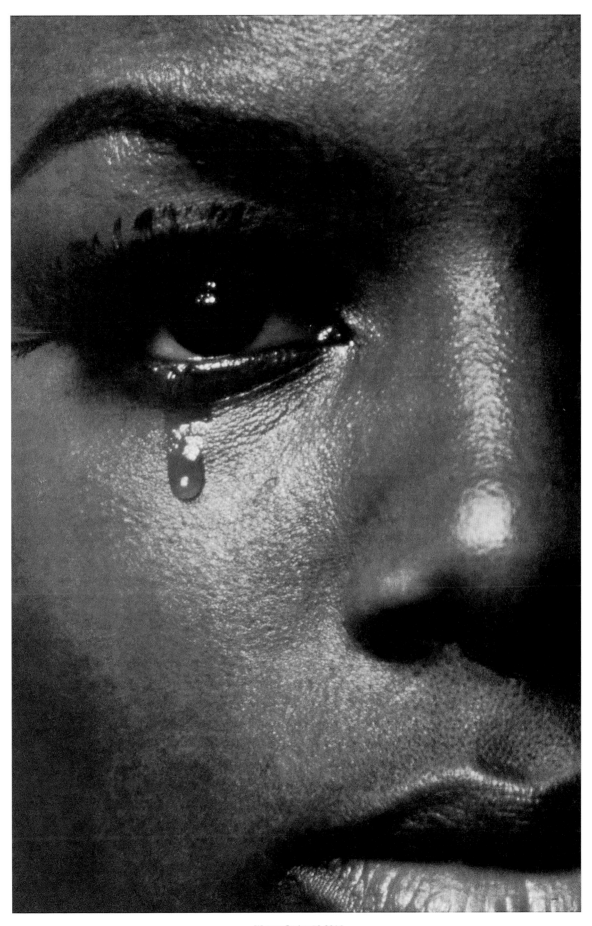

Woman Crying #2, 2016
C-print, 134.6 x 89.6 cm (53 x 35¼ in)
Courtesy of the artist

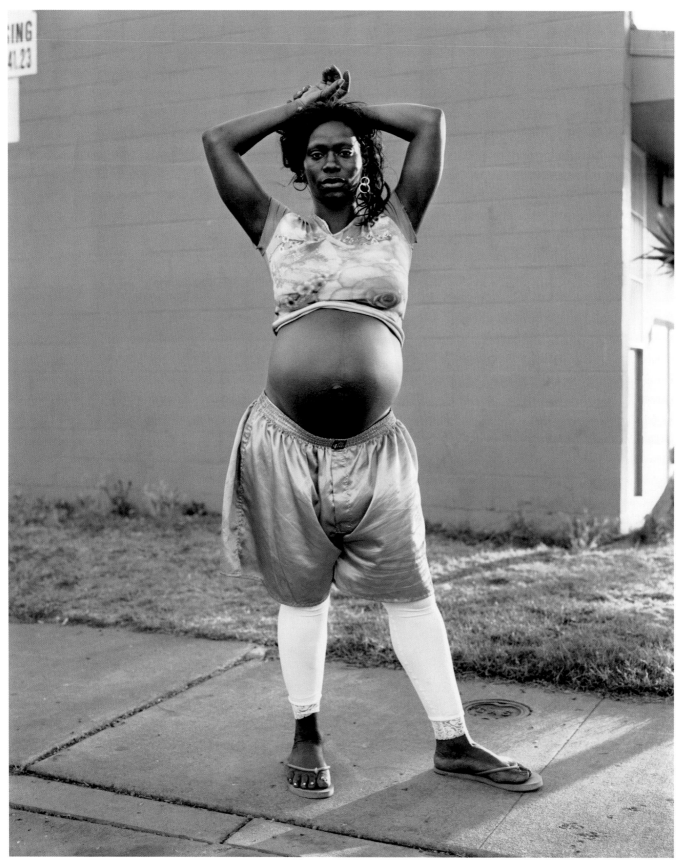

J 50, 2008
from the series 'Imperial Courts', 1993–2015
Black and white photograph
Courtesy of the artist and GRIMM, Amsterdam | New York

RONI HORN

You Are the Weather (detail), 1994–95
64 C-prints and 36 gelatin-silver prints, each 26.5 x 21.4 cm (10⅜ x 8⅜ in)
Courtesy of the artist and Hauser & Wirth

The formality of an image in which one person is portrayed by another has a different kind of impact and resonance. The works by Dutch photographer Dana Lixenberg (b.1964), from the series 'Imperial Courts', document the Los Angeles public housing project of the same name, which she first visited in March 1993, after the Rodney King riots. This marked the beginning of a 22-year period during which she formed relationships with the residents, documenting and reflecting their friendships, their families and three generations of children. 'I have grown extremely attached to the community shown in these photographs ... The series became a documentation of personal histories.'[16] Lixenberg was interested in exploring gang culture through 'a stripped-down and de-sensationalized photographic approach, particularly after witnessing the extremely one-dimensional reporting of the outrage that followed the acquittal of the officers involved in King's beating.'[17] Lixenberg's work concentrates on communities on the fringes of society, but she has also photographed many celebrities. Here she used a large-format camera and black and white film, working with available light and shooting outside. 'I've discovered my language as a photographer with this work.'[18]

Roni Horn (b.1955), in her series *You Are the Weather* (1994–95), is less interested in the identities of communities and, notionally, more curious about how we are than who we are. In this photographic cycle she records the impact of almost imperceptible changes in weather on the sitter, the artist Margrét Haraldsdóttir Blöndal, submerged up to her neck in Icelandic geothermal pools. Horn, who is interested in notions of sameness and difference that make the viewer look harder, has said of the series, 'I was curious to see if I could elicit a place from her face, almost like a landscape. Not in a literal sense, but how close these identities were'.[19] Horn reinforces the sense of the viewer being immersed in this 'landscape' by controlling the method of installation of the 100 photographs so that the visitor is surrounded by the works within a single, enclosed space. The cycle, which she has revisited more recently, continues Horn's work on gender, identity, androgyny and the relationship between object and subject. Of the work, she says that she found them 'deeply erotic in a genderless way'.[20]

Life

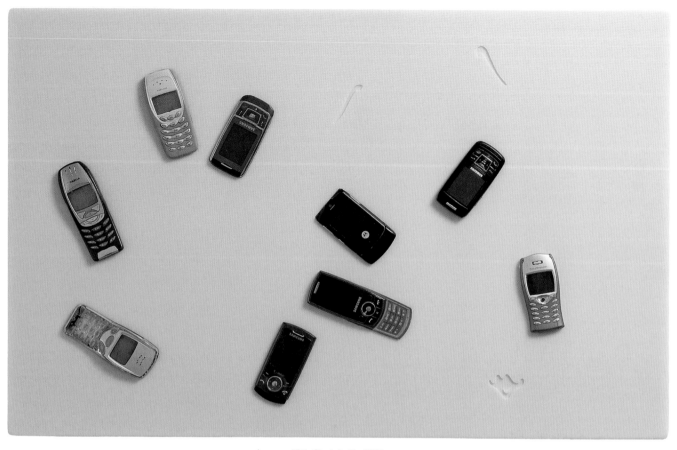

All the Single Ladies, 2010
Cast and CNC-routed Corian and mobile phone handsets, 55 x 85 x 3 cm (21⅝ x 33½ x 1⅛ in)
Courtesy of Sadie Coles HQ, London

Human life is mostly made up of mundane occurrences, and many women artists have focussed on exposing the humdrum in their work, sometimes in the manner of a scientific observation, and at other times as a fond look at the stuff of life. Helen Marten (b.1985) takes the ubiquitous mobile phone and turns it into a painterly sculpture that references a well-known Beyoncé pop song of the 1990s, 'All the Single Ladies'. Marten comments: 'The phones are grounded in a pink material, Corian, which is very heavy, chalky, almost classical, even as it has a very domestic quality (it is used in kitchens). The title All the Single Ladies imagines this troupe of semi-drunk women, defiant but hopeless as well.'[21] Marten's work is riddled with models and motifs from contemporary culture to create an imagery of our everyday lives. The feminine and domestic nature of her installations is often compounded by her use of familiar objects from the home, such as ironing boards.

Susie Hamilton (b.1950) explores notions of 'the comedy of human pursuits'[22] in her series of paintings set in supermarkets. Self-service supermarket shopping revolutionized the way in which people organized food and cooking, revealing itself to be both a liberation and a shackle. The idea of the supermarket as a social space emphasizes the isolation of Hamilton's figure, caught between the glassy walls of the freezer cabinets. Throughout her work, Hamilton is as much interested in light as she is in form. 'I suppose I see my figures as part of a world of power and dynamism but they themselves are struggling in that world, vulnerable to things that are more powerful than they are. Light in my pictures can overwhelm them.'[23] Her paintings are made from a range of sources, including video, photographs and drawings, that she creates on site. Her drawings are the most valuable to her, as they provide distilled and abbreviated figures, which then allow her to create the abstracted, slightly grotesque subjects that appear, solitary and vulnerable, in the final work.

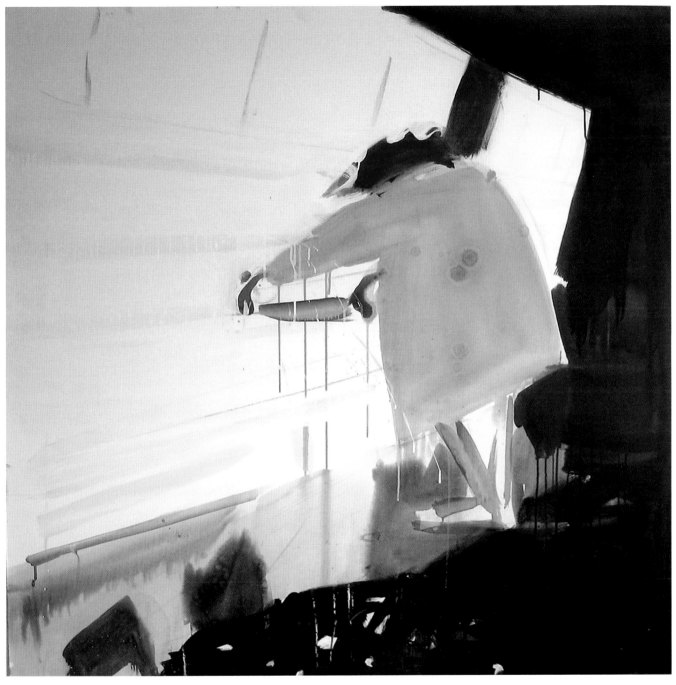

Freezer, 2012
Acrylic on canvas, 132 x 132 cm (52 x 52 in)
Courtesy of the artist

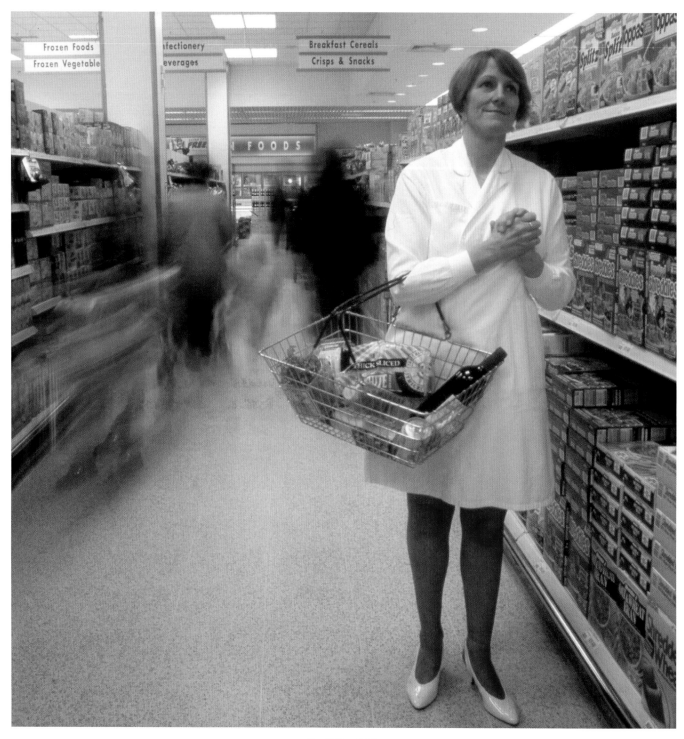

How To Shop, 1993
from the series 'Daily Life'
Performance at the London International Festival of Theatre

LIZ CRAFT

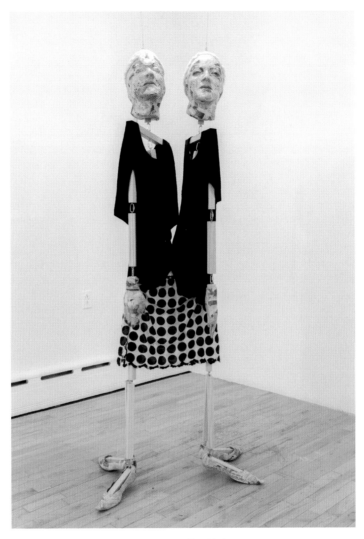

Wendy and Lisa, 2016
Papier-mâché, wood and fabric, 152.4 × 55.9 × 61 cm (60 × 22 × 24 in)
Courtesy of the artist and Real Fine Arts, New York

The performance artist Bobby Baker (b.1950) has made an art out of shopping in her 'Daily Life' body of work, in which she dons the uniform of a faceless domestic, or a doctor's white housecoat, accessorised with a pair of cheap but dainty white shoes. While the richness of the visual imagery in a supermarket delights her, she also reads it as an influencer on world affairs: 'How we treat each other in supermarkets, how we care for our children, are symbolic of something much larger, international relations – war and peace.'[24] She established the arts organization Daily Life Ltd with the intention of changing the way people think about mental health, based on her own experience of severe depression. Her focus on the relentlessness of daily life, as personified in the ritual of the

supermarket visit, permits us to distance ourselves from the banality of the everyday and connect with the fragility of her personal performance.

Liz Craft (b.1970) also engages with the notion of capitalism and how it has impacted on the lives of women by turning them into passive consumers. Like a pair of conjoined twins, Wendy and Lisa have heads that have been modelled with a degree of accuracy, but the fact that they both wear six eyes cut from glossy magazines, and their skin is made up of newspaper with the cuttings still visible, quickly dispels the illusion. These women have become the inanimate mannequins that sold us the products in the first place.

Untitled – March 2002
C-type print, 122 x 183 cm (48 x 72 in)
Courtesy of Maureen Paley, London

Hannah Starkey's photographs have documentary-style settings that suggest a depth of story which, ultimately, is pure invention. Starkey (b.1971) largely makes use of actors to create the scenarios, and there is a bathos and understatement to her work, partly thanks to the bored or melancholic expression of the women that often populate her images. She has described her work as 'explorations of everyday experiences and observations of inner city life from a female perspective.'[25] Her interests lie in capturing moments of reflection and contemplation in the rush of our daily lives. Our imaginations run rampant when considering the photograph; no end of possibilities await the older woman (which we deduce from the colour of her hair) in *Untitled – March 2002*. The visual clues all contribute to our own versions of the story, but the overwhelming sense of loneliness and loss is palpable as she waits for her fish and chips, or sushi.

The mundanity of our existence is further highlighted in the video *Housework Ritual* by Fang Lu (b.1981), for which she invited the female staff of a hotel to perform

Housework Ritual, 2009
Video, 10 min 58 sec
Courtesy of the artist

menial housework in various locations around the property. These performances are ritualized by the slow repetition and the fruitlessness of the activities, which gives the functionality of domestic labour a new meaning. Of the work, Fang has said 'the aesthetic of women in our society is often separated from the everyday labour they [are] engaged in, and these works are often identified as actions that are internal, domestic and with no transcendental value. This video takes out the functionality from the housework and use[s] it to create ritual and aesthetic.'[26] The viewer feels slightly voyeuristic while watching the set of surreal tableaux that are enacted as the women wash peppers in a bathtub while they bob around, cleaning and then throwing them onto the bathroom floor, or while they carefully chop vegetables piled onto a reception desk, brushing the remains onto the lobby floor.

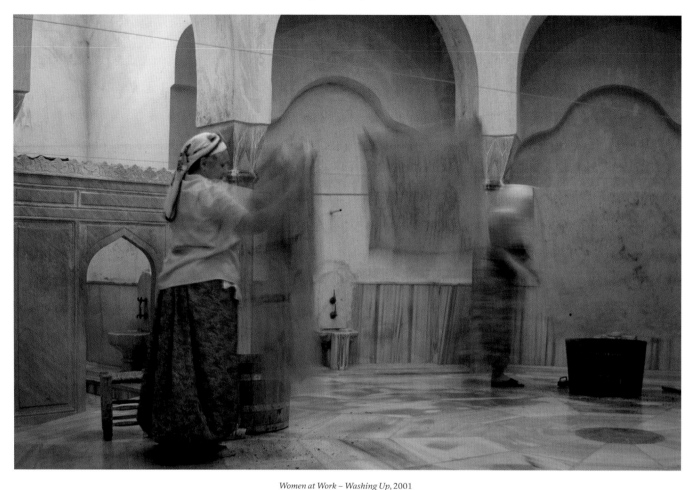

Women at Work – Washing Up, 2001
Photographs and video, 18 min, 9 sec, showing five-day performance at Cemberlitas bathhouse, Istanbul
Courtesy of the artist, Galerie Peter Kilchmann, Zurich and Galerie Michel Rein, Paris

Maja Bajevic (b.1967) takes the domestic labour of washing to an entirely different level, away from the banal and into the political realm. *Washing Up* is part of the trilogy *Women at Work* (2001) and features the artist and two other women in a Turkish hammam in Istanbul, repeatedly washing cloths over a five-day long performance. The cloths have been embroidered with positive slogans from the Tito era; during the five days of washing the words fade and eventually disappear, and the material begins to deteriorate. Bajevic's work frequently focuses on women's handiwork – washing,

stitching and sewing – which she transposes into public spaces in order to transform the activities and give them a richer meaning and value. Her performances often include biographical elements from her childhood in Sarajevo, where she witnessed the ethnic cleansing and violence that took place during the war in the 1990s.

The video and performance artist Berna Reale (b.1965) has never been afraid to confront and challenge. While much of her work is political and fights against

Purple Rose, 2014
Video, 3 min, 2 sec
Courtesy of the artist and Nara Roesler Gallery, Sâo Paulo

corruption and the abuse of power, she has mostly focussed on the theme of violence against, and the exploitation of, women. So sincere is her intent that she studied to become a crime specialist at the Center for Scientific Specialization of the State of Pará, Belém, to better understand and represent the issues involved. Reale lives and works in Belém, a city in Brazil plagued by violence, and has consequently grown up surrounded by criminal activity. In *Purple Rose*, she leads a troupe of 50 young women wearing traditional high-school uniform (albeit with a shocking pink skirt), followed by a military band. As they march through São Paulo, the women are apparently robbed of their innocence by the inflatable sex-doll prosthetic mouths they wear. Reale's stated intention here is to draw attention to issues of sexual violence against women, most notably young girls and adolescents, and to make a visual analogy between these mouthpieces and babies' dummies, which impede speech.

PENNY SLINGER

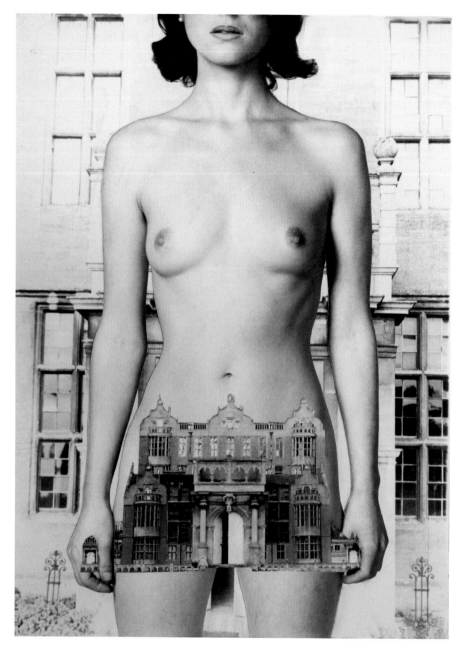

Perspective, 1970–77
from the series 'An Exorcism'
Photocollage, 34.3 x 7.6 cm (13½ x 19¼ in)
Courtesy of Riflemaker, London

Penny Slinger (b.1947), an artist known for her meticulous collage and Surrealist-inspired approach to splicing imagery, presents us with the house as ideal home and dream world, conflated into a composite whole, in which her crotch forms the doorway in this image from her series *Perspective* from 'An Exorcism'. The series of photographic collages was made over a period of seven years and was set in a derelict stately home that she came across in Northamptonshire in 1969. Her witty visualization prefigures the type of easy computer layering that we are now familiar with. It is also a neat analogy with the idea of the home and the heart, the home and the castle, and finally of a woman's place being in the home. Of the work, Slinger says, 'I was trying to look at all the skeletons in the cupboard, open up all the doors in the psyche, all those taboo and forbidden places, to look in and try to confront them … to exorcise them in myself and, hopefully, create a path through the darkness for others.'[27]

STORY

THERE IS NOTHING SO
BEAUTIFUL AS THE FREE
FOREST. TO CATCH A FISH
WHEN YOU ARE HUNGRY,
CUT THE BOUGHS OF A TREE,
MAKE A FIRE TO ROAST IT,
AND EAT IT IN THE OPEN
AIR, IS THE GREATEST OF ALL
LUXURIES. I WOULD NOT
STAY A WEEK PENT UP IN
CITIES, IF IT WERE NOT FOR
MY PASSION FOR ART.

Edmonia Lewis, in the *National Anti-Slavery Standard* (1864)

Having a chapter called Story, so richly filled with examples, bears witness to the fact that women are often thought of as the better communicators, able to bring a level of honesty and openness to their tales along with the magic of folklore, fantasy and invention; their narratives often pay little attention to the kind of male aggrandizement, or the reinforcing of stature or power, that you might expect to find in stories and images of men. We also consider the story of sex, in both humorous and macabre terms, sensing the male gaze but reframing it through female eyes. Imagined stories of innocent childhoods are celebrated alongside works that highlight political issues or abuses of power through the lens of narrative, by artists who reflect on the impact of contemporary culture on our lives, and on the art that is made as a result. Stories are often repeated, and some of our artists take great pleasure in appropriating the established art histories of the great masters, claiming and embellishing them for their own use. In these postmodern days, sampling and re-appropriation from all kinds of sources have become more familiar, and the standard practice of paying homage to other artists' work through different kinds of iteration allows reference to the past while simultaneously engaging with the future.

People's lives create a narrative backdrop to our world. Biography can be as fascinating as its 'real-life' iteration, seducing the reader or viewer into another world and allowing them to become a voyeur. The voyeur in turn interprets and elaborates the story. Because art is visual, these aspects can be embroidered and expanded upon to embrace the fantastic, the surreal and uncanny in non-linear ways. Written accounts usually have a beginning, middle and an end, but in a painting the entire story can appear on the canvas simultaneously. Elements of the narrative, unless serialized in cartoons, murals or numbered paintings that echo the chapters in a book, merge together to form a whole, or at least to give a flavour of the entire sequence of events. Mood, tone and atmosphere, along with technical agility, tension and surprise, coalesce to imagine new tales.

Truth conspires with paint to tell lies about the reflected reality of a canvas. We imagine photographs do not lie but we know that they can. We know how to 'read' images because we are practised at it; our ability to interpret visualizations of our world grows with our own experience of it, and through their work artists provide the means for us to do this. Stories reflect both the positive and negative aspects of life, and the knocks we endure can make indelible marks that reveal the whole story in one fell swoop. Stories also evolve, and painting, film and photography encourage this expansion. Limitless tales can be spun around the axes of reality or fiction, the polarities of comedy and tragedy, and one work of art can recount a whole, a variety of perspectives, or perhaps just one incident. In the biblical tale of Judith and Holofernes we usually see depicted the moment immediately after the beheading, or in Sharon Lockhart's photograph (p.160) a pivotal point of space between actions. With paintings, one could argue that there is more scope than in literature to tell a story using the work as a whole, drawing on the length of time it takes to make it, the quality of the surface and the technique, and the artist's stylistic traits; and likewise in sculpture, where three-dimensionality offers yet more possibilities. An atmosphere can be distilled to communicate the essence of a tale, and all artists aspire to that indefinable, immutable something that speaks to emotion and encapsulates the energy of a work, whether visual art, literature or film. The artists in this chapter harness the varied powers and traditions of storytelling to weave arresting, and often mysterious, tales that reveal much about ourselves and the world we live in.

KAYE DONACHIE

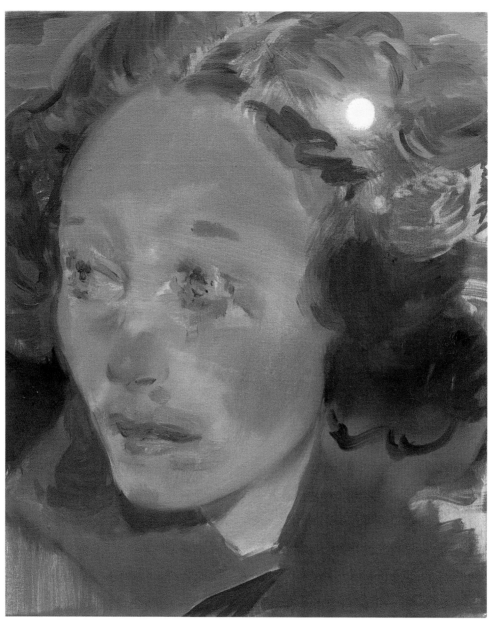

Motionless Forever, 2013
Oil on canvas, 51 x 41 cm (20⅛ x 16⅛ in)
Courtesy of Maureen Paley, London

Kaye Donachie's paintings sit in a muted, dreamlike ambiguity; her young women are solitary, nestling in pairs or in cultish groups. They inhabit another place, with its own atmospheric pressure and curiously filtered light. We are intrigued enough to enter this magical cinematic space, suspending disbelief in order to join the story, aided by the works' poetic titles. Our engagement completes the narrative but does not provide a dénouement, since we remain on the outside looking in. What we 'get' from this type of work is a lyrical pause, a stasis, a chance to daydream and contemplate. Pretending to merge with the narrative gives us a brief respite from our own real lives, but it doesn't tell us what is really going on in the image. Works by Donachie (b.1970) retain a moody and painterly ambiguity, whereas in the following image, the visual mapping-out is clearer, suggesting a more specific interpretation.

LISA YUSKAVAGE

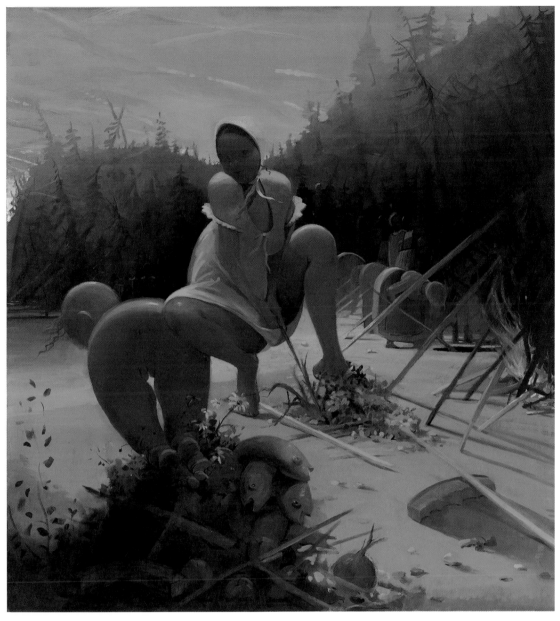

No Man's Land, 2012
Oil on linen, 195.6 x 177.8 cm (77 x 70 in)
Courtesy the artist and David Zwirner, New York/London

Fairy-tale eroticism is one way of describing the ironic take on the male gaze by Lisa Yuskavage (b.1962). Her sugar-coated inventions of bendy, wide-eyed Barbie dolls appear to suggest, like traditional porn models, that your fantasy is their command. The lurid palette enhances the surreal quality of the scenarios, the quiet landscapes, all muted greens and pastel pinks, creating an erotically charged space into which the viewer is invited to project a personal storyline. Greatly influenced by film, and filmmakers such as Rainer Fassbinder and David Lynch, her work is filled with narratives that feel real and unreal at the same time. Although it has often been linked with Surrealism,

Yuskavage's view is that her work has more in common with the metaphysical art of Giorgio de Chirico, because it is produced in a way that is more closely allied to free association. She became a major force in figurative painting in the 1990s shortly after leaving art school, where she studied with John Currin (with whom her works shares some commonalities), but her work was met with scorn and derision by the feminist contingent, who considered it detrimental to the cause. Yuskavage refuses to refute or to engage with the accusations, merely saying of her paintings: 'I do intend them to be little troublemakers in some way'.[1]

CECILY BROWN

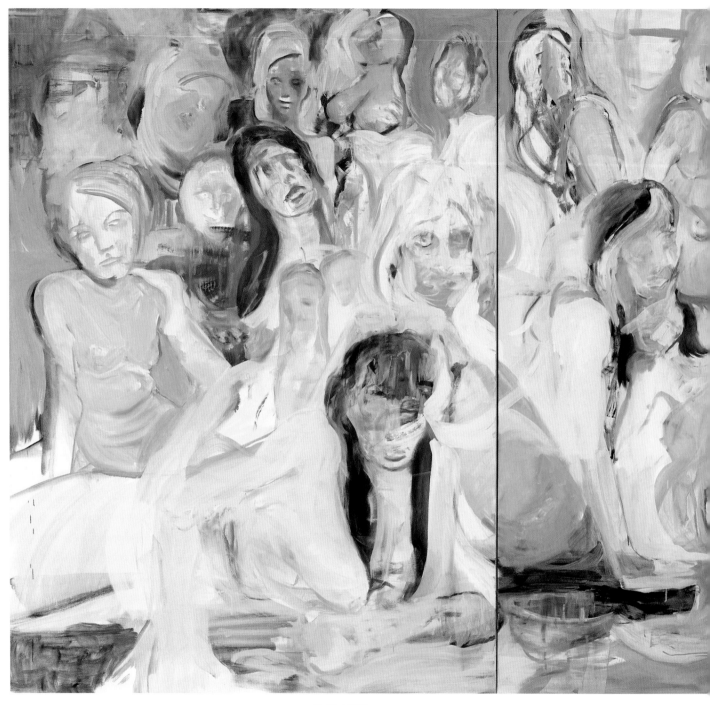

Untitled, 2013
Oil on linen, 195.6 x 419.1 cm (77 x 165 in)
Courtesy of Gagosian Gallery

Yuskavage's smoothly painted dollies with extended bellies inhabit the open spaces of a 'la la land' and contrast vividly with the more visceral, clashing impact of the smash-and-grab claustrophobic sex romps by Cecily Brown (b.1969). Her impasto orgiastic gatherings possibly owe something to her interests in the great storytelling artists Hieronymus Bosch and Pieter Bruegel the Elder. Brown's works employ the pinks and browns of Pablo Picasso's *Les Demoiselles d'Avignon* (1907) but are less angular and more realistic

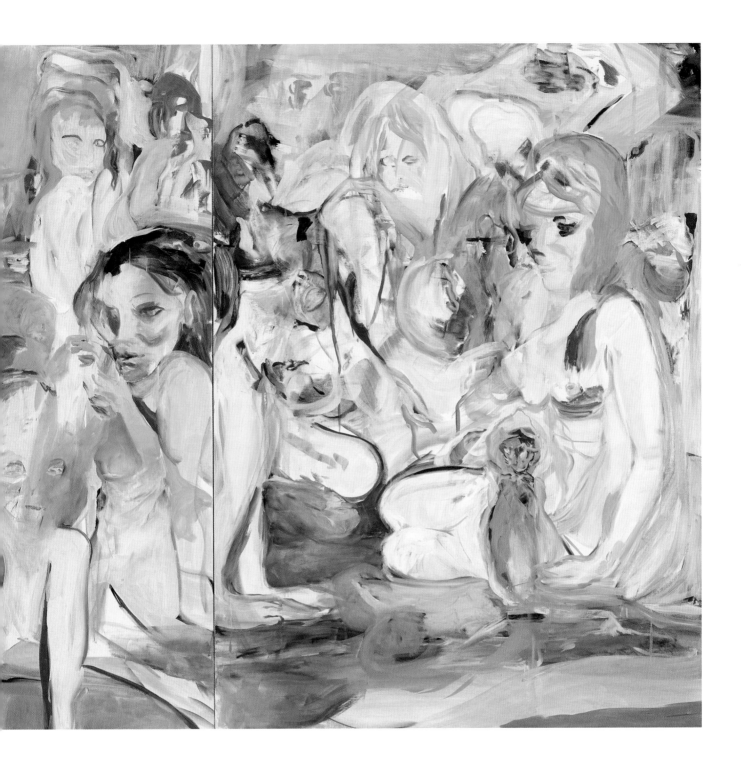

than his African babes; her women don't posture, but riff and pulse with action, confined in their breathy playground. The looseness of her technique is intended: 'The whole figurative/abstract thing is about not wanting to name something, not pin it down. I've never wanted to let go of the figure, but it keeps wanting to disappear. It's always a fight to hold on.'[2]

Story

ROSE WYLIE

Dr Lacra's Cherry Frock – A Repeat, 2006
Oil on canvas, 416 x 366 cm (164 x 144 in)
Courtesy of the artist and Union Gallery, London

As well as real stories, archetypal mythic narratives can also emerge from, or fantasies materialize into, painting. The familiarity of the former often merges with the dream world of the latter. *Dr Lacra's Cherry Frock: A Repeat* by Rose Wylie (b.1934) is a fine example of this. The little girls are reiterations of happy children disporting themselves and mucking around. Their clothes have a slight 1950s nostalgia and the limited palette of blacks and pinks makes an impact along with the dress patterns. The subjects are not specific children, but are representative of a remembered ludic childhood state in which energetic-rough-and tumble play, and the restrictions of pretty girlish clothes and the need

to behave appropriately, appear in tandem and subvert the stereotypes around how girls are expected to conduct themselves. The very way that the paint is layered onto the canvas echoes the complexity of societal mores while celebrating painterly freedom of expression. The repetition is important: zooming in for the second frame, the clothes seem more like a uniform, and the girls are similar, but not the same. They owe something to Wylie's interest in collage and film, and many of her paintings pay homage to a personal pantheon of favourite directors, including Werner Herzog, Quentin Tarantino, Pedro Almodóvar and Claudia Llosa.

LYNETTE YIADOM-BOAKYE

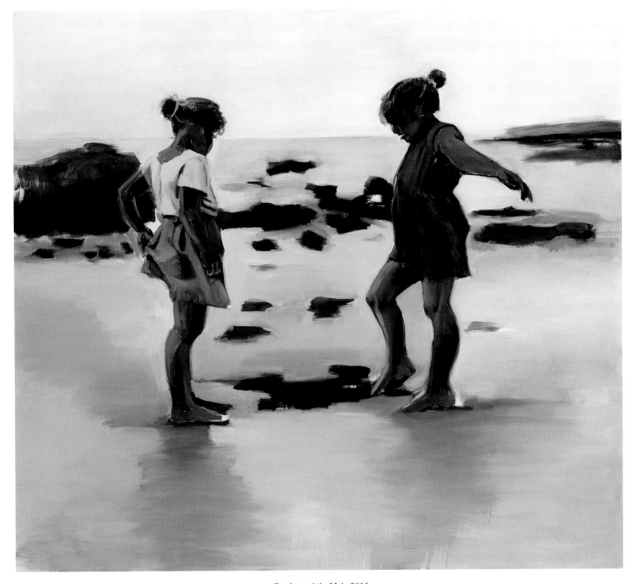

Condor and the Mole, 2011
Oil on canvas, 230 x 250 cm (90½ x 98⅜ in)
Courtesy of the artist; Jack Shainman Gallery, New York and Corvi-Mora, London

Condor and the Mole is a painting about the holidays: little girls at play on the beach, with their hair tied up and wearing similar clothing. What is remarkable here is the connection between the figures, the way we sense their communication even though we can see that their eyes do not meet. Somehow we hear them chatting: one gestures, opening up her arm and moving her foot, and we can see her mouth open; the other is more static apart from her left hand, which might be scratching or untucking her skirt from her knickers. It is a natural, unthinking gesture, and her concentration follows her downturned eyes. The composition places them at the centre, echoing each other, the middle of their heads resting on the horizon, which symbolizes perhaps their respective lives stretching out before them. The sky and sea and shore are dull white; it is not cloudy but luminous, almost moonlit or overcast, and they stand in wet sand, the sheen of the water reflecting their bodies. What or who is Condor, and what is the blue-clad girl poking with her foot? Something definitely has their joint attention. Lynette Yiadom-Boakye (b.1977) has said, 'Race is something that I can completely manipulate, or reinvent, or use as I want to. Also, they're all black because ... I'm not white. People are tempted to politicize the fact that I paint black figures, and the complexity of this is an essential part of the work ... But my starting point is always the language of painting itself and how that relates to the subject matter.'[3] The scenarios of Yiadom-Boake's paintings come from her imagination, despite sometimes appearing to be a painted snapshot, as in this case. The little girls here have much in common with those Rose Wylie gives us. The difference here is that they seem real, yet we know that they are inventions.

Story

BARBARA KRUGER

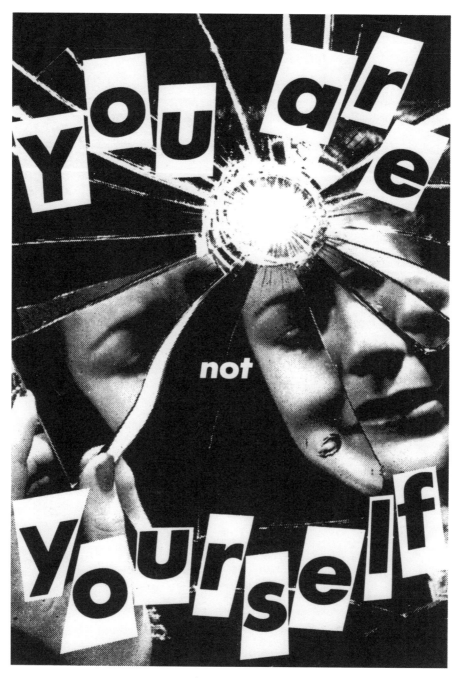

Untitled (You Are Not Yourself), 1981
Black and white photograph and type on paper, 27.3 x 18.1 cm (10¾ x 7⅛ in)
Courtesy of the artist

Barbara Kruger (b.1945) dispenses with mythology, fantasy or any subtle forms of communication and tells it like it is using text, bang and image. She seems to tell us stories by giving us pithy statements, and we respond by bringing our own context to the work. Her art straddles the business of art, life and politics with wit and intelligence, but her commentary is critical and her statements famous: 'Your body is a battleground', 'I shop therefore I am', 'We don't need another hero'. These brief statements became so familiar in the 1980s, before the advent of text messaging, that they gained a potent currency within the politics of feminist logic. Kruger believes that language manifests itself in her work because she understands short attention spans, and her recognition that our culture is saturated with irony also informs the resulting work. Using slogans together with graphic design in the way she does has allowed her to create work for a mass audience that was simply not possible with other media at that time. Here, her statement confounds our expectations. The diminiutive 'not' at the centre of the work clearly subverts what we believe the 'truth' of the mirror's reflection to be, as well as alluding to issues of identity and self-perception.

AMALIA ULMAN

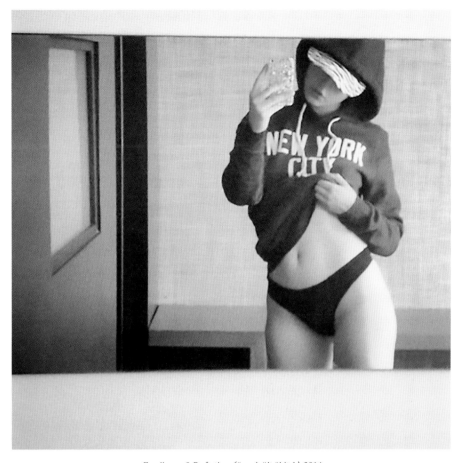

Excellences & Perfections (#work #it #bitch), 2014
Instagram update, 4 July 2014
Courtesy of the artist and Arcadia Missa, London

In commenting on imagined identities in her fabricated autobiography entitled 'Excellences & Perfections', Amalia Ulman (b.1989) writes, 'It's more than a satire. I wanted to prove that femininity is a construction, and not something biological or inherent to any woman. Women understood the performance much faster than men. They were like, we get it and it's very funny. What was the joke? The joke was admitting how much work goes into being a woman and how being a woman is not a natural thing. It's something you learn.'[4] The series of 175 photographs, issued through Instagram and Facebook social media accounts,

featured her pole-dancing classes or discussed her planned breast augmentation. The posts drew outrage from some in the art world, appalled that she should be damaging her position as an artist by succumbing so easily to the vacuous and narcissistic concerns of contemporary culture. Ulman remained in character for the full five months of the series, only revealing that it had been a complete fabrication in her final post, accompanied by the text 'The End', by which time she had acquired nearly 90,000 followers.

EILEEN COOPER

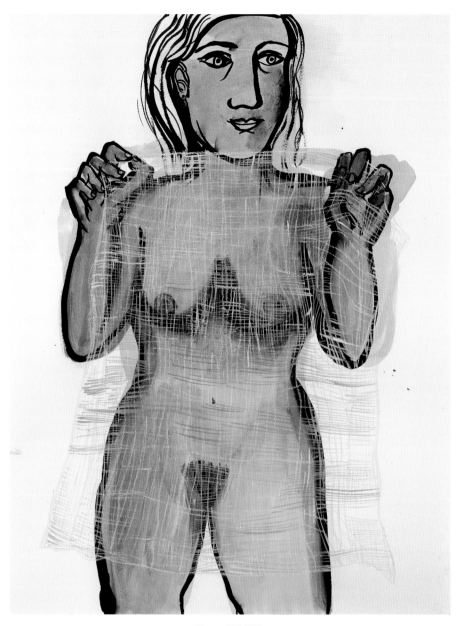

Mystery Girl, 2013
Ink and pastel on paper, 76 x 56 cm (29¾ x 22 in)
Private collection

Eileen Cooper's work has remained steadfastly figurative and interested in narrative. It is hard not to make an autobiographical reading of her portraits of women or young families, but in this case she is directing us, through the title, to believe that we cannot possibly know who we are looking at in the drawing. Active women, busy within the confines of the space, usually fill her canvases and prints. This example by Cooper (b.1953) shows a rather coy woman wavering between a dance of the seven veils and a moment of indiscretion, holding up a see-through cloth, perhaps in surprise at having been caught in her nakedness. Her face is oddly expressionless, the far-away look of the eyes unconnected to the full-frontal display that she is giving the viewer. Is the girl herself a mystery, or is she a mystery to the universal self? The work serves as a vehicle for the positive energy of ink and wash, an unforgiving medium that allows no mistakes.

CHRISTINA RAMBERG

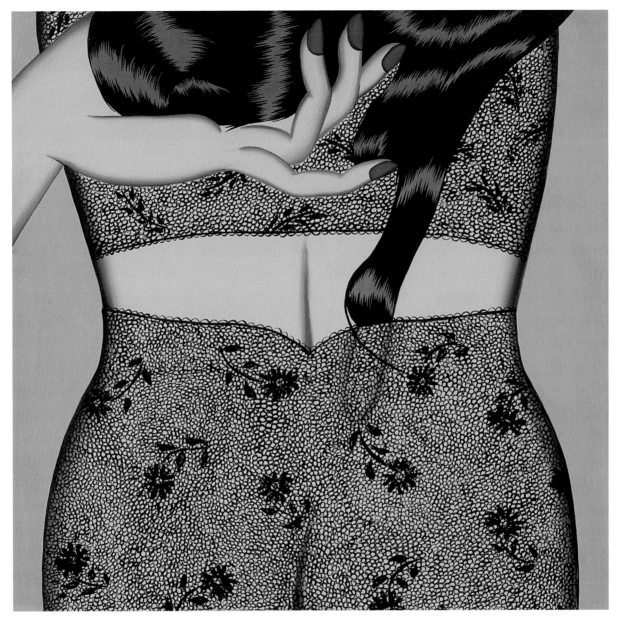

Shady Lacy, 1971
Acrylic on masonite, 33.7 x 33.3 cm (13¼ x 13⅛ in)
Courtesy of the Estate of Christina Ramberg and Corbett vs Dempsey, Chicago

In a far more assertive and overtly sexual world, the painting *Shady Lacy* by Christina Ramberg (1946–95) is clearly in the seduction camp, the neat depiction of long, flexible fingers with elegant red-lacquered nails contrasting the black lace underwear with its simple, understated floral decoration and the anticipation of a striptease. The hair is as glossy as the nails, with a sheen redolent of a car bonnet. The shadow between the back ribs guides our eyes downwards to what we know, and almost feel, are the cheeks of her bottom. We look through the square window at the curved torso and, through this tight focus and restricted palette, take in the outlined information and the clear story;

but here, too, the artist retains the complete picture, and we are none the wiser as to the events before and after this part of the narrative. The quality of Ramberg's surfaces, sometimes described as 'finish-fetishism', is a common feature of the Chicago Imagists group of artists with which she was affiliated. The subject matter was clearly related to the experience of watching her mother putting on one such corset: 'I can remember being stunned by how it transformed her body, how it pushed up her breasts and slenderized down her waist. I think that the paintings have a lot to do with this … I thought it was fascinating … in some ways, I thought it was awful.'[5]

ANJ SMITH

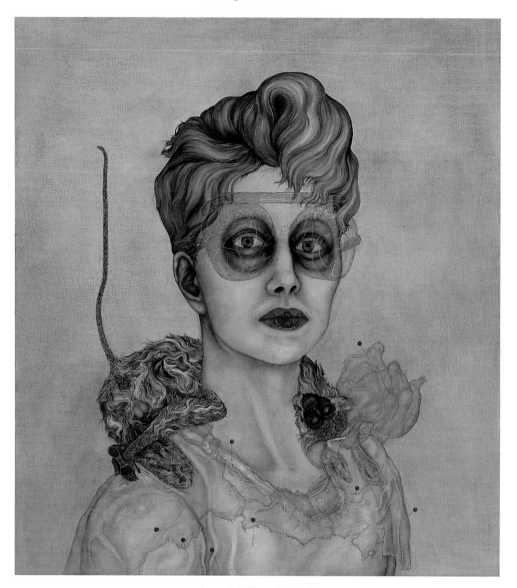

Letters of the Unconscious, 2015
Oil on linen, 51 x 44.1 cm (20⅛ x 17⅜ in)
Courtesy of the artist and Hauser & Wirth

Anj Smith (b.1978) paints women who return our gaze. They inhabit a world that they share with small mammals and marsupials that scurry and nest, or fly and perch. The bats and monkeys are content on the shoulders of these wide-eyed, self-contained madonnas. Spiders and lizards are executed with such decorative minutiae that the canvas becomes a site of wonderment and admiration, and thus anxieties about the creepy crawlies are dispelled. This cast of extras expands the context and capitalizes on the potential energies of fear and intrigue to open up the space of the painting.

These contemporary works reference the odd medieval landscapes of Bosch, have a veneer of the digital world of horror vines and an aesthetic reminiscent of the fantasy television show *Game of Thrones*. Smith is interested in blurring the edges, combining portraiture, still life and landscape in a single work. In some of her other works, which she refers to as 'museum paintings', the sitters are not depicted, but their presence is suggested by the arranged objects, which are not imagined, but taken directly from nature.

NEZAKET EKICI

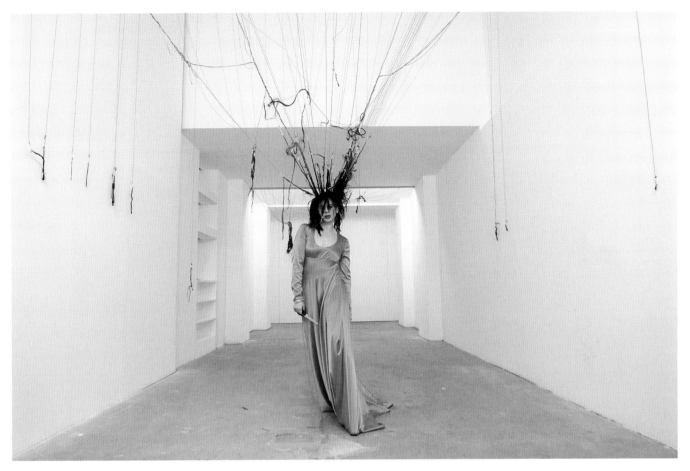

Atropos, 2006
100 ropes, hairlines and pitons; spotlight
Performance at International Sinop Biennial, Turkey

By touching on mythology in her work *Atropos*, Nezaket Ekici (b.1970) is also looking back to the histories of the past and challenging the inevitability of our futures. As a performance artist, Ekici is interested in creating durational works of physical endurance, more often than not with an element of pain involved. In this work we see the figure chained to its environment by the ropes that attach strands of her hair to the ceiling and walls of the room in which she stands. As she proceeds to struggle and squirm in an attempt to free herself, she references the myth of the Moirai, the goddesses of fate who controlled our destinies from birth to death through the mother thread of every mortal. Atropos was the oldest of the three fates and the cutter of the thread of life, associated with bringing all things mortal to an end. In ancient times, Greek brides would make an offering of a lock of their hair to Atropos on their wedding day.

MARIKO MORI

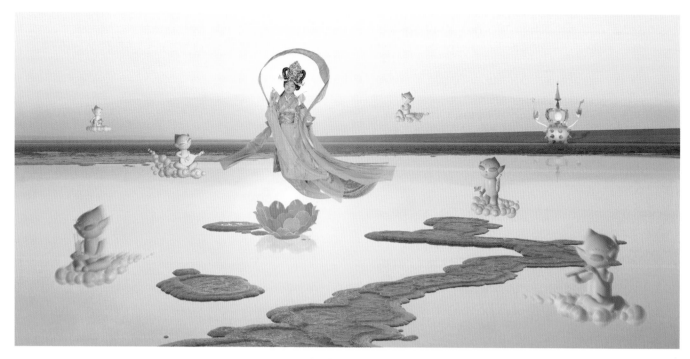

Pure Land, 1996–98
from the series 'Esoteric Cosmos'
Glass with photo interlayer, 304.8 x 609.6 cm (120 x 240 in)
Courtesy of the artist

Mariko Mori (b.1967), the lead figure in the *Pure Land* production from her 'Esoteric Cosmos' series, comes as if from the future, like a floating mystic from another world. She envisions a pinkish, wafting avatar that hovers with pastel-coloured, pointy-headed pixies above a dreamy, manga-esque landscape that could be our mind or a foreign planet. Her fusion world of Eastern mythology and spirituality merges with Western cultural references to cartoons and digital imagery, creating a heady visual cocktail of clashing thoughts and emotions wrapped in softly bouncing cotton balls. This image captures sunrise on the Dead Sea, the lowest point on earth, in which plant and fish life cannot flourish due to the high salinity. In the Shinto tradition, salt is associated with purification and the lotus flower on the water is a symbol of purity and of rebirth into paradise. Mori's own beliefs centre around notions of birth, death and rebirth, and her work, which reveals these interests, combines the ancient with the futuristic. The title, *Pure Land*, references the paradise of Buddha, often shown resting on a lotus blossom, who takes the newly dead to his 'Pure Land of Perfect Bliss'. Mori floats above it all, her pose and clothes connecting her to eighth-century Buddhist paintings, nodding to her role as the goddess of fortune.

CAO FEI

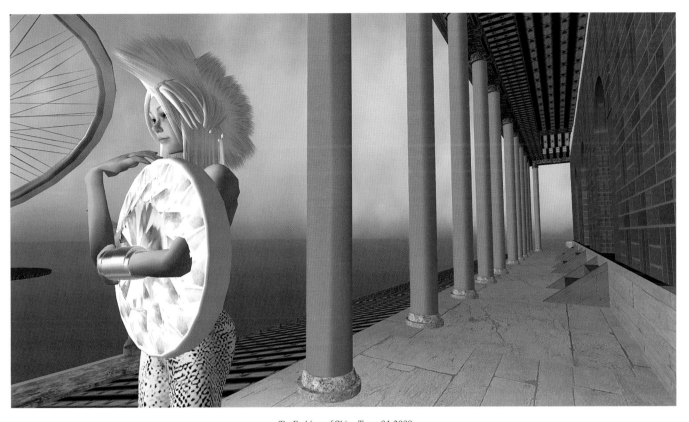

The Fashions of China Tracy 04, 2009
from the series 'Fashions of China Tracy'
C-print, 30 x 50 cm (11¾ x 19⅝ in)
Courtesy of the artist and Vitamin Creative Space, Guangzhou and Beijing

In her work Cao Fei (b.1978) has adopted an avatar, China Tracy, who allows her to develop a commentary on the contemporary real-life world and the virtual world, in which so many of us play. Having seen rapid social and commercial development in her home town of Guangzhou in China, Cao is concerned with the dramatic changes that young people have experienced, and through the mixing of social commentary, pop/manga influences and references to Surrealism and Chinese opera, she creates multimedia installations and photographs with a computerized aesthetic that is instinctively familiar to those of a certain age. Cao spent many years, and up to eight hours a day, creating a virtual Chinese city (RMB City, so called after Chinese currency, the Renminbi) in the online site Second Life, which China Tracy inhabited. At the time, few Chinese people were able to download, or even access, the site on which Cao created a futuristic land, where the interplay between fantasy and reality, the past, present and future is a dynamic, melange. Of the virtual world, she has said that she finds it 'more interesting. I really mean that. I can walk around, overhear conversations, speak to anyone I like. I feel freer there.'[6]

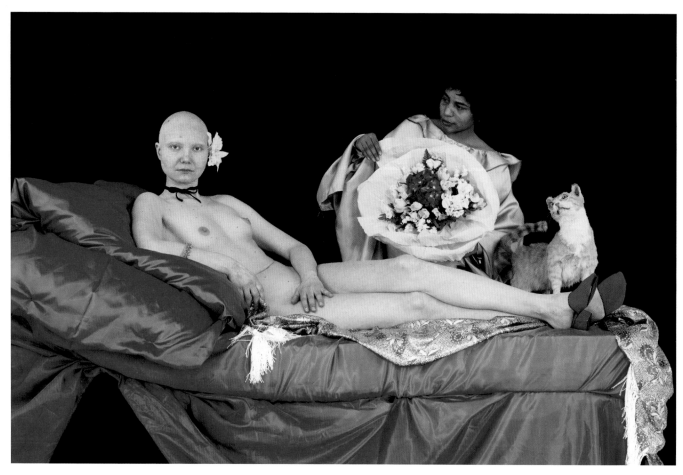

Olympia, 1996
Photograph, from a series of three colour photographs, each 120.5 x 180 cm (47½ x 70⅞ in)
and a single channel video projection, 12 min 40 sec
National Museum in Krakow

Many artists respond directly to art that has been celebrated in the past, reworking imagery in a postmodern fashion by taking aspects of it and reinventing the original. Artists are always looking over their shoulders to appraise the work of others, and it is natural to admire and pay homage with new works that are not pastiche but take part in a live debate about art and the hierarchies and discussions that surround it. Edouard Manet's *Olympia* (1863) is a case in point. When it was first shown, it shocked the French art world because it seemed so modern. In it, Manet portrays a real – not idealized – woman whose features are not perfect, and furthermore the model was recognized as a prostitute (the name Olympia was known to describe a high-class call girl). The work is doubly challenging because the woman returns our stare in an unconventional way for that era, which makes it a prime candidate for recycling by other artists who want to expand the discussion around it, applying feminist ideologies that criticize the male gaze or commenting on prostitution and black servitude.

Works created in response to *Olympia* acknowledge that Manet's painting was also based on Titian's *Venus of Urbino* (1538), which celebrated the beauty of the goddess, and in turn salutes Giorgione's *Sleeping Venus* (c.1510). All of these works bring to mind Goya's *La Maja Desnuda* (c.1800) and Ingres's *Grande Odalisque* (1814). Nineteenth-century poet and art critic Charles Baudelaire urged artists to paint the beauty of modern life, not simply to reiterate the old formats; but if an artist's interest and passion is art, this interest is likely to extend to beauty of the past and how that beauty was manifested, defined and interpreted in artistic media, whether in painting, sculpture or film. In this way we discover many other versions of this no-longer-sleeping beauty.

Katarzyna Kozyra's 1993 diploma work, *Pyramid of Animals*, consisted of four animals that were stuffed specifically for the sculpture. Its reception caused such outrage and controversy that she believes it actually made her ill. Rather than hide that illness, she decided

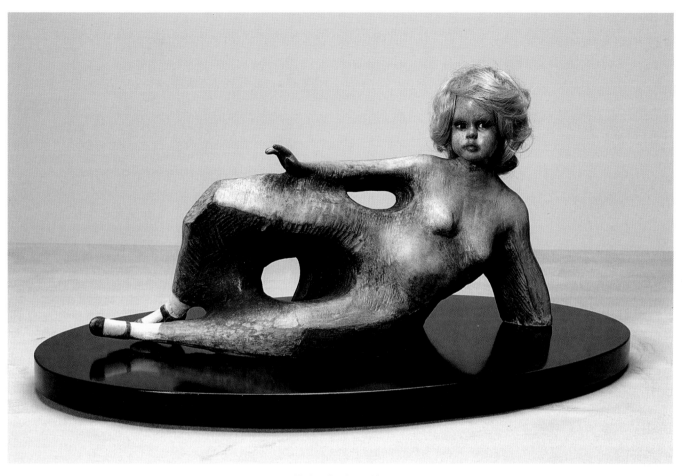

Northern Landscape, 2014
Patinated bronze, oil paint and synthetic wig, 21 x 41 x 30 cm (8¼ x 16⅛ x 11¾ in)
Courtesy of the artist

that the level of scrutiny she had suffered demanded that she share all elements of her life, including the negative and the ugly. In the version of *Olympia* by Kozyra (b.1963) we bear witness to her cancer-ravaged body propped up on a hospital bed sheathed in a blue silk or nylon cloth. John Berger, in his book *Ways of Seeing*, is famous for saying, 'men act and women appear. Men look at women. Women watch themselves being looked at. This determines not only most relations between men and women, but also the relation of women to themselves. The surveyor of woman in herself is male: the surveyed female. Thus she turns herself into an object – and most particularly an object of vision: a sight.'[7] Kozyra's 'sight' is a disturbing one: her Olympia, like Manet's, invites the gaze and meets it, her hand both covers the genitals and directs you to them, the black servant in the background signals her servitude. Once seen, it is hard to unsee.

The same Olympia pose is echoed in the sculpture *Northern Landscape* by Cathie Pilkington (b.1968),

who often takes delight in creating composite works that play with notions of good and bad taste. This reclining nude has an outsize arm that roots her firmly to the circular black base and a pair of old-fashioned Mary Jane patent shoes worn with white ankle socks. Coupled with the blonde 'wig', these accessories give the piece a surreal allure, harking back to Titian via Manet, while the figure herself evokes the familiar sculptures of Henry Moore or Barbara Hepworth. The scale alone puts it in another category – that of doll's house plaything – and this view is encouraged by the baby-doll face and the short socks. However, this little girl has nothing on and so strays into the suspicious world of underage sex. Her piercing, magnificently confident stare and the tension in her right hand are indicative of an awareness of public posing and a strained-for elegance in this ungainly and macabre form.

FAITH RINGGOLD

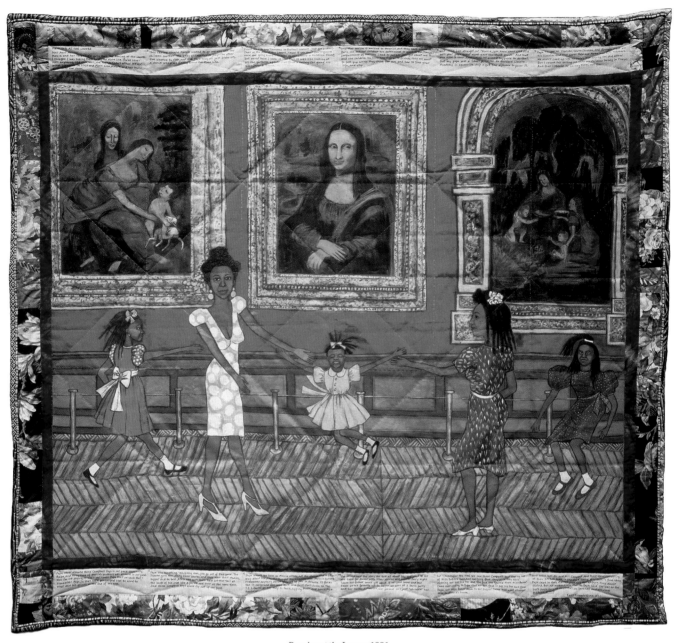

Dancing at the Louvre, 1991
from the series 'The French Collection', #1
Acrylic on canvas with fabric borders, 186.7 x 203.2 cm (73.5 x 80 in)
Private collection

Faith Ringgold (b.1930) invites us into her tapestried art gallery with a composition that is a constellation of colour, texture and pattern. This work is one of twelve quilts that she created as part of her series 'The French Collection', in which Ringgold tells the story of the imaginary character Willa Marie Simone and her adventures in Paris, where she encounters the likes of Pablo Picasso, Josephine Baker and Henri Matisse. Ringgold was taught to sew by her mother, who was a fashion designer, and by her great-great-grandmother. Quilt-making has a long tradition in African-American history. Many were originally made by men who, as slaves, brought them from Africa to use for warmth,

for a sense of home, for storytelling and even as a form of a map that could help guide them to their freedom. What we are shown in Ringgold's work are black women and children cavorting and having a great time in the open spaces of the re-created Louvre galleries, where Ringgold is colliding art and life. She had travelled to Europe with her mother and her two daughters shortly after graduating from art college, in order to study painting. She describes how these paintings can be admired and loved, yet also imbibed as part of a different experience and history, noting the absence of black people in the European art-historical tradition on the walls of these prestigious galleries.

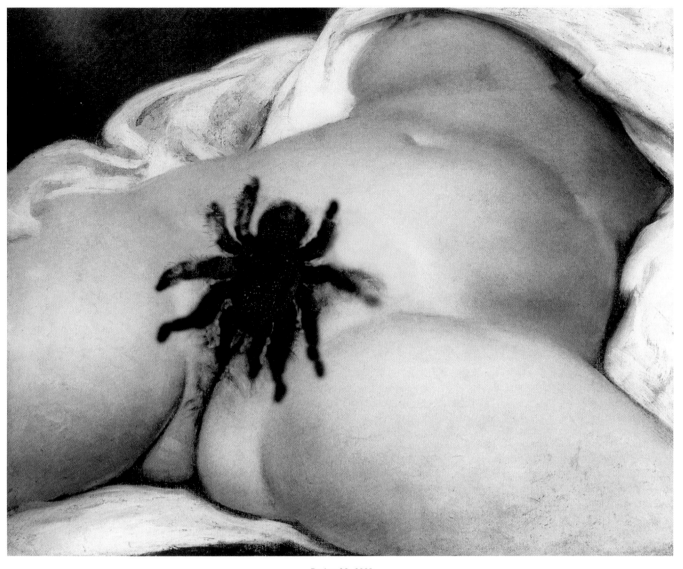

Replace Me, 2009
Black and white digital print, 32.5 x 40 cm (12¾ x 15¾ in)
Courtesy of Sprüth Magers

Rosemarie Trockel (b.1952) gets right to the heart of European art history and shamelessly appropriates *L'Origine du monde* by Gustave Courbet (1866), a work that still shocks today. Known more for her use of wool or fabric in her work, Trockel has consistently challenged notions, and the value, of what is traditionally thought of as women's work. Her use of these materials was very much part of her own personal feminist strategy; she once commented that 'what is most painful, what is most tragic about the matter is that women have intensified this alleged inferiority of the 'typically female'.'[8] It is no surprise, therefore, to see Trockel take an image that is so ultimately objectifying and to reclaim it with venom. The careful positioning of the spider on the now fashionably depilated pudenda, hints at the danger of coming too close and alludes to the perceived threat posed by unfettered female sexuality. The title, *Replace Me*, challenges art history to change the conversation around the female form in art, and women artists in general.

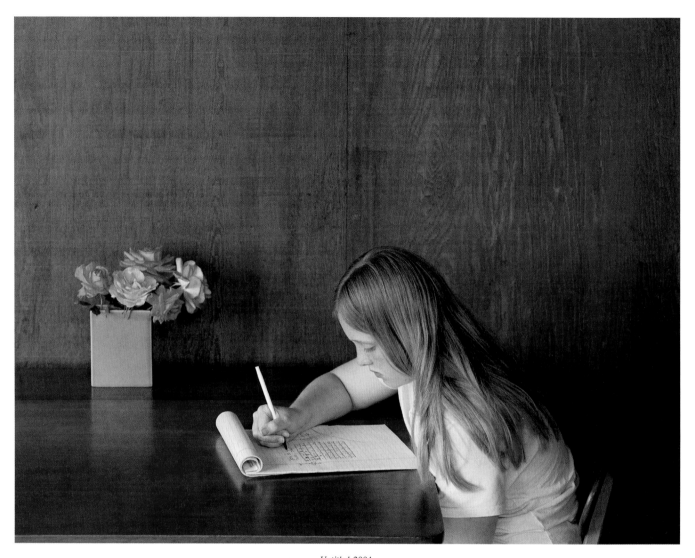

Untitled, 2004
Chromogenic print, 93 x 117.5 cm (36⅝ x 46¼ in)
Courtesy of the artist, neugerriemschneider, Berlin and Gladstone Gallery, New York and Brussels

Sharon Lockhart (b.1964), like Trockel (p.159), quotes Courbet as an influence on her work. 'I've always been interested in labor as well as leisure, and 19th-century realist painting takes both as subjects. Courbet is definitely a precedent. So are the works of Millet – especially his paintings of women laborers, as in *The Gleaners* (1857)'.[9] However, her chromogenic print *Untitled* reeks of Vermeer. It is so well-crafted and perfectly lit that the qualities of the print seem to emanate and have more importance than the figure of the child leaning over her script, apparently doing her homework. The legal-style lined notepaper is characteristically pale yellow, and this colour

chimes with the straw tint of the girl's top. In perfect synchronicity, the blue of the rectangular vase is the ideal receptacle for the reddish roses, and these three primary colours go together in a mini symphony, enveloped by the warm nut-brown of the wooden wall, table and chair. The concentration of the girl is caught by the definition of the incline of her head, the white pen poised at the ready (she is 'in thought') and the roll of the used paper provides another form to populate the perfect composition. The reflection on the table top and the patterning in the wood generate a gentle sense of activity as a background to the main 'non'-action.

NINA KATCHADOURIAN

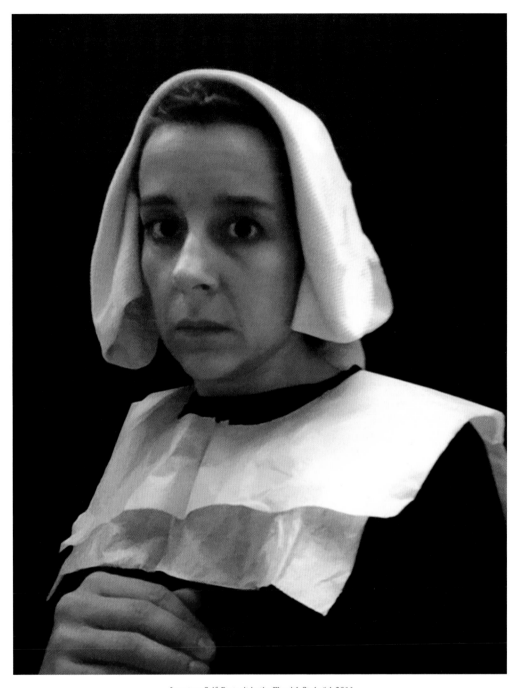

Lavatory Self-Portrait in the Flemish Style #4, 2011
from the series 'Seat Assignment'
C-print, 33.9 x 25.4 cm (13⅜ x 10 in)
Courtesy of the artist and Catharine Clark Gallery, San Francisco

Nina Katchadourian (b.1968) has created an impressive, witty and inventive body of work as a homage to fifteenth-century Dutch and Flemish artists, but with her own self-imposed limitations. All the photographs in her ongoing *Lavatory Self-Portraits in the Flemish Style* project, from her 'Seat Assignment' series, are created using the facilities available on a flight – eye masks, toilet seat covers, hand towels, toilet tissues, inflatable pillows, paper cups – and taken with a camera phone within the confines of the airplane toilet, like a confessional photo-booth-cum-five-mile-high lavatory studio. The project began spontaneously in 2010 and is continuing, with over 2,500 photographs and video now in existence, taken on over 200 flights. The real seduction of these clever pictures is the fact that the artist is working with a very limited palette in a standardized situation, within a limited time-frame.

Story

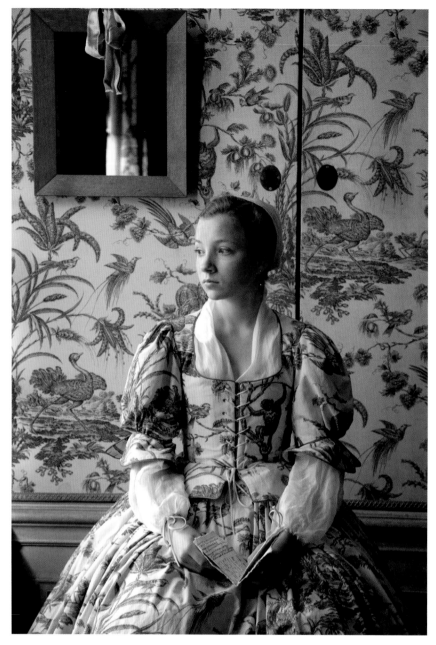

Nellie, 2013
Video installation, 3 min 9 sec
Courtesy of the artist and Frith Street Gallery, London

In her film *Nellie*, Fiona Tan (b.1966) revels in her customary play on memory, storytelling and the shaping of identity. The work emerged when Tan was researching links between painting and filmmaking, during which time she claims she kept colliding with Rembrandt. Further study revealed the story of his illegitimate daughter, Cornelia van Rijn, who emigrated to Batavia (now Jakarta) at the age of 15, after which there is no trace of her story. Having been born in Indonesia and now living in the Netherlands, Tan had made the same journey in reverse. The lack of a true story for *Nellie* allowed Tan to create one of her own. The work was filmed in the Museum Van Loon in Amsterdam, which houses a collection on bourgeois domestic life during the Golden Age. The Museum had been the home and office of the Van Loon family, which had profited from financing trade with Batavia, and had previously housed Rembrandt's pupil, Ferdinand Bol. In the video, Nellie's dress, the wallpaper and the sofa all appear as one, and are covered in exotic plants, monkeys and birds, referencing the colonial. Pacing backwards and forwards like a caged animal, she appears to suffocate in the decorative prison, while the sounds of jungle animals echo around her. 'For me,' said Tan 'the work is an homage to a forgotten woman.'[10]

MAUD SULTER

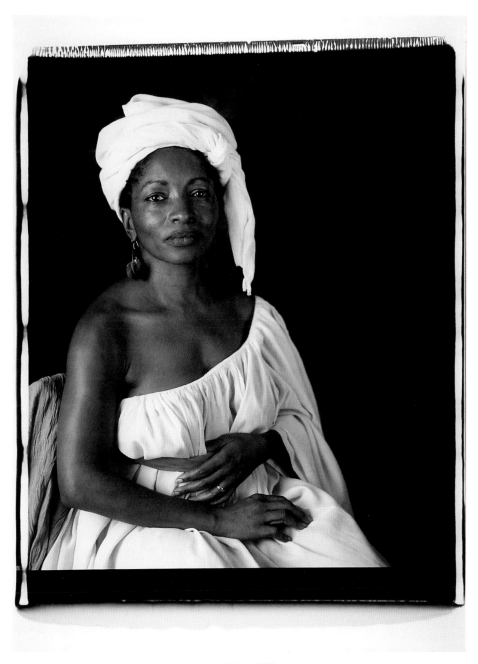

Bonnie Greer, 2002
Polaroid print, 80.4 x 56 cm (31⅝ x 22 in)
National Portrait Gallery, London

Statuesque and beautiful, Bonnie Greer is a perfect contender for a place in a commissioned series of writers' portraits by Maud Sulter (1960–2008), which recalls George Frederick Watts's 'Hall of Fame' series of eminent Victorians in their repetition of format, scale and medium. The inspiration for the portrait was Marie-Guillemine Benoist's 1800 painting *Portrait d'une Negresse*, although Greer is a well-known sitter, and retains her wedding ring and the privacy of her right-hand breast. Like the original subject, Greer is wrapped simply in a toga-like costume, which invokes not only the issues around slavery attached to the original painting, but also adds a contemporary reading: the concept of the muse and mystic from ancient times. As in eighteenth-century portraiture, this type of *deshabillé* dress is designed to be timeless, but here it also enhances the bronzed tonality of skin and creates a brilliant contrast with the white drapery.

ALEKSANDRA MIR

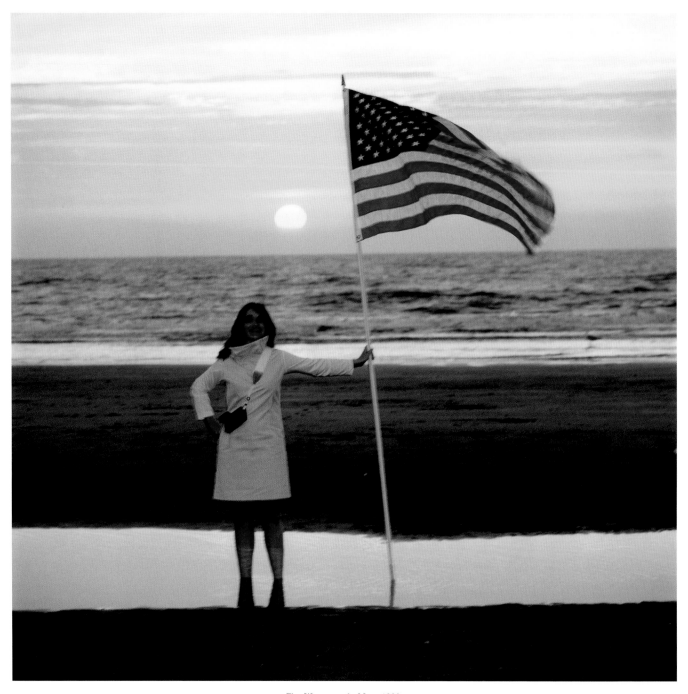

First Woman on the Moon, 1999
Video, 14 min 8 sec, showing performance at Wijk aan Zee, the Netherlands
Courtesy of the artist

Aleksandra Mir (b.1967) is also concerned with lost history and the potential achievements of women. In *First Woman on the Moon* she creates a new story, using as a springboard the historical reality of astronauts Neil Armstrong and Buzz Aldrin's space journey in 1969. Mir recreated a moon landing on the Dutch coast at Wijk aan Zee, using bulldozers to move sand into (and out of) place for one day only, 28 August 1999, when the land-art-cum-performance made the local TV news. The documentation of the project includes a letter from Neil Armstrong's office thanking them for the videotape that Mir had sent, accompanied by the words, 'He is looking forward to the opportunity to view it'.[11]

LUBAINA HIMID

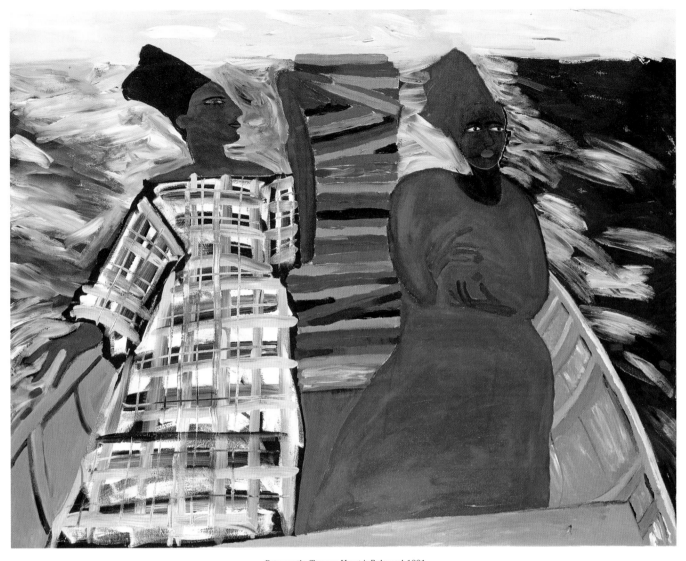

Between the Two my Heart is Balanced, 1991
Acrylic paint on canvas, 121.8 x 152.4 cm (48 x 60 in)
Tate, London

Lubaina Himid (b.1954) also talks of travel in her painting *Between the Two my Heart is Balanced,* but her journey speaks both of the progress of black history and of the history of migrant travel around the world. Her work has regularly considered the value of migrant cultures to their new homelands. The title of this work alludes to a painting by James Tissot, *Entre les deux mon coeur balance* (1877), which shows a British Highland soldier in uniform sitting between two white women; the title and image suggest that the man is torn between the two. Between the two black female characters in Himid's work lie representations of maps. Of the work, Himid has said that she wonders what would happen 'if black women got together and started to try to destroy maps and charts – to undo what has been done'.[12]

Story

DORIS SALCEDO

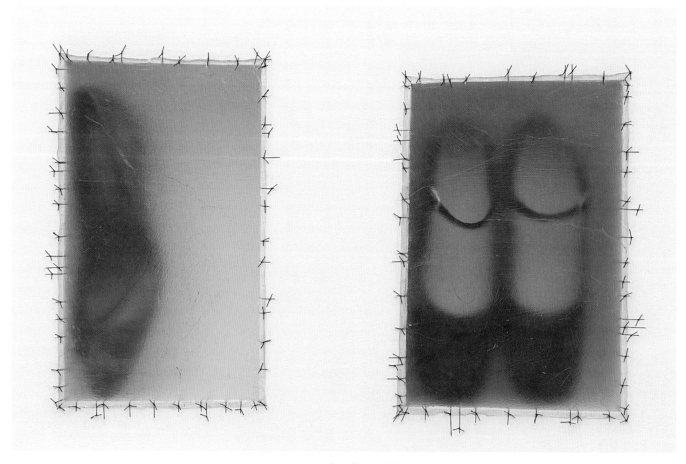

Atrabiliarios (detail), 1992–2004
Shoes, drywall, paint, wood, animal fibre and surgical thread in 43 niches and 40 boxes, dimensions variable
Courtesy of Alexander and Bonin, New York

In her work *Atrabiliarios,* which references the people who disappeared during the wars in her native Colombia, Doris Salcedo (b.1958) is interested in displacement. 'I believe that the major possibilities of art are not in showing the spectacle of violence but instead in hiding it. ... It is the proximity, the latency of violence that interests me.'[13] she has remarked, by way of explaining why the work seals women's worn shoes within walls, behind stretched and stitched skins, creating a form of reliquary for those who are no longer with us. The blurred presence of the objects behind the taut veil serves to represent the fading-out of each life and the loss that each family suffers. When creating her work, Salcedo often precedes it with a period of in-depth research, which allows her to become a secondary witness to the traumatic subject matter she goes on to illustrate. During her investigations into the lasting effects of violence, she discovered that women

were regularly treated with great cruelty, and that their remains were often identified by their shoes.

Yael Bartana's work is rooted in her experience of her native country, Israel, and of growing up surrounded by conflict and aggression. Her films, installation and photography have combined reality and imagination and focused on politics, diasporas and on the plight of the Jewish people. *What if Women Ruled The World* saw Bartana (b.1970) creating a series of works inspired by Stanley Kubrick's film *Dr Strangelove*, in which his war room has been abandoned by the men, and a group of female scientists, politicans, thinkers, movers and shakers have moved in to try and solve our world emergencies before it is too late. Promising a matriarchal world in which women rule, make decisions and seek solutions to humanity's most urgent problems, Bartana is hopeful of a new world order.

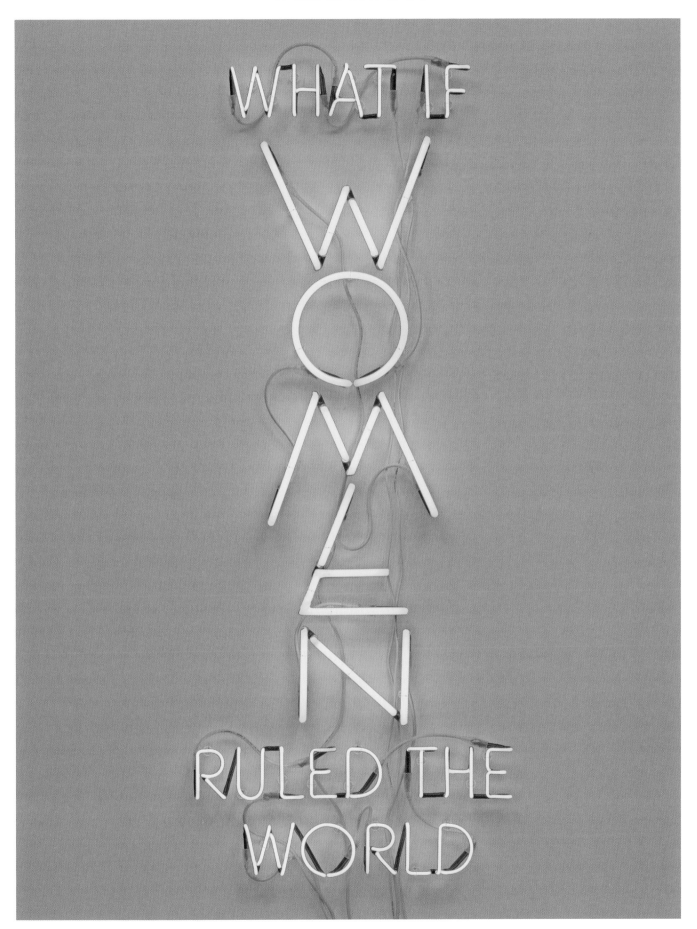

What if Women Ruled the World, 2016
Neon light, 58.8 x 150.7 cm (23⅛ x 59⅜ in)
Courtesy of the artist

RUNA ISLAM

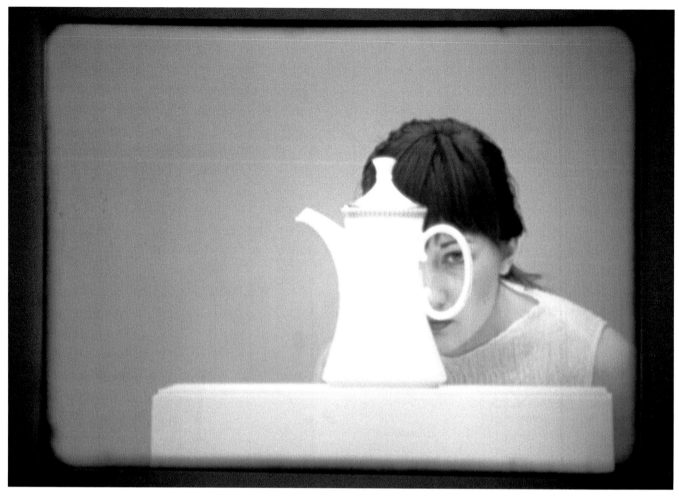

Be the First to See What You See as You See It, 2004
16mm film with sound, 7 min 30 sec
Courtesy of White Cube Gallery, London

There is a cruel edge in the film *Be the First to See What You See as You See It* by Runa Islam (b.1970), which hovers just below the surface throughout, making the work uncomfortable and tense to view. The title pays homage to Robert Bresson, the celebrated French director of minimalist and spiritual films, as the title, a direct quote from Bresson's highly respected *Notes on the Cinematographer* (1975), attests. Islam has always sought to make film that is more than just physical. Here, her camera follows the passage of a young, elegant white female through a gallery space, in which ceramics are on display. The mood of the film is gentle and soft as she carefully scrutinizes the pieces and uses them to perform a teatime ritual, which is then rudely punctured when she crashes the china to the ground. The character in the film has disturbed the traditional values that we expect her to conform to. But, as the title asks, what do we see? Is the work loaded with further meaning associated with Britain's colonial past, or with female behavioural constraints, or is it about power and authority?

Sheela Gowda (b.1957) works with a wide range of materials that are steeped in traditional Indian culture. While training in London as a painter in the 1980s, after witnessing the cultural upheaval and the negative impacts of dramatic economic development in her home country, she changed course, and is now better known for her sculptures and installations. For *And Tell Him of My Pain*, she suspended red cords around the gallery that snake and wind their way around before coming to a stop at a needle. On closer examination, it becomes apparent that the thread is stained blood-red using Kum Kum, a red dye used for body adornment and rituals, and that it has been pulled through the eye of every single needle in order to create the installation. The painstaking labour involved in that exercise suggests a subtext about the undervaluing of cheap female labour and the hardship of domestic life as a woman in the patriarchal society of India.

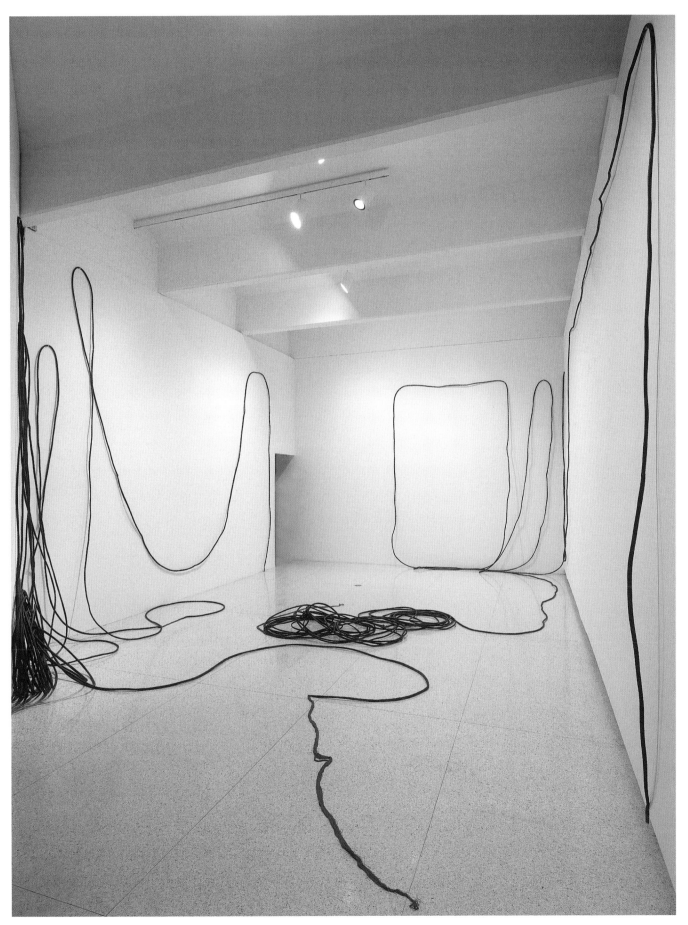

And Tell Him of My Pain, 1998/2001
Thread, pigment, glue and needles, dimensions variable
Walker Art Center, Minneapolis

Lolita Carpet, 1999
Wall carpet, 243.8 x 152.4 cm (96 x 60 in)
Courtesy of the artist and Rafaella Cortese Gallery, Milan

The needle has played its part in Barbara Bloom's reconfiguration of Vladimir Nabokov's 1955 novel *Lolita*, which takes the form of a tufted green rug with black and white borders and black text. The work relies on the viewer knowing the characters in the story and how the subject of the tale, Humbert Humbert, lusts after the pubescent Lolita, who in turn taunts him and plays with his powerlessness over his desire. To take desire as the subject of an artwork is a time-honoured path; to create a rug, which is usually for standing

on, as an artwork that cannot be used is a perversity that perhaps echoes the complex emotional battle that takes place within the novel. Bloom (b.1951) is a fanatical Nabokov reader and collector of memorabilia associated with the novel, and she has taken her own green first-edition paperback novel as the model for the work, including her own hand-written notes, which are knitted into the surface of the rug in purple. Her work inhabits a semi-fictive realm that is both funny and philosophically provocative.

DEATH

BECAUSE I COULD
NOT STOP FOR DEATH
— HE KINDLY STOPPED
FOR ME — THE CARRIAGE
HELD BUT JUST OURSELVES
— AND IMMORTALITY.

Emily Dickinson, 'Because I Could Not Stop for Death' (1890)

As the poet Sylvia Plath wrote, 'Dying is an art, like everything else.'[1] The recording of this final event, and the thoughts and experiences connected to it, have an ingrained significance and are powerfully resonant. There are many traditional behaviour patterns connected to death – delineated by history, culture, religion and societal mores, and these patterns provide rich material for documentation and art. This chapter considers the work of artists who have recorded the deaths of lovers, family and friends, and who have observed and documented painful illness and the grief that accompanies it. For many artists, the hovering presence of death in life is a constant concern in their work, much as it was for the vanitas painters of the seventeenth century. For some, the interest lies in violent death through war, politics or crime, but we also look at ritual, the mythology of death and *memento mori*. Ultimately, however, there are the physical concerns that linger: decay and absence.

The attempt to record the departure of what could be called the spirit or soul from the body at the cessation of the heartbeat has been a part of the narrative of art-making since its very beginnings. Furthermore, the *raison d'être* of portraiture has its roots in death and remembrance. Tomb sculptures, as a record of passing, reveal the death-related customs and beliefs of many cultures, including that of ancient Egypt with its spectacular mummies and encaustic portraits. Civilizations from around the world can be seen to pay respect to their dead in all manner of artistic formats. The sculpted and painted death portrait and the death mask were integral to royal messaging, both in ancient Egypt and in Europe since medieval times, indicating the transfer of power and affirming its continuation over time, anticipating the cry: 'The King is dead, long live the King.'

Death is not only royal, but for the proletariat also; it does not discriminate. Death can also consolidate the status of an icon, fuelling the mythology through the repetition and dissemination of imagery. The shooting of President Kennedy in 1963 became a global television phenomenon that revelled in the powerful imagery of the reaction of his wife, Jackie Kennedy, at the time and subsequently at his funeral, where the expression on her face through her mourning veil inspired Andy Warhol, who added her to his repertoire of canonized women. In this chapter we consider natural death alongside sudden, shocking endings, rape and violence against women.

SUSIE MACMURRAY

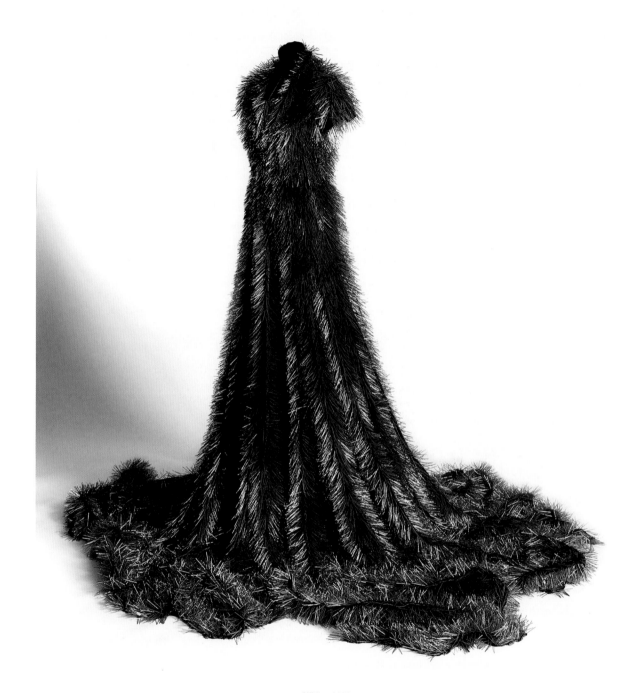

Widow, 2009
Black nappa leather, 43 kg (95 lb) of adamantine dressmaker pins and tailor's dummy, dimensions variable
Manchster Art Gallery, courtesy of the artist

In the sculpture *Widow*, Susie MacMurray (b.1959) has created a *memento mori* following the death of her husband in 2006, but rather than recording his presence or absence, she has created a shroud-like work that reveals her own experience of a profoundly disabling event in her life. The exercise of pushing over 100,000 (roughly 43 kg) of adamantine dressmaker pins through the black leather skin was itself a torture and a meditative homage. The pins face outwards,

making the work appear like a protective armoured dress, but, rather, it was meant to reflect the rawness of MacMurray's emotions. She says that for long time after her husband's death she felt physically sore and overly sensitive to touch, as if her skin had been turned inside out. This tension between armour and vulnerability is echoed in the sparkly, seductive, fur-like appearance of the object, which on closer inspection repels and gives a spiky rebuff.

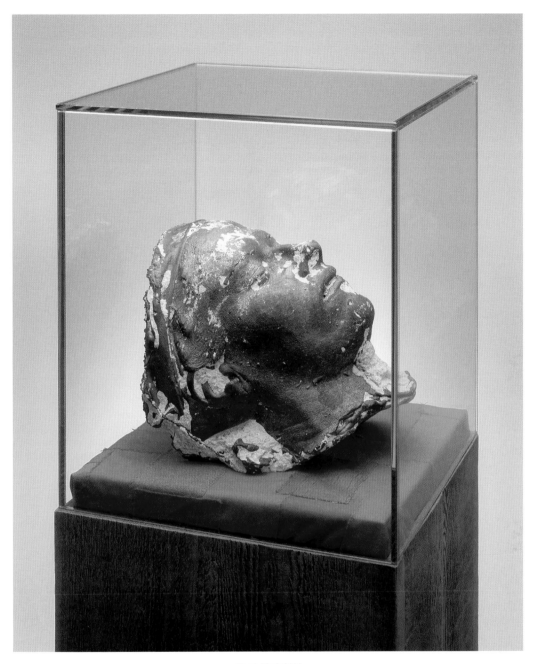

Death Mask, 2002
Black patinated bronze, 19.5 x 17.5 x 23.5 cm (7⅝ x 6¾ x 9¼ in)
Courtesy of White Cube Gallery, London

Death masks, a form of homage to the departed, become three-dimensional shadows of the person, transmuting into cold 'living' sculptures that record the absent form. Tracey Emin (b.1963) created a life mask that masquerades as having been taken from her face soon after death. *Death Mask* is a painted bronze that records the features and scale of the head and face but lacks the flesh tone colouration and the vitality of the eyes, which are, by necessity, closed during this process of recording, in order to make the initial mould with plaster. Traditionally, death masks of men have been more common. Emin places her sculpture on a quilted red appliqué cushion, creating an extra layer of meaning through stitching and needlework. This is her way of reiterating the value of the stitch and acknowledging dual references to the grand tapestries of the past and 'women's work'.

JO SPENCE

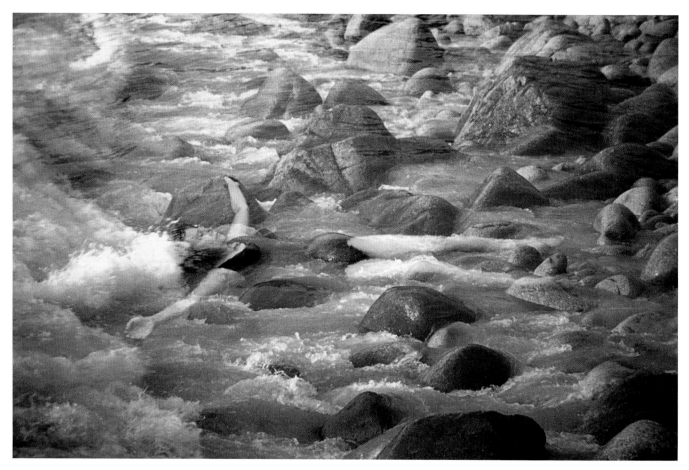

Jo Spence's self-portrait, with arms outstretched like a waterborne Christ, sees her place herself at the edge of a tumultuous sea, heading towards the abstract unknown behind her, yet still surrounded by rocks that hint at the imminence of physical danger. The static floating pose also evokes the horizontal plane of the crucifix. The work is part of a series of images produced during the last two years of her life, which Spence (1934–92) began after she was diagnosed with leukaemia in 1991. Implicit is the understanding that she has been martyred by this disease: 'How do you make leukaemia visible? Well, how do you? It's an impossibility.'[2] she said. This recording of herself, created very simply by superimposing the projected self-portrait onto a seascape, has a bizarre contemporary synergy with David Bowie's orchestrated departure from this world in early 2016. Like Bowie returning to simple mime in the video for his song *Lazarus*, so Spence revisits her youthful method of making pictures, in which she frequently used superimpositions to create a hybrid dominant image.

Helen Chadwick (1953–96) would have been well aware of the ironic symbolism embodied in *Ruin*; she died suddenly and unexpectedly aged 42, having made the piece for her ICA show ten years prior, in 1986. As often with her oeuvre, she includes herself interacting with her sculpture. The pillar, a traditional portrait device, behind her includes a monitor that displays an image of her work *Carcass* (1986). This glass upright filled with rotting organic matter signifies the gradual decay of the body in the ground. It is an emblem of death and mortality, a kind of tower of Babel heralding corruption and decay. Her hand is placed upon a skull, a classical symbol of the grim reaper, yet simultaneously turns away from it, as if in denial of the inevitable. Chadwick became notorious for challenging chauvinist attitudes towards women's art and life itself. She revelled in manipulating and re-presenting traditional genres, updating them by undermining and adjusting the content to reflect a new consciousness. Energetic, fearless, intelligent and a brilliant teacher, she was at the forefront of a new kind of woman artist, and passed the baton on too soon to the likes of Tracey Emin and Sarah Lucas, who have benefitted from her trailblazing.

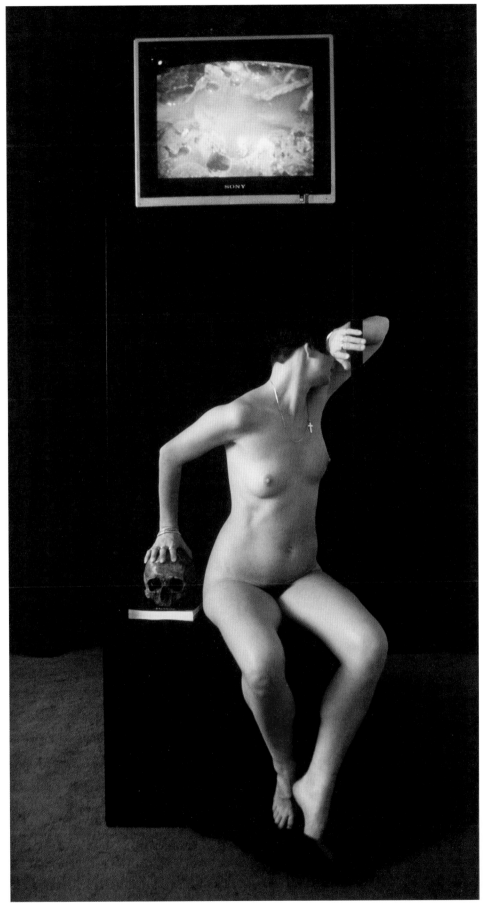

Ruin, 1986
Cibachrome photograph, 91.5 x 46 cm (36 x 18⅛ in)
Courtesy of Richard Saltoun Gallery, London

Death

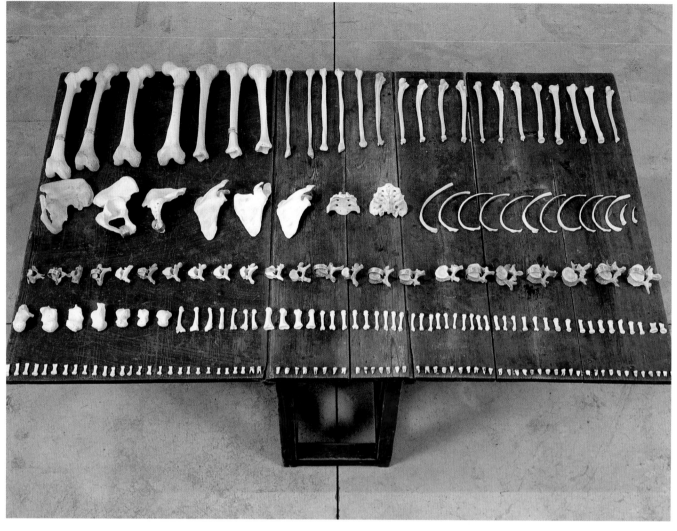

Lustmord Table, 1994
Human bones, engraved silver and wooden table, dimensions variable
Courtesy of the artist

Jenny Holzer (b.1950), like Chadwick, showed avant-garde work at London's Institute of Contemporary Arts in the early 1980s, including site-specific imagery on the moving light displays at Piccadilly Circus in one of the first Artangel collaborations, where her work vied for space with Coca Cola adverts. Holzer's *Lustmord Table* reeks of death, and is composed of real human bones displayed on humble wooden domestic tables. The German word *lustmord* translates as sexual murder, and in this work Holzer is alluding to the war in the former Yugoslavia, during which ethnic cleansing was rife and the rape of women formed part of a military strategy to eradicate a race. Some of the bones have silver rings attached, stamped with texts that come from Holzer's accompanying poems, in which she captures snippets of phrases from victims, perpetrators and observers of the tragedy. Evocative lines include: 'My nose broke in the grass. My eyes are sore moving

against your palm.' Like Chadwick revisiting classic genres, this work revamps the history painting known through images such as Rubens's *The Rape of the Sabine Women* (1635–7). Holzer creates a simple array of clean bones laid out and classified, recalling the piles of possessions familiar to us through documentary records of World War II extermination camps, and reiterates the idea of the passive, colluding silent witness. 'I went with human bones because the situation was so extreme that it seemed appropriate to have a presentation that was equally disturbing as the targeting of women in wartime.'[3] The rape of the Sabine women, an event in the history of ancient Rome in which Roman men committed a mass abduction of women from local towns, has long been regarded as dramatic subject matter for the illustrious artistic elite, including Titian and Rubens. It is by dint of the circumstances of war that history painting includes the brutal crime of rape.

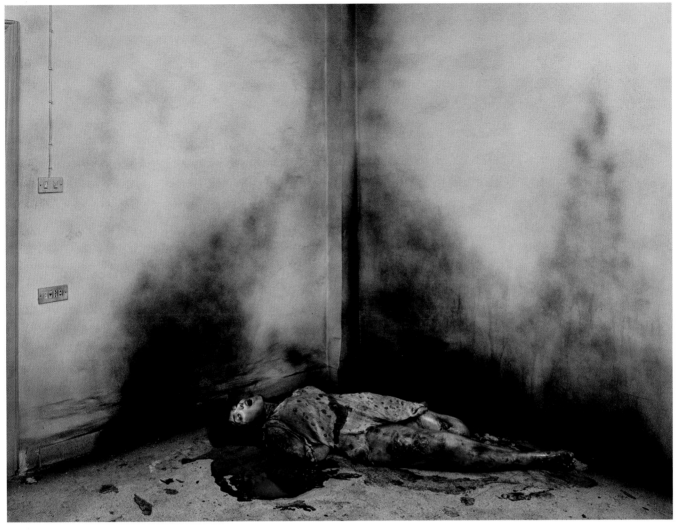

Zahra/Farah, 2008/2009/2011
Archival inkjet print, 155.3 x 202.6 cm (61⅛ x 79¾ in)
Courtesy of Gagosian Gallery

The problematic and emotive subject of rape as a weapon still exists today and there are depictions of it in all media, including Jodie Foster's Oscar-winning performance in the film *The Accused* (1988), based on the 1983 Bedford rape case, and Sue Coe's *Woman Walks into Bar – Is Raped by Four Men on the Pool Table – While 20 Watch* (1983). Taryn Simon (b.1975) is an artist whose shocking recreation of the events of war in Iraq was made for the final frame in Brian De Palma's film *Redacted* (2008). The image shows a dead woman bloodied by violent rape and murder, alone on the floor of a besplattered interior. The actress Zahra Zubaidi played the role of the fourteen-year-old Abeer Qassim Hamza, who suffered at the hands of four American soldiers from the 502nd Infantry Regiment on 12 March 2006 (they were later convicted of their crimes). The victim's parents and six-year-old sister were murdered while the soldiers raped her, then shot her in the head and set her body on fire. This distressing tale provokes a similarly abject image, and the sadness does not stop here, for Zubaidi received death threats and criticism from people who considered her work in the film to be pornographic. The image was exhibited at the Venice Biennale and Zubaidi was granted political asylum in the USA, with Simon's photograph cited as a contributing factor to her life being in danger. Over time, the work itself has taken on further meaning as its impact on the lives of those involved has developed. As Simon pointed out in her conversation with the film director De Palma: 'You could see an image's very real influence on an individual life from start to finish: from a casting call with you in Jordan to ending up in the United States and receiving political asylum.'[4] In recognition of this developing history over the years, the work is always shown with each of the changing historical captions that have accompanied the photograph at different stages of its exhibiting life, at each point updating the information related to those involved in both the real and the re-created scene.

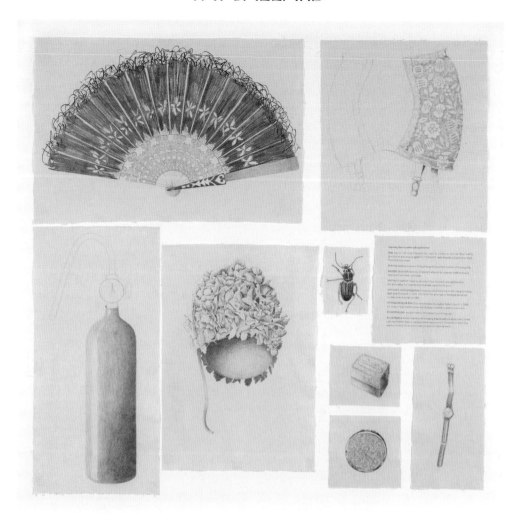

Memory Box: Dead Mother, 2014
Pencil on Griffin Mill paper, 91.4 x 91.4 cm (36 x 36 in)
Courtesy of the artist

Death and commemoration go hand in hand. Clothing and objects belonging to the dead testify to that person's existence by their dumb presence, and can be fetishized or celebrated. Elaborate reliquaries frame bones, blood or hair, portraits echo the deceased and other visualized remnants also offer a way through grief and mourning. Simple drawings by Fay Ballard (b.1957) categorize found objects that relate to her mother, who died suddenly at the age of 34 in 1964. Laid out in serried ranks on a table, recorded like botanical specimens, the objects evoke specific family memories. These 'frozen' fashion items stand as points in time and are physically linked to dress codes, so an actual 1950s body shape is magicked into existence by the Playtex girdle; a rubberized floral swimming cap looks like a kind of grand papal cone, is shown alongside a wrist watch that becomes ever more redundant with the advent of mobile phones. 'All I had was her watch which I'd stolen, aged seven, from the bedroom apartment where she died, and I never told my father. Perhaps he knew I had it, locked away in my bedroom drawer for all those years and then taken with me when I moved away. Like an archaeologist looking for clues to the past, I found a golden Stratton powder compact on my father's writing desk after his death and researched its design to the early 1960s. It must have been my mother's because she powdered her nose with a gold compact.'[5]

North Pole, 2009
Light box, sandblasted porcelain plaques, video, screen and framed colour photographs, dimensions variable
Courtesy of Galerie Perrotin, Paris

A rather more conceptual approach to commemoration comes from Sophie Calle (b.1953), the story of which is best conveyed in her own words: 'Yesterday I buried my mother's jewels on Northern Glacier. … She had a dream. Go to the North Pole. It was a part of our life: One day she would go. She died two years ago having preserved her dream. I guess that's why she never went. I never had this dream. It was hers. But I was invited to go to the North Pole. And maybe I went a little for her. To take her there. In my suitcase: a photo, a necklace, a ring. I chose a portrait of her in the snow. Winter holidays. Her white and red Chanel necklace. I grew up with those pearls around her neck. And her diamond ring. During the war my grandfather, running away from the Germans to hide in the mountains of Grenoble, afraid a building he owned would be seized, exchanged it for a diamond ring. Not a good deal. My grandmother did not talk to him for a year. So I waited to reach the most northern place of this trip, where I could go ashore with my mother. Laurie, my roommate on the boat, suggested that, if the weather did not allow us to do so, I still could flush the ring down the toilet. Actually, it is a thought my mother would have loved. During a few minutes I imagine her laughing to tears to this idea. But the weather was good. I chose a beautiful stone in the center of the beach. I buried the portrait, the necklace, the diamond. Cried a little. Took a photo. Martha sang a verse of Marilyn Monroe – my mother's other passion along with the North Pole – diamonds are a girl's best friend. Now, my mother has gone to the North Pole. I wonder if her glacier will advance or retreat, if the climate changes will carry her to the sea to be taken north by the West Greenland current, or retreat up the valley towards the ice cap, or if she will stay on the beach as a marker in time where the glacier was in the Holocene period. And maybe in thousands of years, specialists in glaciology will find her ring and discuss endlessly this flash of diamond in Inuit culture. Or if a treasure hunter or beachcomber will discover it and exchange it for a house in the mountains of Grenoble.'[6]

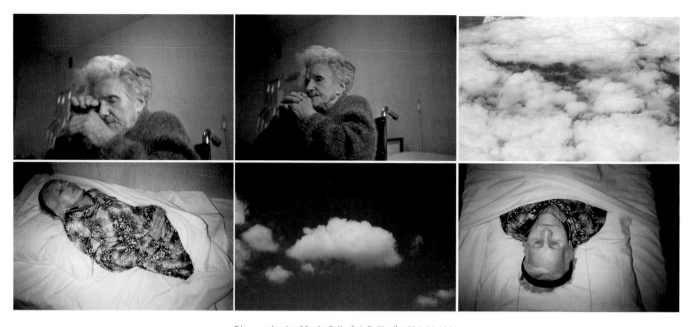

Disappearing Act: Marthe Callet (née Bailleul), 1896–93, 1993
6 black and white photographs, each 40.6 x 50.8 cm (16 x 20 in)
Courtesy of the artist

Liz Rideal (b.1954) looks to capture the physical reality of her grandmother, unlike Calle and Ballard, who, to a degree, hold on to a sense of the person by way of associated objects or memory. The laying out of a dead person is part of the ritual of death, and the bed figures largely in this final practice, as it often does in the conception and the delivery of newborns. Laying out includes washing the body, stopping up the orifices with cotton wool, and dressing and tidying the corpse. Rideal's six-part photographic work was the culmination of a ten-year project undertaken from 1983–93, during which she visited her maternal French grandmother three times a year and recorded her gradual demise. Marthe Callet is shown both when alive and dead, aged 97. The clouds were photographed on the plane journey back to the UK after the last 'living' visit, and represent the standard pictorial trope for heaven. As curator Val Williams has explained, 'There is a suggestion of some spiritual continuity, and intimation of an afterlife, all raised with obliqueness and inquiry.'[7] The work hints at that in-between space experienced by people with dementia; they exist in a kind of hinterland. Given the strong familial bond between the sitter and the artist, it is hard not to read this as some form of prescient self-portrait.

DAPHNE TODD

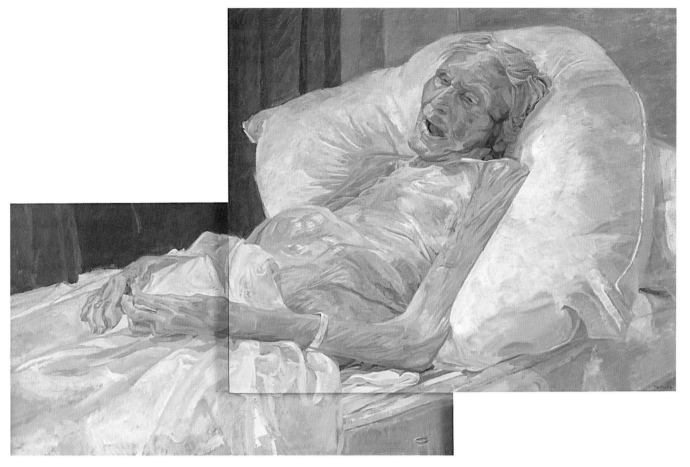

Last Portrait of Mother, 2009
Oil on wood (two panels), 65 x 92 cm (25⅝ x 36¼ in)
Courtesy of the artist

We are not pretty in death. We cannot control how we look, and here selfhood begins an alternative life of memory and negotiation of legacy. The second the heart stops the decay sets in, and the body is but matter. 'People do change and move after death. They sink into themselves – they continue on their way' the artist commented.[8] Daphne Todd (b.1947) had painted her mother, Annie Mary Todd, many times over the years and, after celebrating her hundredth birthday five months earlier, had agreed with her that she should paint this post-mortem portrait. Todd created the painting at the undertakers over a three-day period, saying: 'For me it was a form of digesting facts … it was very therapeutic spending that amount of time making the work; in fact, though I miss my mother very much, I didn't seem to do any other sort of grieving.'[9]

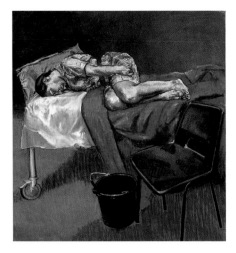 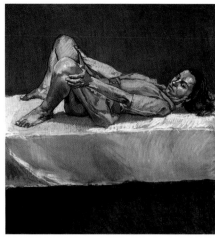 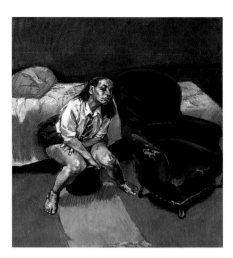

Triptych, 1998
Pastel on paper mounted on aluminium, each panel 110 x 100 cm (43¼ x 39⅜ in)
Courtesy of Marlborough Fine Art, London

Paula Rego's (b.1935) lively narrative paintings caused a storm in the 1980s. Rego dealt with all aspects of women's lives and gave her storyboard paintings an edge of surreality and a hint of nineteenth-century nostalgia with her cast of white-aproned, white-collared young women dressed soberly in dark pinafores. Her tales were spun around an often-repeated cast of characters in recognizable scenarios, and her abortion series was no exception. Stark, honest and shockingly bald in the perfunctory communication of the termination, this set of works is candid. Rego made the work in response to a referendum on abortion in her native Portugal, which voted to maintain the strict legal limitations on its availability. Having witnessed at first hand the suffering that results from illegal abortions, Rego was furious and driven to create the work. The triptych presents three different

scenarios: the first contains the hospital bed, the institutional grey plastic chair and the plastic bucket, and this last has all the resonance of misery fused with practicality. The other beds are equally perfunctory and the last image contains a red armchair – a favourite from the artist's studio. Each protagonist wears a school uniform and is shown in stark solitude. Rego commented that, 'I tried to do it full frontal but I didn't want to show … anything to sicken, because people wouldn't look at it then. And what you want to do is make people look … make it agreeable, and in that way make people look at life.'[10] The loss of a child, whether by natural means or aided by abortion, is a messy and bloody affair. It is painful too, and these women suffer, their faces screwed up in grimaces as they push, strain and wait, perched, crouching or lying in foetal form.

VANESSA BEECROFT

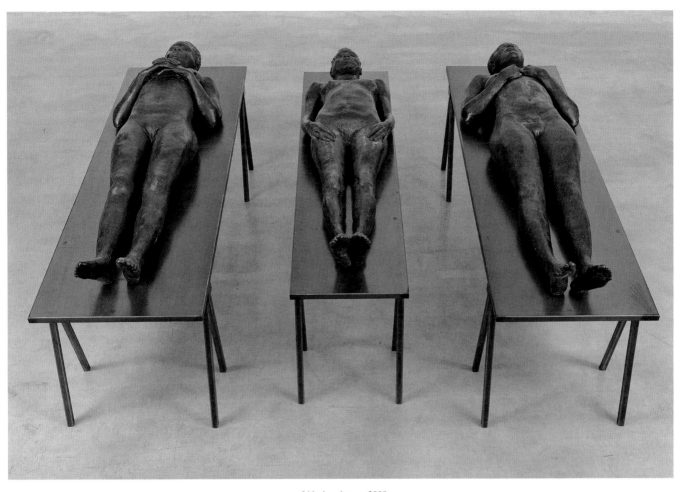

+3 black sculptures, 2008
Black microcrystalline wax, sculpture 1: 167.6 x 38.1 x 21.6 cm (66 x 15 x 8.5 in),
sculpture 2: 185.4 x 53.3 x 28 cm (73 x 21 x 11 in), sculpture 3: 185.4 x 57.2 x 24.1 cm (73 x 22.5 x 9.5 in)
Courtesy of the artist

As the Old Testament tell us, all flesh is grass, and life is transitory no matter how young or old. At the end, the body uncurls, relaxing into another form that then fixes into rigor mortis. *+3 black sculptures* by Vanessa Beecroft (b.1969) is cast from bodies displayed on trolleys in the manner of a morgue, evoking a scene in which corpses require investigation by forensic scientists. They are women who seem almost asleep, with their arms placed in three different poses, and by virtue of this triple placement they somehow echo the saying 'see no evil, hear no evil, speak no evil'. Reinforcing the somber and sinister mood, the elegant tables serve as platforms – not unlike sculpture plinths – for the bodies, which turn them into bizarre charred offerings, sealed in the colour that we associate with death, despair and departure.

Death

ANA MENDIETA

Untitled, 1978
from the 'Silueta' series
Gelatin silver print, 17.1 x 24.8 cm (6¾ x 9¾ in)
Solomon R. Guggenheim Museum, New York

Ana Mendieta (1948–85) made her most famous artworks for her 'Silueta' series, which she called 'earth-body-works', for which she would imprint her form onto the landscape, creating a grave that doubled as a performance site and revealed the elements that make up life: earth, air, fire and water. Like a slimline Venus of Willendorf (the Paleolithic statuette of a curved female body), her shape echoes humanity. The photographic record of these silhouettes may be frozen, but the forms recorded give a sense of the performance that would have occurred during the creative process. Here, Mendieta's empty form is filled with white feathers and surrounded by fresh new grass. Feathers are a frequent presence in her work, referencing the ancient bird-sacrificing traditions of her South American culture. Mendieta uses this symbol to highlight the idea of the

artist and woman as sacrificial victim. The colours and textural combinations in this image work together to resonate between life and death, growth and decay.

This falling figure by Susan Rothenberg (b.1945) is neither floating nor drifting; shown in gravitational descent, more like a torpedo than a human catapult, the figure is being dragged down and we can feel the pull. It is a self-portrait and the body described depicts a state of mind. Abstract figuration is the perfect solution to the problem of describing the embodiment of an emotional state and provides a template for broader interpretations of the mental landscape – so this is not only her, but also us in freefall, struggling to live our lives and stay afloat.

186

SUSAN ROTHENBERG

Endless, 1982
Oil on canvas, 223.5 x 144.8 cm (88 x 57 in)
Courtesy of Sperone Westwater, New York

Death

Ana Falling (Was She Pushed?), 1989
Acrylic and paper collage on canvas, 203.2 x 101.6 cm (80 x 40 in)
Garth Greenan Gallery, New York

ANDREA MODICA

E20 Female, 32 Years Old, 2000
Platinum/palladium print 20.3 x 25.4 cm (8 x 10 in)
Courtesy of the artist

Ana Falling by Rosalyn Drexler (b.1926) is typical of her Pop art style, the pink-skinned figure in a bikini caught in mid-flight, a trail of coloured rays emanating from behind her, sharply delineated by the all-black background. This stencil-like image alludes to the figure of the Cuban artist Ana Mendieta falling to her death on 8 September 1985, although in reality it is a picture from a news report about a woman and child who had fallen down a fire escape. Mendieta's death has been the subject of much controversy – she fell from her apartment on the 34th floor at 300 Mercer Street, Greenwich Village, New York. Her artist husband Carl Andre was tried in 1988 and acquitted of murder; the jury found him not guilty on grounds of reasonable doubt. However, the story haunts every person connected to it, and this painting uses the tale to focus on the vulnerability of women victims of murder or suicide. Andre said at the time that they had quarrelled about the fact that he was 'more exposed to the public' than she was, and so the familiar issue of competitiveness between artist couples raises its head.

Fashions surrounding mourning are subject to the flux of time and taste; you do not often see people these days wearing armbands to mourn the loss of a close relative,

for example. The skull, however, rules supreme as symbolic device, whether as an emoji on a screen, a decoration on designer wear, or replicated in jewellery for low- and high-life consumption. Andrea Modica (b.1960) made a series of photographs depicting crania, staying close to the compositional conventions of forensic photography. Although this technique might seem devoid of feeling, the resultant work is full of humanity. The pictures grew from a study of a group of more than 100 skeletons that had been buried secretly a century ago, and were discovered by prisoners in 1993 when they were preparing the ground for an asylum extension for the criminally insane at the Colorado Mental Health Institute. Modica gained permission to photograph these remains of life and produced works of great calm and strange beauty. Recorded from unexpected viewpoints, the skulls become ovoid footballs with decorative winding rivulets, which in turn suggest doodled faces on the rounded surface. Sometimes the edge of a cloud appears, or a solid, smooth rock from the seaside; wounds and interiors are glanced, along with fissures and breaks, and shadow remnants of the striation of hair. This hard casing for the soft brain is all that remains of the sentient human.

Death

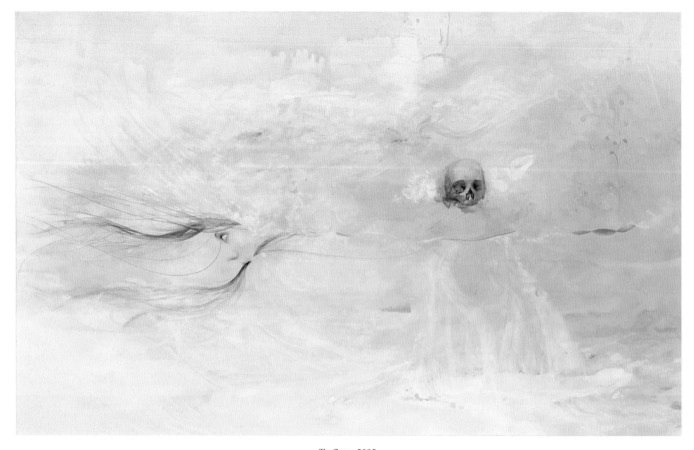

The Grave, 2005
Oil on canvas, 190 x 300 cm (74¾ x 118 in)
Courtesy of the artist; Collection Dean Valentine and Amy Adelson, Los Angeles

Monika Baer (b.1964) attended the Düsseldorf Art Academy in Germany in the late 1980s at a time when the male titans of contemporary art were dominating. This lyrical painting recalls the work of the Belgian artist James Ensor with its pale colours and the inclusion of a skull as an undercutting element. Much as we would like to ignore this symbol of the Grim Reaper, the angel of death is undeniably present in the floating and delicious world of spare sensuality.

The artist shows us the eternal balance of life and death, youth and age, immaturity and maturity. These polarities waft together on the pallid space in a soft ballet composed of thin, carefully painted lines and smudgy gradations of pastel colour. The work is innocuous, frustrating even, in its lack of substance, but nonetheless demands our attention precisely because it is so unassuming.

NICOLE EISENMAN

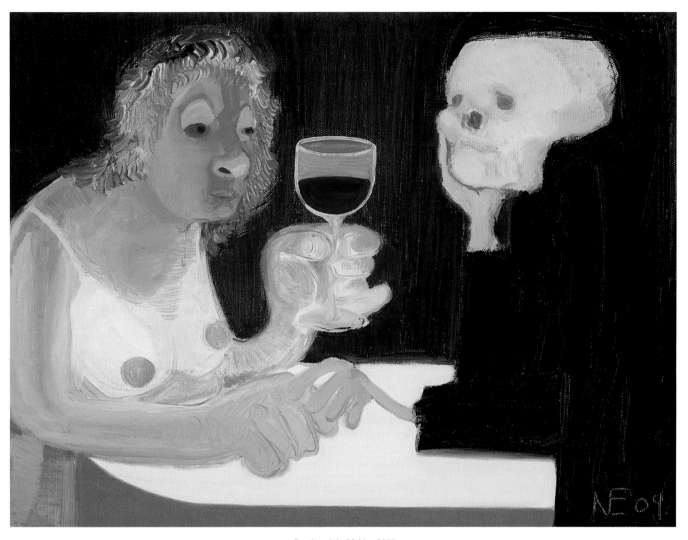

Death and the Maiden, 2009
Oil on canvas, 36.8 × 45.7 cm (14½ × 18 in)
Courtesy of Anton Kern Gallery, New York and Susanne Vielmetter, Los Angeles Projects

In youth there is little thought of death, yet there is always the pressure to live life to the full. The maiden depicted in this painting by Nicole Eisenman (b.1965), based on her centenarian great-aunt, is already sodden and fragile, her pink-nippled bosoms a stark white against her body. They loom rather like the skull emerging out of the darkness, this time clothed in a dark cloak. The white table connects the two; we don't know if they are lovers, but the raised wine glass and the green-fingered hand that touches hers suggest an understanding between the characters. Death (of indeterminate sex) stares into her eyes, chin propped on an upturned hand. It is grotesque and yet tender, a feeling or atmosphere that Eisenman has continued to incorporate into her work with its strong social commentary, much in the manner of William Hogarth. The blank, dark eyes of both characters are empty holes that swallow up the void of the blackness that surrounds them, their stooped frames enhance that complicity as they lean in towards each other. 'I reflect a certain desire in my work, I want my work to be authentic and reflective of my body, what it's interested in. The work is nothing if not feeling-based.'[11] The theme – death and the maiden – is a Renaissance standard that was widely used in music and painting, but here the erotic frisson adds an extra charge that differentiates the motif. Eisenman's eroticism is ironic, downbeat and worn out in contrast to the comely, flexible maidens that appear in the more traditional examples.

MARIELE NEUDECKER

Truth is an Overrated Virtue, 2007
Photogravure, 69 x 57 cm (27⅛ x 22½ in)
Courtesy of Barbara Thumm Gallery, Berlin

The clarity of a simple skull is what Mariele Neudecker (b.1965) presents with her photograph *Truth is an Overrated Virtue*, made from an X-ray of a female skull taken in 1952. The skull is placed squarely on the page, filling two thirds of the space, the shadows appearing ghostly and ominous. The iconography associated with the skull, and its sense of horror and foreboding, is never more manifest than in the manipulation of a medical technique to render this sinister form. X-ray's ability to uncover what lies beneath our mortal casing causes us to confront the time-limited nature of our engagement with this world. Neudecker is better known for her sculpture, film and vitrines filled with sublime landscapes that are sealed in their liquid environments, but this photograph plays to her interests in toying with notions of perception, imagination and memory, and the title of the work hints at a personal meaning as yet unrevealed.

BENEDETTA BONICHI

Pearl Necklace, 2002
Mixed media and X-ray, 140 x 220 cm (55⅛ x 86⅝ in)
Courtesy of the artist

Benedetta Bonichi (b.1968) also uses X-ray, the process whereby tumours, breakages and anomalies can be detected in our bodies, to create her images. In her witty and somewhat macabre combination of X-ray imagery, the octopus tentacles dance like so many mermaid tails, their suckers an alternative diamante dress swirling to a watery tango. The torso is adorned with jewellery, bangles and rings, recalling Meret Oppenheim's *X-ray of My Skull* (1964). These objects, together with the elegant gesturing of the arms, suggest that this is a female emanation, a ghost-like apparition that hovers between seeming substantial and fragile, light-sensitive and fugitive. There is a beautiful synergy between the implied movement of the writhing tentacles and the boney arms; this spliced picture is an underwater collage. It could be read as an alternative and contemporary *danse macabre* (dance of death) that unites us all, rich or poor – a *memento mori* that reminds us about the fragility and vanity of human life.

Death

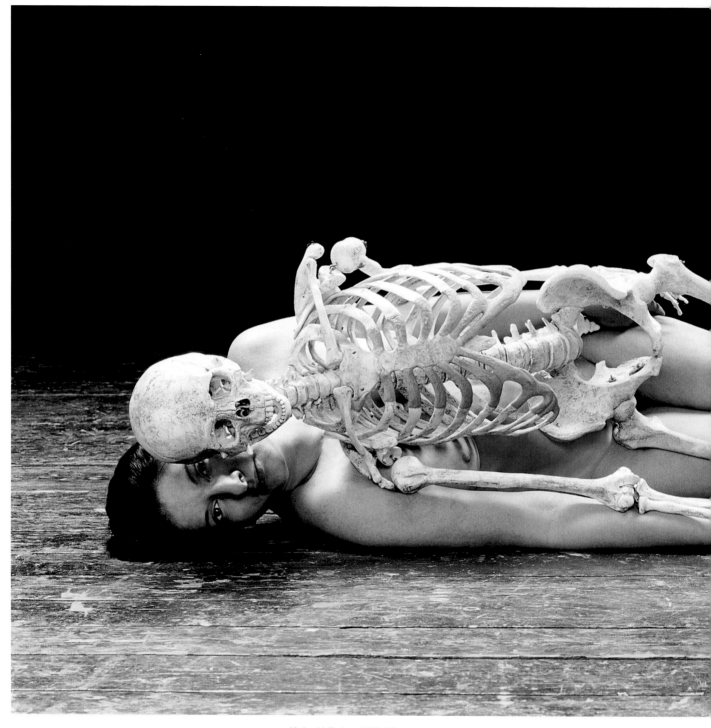

Nude with Skeleton, 2002–05
Performance in Belgrade, Serbia
Courtesy of the artist

The female tibia bone completes its development at around 16 years old, and the male at around 18, which means that male bones often have longer to form and are therefore more pronounced, stronger and thicker then female bones. Marina Abramović's *Nude with Skeleton* shows the artist (b.1946) prone with a full-length skeleton lying on top of her naked body. The film recording of this performance concentrates on the regular breath of the artist and the resulting movement of the skeleton frame lying on top of her. Without the breath there is no life, but the bones of the skeleton, though moving, lifelessly mirror the living bones of the artist below.

The work is visually simple but powerful and full of impact, reflecting Abramović's insistence on exposing the profound realities of being alive and in the moment. In making this work, Abramović has said that she was inspired by the practice of Tibetan Buddhist monks, who sleep alongside the dead in various states of decay in order to understand the process of death. As Abramović so aptly demonstrates in her many works with skeletons, the skull and bones are a familiar signpost to the great mystery of our world: that all flesh is grass. What happens next?

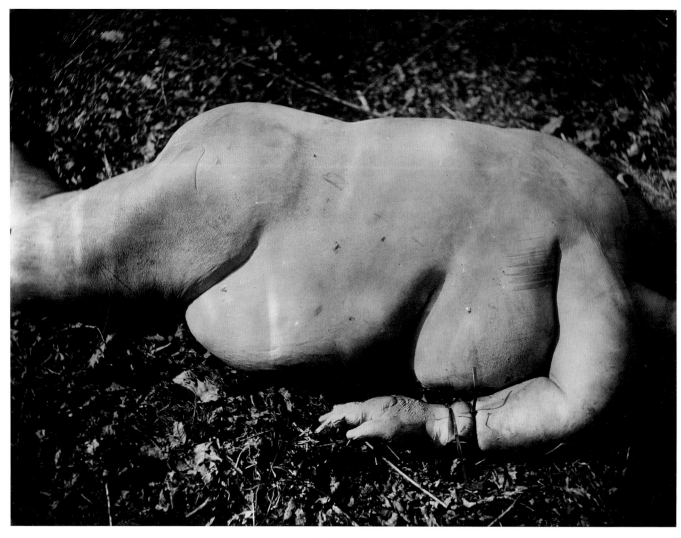

Untitled, 2000
from the series 'What Remains'
Black and white photograph, 76.2 x 96.5 cm (30 x 38 in)
Courtesy of Gagosian Gallery

We are reminded of the base nature of our construction and its fundamental connection to the natural world through the work of Sally Mann (b.1951), who took a series of photographs of dead bodies in varying states of natural decomposition in the open-air surroundings at the University of Tennessee's anthropological facility in Knoxville, known as the 'body farm'. Bodies are left to disintegrate like this for months or longer and are studied scientifically and forensically in order to help solve crimes. Mann has commented that, 'I have long been afflicted with the metaphysical question of death: what does remain? What becomes of us, of our being?'. She goes on to say, 'Death makes us sad, but it can also make us feel more alive. I couldn't wait to get there. The smell didn't bother me. And you should see the colours – they're really beautiful. As [the poet] Wallace Stevens wrote, "death is the mother of beauty".'[12]

That Mann entitled the series of photographs 'What Remains' is an indication of her view that death is not an end; that nature will continue to do 'her' work.

ICONS

ONE CAN'T POSSESS
REALITY, ONE CAN POSSESS
(AND BE POSSESSED BY)
IMAGES —

...

TO POSSESS THE WORLD
IN THE FORM OF IMAGES IS,
PRECISELY, TO RE-EXPERIENCE
THE UNREALITY AND
REMOTENESS OF THE REAL.

Susan Sontag, *On Photography* (1977)

Celebrities and idols are not recent inventions; throughout history, religion and mythology have helped to endow individuals with iconic status. The word 'icon' means image, usually associated with a religious figure, a person or a thing that is revered. The dissemination of power portraits through coinage, books, print and mass reproduction (after the invention of the printing press), ensured that the myth of sovereign power was perpetuated, shared and continually constructed, reinforced and improved. This often resulted in the creation of stereotypes or caricatures that in themselves become iconic, for better or for worse. This occurred not just across sexual types, but also across race and profession , such as with King Henry VIII, Florence Nightingale, Mao Tse-tung, Dolly Parton, Madonna and Donald Trump.

With the invention of photography, it became easier to use and disseminate images to help create fan bases for famous people. Queen Victoria's loyal servants led the way with collectable *cartes de visite*, and Hollywood's silver-screen idols were quick to follow with magazine exploitation. A crush on an actor or pop star is an emotion in need of visual stimulus, and reprographics are on hand to multiply the picture, reiterating the larger-than-life aspect and adapting it at will. Pictures – digital or televized – of heroines or villains appear alongside those of our closest friends in the landscape of our minds; repetition puts them there. That familiarity means that we can instantly recall the Marilyn Monroe pout, the innocent, wide-eyed Audrey Hepburn expression and Princess Diana's victim-like doe eyes.

The individuals themselves often get lost behind the construction of their iconic status, and there is little substance beneath the brand of many popular contemporary icons. Others, however, achieve the status of icon through valued achievement and contribution to our cultural development, writers, artists, filmmakers and musicians amongst them. To be famous is to have currency, to be recognized, to be other and outside the norm, and to be known by a single name only – often, if female, by their first name: Hillary, Amy, Frida, Oprah, Angelina, Zaha, Aretha, Malala, Diana.

Diana was devoured by the media and feasted on by the public, as was Marilyn before her. Greta Garbo knew the secret of successful survival with her famous, seductive and useful mantra, 'I want to be alone'. The phrase itself became an oft-repeated iconic statement, as were phrases like Lauren Bacall's, 'You just put your lips together and blow', or Mae West's, 'Why don't you come up and see me some time?', which is iconic despite being one of the most popular misquotes around (she actually said 'Why don't you come up some time, and see me.') These phrases became part of the structure and identity of the brand, nearly all with some level of sexual allure or hint of promise. Of Garbo, literary theorist Roland Barthes said, 'Garbo still belongs to that moment in cinema when capturing the human face still plunged audiences into the deepest ecstasy, when one literally lost oneself in a human image as one would in a philtre, when the face represented a kind of absolute state of the flesh, which could be neither reached nor renounced.'[1]

This chapter considers the range of icons that women have come to inhabit, both in real and imagined terms, from the religious and the regal to the stereotypical and the cartoon. We reflect on how religious devotion seems in some way to have transferred itself to media stars, altering our ideas of what it means to adore and hold precious, as witnessed by the outpourings of grief at, for example, the deaths of Princess Diana and Amy Winehouse.

MARY MCCARTNEY

Twiggy as Garbo, London, 1997
Bromide print, 30 x 22 cm (11¾ x 8⅝ in)
Courtesy of the artist

In a curiously visible conflation, Mary McCartney
(b.1969) conjured up Greta Garbo's ghostly essence
in a photograph of another icon, Twiggy, who was
equally famous, but in the realm of fashion. Her impish
features, wide, mascaraed eyes and skinny frame took
London by storm in the Swinging Sixties. In this image,
taken in 1997 when Twiggy was almost fifty, she
glows like a lightbulb in the pitch dark of the surround,
all the focus on her angular face and hands. It has the
feeling of a bygone era, of the 1930s when Garbo was at
her peak. She retired from the screen, aged 35, in 1941.

By contrast, *Vogue* magazine's first 100-year-old model,
Bo Gilbert, appeared in the June 2016 issue, in a Harvey
Nichols advertising campaign.

We love to gape, gawp and wonder. The famous person
is our familiar, they come into our homes digitally,
share our space and we feel we know them because
we recognize them. We do, but only in the surface
sheen of a photograph, the sliding by of a film image,
the frozen reflection of a painting. Accumulations
of images multiply to open up our fantasies and the

Display Stand with Madonnas, 1987/89
Aluminium, plaster and paint, 269.9 x 81.9 cm (106¼ x 32¼ in)
Courtesy of Matthew Marks Gallery, New York

famous person is transformed, attaining god-like status; whether deserved or undeserved, the image rules. The Madonnas of the Christian tradition are examples of this, and contemporary artists elaborate on the theme of repetition and use it as a way of investigating formal aspects of sculpture. Katharina Fritsch's *Display Stand with Madonnas* is made up of 288 copies of figurines sold in souvenir shops in the pilgrim town of Lourdes. They oppress us with their repetition and, formed into a yellow tower of Babel, reference all those important phallic towers from Pisa to the Eiffel, the Empire State

to the Gherkin or the Burj Khalifa. The acid yellow is in direct opposition to the sky blue usually associated with the Virgin 'Mother of God', and hints more at golden showers than manna from heaven. Of the icon, Fritsch (b.1956) has herself said, 'The Madonna is just a plaster figure, not Mary herself. To that extent the plaster figure is just as much a thing as a vase. Of course the plaster figure symbolizes something, even something unique. The uniqueness disappears in my work, but essentially it disappears long before, in every souvenir shop.'[2]

Icons

DOROTHY CROSS

Virgin Shroud, 1993
Cowhide, muslin, satin, wood, plaster and iron, 201 x 81 x 120 cm (79⅛ x 31⅞ x 47¼ in)
Tate, London

In her sculpture *Virgin Shroud*, Dorothy Cross (b.1956) uses a cowhide, complete with udders that form the crown, and a satin wedding dress train that was given to her by her grandmother when she was a teenager, draped over a steel dress rack to suggest the figure of the Virgin Mary. Cross has commented that in Irish Catholic culture, the Virgin Mary is considered the perfect woman. The work has a powerful presence, not least because a full cowhide is a large and heavy object and, as the figure is turned away from us, it demands our attention. The natural material of cured skin is in opposition to the spiritual idea of a Virgin Birth. The shroud may suggest the death of this concept. In this way, Cross broadens the reference to art-historical depictions of the subject and alludes to countless other images of birthing in a stable filled with animals. Cross has stated that this sculpture pays homage to a seminal work by the Surrealist artist Meret Oppenheim, *Object (Le Déjeuner en fourrure)* of 1936, which used animal fur to line a teacup, saucer and spoon.

Our Lady of the Iguanas, Mexico, 1979
Gelatin silver print, 50.8 x 40.6 cm (20 x 16 in)
Courtesy of Throckmorton Fine Art, New York

In *Our Lady of the Iguanas* by Graciela Iturbide (b.1942), we are presented with another slightly unsettling interpretation of the Madonna. The headdress here is a cluster of reptiles that recall a frightful underworld of death, destruction and slithering unpleasantness. In fact, the portrait describes a Zapotec woman, Zobeida, who specialized in selling iguanas, for food, in Juchitán market in Oaxaca, Mexico. One of Iturbide's most renowned works, the portrait has almost become a symbol of Zapotec womanhood and is celebrated locally as the Juchitán Medusa. 'Only one photo from the 12 I took of her was good, because it was the only one where the iguanas raised their heads as if they were posing,'[3] The painter Diego Rivera had visited the region previously and commented on the community of strong women living there who had more power and freedom than other Mexican women at the time. When Iturbide visited, she noted that their authority came from being in charge of the finances.

LIZA LOU

Super Sister, 1999
from the series 'Super Diva'
Glass beads and mixed media, 213 x 91 cm (83⅞ x 35⅞ in)
Courtesy of White Cube Gallery, London

The African-American super heroine made entirely of beads and created by Liza Lou (b.1969) is a sassy, flamboyant sculpture: *Super Sister*. Lou is known for the gritty political and social commentary in her work, which is subverted by the prettiness of the materials that she works with. Much of it is created in her studio in Durban, where she works closely with a community of Zulu women bead workers. In *Super Sister*, the aggressively sexy figure with an Afro (which brings to mind the 1960s iconic campaigner Angela Davis) holds a gun at a jaunty angle, suggesting that she might just shoot straight from the hip. This caricature of a black woman is a trenchant comment on how our visual sensibilities are affected by our preconceived

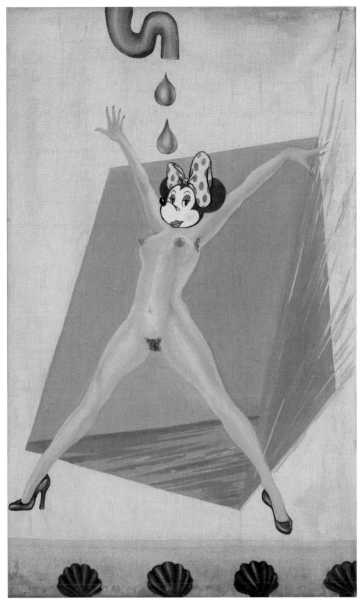

Women of the World Unite, You Have Nothing to Lose but Cheesecake, 1969–70
Acrylic on linen, 88 x 53 cm (34⅝ x 20⅞ in)
Arts Council England

perceptions. The figure is ridiculously tall, the hair massively overblown, the lips huge and madly red, to match the platform shoes. Together with the saucy cut-off jeans and sparkly bra top, the large hooped earrings and heavily made-up eyes, the effect is that of an oversized doll in control of a dangerous weapon. The weapon is sex for sale, but the gun implies danger. Easy to read and yet totally ambiguous and unsettling, *Super Sister* is one of three visions of the perfect woman in Lou's 'Super Diva' series, the others being *Bridal Barbie* and *Business Barbie*. This towering Amazon is a force of nature dressed up as an icon, her energy sandwiched between a sequinned and beaded helmet of hair and a circular launch pad to keep her stable – a force to be reckoned with, and witty to boot.

Minnie Mouse is another fictitious American icon, used by Margaret Harrison (b.1940) as a sexy Pop vehicle on which to hang her feminist viewpoint. Harrison became famous for depicting Hugh Hefner as a naked Bunny Girl, and the result was the raiding and closure of her exhibition by the police in 1971. Such over-reaction is, we hope, a thing of the past, but art can still be provocative and incite all types of behaviour. Harrison was the founder of the London Women's Liberation Art Group in 1970. Minnie Mouse is in exuberant stance as she spreads both legs and arms beneath a tap that drips unknown liquid onto her waiting head. Is she being anointed with a precious substance or is this some kind of shower?

GHADA AMER

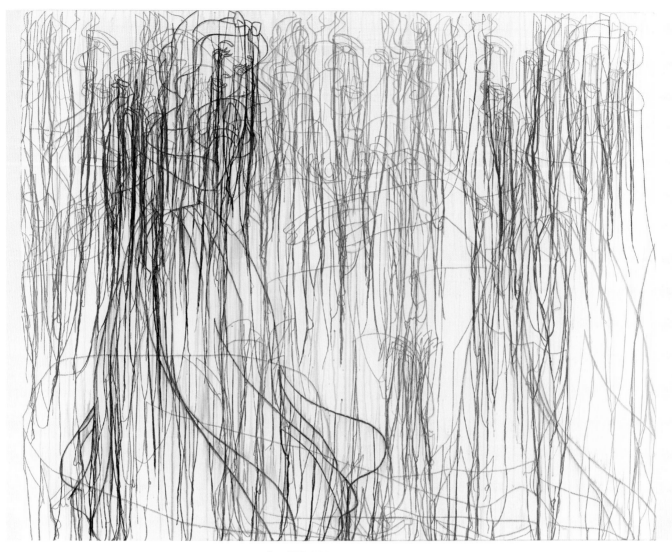

Snow White Without the Dwarves, 2008
Acrylic, embroidery and gel medium on canvas, 127 x 152.4 cm (50 x 60 in)
Courtesy of the artist and Cheim & Reid, New York

Ghada Amer (b.1963) embroiders images of female forms onto canvas, often leaving threads hanging down in front of the bodies so that the multi-coloured skeins become a three-dimensional element of the work. This creates a delicate veiling that speaks of the passing of time and the hours involved in the artwork's production, while also referencing historical tapestries. Although her images are frequently erotic, showing explicit sexual activity, in *Snow White Without the Dwarves* she has playfully depicted one of the icons of childhood, reminding us how, in theory, all little girls (and some boys) want to grow up to be princesses. In this work, Amer repeats the figure, suggesting the animated movement of the original Disney-drawn acetate cells from the 1937 film *Snow White*. Amer has said, 'I believe that all women should like their bodies and use them as tools of seduction'[4] and has not been afraid in her work to explore religious fundamentalism, cultural identity and issues related to the East-versus-West nature of our world today.

BRACHA L. ETTINGER

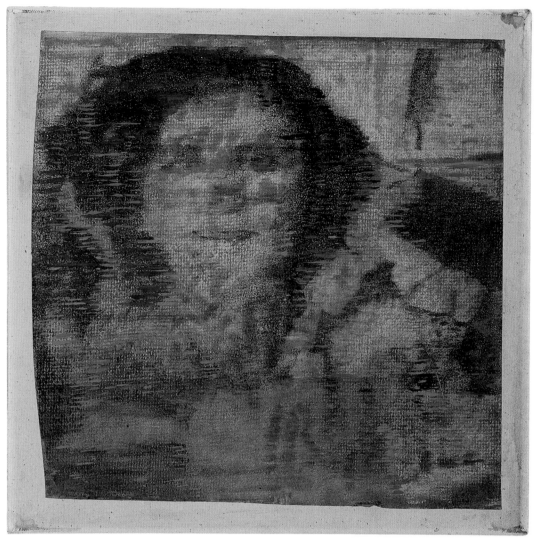

Eurydice n.10., 1994–96
Oil and photocopic dust, pigment and ashes on paper mounted on canvas, 27.8 x 28.1 cm (11 x 11 in)
Courtesy of the artist

If Snow White or Elsa from the film *Frozen* are one type of aspirational role model, then Apollo's daughter Eurydice is another. Bracha L Ettinger's more recent work has been concerned with iconic Greek mythological figures such as Medusa, Persephone and Eurydice. The latter was the wife of Orpheus, and their love was the subject of many visual interpretations from Titian to Jean Cocteau. Ettinger (b.1948) is both artist and psychoanalyst, so one might assume a predisposition to referencing the unconscious symbolism redolent in these mythical stories. As a theoretician, her book *The Matrixial Gaze* (1995) has gained her a place among intellectuals of contemporary French feminism and feminist psychoanalytical thought. *Eurydice n.10* is an ambiguous work; there is a trace of a fleeting, anxious smile and a sense of deep sadness evoked by the purple and dark blood red, coupled with the fact that the portrait seems off register. Her works in this series are created with found images (family photographs, documents from the Holocaust and other sources), which she manipulates and distorts with the use of a photocopier, subsequently filling in the spaces, making marks linked to memory, exile, history and trauma, always with a focus on the gaze.

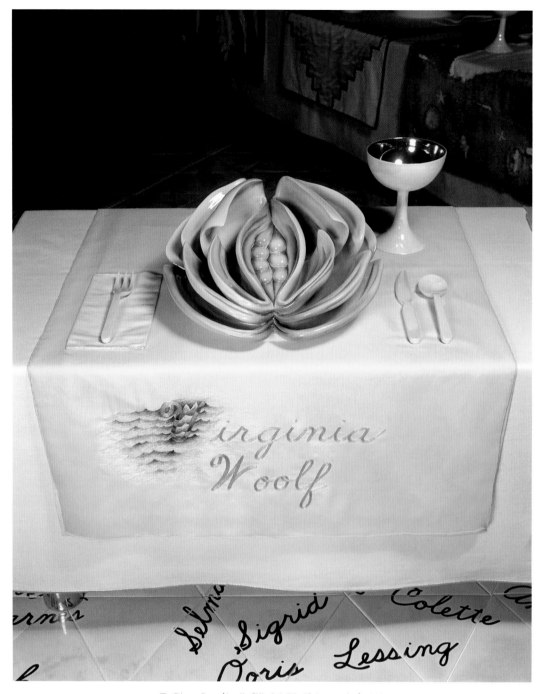

The Dinner Party (detail of Virginia Woolf place setting), 1979
Ceramic, porcelain and textiles, 1463 × 1463 cm (576 × 576 in)
Courtesy of the artist

Judy Chicago's seminal installation *The Dinner Party* scoops up mythology and the real world in a glorious celebration of the richness of women's heritage across the ages. The installation comprises a large triangular table, 48 feet long on each side, which is laid with cutlery and crockery for 39 significant women, including the likes of Virginia Woolf, Artemisia Gentileschi, Sappho, the Hindu goddess Kali and Mary Wollstonecraft. The table cloth and runners on the tables are also embroidered with names and the tiles on the floor bear more, bringing the total tally of women honoured to 1,038. The plates are all designed by Chicago and depict vulva-shaped ornaments that caused huge offence at the time, although the critic Robert Hughes said that it was 'mainly cliché … with the colours of a Taiwanese souvenir factory'.[5] Chicago (b.1939) has said that the work was made with a view to bagging herself a place in the canon.

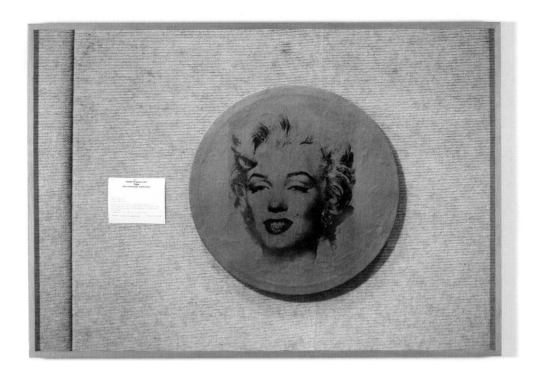

Does Andy Warhol Make You Cry?, 1988
Cibachrome, plexiglass wall label with gilded letter, 69.2 x 99.1 cm (27¼ x 39 in)
Courtesy of the artist and Metro Pictures, New York

We move to one of the most powerful icons of twentieth-century woman, Marilyn Monroe, as troubled and tormented as she was. Louise Lawler's *Does Andy Warhol Make You Cry?* explores the business of reproducing an image of an artwork already in existence, focusing on recording the object as chattel, in this case at auction. Lawler (b.1947) takes other artists' work, repeats their iconography and through repetition and re-presentation draws attention to the

very nature of what constitutes their image making, and the nature of the bought, owned and displayed artwork. Here she appropriates an iconic image by Andy Warhol, the father of appropriation, and makes money and art on the back of both Warhol and the famously exploited Monroe.

ELAINE STURTEVANT

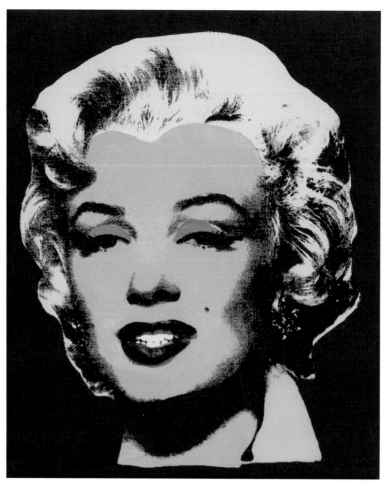

Warhol Licorice Marilyn, 2004
Synthetic polymer silkscreen and acrylic on canvas, 41 x 33 cm (16⅛ x 13 in)
Courtesy of Thaddaeus Ropac Gallery, London, Paris and Salzburg

Marilyn Monroe was known for her naturalness, appearing at ease with her body and the effect that it had on men especially. Much has been made of her shapely size, in that she was not the stick-thin version of female perfection beloved of the modern media. Unusually for a woman, Monroe was often referred to by her surname, a name that immediately conjured up her sexualized, ditzy image, a stereotype that was applied to her and to many other women who were renowned for their beauty and sexual allure. Elaine Sturtevant (1924–2014) recognized the power associated with the use of the surname alone and insisted she be called Sturtevant for much of her career. She, too, was in the business of appropriating images, frequently re-making Warhol's images with his approval. Once asked about his silkscreen technique, he had replied 'I don't know. Ask Elaine'.[6] Her use of repetition, as she liked to call it, allowed her to explore issues of authenticity, changing public taste, iconicity and the making of artistic celebrity.

Throughout her work, Niki de Saint Phalle (1930–2002) worked with the concept of voluptuous women that emerged from a land of caricature and fantasy, inspired by her pregnant friend Clarice Rivers. Her works were often called *Nanas*, the French slang for 'chick', 'broad', 'girlfriend'. The artwork shown here typifies her trademark sculpted female: broad-hipped, colourful and joyful, she possesses the space with confidence. Saint Phalle, originally famous for her gun-slinging exploded pigment paintings, was herself a extraordinary character. From a privileged background, she had an irrepressible urge to become an artist despite family pressures. Her marriage in 1970 to Jean Tinguely set her among a group of heterosexual mid-twentieth century partnerships that provoked mutual artistic developments, both positive and negative, as well as her flowering as an innovative, witty, colourful and pro-women sculptor creating joyous, bounding figures. Her walk-in mythological mother, *HON–en Katedral*, which means 'SHE–a Cathedral', for Moderna Museet, Stockholm, in 1966, was a collaboration with Tinguely and the architect Per Olof Ultvedt. It was large enough for the public to be engulfed between the monster thighs of womanhood that acted as a reverse metaphor for birth.

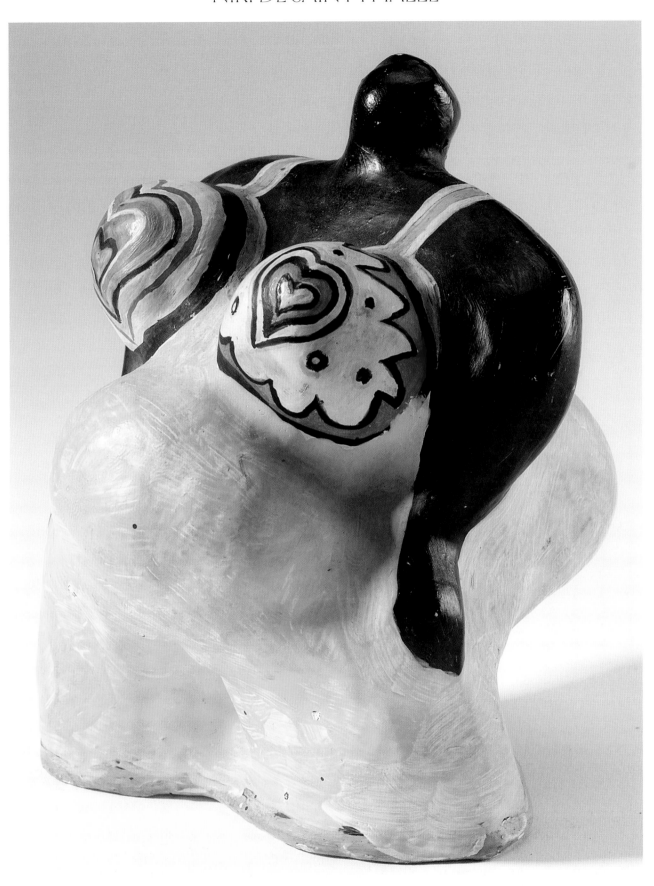

Mini Nana Boule, c.1972
Painted plaster resin, 13.2 x 10.6 x 11 cm (5¼ x 4⅛ x 4⅜ in)
Moderna Museet, Stockholm

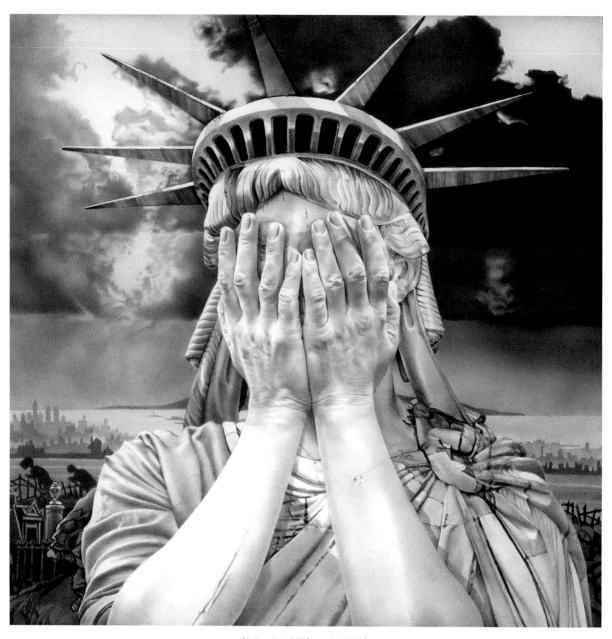

Oh America, 1989 (reworked 1990)
Gouache, 23 x 23 cm (9 x 9 in)
Courtesy of the artist

Scale in figuration can be a sledgehammer, and the representations of our public icons are often so big as to reinforce the message. The US presidents on Mount Rushmore, the now-destroyed monumental sculptures of Stalin, Lenin and Saddam Hussein, and the Buddhas of Bamiyan have all become characters writ large in our public consciousness. The Statue of Liberty took centre stage in this portrait in which Gee Vaucher (b.1945) bemoans the American propensity for war. Vaucher is best known for her radical creativity and for designing record covers for the anarcho-punk band Crass in the late 1970s and early 1980s, work that went on to define the iconography of the punk era. Her work is strongly

political and has continued to be a strong influence in the protest art field. Working with stencils, font and collage, she claims inspiration from the Surrealists, with a particular interest in Max Ernst.

Lynda Benglis (b.1941) herself became a feminist pin-up icon, thanks to her purposefully outrageous self-portrait with dildo, published in *Artforum* (November 1974). The two-page advertisement drew attention to her exhibition at the Paula Cooper Gallery and cost her $3,000. Her mother apparently commented, 'They'll remember you for this,'[7] and so they did. At the time, a slew of powerful female critics

Pink Ladies, 2014
from the series 'Water Sources'
Bronze and cast pigmented polyurethane, element 1: 316.2 x 82.6 x 82.6 cm (124½ x 32½ x 32½ in),
element 2: 330.2 x 91.4 x 63.5 cm (130 x 36 x 25 in), element 3: 241.3 x 76.2 x 68.6 cm(95 x 30 x 27 in)
Courtesy of the artist

were against her approach; undaunted then and now, her artworks have continued in creative and exuberant manner. *Pink Ladies* is one example, from a series 'Water Sources' representing symbolic fountains, this one a group of toppling pink figures in jaunty hats. The title is conceptual, for a Pink Lady is many things: a type of apple (eaten by Eve?); an Edwardian musical, the star of which, Hazel Dawn, was known as the Pink Lady; a Californian mural of a naked (pink-painted) lady; a cocktail that Jayne Mansfield was purported to enjoy on a daily basis in her home, the Pink Palace. All these citations combine to remind us that repetition is part of the remit of the icon, and that the notion of

pink as the colour for girls is still prevalent, whether ironically quoted or not. In reality, however, the colour is inspired by a kite that Benglis saw with Indian designer Asha Sarabhai during the annual kite festival in Ahmedabad, where she also met her partner of 30 years, Anand Sarabhai. The colour also references the fashion editor Diana Vreeland, who once called pink 'the navy blue of India'. Benglis, with her *Artforum* badge of honour, can afford this jokey title because it is a work that, like her, smiles with us.

KAREN KILIMNIK

Me in Russia 1916, Outside the Village, 1999
Oil on canvas, 50.8 x 61 cm (20 x 24 in)
Courtesy of 303 Gallery, New York

Kate Moss, like Twiggy before her, is the 'it' girl of our time. Thanks to the international and vast proliferation of digital imagery, she has emerged as a universal icon of today. Karen Kilimnik (b.1955) uses Mario Testino's Russian *Vogue* image of Moss from 1998 for her portrait, *Me in Russia, 1916, Outside the Village*. In a kind of feeding-frenzy of mutual appreciation, Testino subsequently referenced her painting on his own website. Draped across two gold-leafed, oval-backed chairs and wearing only a coat, the belt is wound around the head as quasi-turban crown. The unfamiliarly dark-haired model gazes at the camera in a semi-petulant manner; she is both ingenue and seductrice doing what she is famous for – portraying the louche nonchalance of an everyday girl put into a supermodel situation. In terms of painting, Kilimnik exploits what we know of the model or, more precisely, what we think we know. Through our easy familiarity with the format, and perhaps riffing on the fact that viewers might have seen the magazine image she appropriates, Kilimnik frees herself of the usual portrait constraints to concentrate on surface.

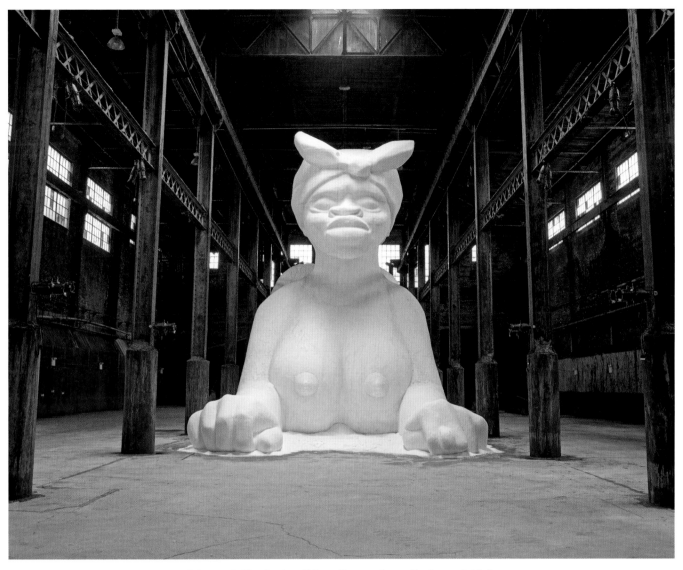

*A Subtlety, or the Marvelous Sugar Baby: an Homage to the unpaid and overworked Artisans
who have refined our Sweet tastes from the cane fields to the Kitchens of the New World
on the Occasion of the demolition of the Domino Sugar Refining Plant*, 2014
Polystyrene foam and sugar, 1,082 x 792.5 x 2,301.2 cm (426 x 312 x 906 in)
Courtesy of the artist and Creative Time

Kara Walker (b.1969) also delves into historical narratives and the way they are distorted, falsified, expanded and suppressed. *A Subtlety, or The Marvelous Sugar Baby* cleverly recycled the black 'mammy', questioned the mythologizing of black women's bodies and offered instead a massive sphinx-like figure made out of pure white sugar. Constructed in Brooklyn's Domino Sugar Factory, the full title clarified the meaning of the work: *an Homage to the unpaid and overworked Artisans who have refined our Sweet tastes from the cane fields to the Kitchens of the New World on the Occasion of the demolition of the Domino Sugar Refining Plant*. This located the work specifically and referred directly to colonialism, slavery, violence and oppression. A 'subtlety' or a 'sotiltee' was an edible sugar sweetmeat sculpture created for medieval banquets,

fashioned in the form of castles, ships and people, advertising the great wealth of the hosts who were able to afford such a valuable commodity. The genius of Walker here was to combine the form of the sphinx (a memorial to the slaves who built the Great Sphinx of Gaza and pyramids of Egypt) and the headscarfed negress, referencing the domestic role that many took on for white families, with yet another racist stereotype: the caricatured body of an overly sexualized black female. *A Subtlety* was a public art project by Creative Time that involved 35 tons of sugar, 32 crew members and countless visitors, but was grounded in the simple fact that it was dealing with the archetypally recognized concept that white equals purity and that the sugar trade, on which so much great white wealth is built, is the story of black slave history.

ELLEN GALLAGHER

Oh! Susanna, 1993
Oil, pencil and paper on canvas, 152.4 x 91.4 cm (60 x 36 in)
Courtesy of Gagosian Gallery

Ellen Gallagher's work has concentrated on race-related identity and gender. Her work often involves transforming ready-made images of racial types found in magazines aimed at African-Americans, such as *Ebony*, her use of collage drawing attention to, and away from, the 'defining' characteristics. In *Oh! Susanna*, Gallagher (b.1965) repeatedly draws the eyes and mouths of what she refers to as the 'disembodied ephemera of minstrelsy',[8] with the occasional intervention of a blonde-headed woman sticking her tongue out. Gallagher has defined minstrel shows as

'the first great American abstraction … Disembodied eyes and lips float, hostage, in the electric black of the minstrel stage, distorting the African body into American blackface.'[9] The title of the work relates to the Stephen Foster song that was originally a slave lament about the breaking up of families, but was soon appropriated by settlers heading out to the California Gold Rush. As a consequence of that adoption, the artist commented that 'The race element is erased, as it becomes an American song of loss. A very specific loss became a universal loss once race is removed.'[10]

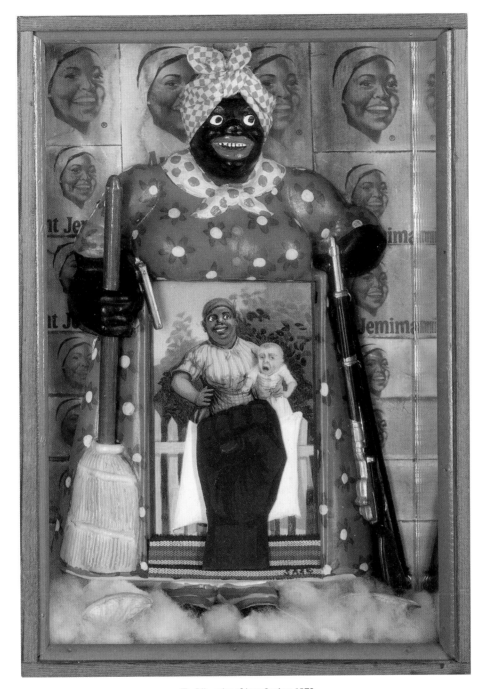

The Liberation of Aunt Jemima, 1972
Mixed media assemblage, 29.8 x 7 x 20.3 cm (11¾ x 2¾ x 8 in)
Berkeley Art Museum and Pacific Film Archive, California

A similar stereotype is quoted in the work of Betye Saar (b.1926) in her *Liberation of Aunt Jemima*, the construction of which owes something to the assemblage sculptor Joseph Cornell. Saar recycled the *Aunt Jemima* logo used by a food company to sell pancake mixture and syrup to draw attention to its obvious racism. Nancy Green, an African-American, born a slave in 1834, was the original model for the logo. Saar reinforces the irony by using multiple images of Jemima armed with both gun and rifle, making this a protest against sexism and racial discrimination; the cotton balls at her feet allude to the fields tended by the slaves for the white American land owners, and the black power fist is prominent in her skirts.

LISA BARNARD

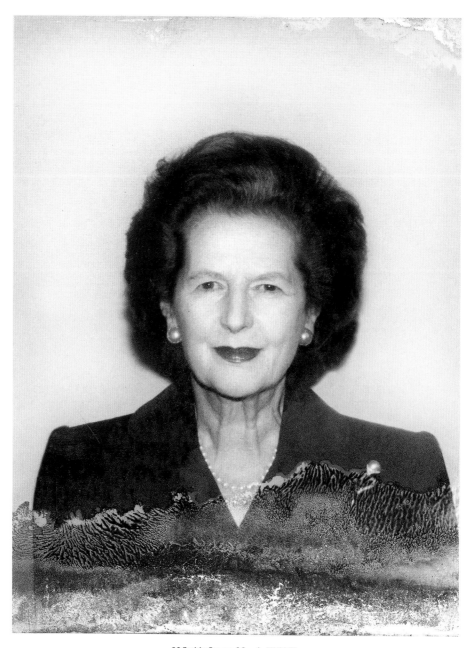

32 Smiths Square, Maggie #7, 2010
C-type print
Courtesy of the artist

Few female politicians are raised to the status of icons, but when their actions are matched by steely resolve and grab public attention, their status transmutes into notoriety, as with Margaret Thatcher, and more recently with Angela Merkel. The latter has been variously portrayed in the guises of the Mona Lisa, Mother Teresa (both on the cover of German magazine *Der Spiegel*), as dominatrix, cross-dresser, the girl with the pearl earring from Vermeer's painting, and as Goethe in Johann Heinrich Wilhelm Tischbein's painting of 1787. It is interesting to note that during the US Presidential campaign of 2016, Hillary Clinton, who has adopted many traditionally male characteristics in order to succeed in her profession, was pilloried and bullied in a way that highlights the misogyny that our female

political leaders still have to endure. Thatcher, who won three general elections in a row, glares out at us with her piercing blue 'Caligula' eyes, as described by then French President François Mitterand. Lisa Barnard's portrait suggests that Thatcher is rising triumphant out of a sea of pollution and her vengeful political actions. The original photograph, originally a press print, was discovered by Barnard (b.1967) when she visited Conservative party headquarters after the building had been decommissioned. Sorting through the paper remains left in the offices, she came across the image and realized that its physical decay was key to a very distinctive and unusual portrait. She reprinted it with all its mess and crumpled edges, making Thatcher herself appear fragile, vulnerable and at risk of fading.

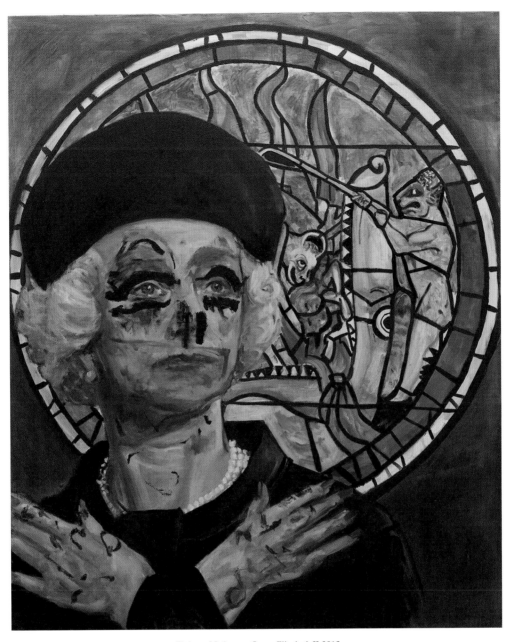

Claire as Madame as Queen Elizabeth II, 2013
Oil and oil stick on canvas, 152 x 120 cm (59⅞ x 47¼ in)
Courtesy of the artist

Artists can be notoriously anti-establishment, and Dawn Mellor (b.1970) takes no prisoners. Her interest lies in celebrities, stars, idols and icons, and in the actor Helen Mirren she has managed to wrap all these elements into one individual. She has obsessively created work related to Mirren, who is known for her strong, sometimes risqué, character roles. Mellor herself is in character when stalking Mirren in this campaign, not unlike a delusional fan. In *Claire as Madame as Queen Elizabeth II* we see her conflate four characters. At the heart of these works lies a subtext that sees Mellor consider the portraits through the eyes of the

servants Claire and Solange from Jean Genet's 1947 play *Les Bonnes* (The Maids), who role-play master and servant while Madame is away. Mellor takes pleasure in allying this story to Mirren's conflicting backstories of both working-class and aristocratic Russian heritages. Claire and Madame are two of the characters represented in this painting, Helen Mirren is recognizable in the portrait as the third, and her stage and screen role as the Queen as the fourth. The halo-like stained glass behind the figure references quasi-religious imagery, drawing the work together in a mass of layered referencing.

Icons

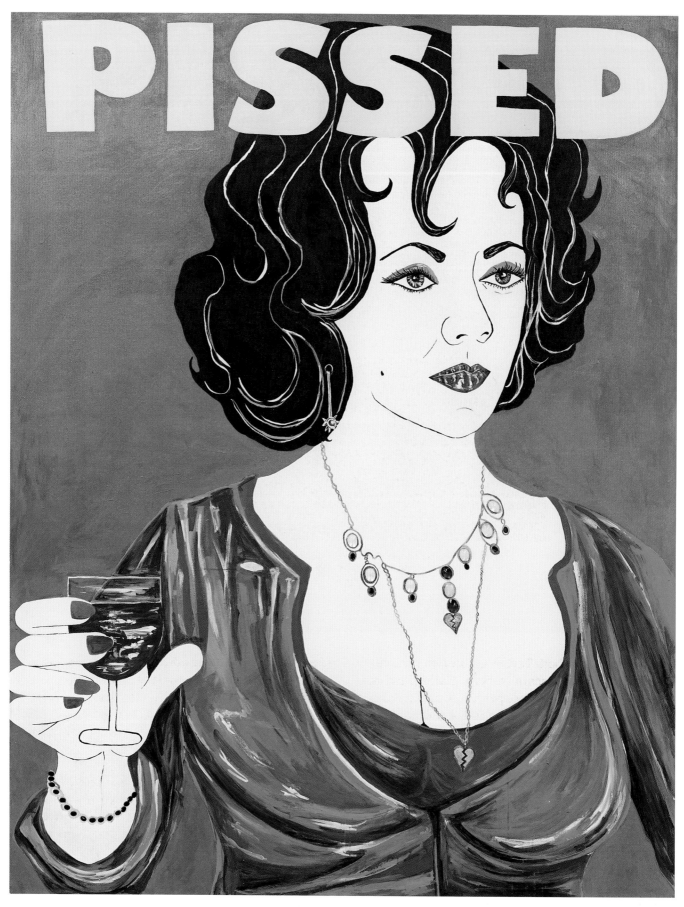

KATHE BURKHART

Pissed, 2007
from the series 'Liz Taylor (Who's Afraid of Virginia Woolf?)'
Acrylic, composition leaf and fake gems on canvas, 259.1 x 200.7 cm (102 x 79 in)
Collection Fabio Zambernardi, Italy

EVELYN HOFER

Lee Krasner's Shoes, Pollock Studio, Long Island, 1988
Dye transfer print, 40.6 x 50.8 cm (16 x 20 in)
Courtesy of the artist

Iconic actress Elizabeth Taylor has been the source of inspiration for a series of works by Kathe Burkhart (b.1958) since 1982. In these parody portraits, Burkhart depicts a sexually empowered, dominant woman – essentially a self-portrait – referencing many of the roles that Taylor has taken on in her impressive movie career. Using a Pop art aesthetic to support the portraits taken from film stills, Burkhart loads the canvases with obscenities that address feminist resistance, female power and unapologetic sexuality. Burkhart's intention is to highlight the prejudice of the media and a public that is keen to see a beautiful and successful woman dragged through the mire, often confusing the characters that she played with the person herself. Burkhart found parallels between her own experiences of sexism in the art world and those Taylor would have encountered in the movie business and – like Taylor – she considers herself ultimately to have managed

success on her own terms, despite the exploitation. In many respects, she champions Liz Taylor as the ultimate feminist icon who, despite her addictions, managed to take on and manipulate male-dominated Hollywood and later went on to become an impressive AIDS activist.

Pictures can themselves become iconic, and Van Gogh's still life of his boots is one such. In this context, the photograph by Evelyn Hofer (1922–2009), who records the American artist Lee Krasner's paint-splattered shoes, connects them to those of Van Gogh, while commenting on the ability of Krasner to drip paint onto a surface much in the same manner as her more famous husband, Jackson Pollock. The irony embedded in this image is huge and yet brilliantly understated; we understand the implications of the work immediately, and can consider it also as a formal portrait.

ANNIE KEVANS

Edmonia Lewis, 2014
from the series 'Women and the History of Art'
Oil on paper, 40 x 30 cm (15¾ x 11¾ in)
Courtesy of the artist

Edmonia Lewis is part of the series 'Women and the History of Art' by Annie Kevans (b.1972), which consists of 30 portraits of successful artists. In some cases, such as this, the portrait both reinstates and creates an icon. Lewis was a phenomenon of the nineteenth century, with a life story that deserves preserving. Born in 1844, Mary Edmonia Lewis's rich background included a father who was a free African-American and a mother who was a Chippewa Native American. Despite enormous difficulties (she was orphaned aged five) and the societal problems of discrimination on grounds of both colour and sex, she trained as a sculptor and made her way to Rome in 1865. In 1876 Lewis participated in the Philadelphia Centennial Exhibition, for which she created her own monumental two-ton marble sculpture, *The Death of Cleopatra,* portraying the queen in time-honoured fashion: post adder bite, and as she was dying. Of her reason for choosing to paint iconic women of the past, Kevans says, 'For hundreds of years there was this very strong control over the canon and [the male-dominated establishment] didn't want women written into it … As a contemporary artist, there are still concerns. I do think, what if that happened to me?'[11]

LORRAINE O'GRADY

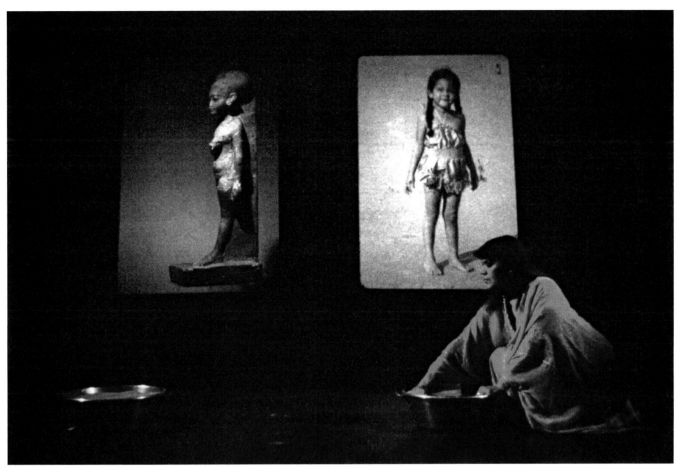

Nefertiti/Devonia Evangeline, 1980
Performance at Midtown Galleries, New York
Courtesy of Alexander Gray Associates, New York

Lorraine O'Grady (b.1934) made her entry into the performance art world in 1980 as Mademoiselle Bourgeois Noire, wearing a dress made of 180 secondhand white gloves and a whip garlanded with white chrysanthemums, making racism her subject matter. In *Nefertiti/Devonia Evangeline* she juxtaposes a photograph of her sister Devonia Evangeline, who died aged 37, with a photograph of the famous sculpture of Nefertiti the Egyptian Queen. O'Grady has also performed a work in which she considers the fractured relationship that she had with her sister, as Nefertiti had with her sister Mutnedjmet. It was only a few weeks before her sister's death that O'Grady had re-established their relationship after years when they did not speak to each other. Two years later, when visiting Cairo, O'Grady felt for the first time that she was among people who were physically like her and her own family, reminding her of the likeness she had always seen between Nefertiti and her own sister. Her intention in the work was also to condemn the attempts of some African-American artists at the time to draw tokenistically on African cultures, as well as to comment on the racism associated with Egyptology.

ISA GENZKEN

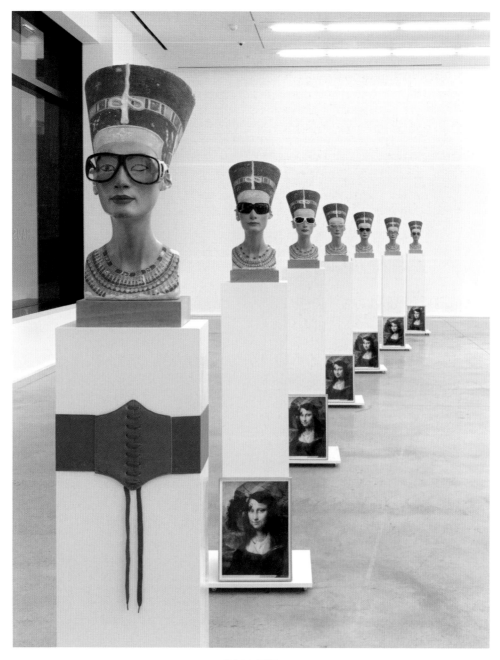

Nofretete, 2012
7 parts: Nefertiti plaster busts, wooden plinths, belt, glasses, colour photographs in aluminium frames, dimensions variable
Courtesy of the artist, Hauser & Wirth and Galerie Buchholz, Cologne, Berlin and New York

Nefertiti was also known as 'lady of all women' and in her work *Nofretete*, Isa Genzken (b.1948) provides us with multiple Nefertitis, adding sunglasses in a light, witty move designed to encourage us to regard this sculpted head in a different and less reverential way. The sunglasses are not standard, nor are they all intact, and the heads are on plinths mounted on casters, so that these are moveable icons. 'I always wanted to have the courage to do totally crazy, impossible, and also wrong

things,'[12] she said in 1994, a year after separating from her husband, the artist Gerhard Richter. At the foot of each mobile pedestal, Genzken places a reproduction of another monumental icon of the Western art canon, Leonardo da Vinci's *Mona Lisa*, with her own features superimposed onto the face and that 'enigmatic' smile. In so doing, Genzken immediately positions herself within the traditions of perceived beauty, history and art history and reiterates standard feminist questions.

MARILYN SILVERSTONE

Mother Teresa, with Indira Gandhi in the background, Delhi, 1972
Black and white photograph
Courtesy Magnum Photos

Statuesque, despite what we know was a tiny frame (she measured less than 5 foot in height), Mother Teresa, photographed by Marilyn Silverstone (1929–99) is instantly recognizable. The crumpled, virginal-pure white cotton with the blue striped border was the uniform of the now-sainted charity worker, who wore a simple sari that recalled the familiar costume of images of the Virgin Mary. The sari also references the plain, homespun *dhoti* made famous by Mahatma Gandhi, as a political statement of independence from British colonialism. Silverstone herself led an interesting life and was ordained a Buddhist nun. The concept of a charitable life led in the service of others appears today as an outdated idea, although in the past public service was a noble ambition for politicians too. That women still do the lion's share of housework and childcare, despite years of 'liberation', points to other unresolved issues related to the glass ceiling and financial independence.

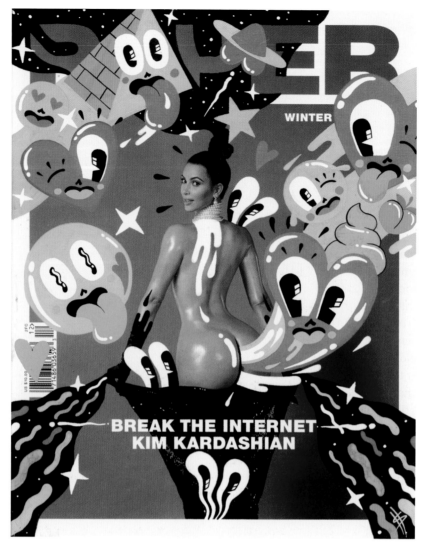

Kim Kardashian, Paper, 2014
Posca marker on magazine cover
Courtesy of the artist

For younger women today, social media-friendly art is on the increase – big, bold and photogenic – a situation entirely in keeping with the Warhol dictum about everybody's 15 minutes of fame. Previously, it tended to be the death of an artist that led to the mythologizing of their output, but today this is revealed through the number of internet hits.

It seems only appropriate to close a chapter on icons with the individual who famously broke the internet with her naked image on the cover of *Paper* magazine in 2014. Kim Kardashian and her family have wholly embraced the potential for fame, celebrity and icon status that social media and television afford. The reality TV show that tracks their lives has established a whole new way of being a voyeur, and has also dramatically influenced the aspirations of people in their own lives today with their desire for money, fame, possessions. Like all good feminists, Kardashian claimed that the stance taken was to encourage women to love their bodies and reject body shaming, claiming, in a tweet on International Women's Day in 2016, that her intention was to empower women and girls all over the world. Her public take as much delight in aspiring to live her life as they do in revelling in her moments of despair. The irreverence that artist and illustrator Hattie Stewart (b.1988) displays in her work for magazines and major brands comes into play in her lenticular portrait of the Kim Kardashian moment: one view presents an image of the genuine article, while the other view, as you slide past, shows the tongue-in-cheek intervention. Employing her doodle-bombing technique to populate the image with colourful characters and emoji-style figures, Stewart both revels in the Kardashian moment, recognizing herself as a young woman of this time, and is able, at the same time, to smile at the nonsense of it all.

CONCLUSION

History and art history are written in diverse and complex ways that have been subject to many political, educational, social and cultural shifts over time. These shifts have been influenced by the evolution of arguments and debates; in relation to the representation of women, most notably by feminists who have sought out and championed women's rights, and women artists, over the last 50 years. While these debates are not the primary subject of this book, *Madam and Eve* stands on those impressive foundations and has sought to celebrate the broad range and quality of work by women artists – those who are already well known, as well as those who deserve to be better known for the impact and quality of their creative practice.

These pages reveal the significant contribution made by women artists to the visual document of the last 50 years. The art they make, and have made, helps us understand and negotiate our world in ways that it would be have been hard to invent without the passion of these talented individuals, many of whom have actually changed the world through their acts of self-expression. Distinguishing female from male art history inevitably risks generalization, but overall we believe that the work featured in this book supports the argument that women artists tend to approach their subject matter with a greater honesty and depth of observation than that of male artists, as well as with a touching, often self-effacing, sense of humour. We are aware from history that radical partisan changes provoke exciting new art and we expect that the altered Western political climate will open the door to powerful artistic innovation, as witnessed with Russian Constructivism in the early twentieth century, German Expressionism in the 1920s and the women's art of the 1970s, which was inspired in part by the freedoms of the previous decade.

Expectations of female artists today have, rightly, moved on, and unlike their predecessors they are not interested in fighting for small victories, but begin their careers with the belief that they deserve the same opportunities as their male counterparts. Suprisingly, perhaps, given the progress of the last 50 years, statistics (see p.54) still provide compelling evidence that a strong bias towards male artists remains. The current trend of re-appreciating women and the women artists in museum collections, alongside a growing list of publications and exhibitions focussing on female artists alone, coupled with the appointment of great women leaders to the influential cultural positions in our world, will, we hope, help achieve a more equal representation in the near future.

What continues to impress is the fluidity and creativity of the ways in which women artists use different media, and their ongoing challenges to established hierarchies. It is now increasingly evident that artists of any gender will use anything that they wish to make art, and often segue happily between painting, photography, writing, sculpture, film and performance. The emphasis is no longer on an exclusive practice.

To some degree, our work on *Madam and Eve* inevitably exposed the narrowness of our perspective and our experiences, and has demanded of us that we broaden our view further so that it is not so focussed on the Western canon in future. In our aim to open the world of women artists as widely as possible, after many years of relegation, we had to sacrifice some depth of examination for each artist in order to include as many as possible, but we encourage our readers to consider the book as a platform from which to leap, delve and discover further.

Madam and Eve began as an opportunity for the two authors to spend more time together looking at and talking about art. Through the process of research and (re)discovery, we experienced many happy and revelatory encounters, and we hope that the reader relishes looking at and sharing these images and artists as much as we did.

LIST OF ARTISTS

Arwa Abouon (b.1982)
Born Tripoli, Libya; lives and works in
Montreal, Canada

Marina Abramović (b.1946)
Born Belgrade, Serbia; lives and works in
New York, USA

Eileen Agar (1899–1991)
Born Buenos Aires, Argentina; lived and
worked in Dorset and London, UK

Ghada Amer (b.1963)
Born Cairo, Egypt; lives and works in
New York, USA

Laurie Anderson (b.1947)
Born Wayne, Illinois, USA; lives and
works in New York, USA

Mamma Andersson (b.1962)
Born Luleå, Sweden; lives and works in
Stockholm, Sweden

Sofonisba Anguissola (1532–1625)
Born Cremona, Italy; lived and worked
in Madrid, Spain, and Genoa, Italy

Eve Arnold (1912–2012)
Born Philadelphia, Pennsylvania, USA;
lived and worked in New York, USA and
London, UK

Elizabeth Alice Austen (1866–1952)
Born Rosebank, New York, USA; lived and
worked in Staten Island, New York, USA

Gillian Ayres (b.1930)
Born London, UK; lives and works in
Cornwall, UK

Monika Baer (b.1964)
Born Freiburg im Breisgau, Germany,
lives and works in Berlin, Germany

Alice Bailly (1872–1938)
Born Geneva, Switzerland; lived and
worked in Paris, France; Geneva and
Lausanne, Switzerland

Maja Bajevic (b.1967)
Born Sarajevo, Bosnia and Herzegovina;
lives and works in Paris, France

Bobby Baker (b.1950)
Born Kent, UK; lives and works in London,
UK

Fay Ballard (b.1957)
Born, lives and works in London, UK

Phyllida Barlow (b.1944)
Born Newcastle upon Tyne, UK; lives and
works in London, UK

Lisa Barnard (b.1967)
Born Kent, UK; lives and works in Lewes,
East Sussex, UK

Yael Bartana (b.1970)
Born Kfar Yehezkel, Israel; lives and
works in Amsterdam, the Netherlands,
Berlin, Germany and Tel Aviv, Israel

Marie Bashkirtseff (1858–84)
Born Havrontsi, Poltava, Ukraine; lived
and worked in Paris, France

Mary Beale (1633–99)
Born Barrow, Suffolk, UK; lived and
worked in London, UK

Vanessa Beecroft (b.1969)
Born Genoa, Italy; lives and works in
Los Angeles, California, USA

Vanessa Bell (1879–1961)
Born London, UK lived and worked in
Firle, UK

Lynda Benglis (b.1941)
Born Lake Charles, Louisiana, USA; lives
and works in New York and Santa Fe, USA,
and Ahmedabad, India

Charlotte Berend-Corinth (1880–1967)
Born Berlin, Germany; lived and worked
in Berlin, Germany and New York, USA

Dara Birnbaum (b.1946)
Born, lives and works in New York, USA

Barbara Bloom (b.1951)
Born Los Angeles, California, USA; lives
and works in New York, USA

Sandra Blow (1925–2006)
Born London, UK; lived and worked
in London and Cornwall, UK

Benedetta Bonichi (b.1968)
Born, lives and works in Rome, Italy

Pauline Boty (1938–66)
Born, lived and worked in London, UK

Louise Bourgeois (1911–2010)
Born Paris, France; lived and worked in
New York, USA

Claire Bretécher (b.1940)
Born in Nantes, France; lives and works
in Paris, France

Romaine Brooks (1874–1970)
Born Rome, Italy; lived and worked in
Paris, France

Cecily Brown (b.1969)
Born London, UK; lives and works in
New York, USA

Trisha Brown (1936–2010)
Born Aberdeen, Washington, USA; lived
and worked in New York, USA

Kathe Burkhart (b.1958)
Born Martinsburg, West Virginia, USA;
lives and works in New York, USA

Elizabeth Southerden Thompson,
Lady Butler (1846–1933)
Born Lausanne, Switerland; lived and
worked in County Tipperary, Ireland

Sophie Calle (b.1953)
Born Paris, France; lives and works in
Malakoff, France

Julia Margaret Cameron (1815–79)
Born Calcutta (now Kolkata), India; lived
and worked in London and the Isle of
Wight, UK

Mary Stevenson Cassatt (1844–1926)
Born Allegheny City, Pennsylvania; lived
and worked in Paris, France

Isabel Castro Jung (1972)
Born Ostfildern-Ruit, Germany; lives and
works in London, UK

Helen Chadwick (1953–96)
Born, lived and worked in London, UK

Judy Chicago (b.1939)
Born Chicago; lives and works in
New Mexico, USA

Jeanne-Claude Christo (1935–2009)
Born Casablanca, Morocco; lived and
worked in Paris, France and New York,
USA

Camille Claudel (1864–1943)
Born Fère-en-Tardenois, France; lived and worked in Paris, France

Prunella Clough (1919–99)
Born, lived and worked in London, UK

Anne Collier (b.1970)
Born Los Angeles, California, USA; lives and works New York, USA

Ithell Colquhoun (1906–88)
Born Assam, India; lived and worked in London and Cornwall, UK; Paris, France

Beryl Cook (1926–2008)
Born Egham, Surrey, UK; lived and worked in Plymouth, Devon, UK

Eileen Cooper (b.1953)
Born Glossop, Derbyshire, UK; lives and works in London, UK

Liz Craft (b.1970)
Born, lives and works in Los Angeles, California, USA

Dorothy Cross (b.1956)
Born Cork, Ireland; lives and works in Connemara, Ireland

Imogen Cunningham (1883–1976)
Born Portland, Oregon, USA; lived and worked in Seattle, Washington and San Francisco, California, USA

McCrea Davison (1991)
Born in New Haven, Connecticut, USA; lives and works in New York, USA

Mary Delany (1700–88)
Born Coulston, UK; lived and worked in London, UK and Dublin, Ireland

Sonia Delaunay (1885–1979)
Born Odessa, Ukraine; lived and worked in Paris, France

Olga Della-Vos-Kardovskaia (1875–1952)
Born, lived and worked in the Soviet Union

Rineke Dijkstra (b.1959)
Born Sittard, the Netherlands; lives and works in Amsterdam, the Netherlands

Kaye Donachie (b.1970)
Born Glasgow UK; lives and works in London, UK

Rita Donagh (b.1939)
Born UK; lives and works in Oxfordshire, UK

Rosalyn Drexler (b.1926)
Born New York, USA lives and works in Newark, New Jersey, USA

Lili Dujourie (b.1941)
Born Roeselare, Belgium; lives and works in Ghent, Belgium

Marlene Dumas (b.1953)
Born Cape Town, South Africa; lives and works in Amsterdam, the Netherlands

Françoise Duparc (1726–78)
Born Murcia, Spain; lived and worked in Marseille and Paris, France, and London, UK

Nicole Eisenman (b.1965)
Born Verdun, France; lives and works in New York, USA

Nezaket Ekici (b.1970)
Born Kırşehir, Turkey; lives and works in Berlin, Germany

Tracey Emin (b.1963)
Born, lives and works in London, UK

Lalla Essaydi (b.1956)
Born Morocco; lives and works in Boston, Massachusetts, USA and New York, USA

Bracha L. Ettinger (b.1948)
Born Tel Aviv, Israel; lives and works in Tel Aviv, Israel and Paris, France

VALIE EXPORT (b.1940)
Born Linz, Austria; lives and works in Vienna, Austria

Alexandra Exter (1882–1949)
Born Bialystok, Russia (now Poland); lived and worked in Paris, France

Cao Fei (b.1978)
Born in Guangzhou, China; lives and works in Beijing, China

Rose Finn-Kelcey (1945–2014)
Born Northampton, UK; lived and worked in London

Lavinia Fontana (1552–1614)
Born Bologna, Italy; lived and worked in Rome, Italy

Elisabeth Frink (1930–93)
Born Suffolk, UK; lived and worked in Surrey and Dorset, UK

Katharina Fritsch (b.1956)
Born Essen, Germany; lives and works in Düsseldorf, Germany

Ellen Gallagher (b.1965)
Born Providence, Rhode Island, USA; lives and works in New York, USA and Rotterdam, the Netherlands

Giovanna Garzoni (1600–70)
Born Ascoli Piceno, Italy; lived and worked in Venice and Rome, Italy

Artemisia Gentileschi (1593–1652/3)
Born Rome, Italy; lived and worked in Florence, Rome, Venice, Naples, Italy and London, UK

Isa Genzken (b.1948)
Born Bad Oldesloe, Germany; lives and works in Berlin, Germany

Kate Gilmore (b.1975)
Born Washington DC, USA; lives and works in New York, USA

Natalia Goncharova (1881–1962)
Born Tula Province, Russia; lived and worked in Moscow and St Petersburg, Russia and Paris, France

Sarah Goodridge (1788–1853)
Born Templeton, Massachusetts, USA; lived and worked in Boston, Massachusetts, USA

Sheela Gowda (1957)
Born Bhadravati, India; lives and works in Bangalore, India

Guerilla Girls (formed 1985–)
Based in New York, USA
Anthea Hamilton (b.1978)
Born, lives and works in London, UK

Susie Hamilton (b.1950)
Born, lives and works in London, UK

Harmony Hammond (b.1944)
Born Chicago, Illinois, USA; lives and
works in New Mexico, USA

Margaret Harrison (b.1940)
Born Wakefield, Yorkshire, UK; lives and
works in San Francisco, USA and Cumbria,
UK

Mona Hatoum (b.1952)
Born Beirut, Lebanon; lives and works
in London, UK

Margaretha Haverman (active by
1716–22 or later)
Born Breda, the Netherlands; lived and
worked in Amsterdam, the Netherlands
and Paris, France

Barbara Hepworth (1903–75)
Born Wakefield, Yorkshire, UK; lived and
worked in Paris, France; Cornwall and
London, UK

Lynn Hershman Leeson (1941)
Born Cleveland, Ohio, USA; lives and
works in San Francisco, California and
New York, USA

Lubaina Himid (b.1954)
Born Zanzibar, Tanzania; lives and works
in Preston, UK

Hannah Höch (1889–1978)
Born Thuringia, Germany; lived and
worked in Berlin, Germany

Evelyn Hofer (1922–2009)
Born Marburg, Germany; lived and worked
in New York, USA

Jenny Holzer (b.1950)
Born Gallipolis, Ohio, USA; lives and works
in New York, USA

Roni Horn (b.1955)
Born, lives and works in New York, USA

Runa Islam (b.1970)
Born Dhaka, Bangladesh; lives and works
in London, UK

Graciela Iturbide (b.1942)
Born, lives and works in Mexico City,
Mexico

Tess Jaray (b.1937)
Born Vienna, Austria; lives and works
in London, UK

Chantal Joffe (b.1969)
Born St Albans, Vermont, USA; lives and
works in London, UK

Joan Jonas (b.1936)
Born, lives and works in New York, USA

Lucy Jones (b.1955)
Born London, UK; lives and works in
Edinburgh, UK

Birgit Jürgenssen (1949–2003)
Born, lived and worked in Vienna, Austria

Kirsten Justesen (b.1943)
Born Odense, Denmark; lives and works
in Copenhagen, Denmark and New York,
USA

Frida Kahlo (1907–54)
Born Coyoacán, Mexico; lived and worked
in Coyoacán, Mexico

Hayv Kahraman (b.1981)
Born Baghdad, Iraq; lives and works
in Los Angeles, California, USA

Gertrude Käsebier (1852–1934)
Born Des Moines, Iowa, USA; lived and
worked in New York, USA

Nina Katchadourian (b.1968)
Born Stanford, California, USA; lives
and works in Brooklyn, USA

Angelica Kauffman (1741–1807)
Born Chur, Switzerland; lived and worked
in Rome, Italy and London, UK

Minna Keene (1861–1943)
Born Arolsen, Germany; lived and worked
in London, UK and Montreal and Toronto,
Canada

Mary Kelly (b.1941)
Born Iowa, USA; lives and works in New
York, USA

Annie Kevans (b.1972)
Born Cannes, France; lives and works
in London, UK

Karen Kilimnik (b.1955)
Born, lives and works in Philadelphia,
Pennsylvania, USA

Anna Elizabeth Klumpke (1856–1942)
p. 22
Born San Francisco, USA; lived and
worked in San Francisco and Boston, USA,
and Paris, France

Laura Knight (1877–1970)
Born Derbyshire, UK; lived and worked
in Cornwall and London, UK

Katarzyna Kozyra (b.1963)
Born Warsaw, Poland; lives and works
in Warsaw, Poland and Berlin, Germany

Lee Krasner (1908–84)
Born, lived and worked in New York, USA

Klara Kristalova (b.1967)
Born Prague, Czech Republic; lives and
works in Norrtälje, Sweden

Barbara Kruger (b.1945)
Born Newark, New Jersey, USA; lives
and works in New York and Los Angeles,
California, USA

Ella Kruglyanskaya (b.1978)
Born Riga, Latvia; lives and works in
New York, USA

Nicola L (b.1937) p.105
Born Mazagan, Morroco; lives and works
in New York, USA

Jessica Lagunas (b.1971)
Born Nicaragua; lives and works in New
York, USA

Maria Lassnig (1919–2014)
Born Carinthia, Austria; lived and
worked in New York, USA; Paris, France
and Vienna, Austria

Louise Lawler (b.1947)
Born, lives and works in New York, USA

Elisabeth Louise Vigée Le Brun
(1755–1842)
Born Paris, France; lived and worked
in Paris, France, Italy, Austria, Russia
and Germany

Doris Lee (1905–83)
Born Aledo, Illinois, USA; lived and worked in Woodstock, New York, USA

Sadie Lee (b.1967)
Born Yorkshire, UK; lives and works in London, UK

Joanne Leonard (b.1940)
Born Los Angeles, California, USA, lives and works in Michigan, USA

Judith Leyster (1609–60)
Born Haarlem, the Netherlands; lived and worked in Amsterdam, the Netherlands

Dana Lixenberg (b.1964)
Born Amsterdam, the Netherlands; lives and works in New York, USA and Amsterdam, the Netherlands

Sharon Lockhart (b.1964)
Born Norwood, Massachusetts, USA; lives and works in Los Angeles, California, USA

Liza Lou (b.1969)
Born New York, USA lives and works in Los Angeles, USA and Durban, South Africa

Fang Lu (b.1981)
Born Guangzhou, China; lives and works in Beijing, China

Sarah Lucas (b.1962)
Born, lives and works in London, UK

Loretta Lux (b.1969)
Born Dresden, Germany; lives and works in Monaco

Susie MacMurray (b.1959)
Born London, UK; lives and works in Manchester, UK

Jill Magid (b.1973)
Born Bridgeport, Connecticut, USA; lives and works in New York, USA

Vivian Maier (1926–2009)
Born in New York, USA; lived and worked in Chicago, USA

Anna Maria Maiolino (b.1942)
Born Scalea, Italy; lives and works in São Paulo, Brazil

Melanie Manchot (b.1966)
Born in Witten, Germany; lives and works in London, UK

Sally Mann (b.1951)
Born, lives and works in Lexington, Virginia, USA

Marisol [Escobar] (1930–2016)
Born Paris, France; lived and worked in New York, USA

Helen Marten (b.1985)
Born Macclesfield, Yorkshire, UK; lives and works in London, UK

Mary Martin (1907–69)
Born Folkestone, UK; lived and worked in London, UK

Mary McCartney (b.1969)
Born, lives and works in London, UK

Kate MccGwire (b.1964)
Born Norwich, UK; lives and works in London, UK

Helen McGhie (b.1987)
Born Honiton, UK; lives and works in Manchester, UK

Dawn Mellor (b.1970)
Born Manchester, UK; lives and works in London, UK

Ana Mendieta (1948–85)
Born Havana, Cuba; lived and worked in New York, USA

Maria Sibylla Merian (1647–1717)
Born Frankfurt, Germany; lived and worked in Amsterdam, the Netherlands

Marisa Merz (b.1926)
Born, lives and works in Turin, Italy

Annette Messager (b.1943)
Born Berck, France; lives and works in Malakoff, France

Lee Miller (1907–77)
Born Poughkeepsie, New York, USA; lived and worked in Paris, France; London, UK and New York, USA

Aleksandra Mir (b.1967)
Born Lubin, Poland; lives and works in London, UK

Lisette Model (1901–83)
Born Vienna, Austria; lived and worked in New York, US

Andrea Modica (b.1960)
Born New York, USA; lives and works in Philadelphia, Pennsylvania, USA

Tracey Moffatt (b.1960)
Born in Brisbane, Australia; lives and works in Sydney, Australia and New York, USA

Mariko Mori (b.1967)
Born Tokyo, Japan; lives and works in Tokyo, Japan and New York, USA

Sarah Morris (b.1967)
Born Sevenoaks, Kent, UK; lives and works in New York, USA

Trish Morrissey (b.1967)
Born Dublin, Ireland; lives and works in London, UK

Catherine Murphy (b.1946)
Born Cambridge, Massachusetts, USA; lives and works in New York, USA

Ishbel Myerscough (b.1968)
Born, lives and works in London, UK

Alice Neel (1900–84)
Born Gladwyne, Pennsylvania, USA, lived and worked in New York, USA

Mariele Neudecker (b.1965)
Born Düsseldorf, Germany; lives and works in Bristol, UK

Ursula Neugebauer (b.1960)
Born Hamm, Germany; lives and works in Berlin, Germany

Hayley Newman (b.1969)
Born Guildford, Surrey; lives and works in London, UK

Marianne North (1830–90)
Born Hastings, Sussex, UK; lived and worked Australia, Canada, Japan, USA, South Africa, Seychelles, Chile, Italy, India and South East Asia

Lorraine O'Grady (b.1934)
Born Boston, Massachusetts, USA; lives and works in New York, USA

List of Artists

Georgia O'Keeffe (1887–1986)
Born Sun Prairie, Wisconsin, USA; lived and worked in Santa Fe, New Mexico, USA

Yoko Ono (b.1933)
Born Tokyo, Japan; lives and works in New York, USA

Meret Oppenheim (1913–85)
Born Berlin, Germany; lived and worked in Paris, France and Bern, Switzerland

ORLAN (b.1947)
Born St Etienne, France; lives and works in Paris, France; Los Angeles and New York, USA

Jackie Ormes (1911–85)
Born Pittsburgh, Pennsylvania, USA, lived and worked Chicago, USA

Cornelia Parker (b.1956)
Born Cheshire, UK; lives and works in London, UK

Clara Peeters (fl.1607–21)
Lived in Antwerp, Belgium

Patricia Piccinini (1965)
Born Freetown, Sierra Leone; lives and works in Melbourne, Australia

Cathie Pilkington (b.1968)
Born Manchester, UK; lives and works in London, UK

Lyubov Popova (1889–1924)
Born, lived and worked in Moscow, Russia

Pussy Riot (formed 2011)
Based in Moscow, Russia

Carol Rama (1918–2015)
Born, lived and worked in Turin, Italy

Christina Ramberg (1946–95)
Born Fort Campbell, Kentucky, USA; lived and worked in Chicago, USA

Berna Reale (b.1965)
Born, lives and works in Belém, Brazil

Paula Rego (b.1935)
Born Lisbon, Portugal; lives and works in London, UK

Liz Rideal (b.1954)
Born Halton, Buckinghamshire, UK; lives and works in London, UK

Bridget Riley (b.1931)
Born, lives and works in London, UK

Faith Ringgold (b.1930)
Born New York, USA; lives and works in La Jolla, California and Englewood, New Jersey, USA

Sophie Ristelhueber (b.1949)
Born, lives and works in Paris, France

Martha Rosler (b.1943)
Born, lives and works in Brooklyn, New York, USA

Susan Rothenberg (b.1945)
Born Buffalo, New York, USA; lives and works in New Mexico, USA

Mika Rottenberg (b.1976)
Born Buenos Aires, Argentina; lives and works in New York, USA

Rachel Ruysch (1664–1750)
Born The Hague, the Netherlands; lived and worked in Dusseldorf, Germany

Betye Saar (b.1926)
Born, lives and works in Los Angeles, California, USA

Niki de Saint Phalle (1930–2002)
Born Neuilly-sur-Seine, France; lived and worked San Diego, California, USA

Doris Salcedo (b.1958)
Born, lives and works in Bogotá, Colombia

Jenny Saville (b.1970)
Born Cambridge, UK; lives and works in Oxford, UK

Miriam Schapiro (1923–2015)
Born Toronto, Canada; lived and worked in California and New York, USA

Helene Schjerfbeck (1862–1946)
Born Helsinki, Finland; lived and worked in Hvinkaa, Finland, Salsjöbaden, Sweden, and Paris, France

Carolee Schneemann (b.1939)
Born Philadelphia, Pennsylvania; lives and works in New York, USA

Joan Semmel (b.1932)
Born, lives and works in New York, USA

Beverly Semmes (b.1958)
Born Washington DC, USA; lives and works in New York, USA

Zinaida Serebriakova (1884–1967)
Born Kharkov, now Ukraine; lived and worked in Petrograd, USSR and Paris, France

Cindy Sherman (b.1954)
Born Glen Ridge, New Jersey, USA; lives and works in New York, USA

Amy Sillman (b.1955)
Born Detroit, USA; lives and works in Brooklyn, USA

Marilyn Silverstone (1929–99)
Born London, UK; lived and worked in Italy and Nepal

Posy Simmonds (b.1945)
Born in Berkshire, UK; lives and works in London, UK

Taryn Simon (b.1975)
Born, lives and works in New York, USA

Penny Slinger (b.1947)
Born London, UK; lives and works in California, USA

Anj Smith (b.1978)
Born Blackham, Kent, UK; lives and works in London, UK

Kiki Smith (b.1954)
Born Nuremberg, Germany; lives and works in New York, USA

Jo Spence (1934–92)
Born, lived and worked in London, UK

Nancy Spero (1926–2009)
Born Cleveland, Ohio, USA; lived and worked in Italy, France and New York, USA

Hannah Starkey (b.1971)
Born Belfast, Northern Ireland; lives and works in London, UK

Jemima Stehli (b.1961)
Born, lives and works in London, UK

Varvara Stepanova (1894–1958)
Born Kovno (now Kaunas), Lithuania;
lived and worked in Moscow, Russia

Jana Sterbak (b.1955)
Born Prague, Czech Republic; lives and
works in Montreal, Canada

Irma Stern (1894–1966)
Born Schweizer–Reneke, South Africa,
lived and worked in Berlin, Germany
and Cape Town, South Africa

Hattie Stewart (b.1988)
Born Colchester, Essex, UK; lives and
works in London, UK

Elaine Sturtevant (1924–2014)
Born Lakewood, Ohio, USA; lived and
worked in Paris, France

Maud Sulter (1960–2008)
Born Glasgow, Scotland; lived and worked
in Edinburgh and Dumfries, UK

Alina Szapocznikow (1926–73)
Born Kalisz, Poland; lived and worked in
Poland and Paris, France

Sophie Taeuber–Arp (1889–1943)
Born Davos, Switzerland; lived and worked
in Paris, France, and Zurich, Switzerland

Fiona Tan (b.1966)
Born Pekanbaru, Indonesia; lives and
works in Amsterdam, the Netherlands

Dorothea Tanning (1910–2012)
Born Galesburg, Illinois; lived and worked
in New York and Arizona, USA and France

Marietta Tintoretto (1560?–90)
Born, lived and worked in Venice, Italy

Daphne Todd (b.1947)
Born York, UK; lives and works in East
Sussex, UK

Milica Tomić (b.1960)
Born, lives and works in Belgrade, Serbia

Betty Tompkins (b.1945)
Born Washington DC, USA; lives and
works in New York and Mount Pleasant,
Pennsylvannia, USA

Charley Toorop (1891–1955)
Born Katwijk, the Netherlands; lived and
worked in Paris, France and Bergen, the
Netherlands

Rosemarie Trockel (b.1952)
Born Schwerte, Germany; lives and works
in Cologne, Germany

Anne Truitt (1921–2004)
Born Baltimore, USA; lived and worked
in Tokyo, Japan and Washington DC, USA

Amalia Ulman (b.1989)
Born San Bernardo, Argentina; lives
and works in London, UK, Los Angeles,
California, USA and Gijon, Spain

Anne Vallayer-Costa (1744–1818)
Born, lived and worked in Paris, France

Adriana Varejão (b.1964)
Born, lives and works in Rio de Janeiro,
Brazil

Gee Vaucher (b.1945)
Born, lives and works in Essex, UK

Charlotte Verity (b.1954)
Born Germany; lives and works in
London, UK

Kara Walker (b.1969)
Born Stockton, California, USA; lives
and works in New York, USA

Rebecca Warren (b.1965)
Born, lives and works in London, UK

Gillian Wearing (b.1963)
Born Birmingham, UK; lives and works
in London, UK

Carrie Mae Weems (b.1953)
Born Portland, Oregon, USA; lives
and works in Brooklyn and Syracuse,
New York, USA

Martha Wilson (b.1947)
Born Philadelphia, Pennsylvania, USA;
lives and works in New York, USA

Rose Wylie (b.1934)
Born, lives and works in Kent, UK

Madame Yevonde (1893–1975)
Born, lived and worked in London, UK

Lynette Yiadom–Boakye (b.1977)
Born, lives and works in London, UK

Lisa Yuskavage (b.1962)
Born Philadelphia, Pennsylvania, USA;
lives and works in New York, USA

List of Artists

NOTES

A HISTORICAL FRAMEWORK

Epigraph (p.11): Anne Truitt, *Prospect: The Journey of An Artist* (New York: Penguin Books, 1997), p.73

1 Linda Nochlin, 'Why Have There Been No Great Women Artists?', *Art News* (January 1971), in *Art and Sexual Politics* (New York and London: Collier Books and Collier-Macmillan, 1973), p.37
2 Whitney Chadwick, *Women, Art, and Society* (London: Thames & Hudson Ltd, 1990), p.78
3 Lisa Wenger, in Francesco Dama, 'Talking About Meret Oppenheimer: An Interview with Lisa Wenger', *Hyperallergic* (6 December 2013). http://hyperallergic.com/91443/talking-about-meret-oppenheim-an-interview-with-lisa-wenger/
4 *Vivian Maier: Street Photographer*, John Maloof (ed.), (New York: powerHouse Books, 2011), p.15
5 Lee Miller, in Anthony Penrose, *The Lives of Lee Miller* (London: Thames & Hudson Ltd, London, 1985), p.183
6 Madame Yevonde, in 'Madame Yevonde's World', *The British Journal of Photography*, 21 January 1988, note ii, p.15, quoted by Eugenia Parry Janis, 'Her Geometry', in Constance Sullivan, *Women Photographers* (London: Virago Press, 1990), p.23
7 Robin Gibson, 'Yevonde: Gradus ad Parnassum' in Robin Gibson and Pam Roberts, *Madame Yevonde: Colour, Fantasy and Myth* (London: National Portrait Gallery, 1990), p.31
8 Ithell Colquhoun, gallery label for *Scylla,* Tate Modern, London, September 2016
9 Oral history interview with Merry Renk, 18–19 January 2001, Archives of American Art, Smithsonian Institution. http://www.aaa.si.edu/collections/interviews/oral-history-interview-merry-renk-11961
10 Sarah Lucas, in a review of her show *God is Dad*, Gladstone Gallery, New York (2005), quoted in *Women Artists: The Linda Nochlin Reader,* Maura Reilly (ed.) (London: Thames & Hudson Ltd, 2015), p.308
11 Rose Finn-Kelcey, quoted in Lisa Tickner, 'One for Sorrow, Two for Mirth: The Performance Work of Rose Finn-Kelcey', *Oxford Art Journal* vol. 3, issue 1 (April 1980), p.61

BODY

Epigraph (p.58): Margaret Atwood, *The Handmaid's Tale* (1985) (London, Virago Press Limited, 1987), pp.72–73.

1 Joan Semmel, 'Feminist Artist Statement', Feminist Art Base, The Elizabeth A. Sackler Center for Feminist Art at the Brooklyn Museum, New York. https://www.brooklynmuseum.org/eascfa/feminist_art_base/joan-semmel
2 Birgit Jurgenssen, in 'Birgit Jurgenssen: Works from the 1970s', exhibition press release for Alison Jacques Gallery, London, 15 October–14 November 2013. http://www.alisonjacquesgallery.com/usr/documents/exhibitions/press_release_url/99/jurgenssen-final.pdf
3 Mona Hatoum, in an interview with Janine Antoni (1998), *Mona Hatoum,* (London: Phaidon Press, 2016), pp.141–43
4 Hayv Kahraman, in Nina Siegal, 'Dark Memories of War Illuminate an Artist's Work', *New York Times* (11 January 2013)
5 Hayley Newman, caption text, *Meditation on Gender Difference*, 1996
6 Rose Finn-Kelcey, in Kathy Battista, *Renegotiating the Body: Feminist Art in 1970s London* (London and New York: I. B. Tauris, 2013), pp.59–60
7 Carolee Schneemann, quoted in Battista, 2013, op. cit., p.63
8 Carolee Schneeman in conversation with Massimiliano Gioni, 'More Than Meat Joy: Carolee Schneeman', *Mousse* 48 (April–May 2015). http://moussemagazine.it/carolee-schneemann-massimilano-gioni-2015/
9 Franklin Furnace, Mission statement, http://www.franklinfurnace.org/about
10 Ursula Neugebauer, *Enface Kurfürstenstraße Berlin* (Dortmund: Druck Verlag Kettler, 2015), preface
11 Catherine Murphy, in conversation with Francine Prose, *BOMB – Artists in Conversation* 53 (Fall 1995). http://bombmagazine.org/article/1885/catherine-murphy
12 Jessica Lagunas, 'Feminist Artist Statement', Feminist Art Base, The Elizabeth A. Sackler Center for Feminist Art at the Brooklyn Museum, New York. https://www.brooklynmuseum.org/eascfa/feminist_art_base/jessica-lagunas
13 Mika Rottenberg, in *Mika Rottenberg and the Amazing Invention Factory*, 'New York Close Up' online film series, *Art21*, 1 February 2013; quoted in Jonathan Munar, 'Ten Artists on Value', *Art21* (April/May 2014)
14 Nancy Spero, quoted in 'The Figure as Hieroglyph: Nancy Spero's "First Language"', Christopher Lyon, *Nancy Spero: The Work* (New York: Prestel, 2010), *artcritical* (20 October 2010). http://www.artcritical.com/2010/10/25/lyon-on-spero/

LIFE

Epigraph (p.100): Luce Irigaray, trans. Hélène Vivienne Wenzel, 'And the One Doesn't Stir without the Other', *Signs: Journal of Women in Culture and Society* vol. 7, no. 1 (Autumn 1981), p.63. In the original publication, the word 'mirror' has a footnote with commentary from the translator, which reads: 'The word in French, *la glace*, has the second meaning of "ice" that carries more strongly than the English "mirror" a sense of movement frozen and rigidified.' http://www.jstor.org/stable/3173507

1 Marina Abramović, in Elisa Lipsky-Karasz, 'Once Upon A Time', *Harper's Bazaar* (March 2012), p.426
2 Ella Kruglyanskaya, in Madeleine Morley, 'Ella Kruglyanskaya on Painting Modern Womanhood' *AnOther* (25 May 2016). http://www.anothermag.com/art-photography/8718/ella-kruglyanskaya-on-painting-modern-womanhood
3 Patricia Piccinini, 'Big Mother' (2005). http://www.patriciapiccinini.net/writing/50/167/71
4 Lynda Nead, *The Female Nude: Art, Obscenity and Sexuality* (London: Routledge, 1992), p.6
5 Marlene Dumas, *Sweet Nothings: Notes and Texts* (Amsterdam: Marlene Dumas in association with Galerie Paul Andriesse, 1998), p.64
6 Chantal Joffe, in Alastair Sooke, 'Chantal Joffe: I don't find men very interesting to look at', *The Telegraph* (11 January 2016)
7 Ibid
8 Tal Dekel, *Gendered: Art and Feminist Theory* (Newcastle upon Tyne: Cambridge Scholars Publishing, 2013), p.136
9 Anna Maria Maiolino, in conversation with Helena Tatay (Documenta 13) http://d13.documenta.de/research/assets/Uploads/A-Conversation-between-Anna-Maria-Maiolino-and-Helena-Tatay.pdf
10 Carrie Mae Weems, in an interview with Karin Andreas, 'Carrie Mae Weems' best photograph: lobster dinner at the kitchen table', *Guardian* (30 October 2014).
11 Carrie Mae Weems, in an interview with Stephanie Eckardt, 'Carrie Mae Weems Reflects on Her Seminal, Enduring Kitchen Table Series,' *W Magazine* (7 April 2016)
12 From British Women Artists Competition, 2016. http://www.britishwomenartists.com/competition-2016.php
13 Lucy Jones, in Priscilla Frank, 'Artist Lucy Jones' Unapologetic Self-Portraits Shatter Perceptions of Disability', *The Huffington Post* (28 April 2015). http://www.huffingtonpost.com/2015/04/28/lucy-jones-self-portraits_n_7153684.html
14 Loretta Lux, in Louise Baring, 'I Use Children as a Metaphor for a Lost Paradise', *The Telegraph* (12 March 2005)
15 Gillian Wearing, in an interview with Tim Adams, *Guardian* (4 March 2012)
16 Dana Lixenberg, *Imperial Courts 1993–2015* (Amsterdam: Roma Publications, 2015)
17 Ibid
18 Ibid
19 Roni Horn, in 'Structures', *Art in the Twenty-First Century* PBS television series, 30 September 2005
20 Roni Horn, quoted in Kathleen Jamie, 'Roni Horn: The Weather Woman', *Guardian* (14 March 2009)
21 Helen Martin, in an interview with Hans Ulrich Obrist, 'More and More Megabytes', *Kaleidoscope* #11 (Summer 2011), p.174
22 Susie Hamilton, in an interview with Paul Stolper, *In Atoms* (2016). http://www.susiehamilton.co.uk/essays-talks/interview-with-paul-stolper-for-in-atoms-catalogue/
23 Ibid
24 Bobby Baker, in Georgina Brown, 'Right off Her Trolley, *Independent* (8 June 1993)
25 Hannah Starkey, 'Women', exhibition press release, Centre Cultural Irelandais, Paris, 11 November 2016–8 January 2017). https://www.britishcouncil.fr/en/events/hannah-starkey
26 Fang Lu, description from the artist's website. http://www.fanglu.net/housework.php
27 Penny Slinger, in an interview with Anna McNay, in *Studio International* (8 April 2015). http://www.studiointernational.com/index.php/penny-slinger-interview-being-different-is-just-who-you-are-tantra-nik-douglas

STORY

Epigraph (p.140): Edmonia Lewis, quoted in 'Letter from L. Maria Child', *National Anti-Slavery Standard* (27 February 1864), published online in the Smithsonian American Art Museum's biography of Edmonia Lewis. (for more on Edmonia Lewis, see the entry on Annie Kevans on p.222 of this book). http://americanart.si.edu/collections/search/artist/?id=2914

1 Lisa Yuskavage, in an interview with Laia Garcia, *Lenny* (12 February 2016). http://www.lennyletter.com/culture/interviews/a263/the-lenny-interview-lisa-yuskavage/
2 Cecily Brown, in Jackie Wullschlager, 'Lunch with the FT: Cecily Brown', *Financial Times* (10 June 2016)
3 Lynette Yiadom-Boakye, quoted in her entry page, Jack Shainman Gallery, New York, website. http://www.jackshainman.com/artists/lynette-yiadom-boakye/
4 Amalia Ulman, in Laura Bates, 'Are Selfies Empowering for Women?', *Guardian* (4 February 2016). http://www.theguardian.com/lifeandstyle/2016/feb/04/are-selfies-empowering-for-women
5 Christina Ramberg, in a description of her exhibition, 13 November, 2013–2 March, 2014, The Institute of Contemporary Art, Boston. http://www.icaboston.org/exhibitions/christina-ramberg
6 Cao Fei, in an interview with Izabella Scott, *The White Review* (June 2016). http://www.thewhitereview.org/interviews/interview-with-cao-fei/
7 John Berger, *Ways of Seeing* (London: Penguin Books, 1972), p.47
8 Rosemarie Trockel, in an interview with Jutta Koether, *Flash Art* 134 (May 1987), p.42
9 Sharon Lockhart, in 'A Few Questions About Place and Time: Sharon Lockhart and Michael Ned Holte in Conversation', *Jan Mot* newsletter 13.73 (August 2010). http://lockhartstudio.com/Interviews/NedHolte_DT.pdf
10 Fiona Tan, in Rachel Vance, 'A Conversation with Fiona Tan', *Ocula* (10 December 2015). http://ocula.com/magazine/conversations/fiona-tan/
11 Letter from the Office of Neil A. Amstrong to Aleksandra Mir, 20 August 2001. From Mir's project description of *First Woman on the Moon*. http://aleksandramir.info/projects/first-woman-on-the-moon/
12 Lubaina Himid, in Alan Rice, *Radical Narratives of the Black Atlantic* (London and New York: Continuum, 2003), p.75
13 Doris Salcedo, quoted in the gallery label for *Atrabiliarios* from *Contemporary Art from the Collection*, Museum of Modern Art, New York, 2011. http://www.moma.org/collection/works/134303?locale=en

DEATH

Epigraph (p.172): Emily Dickinson, 'Because I Could Not Stop for Death', 1890

1 Sylvia Plath, 'Lady Lazarus', *Ariel* (London: Faber & Faber, 1965)
2 Jo Spence, in 'Jo Spence: The Final Project', exhibition press release Richard Saltoun Gallery, London, 11 February–24 March 2016. http://www.richardsaltoun.com/exhibitions/46/overview/
3 Jenny Holzer, interviewed by John Wilson, *Front Row*, BBC Radio 4 (14 July 2015)
4 Taryn Simon, in 'Blow-Up: Brian De Palma and Taryn Simon in conversation', *ArtForum*, vol. 50, no. 10 (Summer 2012)
5 Fay Ballard, 'House Clearance', The Memory Network (1 June 2015). http://thememorynetwork.net/house-clearance-fay-ballard/
6 Sophie Calle, description text, *The North Pole*, Arndt Gallery, Singapore, 12 June–15 September 2010. http://www.arndtfineart.com/website/page_3538
7 Val Williams, 'In Memoriam', *Who's Looking at the Family?* (London: Barbican Art Gallery, 1994), p.100
8 Daphne Todd, in Charlotte Higgins, 'Artist Daphne Todd's Portrait of Mother After Death Makes BP Prize Shortlist', *Guardian* (29 April 2010)
9 Ibid
10 Paula Rego, in Fiona Bradley and Edward King, *Paula Rego: Celestina's House,* exh. cat. (Kendal, UK: Abbot Hall Art Gallery, 2001), p.11
11 Nicole Eisenman, in 'About Nicole Eisenman,' *Artsy*. https://www.artsy.net/artist/nicole-eisenman
12 Sally Mann, in Blake Morrison, 'Sally Mann: The Naked and the Dead', *Guardian* (29 May 2010)

ICONS

Epigraph (p.198): Susan Sontag, *On Photography* (1977) (London: Penguin, 1979), pp.163–64

1 Roland Barthes, *Mythologies* (Paris: Éditions du Seuil, 1957), p.56
2 Katharina Fritsch, exhibition text, *Katharina Fritsch*, Tate Modern, London, 7 August–5 December 2001 http://www.tate.org.uk/whats-on/tate-modern/exhibition/katharina-fritsch/katharina-fritsch-room-five
3 Graciela Iturbide, in Judith Keller, *Graciela Iturbide: Juchitán* (Los Angeles: J. Paul Getty Museum, 2007), p.8
4 Ghada Amer, in her entry page, Gagosian Gallery website. https://www.gagosian.com/artists/ghada-amer/
5 Robert Hughes, in Rachel Cooke, 'The Art of Judy Chicago', *The Observer* (4 November 2012)
6 Patricia Lee, *Sturtevant: Warhol Marilyn* (London: Afterall Books, 2016), p.15
7 Lynda Benglis's mother, in William Poundstone, 'Dear Artforum: About That Lynda Benglis Ad…' (blog entry, 1 August 2011), *Los Angeles County Museum on Fire* blog http://blogs.artinfo.com/lacmonfire/2011/08/01/dear-artforum-about-that-lynda-benglis-ad…/
8 Ellen Gallagher, exhibition text, *Ellen Gallagher: Axme*, Tate Modern, London, 1 May–1 September 2013. http://www.tate.org.uk/whats-on/tate-modern/exhibition/ellen-gallagher-axme/ellen-gallagher-axme-exhibition-room-guide-4
9 Ibid
10 Ibid
11 Annie Kevans, in Nell Frizzell, 'Why Were So Many Female Artists Airbrushed from History?', *Guardian* (19 May 2014)
12 Isa Genzken, in 'Largest Retrospective German Artist Isa Genzken Ever in the Netherlands', press release for *Isa Genzken: Mach Dich Hübsch*, Stedelijk Museum, Amsterdam, the Netherlands, 29 November 2015–6 March, 2016) http://www.stedelijk.nl/en/press-releases/largest-retrospective-german-artist-isa-genzken-ever-in-the-netherlands

Endnotes

INDEX

PHOTO CREDITS

Collections and some copyright credits are given in the captions below the illustrations. Sources for the remaining copyright credits are listed below by page number; L is left and R is right. Credit information for the images on the jacket is the same as the interior images, except where noted.

10 Inv.: 2222. Photo: Wolfgang Pankoke © 2017 Photo Scala, Florence/bpk, Bildagentur fuer Kunst, Kultur und Geschichte, Berlin; 12 Emma F. Munroe Fund, 60.155. Photograph © 2018 Museum of Fine Arts, Boston; 13 © 2017. Photo Scala, Florence – courtesy of the Ministero Beni e Att. Culturali; 14 Charles H. Schwartz Endowment Fund, 2014.4.1, Photo: Allen Phillips/Wadsworth Atheneum; 15L Peter Horree/Alamy Stock Photo; 15R Bridgeman Images; 16 Gift; of Gloria Manney, 2006 © 2017. Image copyright The Metropolitan Museum of Art/Art Resource/Scala, Florence; 17 Purchase: William Rockhill Nelson Trust, 86–20. Photo: John Lamberton; 18 Photograph © National Portrait Gallery, London; 19 M. Theresa B. Hopkins Fund 42.178. Photograph © 2018 Museum of Fine Arts, Boston; 20R Gift of Mrs. Hermine M. Turner. Acc. n.:; 541.1964. © 2017. Digital image, The Museum of Modern Art, New York/Scala, Florence; 21 © Royal Photographic Society/National Museum of Science & Media/Science & Society Picture Library. All rights reserved; 22 Acc. No.: 1890.1; Gift of the artist; 23 Heritage Image Partnership Ltd/Alamy Stock Photo; 25L © 2017 Photo Smithsonian American Art Museum/Art Resource/Scala, Florence; 26 Charles H. Bayley Picture and Paintings Fund, William Francis Warden Fund, Sophie M. Friedman Fund, Ernest Wadsworth Longfellow Fund, Tompkins Collection—Arthur Gordon Tompkins Fund, Gift of Jessie H. Wilkinson—Jessie H. Wilkinson Fund, and Robert M. Rosenberg Family Fund 2015.3130. Photograph © 2018 Museum of Fine Arts, Boston; 27L Institut für Auslandsbeziehungen e. V., Stuttgart © Labor Liedtke, Stuttgart © DACS 2017; 27R Inventory no. A II 909 © 2017. Photo Scala, Florence/bpk, Bildagentur fuer Kunst, Kultur und Geschichte, Berlin; 29L Gift of Wallace and Wilhelmina Holladay; Photograph by Lee Stalsworth; 30L Courtesy the Trustees of the Irma Stern Estate, Cape Town; 30R Photo: Matias Uusikylä; 31 © DACS 2017; 32 © Estate of Vivian Maier; 33 © The Lisette Model Foundation, Inc. (1983). Used by permission; 34L Given by the War Artists Advisory Committee in 1947. Image provided with the permission of RUSI, Royal United Services Institute.; 34R © Lee Miller Archives, England 2017. All rights reserved. www.leemiller.co.uk; 36 Gift of the Honorable Clare Boothe Luce, Photograph by Lee Stalsworth; 37 © Tate, London 2017 © Samaritans, © Noise Abatement Society & © Spire Healthcare; 38 © The Estate of Eileen Agar/Bridgeman Images © Tate, London 2017; 39 © Bowness © Tate, London 2017; 40 Photo Pino Dell'Aquila, Torino; 41 © 1959–2017 Imogen Cunningham Trust; 42–43 Purchase with funds from the Friends of the Whitney Museum of American Art 64.17ai, Digital Image © Whitney Museum, N.Y © Marisol. DACS, London/VAGA, New York 2017; 44 Collection of the artist, photo Paolo Pellion; 45 Copyright © Guerrilla Girls and courtesy of guerrillagirls.com; 46–47 Courtesy of the Boty Estate, © Tate, London 2017; 48 © VALIE EXPORT, Bildrecht Wien, 2017; 49 © Martha Rosler; 50 Private collection,; courtesy The Estate of Alina Szapocznikow/Piotr Stanislawski/Galerie Loevenbruck, Paris © ADAGP, Paris and DACS, London 2017. Photo Fabrice Gousset; 51 Courtesy of the artist and BROADWAY 1602 HARLEM, New York. Photo copyright © 1973 Babette Mangolte, all rights of reproduction reserved.; 53 Photo: Carly Grebe; 60 © Amy Sillman; 61 © Rebecca Warren; 62 © Mary Kelly © Tate, London 2017; 63 © Jenny Saville; 64 © 2017 Joan Semmel/Artists Rights Society (ARS), New York; 65 Estate Birgit Jurgenssen/Bildrecht, Vienna; 66 © the artist; 68 Photo: Tess Angus; 69 © Mona Hatoum; 70 Loop camera, light: Dušan Joksimović/Makeup: Tina Šubić/Costume design: Dejana Vučićević/Special effects: Boban, Studio Atakos/Editing: Miloš Stojanović/Sound design: Mića Zajc/Sound Studio: Simke music; 71 © Kirsten Justesen; 72 © Hayv Kahraman; 73 © ADAGP, Paris and DACS, London 2017; 76 © Adriana Varejão, Photograph Vicente de Mello; 77 Photo: Casey Orr; 78–79 Photo by Minoru Niizuma ©Yoko Ono; 81 © Kiki

Smith; 83 © ADAGP, Paris and DACS, London 2017; 86 Compositing Artist and Photographer: Kathy Grove; 87 © Trish Morrissey; 88 © Ursula Neugebauer; 89 © Rita Donagh; 91 Photos by: Roni Mocán; 92 Courtesy of the artist, GAVLAK Los Angeles/Palm Beach, and private collection; 93 Courtesy of the artist, Collection Walker Art Center, Minneapolis T.B. Walker Acquisition Fund, 1993; 94 Collection Victoria & Albert Museum, London; 95 © Maria Lassnig Foundation; 98 © The Nancy Spero and Leon Golub Foundation for the Arts/DACS, London, VAGA/New York, 2017; 102 © John Cook 2017. All rights reserved.; 104 © McCrea I. Davison; 106 Photo: Christopher Burke © The Easton Foundation © DACS 2017; 107 Photo: Graham Baring; 111 © Ishbel Myerscough (photo on jacket: Antonio Quattrone); 112 Photography Angus Mill © Chantal Joffe; 113 Photo: Per-Erik Adamsson © Mamma Andersson; 116 Photo: Regina Vater; 117 © Cindy Sherman; 119 © Carrie Mae Weems.; 120 © Melanie Manchot; 121 © Helen McGhie; 122 © Lucy Jones; 123 Photo: AGNSW © Tracey Moffatt; 124 Photo: Carl Henrik Tillberg; 125 © DACS 2017/VG-Bild-Kunst, Bonn; 126 Produced with funds contributed by the International Director's Council and Executive Committee Members: Ruth Baum, Edythe Broad, Elaine Terner Cooper, Dimitris Daskalopoulos, Harry David, Gail May Engelberg, Shirley Fiterman, Nicki Harris, Dakis Joannou, Rachel Lehmann, Linda Macklowe, Peter Norton, Tonino Perna, Elizabeth Richebourg Rea, Mortimer D. A. Sackler, Simonetta Seragnoli, David Teiger, Ginny Williams, and Elliot K. Wolk, and Sustaining Members: Tiqui Atencio, Linda Fischbach, Beatrice Habermann, Miryam Knutson, and Cargill and Donna MacMillan; with additional funds contributed by the Photography Committee, 2004; 127 Courtesy of the artist; Anton Kern Gallery, New York; Galerie Neu, Berlin; The Modern Institute/Toby Webster Ltd., Glasgow; Marc Foxx Gallery, Los Angeles.; 128 © Dana Lixenberg; 129 © Roni Horn; 130 © the artist; 132 Commissioned by the London International Festival of Theatre 1993, Photograph © Andrew Whittuck; 133 Photo: Joerg Lohse; 134 © Hannah Starkey; 136 Performance at the 7th Istanbul Biennale, Istanbul, Turkey (Curator Yuko Hasegawa); 137 Performance at the 56th Venice Biennale; 138 © Penny Slinger; 142 © Kaye Donachie; 143 © Lisa Yuskavage; 144–45 © Cecily Brown; 146 © Rose Wylie; 147 © Lynette Yiadom-Boakye; 150 © the artist; 151 Photographer: Tom Van Eynde; 152 Photo: Alex Delfanne; 153 Photos: Stefan Erhard; 154 © Mariko Mori; 155 Cao Fei (SL avatar: China Tracy); 156 Property of Barbara Kabala-Bonarska and Andrzej Bonarski, deposit in the National Museum in Krakow, courtesy of Katarzyna Kozyra Foundation; 157 Photography: Graham Challifour; 158 © Faith Ringgold 1991 © DACS 2017; 159 © Rosemarie Trockel, VG Bild Kunst, Bonn, 2017; 160 © Sharon Lockhart, 2004,; 163 © The Estate of Maud Sulter. Reproduced courtesy of the Estate of Maud Sulter; 164 Produced by Casco Projects on location in Wijk aan Zee, NL, 1999. Aleksandra Mir's royalty fee has been donated to Planned Parenthood, USA.; 165 Presented by the Patrons of New Art (Special Purchase Fund) through the Tate Gallery Foundation 1995 © Lubaina Himid; 166 Installation at the exhibition Doris Salcedo, Museum of Contemporary Art, Chicago, 21 February –24 May 2015. Photo Credit: Patrizia Tocci Photo © Patrizia Tocci; 167 Photo by Hans-Georg Gaul; 168 © Runa Islam. Photo © Gerry Johansson; 169 Julie and Babe Davis Acquisition Fund, 2002; 174 photo: Ben Blackall; 175 © Tracey Emin. All rights reserved, DACS/Artimage 2017. Image courtesy White Cube. Photo: Stephen White; 176 © the Estate of the Artist; 177 © the Estate of the Artist; 178 © 1994 Jenny Holzer, member Artists Rights Society (ARS), NY and DACS, London 2017. Photo: Christopher Burke.; 179 © Taryn Simon; 181 Installation at the exhibition Sophie Calle, 'Rachel, Monique' at La Friche, Palais de Tokyo, Paris, 2010 © ADAGP, Paris and DACS, London 2017. Photo: André Morin; 184 © Paula Rego. Abbot Hall, Lakeland Arts Trust, Purchased with the aid of grants from the Resource/V&A Purchase Grant Fund, National Art Collections Fund, Friends of Lakeland Arts Trust and Calouste Gulbenkian Foundation; 185 © Vanessa Beecroft 2017; 186 Purchased with funds contributed by the Photography Committee, 1998; 187 © 2017 Susan Rothenberg/Artists Rights Society

(ARS), New York and DACS, London 2017.; 188 © 2017 Rosalyn Drexler/Artists Rights Society (ARS), New York; 189 © Andrea Modica; 191 © Nicole Eisenman Collection of Martin and Rebecca Eisenberg; 192 Spike Island Printmakers limited editions project, in collaboration with Arnolfini, Bristol © the artist; 194–95 Photo: Attilio Maranzano, Courtesy of the Marina Abramović Archives © DACS 2017; 196 © Sally Mann; 200 Courtesy Mary McCartney/Trunk Archive; 201 Katharina Fritsch/VG Bild-Kunst, Bonn/© DACS 2017; 202 Presented by the Patrons of New Art (Special Purchase Fund) through the Tate Gallery Foundation 1995 © Dorothy Cross; 203 © Graciela Iturbide; 204 © Liza Lou. Photo © Fanis Vlastaras & Rebecca Constantopoulou; 205 Courtesy the Artist and SILBERKUPPE, Berlin; 208 © Judy Chicago. ARS, NY and DACS/Artimage, London 2017. Photo: © Donald Woodman; 210 © Estate Sturtevant, Paris, 2017; 211 Photo: Moderna Museet/Stockholm; 213 © Lynda Benglis. DACS, London/VAGA, New York 2017; 214 © Karen Kilimnik, courtesy 303 Gallery, New York; 215 Photography by Jason Wyche © Kara Walker; 216 © Ellen Gallagher; 217 Purchased with the aid of funds from the National Endowment for the Arts (selected by The Committee for the Acquisition of Afro-American Art) Photo: Benjamin Blackwell. Courtesy of the Artist and Roberts & Tilton, Culver City, California; 218 © Lisa Barnard; 221 © Estate of Evelyn Hofer; 222 Photograph by Justin Piperger; 224 Installation view at Hauser & Wirth London, 2012 © DACS 2017

Published in 2018 by
Laurence King Publishing Ltd
361–373 City Road, London,
EC1V 1LR, United Kingdom
T +44 (0)20 7841 6900
F + 44 (0)20 7841 6910
enquiries@laurenceking.com
www.laurenceking.com

This book was produced by Laurence King Publishing
Ltd, London

ISBN: 978-1-78627-156-3

Design: Sarah Boris

Printed in Italy

Acknowledgements

Hosking Houses Trust
Pim Baxter
Bénédicte Genet
Mark Gisbourne
Martha Greenhough
Peter Greenhough
Margret Grein
Camille Morineau
Peter Pakesch
Gill Perry
Michael Prodger
Amanda Renshaw
Wayne Tunnicliffe
Dea Vanaghan
Kathryn Wat

Sara Goldsmith
Kara Hattersley-Smith
Charlotte Jansen
Marc Valli and the team
at Laurence King

The Artists and their representatives